Spokane
and the
Inland Northwest
-Historical Images-

Tony Bamonte

Suzanne Bamonte

Towers of wealth melt away as the seasons
with the names of those who possess them.
Should your life be remembered,
let it be for your goodness
and that, in the wholeness of your time,
your greatest gift was love.

Tony Bamonte

Spokane

and the

Inland Northwest

-Historical Images-

Washington Counties:
Ferry, Stevens, Pend Oreille, Lincoln, Spokane

Idaho Counties:
Boundary, Bonner, Shoshone, Kootenai

Tony Bamonte
Suzanne Schaeffer Bamonte

Tornado Creek Publications
Spokane, Washington 1999

Published in 1999
Printed in the United States of America.
by
Walsworth Publishing Company
Marceline, Missouri 64658

Library of Congress Catalog Card Number: 99-96906
ISBN: 0-9652219-4-6

Front cover photo:
Margaret McDonald at the Spokane River, circa 1930
(Eastern Washington State Historical Society, detail of Magee photo, L83-131)

Back cover photo:
Hawk Creek Falls in Lincoln County.
(Photo courtesy Lincoln County Historical Society.)

Tornado Creek Publications
P.O. Box 8625
Spokane, Washington 99203-8625
(509) 838-7114

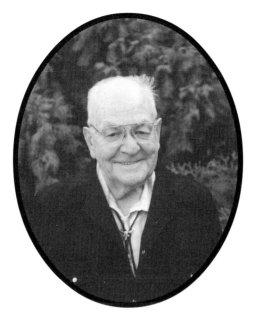

Jerome Peltier
(Bamonte photo 3/23/99)

Standing among the tallest of those who have left their mark in the historic preservation of our Inland Northwest.

As the former owner of Clark's Old Book Store, Jerome "Jerry" Peltier was in a position to procure, preserve and share some of our area's most priceless and forgotten recorded treasures of history. Most of Jerry's life has been generously applied toward that purpose.

Included among the highlights of his life are:

Author of 15 historical books
and over 25 articles in periodical historical publications.

Key founder, contributor and the only lifetime charter member of the
Spokane Chapter of the Westerners Club.

One of the primary founders of the Museum of Native American Culture (MONAC).

One of the key researchers leading to the discovery of the former
Spokane House and Hudson's Bay Company's Fort Spokane.

Contributor of the Frank Palmer photograph and negative collection and over 30 feet
of archival materials to the Eastern Washington State Historical Society.

With our deepest respect and appreciation, we dedicate this book to
Jerome Peltier.

Acknowledgments

We could not have accomplished the production of this publication without the legions of generous individuals who contributed their time, photographs or information. We are deeply grateful and indebted to all named herein for their cooperation. At the inception of this project, one person stands out for her tireless efforts, contributions and support: Shirley Dodson. It is in appreciation of Shirley's participation on behalf of the Stevens County Historical Society and her interest in promoting the preservation of local history that all future rights to this book, upon the deaths of both authors, will pass to the Stevens County Historical Society.

The following people were a constant source of inspiration for the untold hours contributed in editing and proofreading the entire manuscript (in alphabetical order): Anne Anderson, Laura Arksey, Nancy Compau and Ron Miller. To Laura and Nancy, we also extend our appreciation for their dedication to the historical accuracy of the text.

The **contributors of the photographs** have been acknowledged in the credit line accompanying each photo and we encourage the reader to take note of these acknowledgements. Our sincere appreciation is extended to each contributor. Due to limited space, the following abbreviations should be noted: **EWSHS** designates photos from the collections of the Eastern Washington State Historical Society/Cheney Cowles Museum and **NWD** designates photos from Nelson W. Durham's 1912 publication of *Spokane and the Inland Empire.*

We wish to acknowledge the following people for various other contributions such as proofreading sections of the manuscript, checking for historical accuracy, providing research materials or assistance (in alphabetical order):

Mitch Alexander
John Amonson
Wendell Brainard
Dorothy and Bob Capeloto
Jerry Cronkhite
Scott Crytser
Dorothy Dahlgren
Karen DeSeve
Tom Dodson
Nancy Ellis
Larry Elsom
Vern Eskridge
Jennifer Ferguson
Neal Fosseen

Patricia Goetter
Lila Krueger
Dean Ladd
Lois and Dwight Lawyer
John and Dorothy Marchi
Faith McClenney
Jim McGoldrick
Don Neraas
Ray O'Keefe
Jean Oton
Virginia Overland
Frank Peltier
Jerry Peltier
Chuck and Mary Lou Peterson

Sonny and LaVonna Poirier
Evelyn Reed
Eveline Ruhberg
Al and Mae Schaeffer
Lisa Schaeffer
Mary Schell
Thelma Shriner
Dick Slagle
Randy Smith
Andy Szombathy
Doris Underwood
Eva Whitehead

Other Books by Tony & Suzanne Bamonte:

Manito Park: A Reflection of Spokane's Past

History of Newport, Washington

History of Pend Oreille County

Books by Tony Bamonte:

Sheriffs 1911-1989: A History of Murders in the
Wilderness of Washington's Last County

History of Metaline Falls

The Authors:

Tony and Suzanne Bamonte have turned their pastime and passion for writing and publishing Northwest history into a vocation. This is their fourth publication together. They are always looking for access to private photo collections for future publications. If you are interested, they can be contacted at the address or telephone number listed below.

Tony was born in Wallace, Idaho, in 1942 and raised in Metaline Falls, Washington. He was elected and served as Pend Oreille County sheriff for three consecutive terms from 1978 until 1991. He has a master's degree in Organizational Leadership from Gonzaga University and a bachelor's degree in Sociology from Whitworth College. Tony began his law-enforcement career in 1966 as a Spokane city police officer. He has also been a logger, miner, construction worker and a army helicopter door gunner during his tour of duty in Vietnam. In addition to coauthoring and publishing history books with wife Suzanne, he is a licensed Washington State Realtor.

Suzanne was born in Ione, Washington, in 1948 and raised in Metaline Falls, Washington. She graduated from Central Washington University with a bachelor's degree in accounting, subsequently becoming a Certified Public Accountant. Prior to their marriage in 1994, Suzanne lived in Seattle where she worked as the controller of an art glass studio from 1988-1993 and of a publishing company from 1982-1988. Previous to that, she worked in the field of public accounting.

Tornado Creek Publications
P.O. Box 8625
Spokane, WA 99203
(509) 838-7114

Table of contents

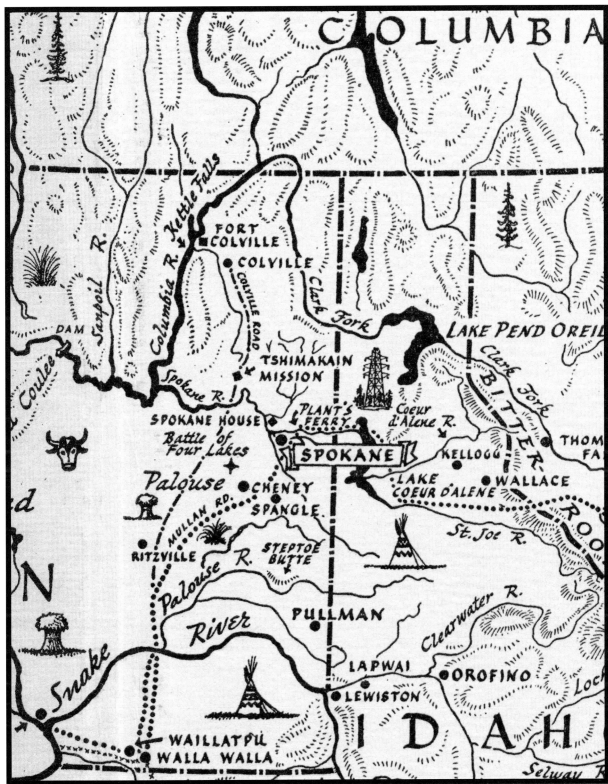

An early map of the Inland Northwest indicating the locations of fur trading forts and missions. Although not shown on the map, the Hudson's Bay Company's Fort Spokane was 1/2 mile from the Spokane House. This map represents the area prior to 1859, the year military forts began to be established. (Note: Because of the early date of this map, some of the place names are not the correct current spellings.)

Introduction:
A Brief History

With the use of sketches, maps, photographs, and enough words to complete a picture, this book offers a visual glimpse of early life, settlement and development in the region that influenced and was influenced by the city of Spokane. The area covered encompasses five northeastern Washington and four north Idaho counties. To begin the presentation, the following history will provide the reader an overview of what drew newcomers into this land already populated for thousands of years by Native Americans.

In 1803 the Louisiana Purchase extended the western United States boundary to the Rocky Mountains. President Thomas Jefferson called upon Meriwether Lewis and William Clark to find what he hoped was a navigable water route to the Pacific Ocean and, to this end, they set out in 1804. This was the beginning of outside exploration into the depths of uncharted territory known as the Oregon Country.

In the early 1800s, several nations (including the British, who occupied Canada) were laying claims to the Oregon Country, which extended from the Rocky Mountains to the Pacific Ocean, Russian Alaska to the north and Spanish California to the south. By 1818 only two contenders were still vying for possession – Great Britain and the United States. Under an unusual arrangement, the two countries agreed to joint possession. This arrangement continued rather amicably in this sparsely populated country for about two decades. During this time, the fur trade was active throughout the region, and the missionaries set out to claim the souls of the native tribes.

The British established a presence in the Oregon Country when David Thompson's party from the North West Company (a Canadian fur trading company) came in search of new fur trade sources in the wild, rich western lands occupied only by Native Americans. Thompson established the Kullyspell House in 1809 and the Spokane House in 1810. Two more fur trading posts soon followed – Fort Spokane in 1812 and Fort Colvile (original spelling – a third "l" has been added more recently) in 1826. These first white settlements in the Inland Northwest were primarily for trade with the Indians, and the atmosphere was amicable. The newcomers were few, bringing new and useful trade goods which influenced the Indians lifestyles. The Whites' survival often depended on the goodwill and helpfulness of the Indians. Consequently, they were, for the most part, on their best conduct.

The next Caucasian settlement in the area were the missions. They are listed chronologically as follows: (1) Tshimakain, a Presbyterian mission, existed from 1838 to 1848. It was founded by the American Board of Commissions for Foreign Missions and was located about 30 miles northwest of Spokane near the present town of Ford, Washington. (2) Sacred Heart Mission was established in 1842 on the north bank of the St. Joe River, near the south end of Lake Coeur d'Alene. The mission moved to a site near Cataldo, Idaho, in 1846 (the "Old Mission" Church), and in 1877 to De Smet, Idaho. (3) St. Ignatius, founded by the Catholics in 1844, was located on the east bank of the Pend Oreille River near Usk, Washington. In 1854 it moved to St. Ignatius, Montana. (4) St. Paul's, also a Catholic mission, was established in 1845 near the Kettle Falls on the Columbia River. Two years later, the original rough-log chapel was replaced with the building that remains today.

After the missionaries opened the way in the late 1830s, eager settlers began to follow. As the population in the Oregon Country grew, so did the need for a single government to handle problems as they arose. A shared arrangement was no longer viable and tensions mounted as each country began to assert its desire for sole

possession. The slogan "Fifty-four Forty or Fight" rang out as the United States sought to establish its northern boundary at the 54th parallel (the southern tip of Alaska, encompassing most of present-day British Columbia). Although the situation came close to erupting in a fight, fortunately a compromise was negotiated and the boundary between Canada and the United States was established at the 49th parallel in 1846.

Two years after the international boundary settlement, the Oregon Territory was officially formed, but further dissection soon followed. Washington Territory was carved from the massive Oregon Territory in 1853, encompassing what is now Washington, northern Idaho and part of Montana. Ten years later Idaho Territory was formed, which included Idaho, Montana and Wyoming. Finally, in 1889 Washington became a state and Idaho followed in 1890. However, territorial boundaries continued to evolve as county lines were drawn and redrawn.

Gold was discovered in the Washington Territory around the time of its formation. The heavy influx of people from the ensuing gold rush caused concern and hostility from the Indians. As the Whites pushed their way into the Indians' lands, many clashes occurred. Unfortunately, to deal with these problems, instead of providing protection for both Indians and Whites, the United States Government established a practice of making war on the Indians. This lack of justice spawned many hostile and deadly encounters from the mid-1850s through the late 1800s.

The government's remedy for ending the bloodshed was the establishment of Indian reservations. As history reveals, the Whites were given priority in land claims with little consideration given to the differences concerning native cultures. Diverse tribes were forced into joint occupation on single reservations, often creating additional tensions. When land within reservations was discovered to be of value to the Whites, boundaries were sometimes redrawn or simply ignored. The task of keeping peace, corralling the Indians onto the reservations and protecting the reservations from the influx of gold-hungry or land-greedy en-croachers fell to the military. The military posts significant to the scope of this book were: (1) Harney's Depot (1859), later called Fort Colville, located near the present town of Colville. (2) Fort Coeur d'Alene (1878), on the banks of Coeur d'Alene Lake near the headwaters of the Spokane River. It was renamed Fort Sherman in honor of General W.T. Sherman following his death in 1891. (3) Fort Spokane (1882) located at the confluence of the Spokane and Columbia Rivers. (4) Fort Wright located near the northwest city limits of Spokane.

The most significant era of settlement occurred in the 1880s. The catalyst for this was a major discovery of placer gold in the Coeur d'Alene Mining District. This was followed by the discovery of some of the world's richest lead, silver, gold, zinc and copper ore bodies, also located in the Coeur d'Alenes. Major mineral discoveries were also made in the northern regions of Ferry, Stevens and Pend Oreille Counties. This aggregate of mineral riches coupled with the vast amounts of timber, agricultural and natural resources brought about the arrival of the railroads and thousands of settlers. It is the intent of this book to preserve some of this rich history.

Hydraulic mining in the late 1880s. Gold was a major factor creating the largest boom to the region. The first gold discoveries in the area were in river and creek beds and along their gravel banks. Compared to later hard-rock mining, it was inexpensive to recover and relatively easy for prospectors to become rich quickly. *(Photo courtesy Spokane Public Library Northwest Room)*

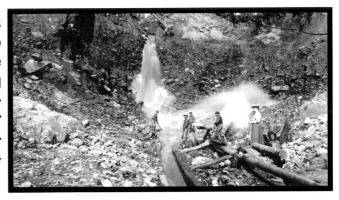

Introduction to Early Photography

Sketches and photographs provide an invaluable record of the external world as it appeared to our ancestors. Consequently, our most accurate visual records of people, places and events began with the advent of photography, which emerged in 1816. The first negative on paper was invented by French physicist, Joseph Nicephore. Eleven years later, he made the first known photograph on metal. At the time, there was no process to preserve these images.

By 1831 the French painter, Louis Jacques Daguerre, had begun perfecting the first permanent photographs. These were called "Daguerreotype photos." This method produced an image on a silver plate (silver-coated tin plate) for each exposure made. The improvement of the daguerreotype process eventually resulted in the modern photography of today.

By 1839, Daguerre had perfected his process enough to announce it publicly. Prior to his announcement a number of newspapers throughout the country had hinted of his ability to reproduce images on paper. Most of these accounts were received by the public with severe skepticism for good reason. Only a short time before Daguerre's announcement, one of the most celebrated hoaxes of the time had been perpetrated on the American public. This hoax was based on a series of articles printed in the *New York Sun* from August 21 to August 31, 1835. These articles announced the reports of the work of Sir John Herschel, a prominent English astronomer, who had been sent by the British government to the Cape of Good Hope to make specific astronomical observations. With this foundation of fact the *Sun* went on to describe an enormous telescope, designed and operated by Herschel, that enabled him to see the geographical features of the moon in minute detail. These articles announced Herschel's description of living inhabitants, including manlike bats. This article created an increase in the circulation of the *New York Sun*; however, when it was later discovered as a hoax, Daguerre's announcement was viewed as another edition of the famed "moon hoax."

A wet collodion (glue solution made of cellulose nitrates) process was introduced in 1851. These are known as Ambrotype photos. Many of these photos are found in museums around the county today. However, because of their flammability, they must be stored cautiously.

In 1883 the American inventor, George Eastman, produced a film consisting of a long paper strip, coated with a sensitive emulsion. In 1889 Eastman produced the first transparent, flexible film support, in the form of ribbons of cellulose nitrate. This invention of roll film marked the end of the early photographic era, and the beginning of a period in which thousands of amateur photographers began creating their own photographic records.

The earliest pictorial illustrations of the Inland Northwest were artists' sketches, both portrait and scenery. These were followed by the early Daguerreotype photos. The first professional photographers to work in this area were the Maxwell brothers, who settled in the Spokane area in the early 1880s. From that point on, there have been numerous other professional and amateur photographers who have magnificently recorded our past as it appeared during their times. Dedicated historians have preserved many of these collections that the images of past generations may be known.

Fur Trading Posts 1809-1871

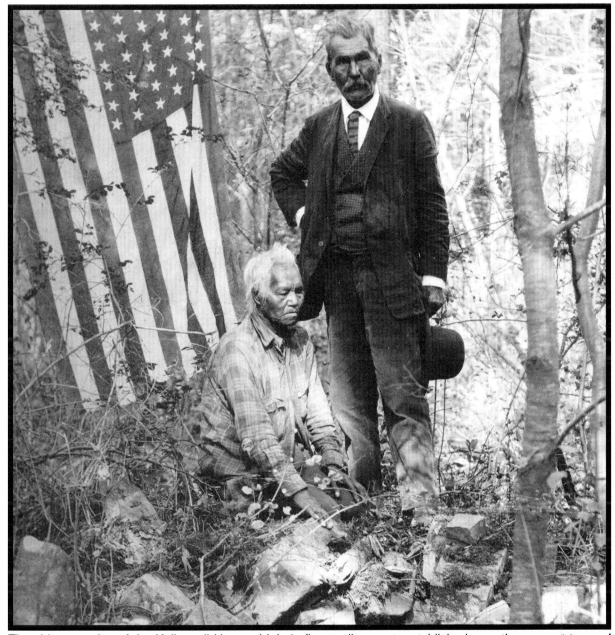

The chimney ruins of the Kullyspell House, Idaho's first trading post, established near the present town of Hope. This photo, taken in 1923, is of Klai-too (also called Alec), a blind Indian guide, and Duncan McDonald, a descendant of Finan McDonald. On September 10, 1809, David Thompson, a representative and partner of the North West Co., entered Idaho from the north and began to erect several substantial log houses on the north shore of Lake Pend Oreille. He named this trading post after the Native Americans who occupied the site at the time.

(Photo courtesy Spokane Public Library Northwest Room, Charles D. Magee collection.)

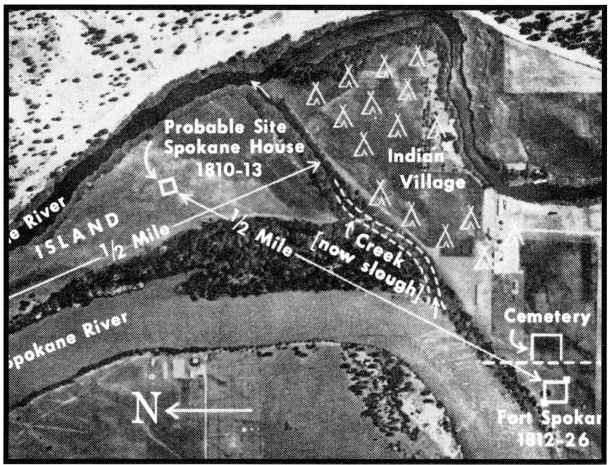

Aerial photo of the locations of the Spokane House and Fort Spokane. *(Photo courtesy Jerome Peltier.)*

The Spokane House was established in 1810 as the first permanent fur trading post in the present states of Washington and Oregon. Its location was at the confluence of the Spokane and Little Spokane rivers a short distance northwest of Spokane. The Spokane House was the North West Company's most important interior post prior to the establishment of Fort Walla Walla in 1818. It continued in importance until 1826 when the Hudson's Bay Company, which had absorbed the North West Company in a merger in 1821, abandoned it in favor of Fort Colvile at the Kettle Falls on the Columbia River.

Interestingly, the original Spokane House was not at the location indicated by a current monument. It had been in operation almost two years when the Pacific Fur Company, founded in New York by John Jacob Astor, built a rival post approximately one-half mile to the southwest. The two posts were in competition for less than a year when the North West Company, a Canadian company, purchased Fort Spokane from the Pacific Fur Company. The original Spokane House was then abandoned and the company moved to the site presently marked as the Spokane House, which is approximately 100 feet south of the Spokane River.

The Spokane House (Old Fort Spokane) did business for 16 years under three flags – Canadian, United States and British. Records of the actual construction are scarce. The accepted date was from notations in David Thompson's journal during his 1810 journey through the area as a representative of the North West Company (a competitor of Thompson's former employer, the Hudson's Bay Company). Its actual construction was delegated to Jacques (Jaco) Finlay and Finan McDonald from the North West Company.

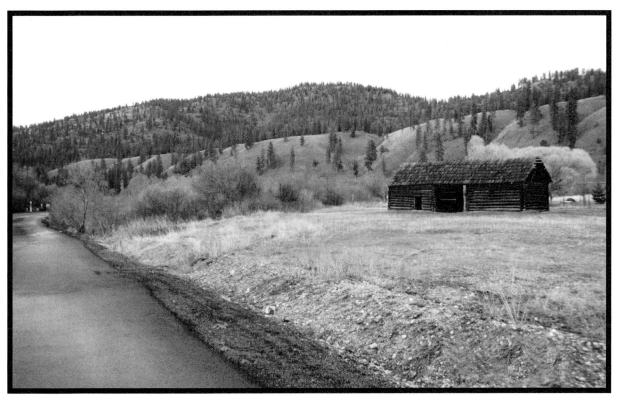

The original site of the Spokane House, built in 1810 by David Thompson's party, was about three blocks north of this building (no connection to the original trading post) and across a small creek. *(Bamonte photo.)*

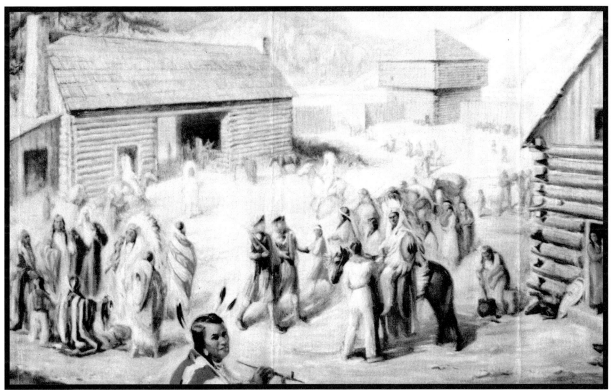

This copy of a mural painted by Bertha Ballou depicts life at the Spokane House about 1/2 mile southwest of the confluence of the Spokane and Little Spokane Rivers. *(Photo courtesy Spokane Public Library Northwest Room)*

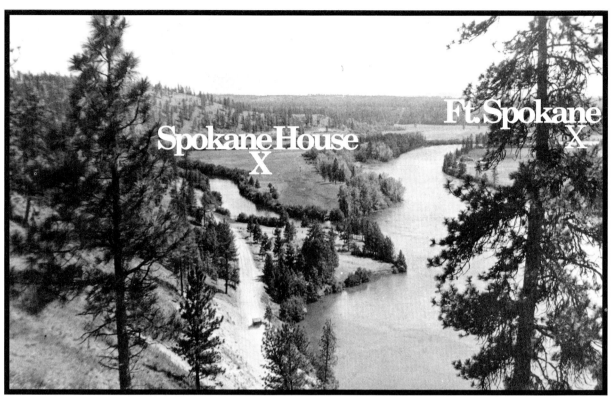

The junction of the Spokane and Little Spokane Rivers. This photo, taken north of the point of convergence, depicts the choice locations for both fur trading posts. *(Photo courtesy Jerome Peltier.)*

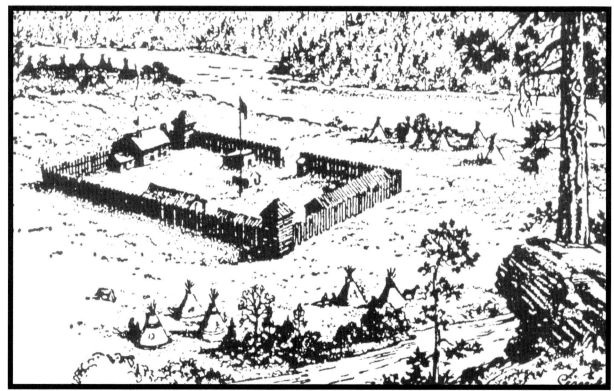

An artist's rendition of Old Fort Spokane (Spokane House) as depicted from an early description. The layout conforms to the traces of its remains. *(Sketch courtesy Jerome Peltier.)*

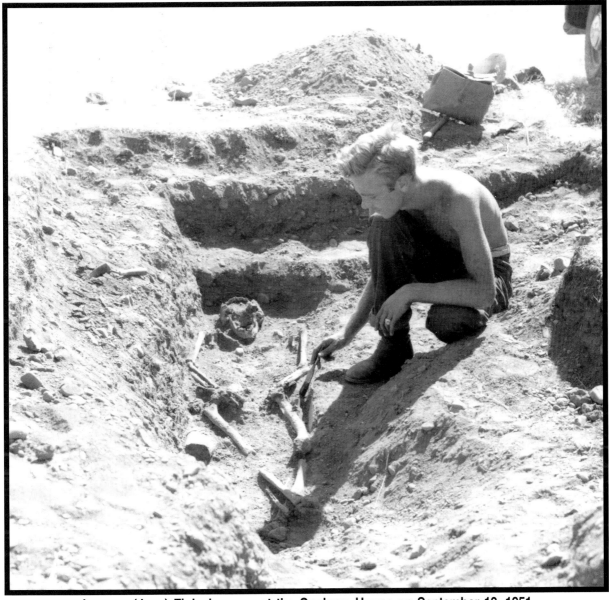

Jacques (Jaco) Finlay's grave at the Spokane House on September 12, 1951.

(Photo courtesy Jerome Peltier.)

In the above photo, Roy L. Carlson, an anthropology student at the University of Washington, is kneeling beside the grave and skeletal remains of Jaco Finlay. Finlay, along with Finan McDonald, built the Spokane House in 1810. After Fort Spokane was abandoned in 1826 and relocated to a new site along the Columbia River (Fort Colvile), Jaco Finlay continued residing at the old fort site until his death. Carlson discovered his grave during an archaeological dig conducted by the National Park Service and Washington State Parks Department. Finlay's grave was located at the southwest corner of the former stockade and included a number of artifacts. One of the artifacts was a clay pipe with a "J" carved on it. The grave was shallow (about 15 inches below the ground) and marked with heavy rocks that, as time passed, had sunk with the grave. Finlay's remains were taken to the Eastern Washington State Historical Society, where they were stored in the Cheney Cowles Museum in Spokane. In 1972, at the family's request, Finlay's remains were re-interred in the exact same grave site.

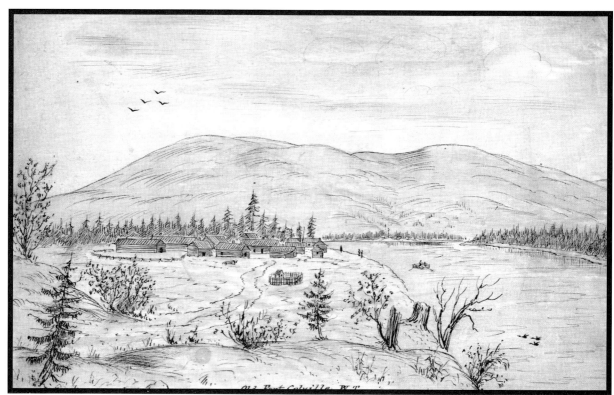

Old Fort Colvile on the Columbia River was a leading Hudson's Bay Company trading post during its existence from 1826 to 1871. *(1882 drawing by Alfred Downing, courtesy Spokane Public Library Northwest Room.)*

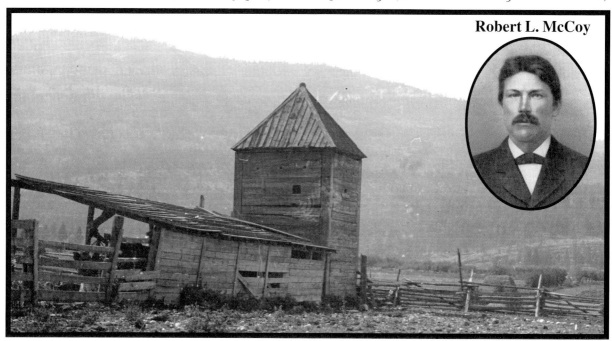

Robert L. McCoy

The last remaining structure of Fort Colvile. Boats transported furs from below the Kettle Falls to Astoria, Oregon. Orchards and gardens were maintained to feed the residents and travelers. Robert L. McCoy (inset) laid out and had charge of the farms for the Hudson's Bay Company at Vancouver and Fort Colvile. He was also married to Suzette Bouchet, a descendant of Captain Lewis of the Lewis and Clark expedition. *(Photo courtesy Stevens Co. Historical Society. Inset photo "History of North Washington.")*

Chapter 2

The Early Missions 1838-1877

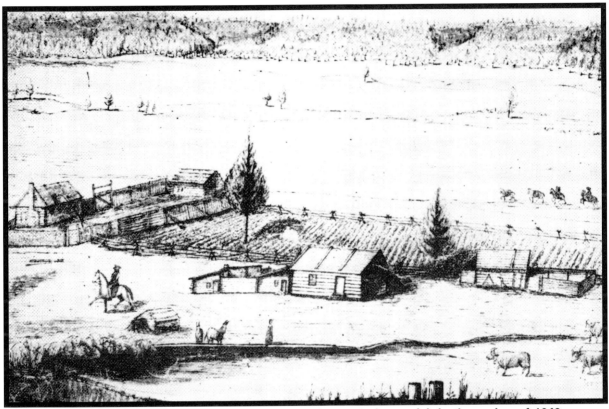

Tshimakain Mission as sketched by Charles Guyer during a visit in the spring of 1843.

(Photo courtesy Washington State University Archives, Container 4, Folder 38 of Cage 57. Original in the Elkanah and Mary Richardson Walker Papers, Washington State University Libraries, Pullman, WA.)

In 1838, under the direction of the American Board of Commissioners for Foreign Missions, the Rev. Elkanah and Mary Walker and the Rev. Cushing and Myra Eells established the first mission in the territory covered by this book. The mission was located approximately 30 miles north of Spokane at a site suggested by Archibald McDonald, who was in charge of the Hudson's Bay post at Fort Colvile. This site was selected partly because it was the home of a chief and an area frequently crossed by various bands of Indians in their nomadic movements to and from the camas fields, fishing dams and winter camps. It was called Tshimakain by the Indians, meaning "the place of the springs," and also referred to as "Walker's Prairie."

Although the Walkers remained at this site for over nine years (1838 to 1848), their mission was unsuccessful. An Indian, with whom Rev. Walker was able to communicate, confessed that he and his fellow tribesmen were not concerned about their souls, but the missionaries could have plenty of Indians around them if they kept a good supply of tobacco on hand. In a letter to her mother in March 1847, Mrs. Eells wrote: "We have been here almost nine years and have not yet been permitted to hear the cries of one penitent or the songs of one redeemed soul."

The Sacred Heart Mission erected this chapel in 1843 on the north bank of the St. Joe River near the south end of Lake Coeur d'Alene. In 1846, because of chronic flooding, it was moved to the vicinity of Cataldo. In 1877, after the Coeur d'Alene Reservation was established, the mission relocated to its present site at De Smet, Idaho. The Sacred Heart Mission is the oldest existing mission in Idaho. *(Photo from "History of the State of Idaho" by C. M. Brosnan, 1918)*

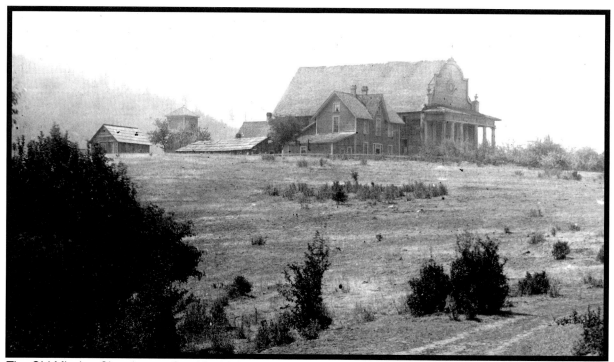

The Old Mission Church near Cataldo, Idaho, was built by the Jesuits with the help of the Coeur d'Alene tribe, who called it the "House of the Great Spirit." It was active as a mission from 1846 to 1877. The building was restored in the late 1920s and again in the 1970s. It is the oldest standing building in Idaho, and is now an Idaho State Park, which provides a comprehensive history lesson. *(Photo courtesy Spokane Public Library Northwest Room.)*

St. Paul's Mission near old Fort Colvile was established in 1845 and closed in 1858. It reopened again for a short time in 1863. It has been restored and is now on national park land. *(Photo courtesy Stevens Co. Historical Soc.)*

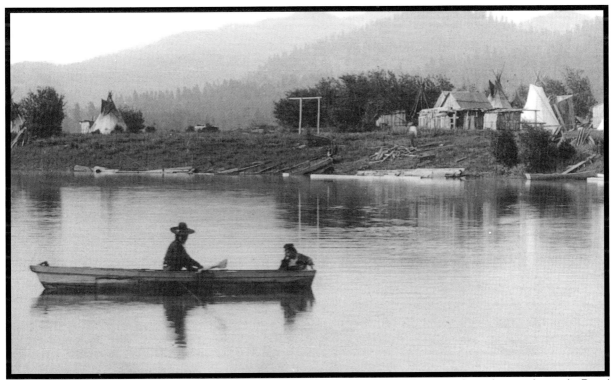

Original site of the St. Ignatius Mission was on the present-day Kalispel Reservation, shown above, in Pend Oreille County from 1844 until 1854. Because of chronic flooding, the mission was subsequently moved to St. Ignatius, Montana. *(Photo courtesy Pend Oreille County Historical Society.)*

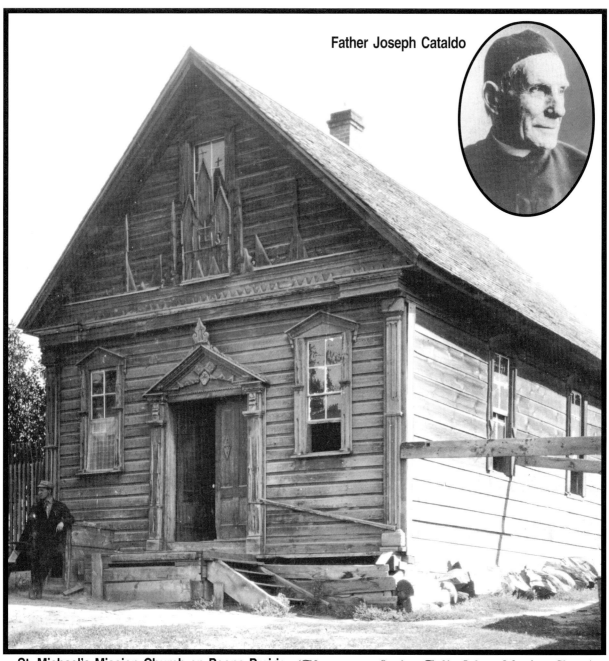

Father Joseph Cataldo

St. Michael's Mission Church on Peone Prairie. *(Photo courtesy Spokane Public Library Northwest Room.)*

In 1866 Father Joseph Cataldo built a small log structure near Chief Baptiste Peone's camp (northeast of present-day Hillyard). It was the first of three St. Michael's Mission chapels erected to serve the Indians. In 1868 it was replaced by another chapel and small residence for Father Cataldo (both were destroyed by fire in 1908). A school building was added in 1880 to provide a day school for the Indians. Father Cataldo became Superior of the Rocky Mountain Jesuits in 1877 and, in this capacity, purchased two 320-acre parcels of land in 1881. The chapel pictured above was built on one of the parcels in 1882 (later Mt. St. Michael's Scholasticate was also built on that parcel); Gonzaga College (now University) was built on the other. After years of deterioration and vandalism had taken their toll, the chapel was removed to the Mukogawa Fort Wright Institute grounds in 1968 and subsequently restored.

Military Forts 1859-1958

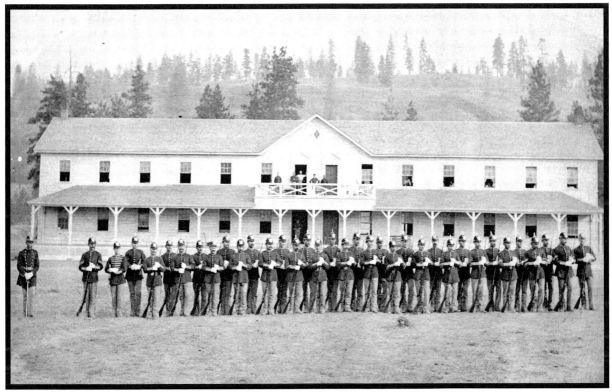

Company C, 2nd Infantry at Fort Spokane, circa 1885
(Photo courtesy Spokane Public Library Northwest Room.)

Major settlement of the Inland Northwest did not begin until the early 1870s. As with the eastern United States, settlement of the West was contingent upon establishing either a relationship or dominance over the native inhabitants. In the *History of Spokane County, Washington* (page 31) by the Rev. Jonathan Edwards (published in 1900), he describes the situation as viewed from that era's perspective:

The original Territory of Washington was the home, or camping and hunting ground of the most powerful and warlike Indian tribes of the Pacific Northwest. The Blackfeet, Nez Perce, Palouse, Pend d' Oreille, Yakima and Spokane tribes were the most numerous, supposed to be able to bring to the field of battle ten thousand warriors. The tribes mentioned were all east of the Cascades, and when Washington was constituted a Territory they were foes to be dreaded.

We make no attempt at a detailed account of the wars in which these tribes were engaged only such as necessary to show the incident to the settlement and development of the country have been desperate struggles. The Nez Perce war and the pursuits of Chief Joseph are matters of history. Nearly every part of the country, including the plains of Spokane and western portion of this county, were scenes of battles. The ingathering of the white people to this region, as elsewhere, excited the apprehension of the Indians. They instinctively prophesied the ultimate result. They knew the white man came never to leave.

Before his ax the forest disappeared, the hunting ground was turned to grain fields and fenced, his rifle annihilated the game and his superiority humiliated the proud native. It is only natural that such anticipations should arouse the Indians to do their utmost to avert such a disaster by keeping out of their country the dangerous invader. Accordingly wars were inevitable.

The Indian conflicts in Eastern Washington came to a harsh conclusion in 1858. Prior to that time, there were significant problems caused by the encroachment on what had been the Indians' ancestral lands for at least 10,000 years. Early historical records reflect that the presence of the Whites and their invasion of the Indians' land was a devastating scourge to the Indians' customs and way of life.

The Whitman massacre was the first major bloodshed in the territory that was to become Washington State. Open hostilities increased between the natives and the newcomers, and were indicators of an approaching showdown. A tragic cycle of violence and retribution in the Indian-White relations ensued. The subsequent events and circumstances influenced the future of all the region's tribes and were typical of Indian-White relations throughout early America. George Fuller, in his book *A History of the Pacific Northwest,* describes the incident that sparked an explosion of bloody warfare in the Inland Northwest:

> In 1858, two men had been killed near the Palouse river, on their way to Colville. Palouse Indians raided the Walla Walla valley early in April and carried off horses and cattle belonging to whites and Indians, including 13 head of beef cattle belonging to the Army. Some forty persons living at Colville petitioned for troops, believing that their lives were in danger. Steptoe decided to march his command through the Palouse Country, in search of the thieves, then go among the Spokanes for the purpose of conferring with them, and finally to investigate the situation at Colville.

In May of 1858, Lieutenant Colonel Edward Steptoe, with an expedition of under 200 men, set out for Colville. Steptoe was anticipating a peaceful mission. He thought the mere sight of the military waving its flags would calm the settlers' nerves, and hoped to resolve the problems peacefully. Unfortunately, word of the 1,000-mile Mullan Road, that was to pass through their beloved homeland, had angered the tribes and they were ready to defend their territory.

As Steptoe's party neared the area where the town of Rosalia, Washington, is now situated, they were attacked by a force estimated at 1000 to 1200 Indians from various northwestern tribes. Steptoe had not come prepared for battle, and his ammunition supply was no match for this attack. Although the potential for this attack to end in a bloody massacre was high, only 11 of Steptoe's men were killed. In the midst of the battle, under cover of darkness (the Indians refused to fight at night) with assistance from their Nez Perce allies, Steptoe and his men escaped. The attack on Steptoe was ironic in that he was sympathetic to the Indians' situation, and had favored making the "Columbia rectangle" (from the crest of the Cascades, south to the Washington-Oregon border, east to the crest of the Rockies) off-limits to the white prospectors and settlers. (A movement to establish the "Columbia Reservation" in this area in the years prior to this battle was met with public outcry, backed by Governor Isaac Stevens' opposition).

The act of hostility against Steptoe's troops brought an immediate response from the United States Army. Colonel George Wright, with a command of 680 men, began a punitive expedition to end the threat of any further Indian uprisings. To the Indians, this became a reign of terror. Those suspected of committing hostile acts were immediately hanged. Wright's mission was to punish the Indians for their past aggressions and bring them to complete submission under the control of the United States Government. This military action, which ended on September 30, 1858, is known historically as the Wright Campaign.

Wright wrote his final report, which summarized the war efforts against the Indians, en route to Walla Walla. He addressed it to the Assistant Adjutant-General, Headquarters of the Department of the Pacific, Fort Vancouver, Washington Territory. The report stated as follows:

The war is closed. Peace is restored with the Coeur d'Alenes, Spokanes and Palouses. After a vigorous campaign the Indians have been entirely subdued, and were most happy to accept such terms of peace as I might dictate:

1. Two battles were fought by the troops under my command, against the combined forces of the Spokanes, Coeur d'Alenes and Palouses, in both of which the Indians were signally defeated, with a severe loss of chiefs and warriors, either killed or wounded.

2. The capture of 1,000 horses and a large number of cattle from the hostile Indians, all of which were either killed or appropriated to the service of the United States.

3. Many barns filled with wheat or oats, also several fields of grain, with numerous caches of vegetables, dried berries and kamas [sic], all destroyed or used by the troops.

4. The Yakima chief, Owhi in irons, and the notorious war-chief Qualchien [sic] hung. The murderers of the miners, the cattle-stealers, etc. (in all eleven Indians), all hung.

5. The Spokanes, Coeur d'Alenes and Palouses entirely subdued, and sue most abjectly for peace on any terms.

6. Treaties made with the above-named nations; they have restored all property which was in their possession, belonging either to the United States or individuals; they have promised that all white people shall travel through their country unmolested, and that no hostile Indians shall be allowed to pass through or remain among them.

7. The delivery to the officer in command of the United States troops of one chief and four men, with their families, from each of the above-named tribes to be taken to Fort Walla Walla, and held as hostages for the future good conduct of their respective nations.

8. The recovery of two mountain howitzers abandoned by the troops under Lieutenant-Colonel Steptoe.

Very respectfully, your obedient servant,
Col. G. Wright, Ninth Infantry Commanding

Wright's campaign had a significant impact on the encroachment and settlement of the Inland Northwest. Following the campaign, the westward wave of white prospectors and settlers soon crowded the Native Americans from their ancestral lands and onto newly established reservations. Military forts were strategically positioned for the purpose of keeping peace, relocating Indians onto the reservations, and arbitrating land-right disputes, often aggravated by the frequent inability of government agents to honor promises.

Fort Colville, the first military fort in northeastern Washington, was established in 1859 about three miles northeast of present-day Colville. The site was chosen by Brigadier General William Harney, who reasoned that a military presence would encourage continued peace in the region. Originally called Harney's Depot, it was soon changed to Fort Colville. At its peak of activity, Fort Colville contained over 45 structures, including a store, stables, hospital and theater. Major Pinkney Lugenbeel, who commanded the Ninth U. S. Infantry, directed the construction of the fort. A settlement grew up on Mill Creek adjacent to the fort, called Pinkney City in his honor. It, too, was later renamed Fort Colville. Pinkney City served as a civilian supply point for miners, settlers, off-duty soldiers and native people. It was also the county seat for a short time and the headquarters for the American Boundary Commission.

In 1880, because of a shift in population, the army closed Fort Colville and, within the next five years, the entire garrison moved to Fort Spokane at the confluence of the Columbia and Spokane Rivers. Today nothing remains of either the fort or the town.

In 1854, Governor Stevens, realizing the tremendous supply of valuable timber east of the Cascades, recommended the passage of a law to extinguish all Indian claims to their land. Complications caused this proposal to fail, but it was sadly reflective of the prevailing attitude of the Whites during the early settlement of our country. It became evident over time that the word of those representing the United States often meant little when it came to Indian treaties.

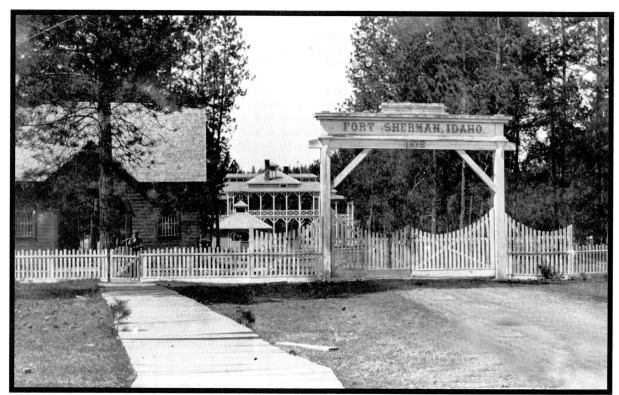

The main entrance to Coeur d'Alene's early military post. Fort Sherman, established in 1878 and now part of North Idaho Junior College, was originally named Fort Coeur d'Alene. (*Photo courtesy Spokane Public Library.*)

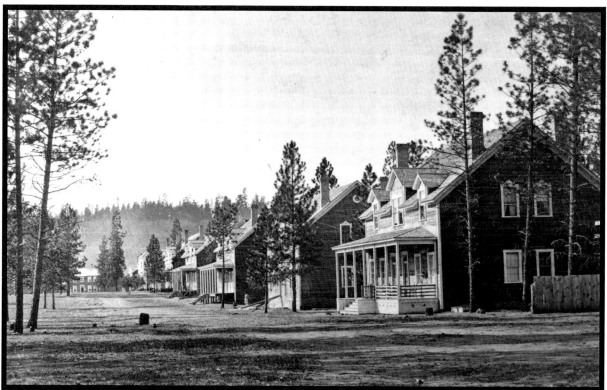

Fort Sherman military housing. During the late 1890s, many of the military band members were reported as AWOL. It was later learned they had been victims of this area's worst serial murderer. (*Photo courtesy Jerome Peltier*)

Prior to 1880, Fort Colville was the main military fort in the heart of the Inland Northwest. As the increased volume of activity and settlement in and around Spokane created a growing potential for more Indian unrest, the army closed Fort Colville and opened a new fort, called Camp Spokane, at the confluence of the Spokane and Columbia rivers. The location, about 60 miles west of Spokane, was at a crossroads of ancient trails and convenient to the main salmon fishery on the Spokane River. It was also close to the main village of Chief Skolaskin, a leader of the San Poil and Nespelem people. At the time of its founding, the running battle against Chief Joseph's Nez Perce had recently ended. The army concluded that a well-placed military presence could avert further clashes between the settlers and natives. Their primary mission was to protect the reservations from encroachment and to manage "Indian affairs."

Many of the first soldiers stationed at the fort came from Camp Chelan or Fort Colville. A substantial number of them were Civil War veterans. When the first soldiers arrived, beginning with the construction of the camp in 1880, they were housed in tents. By 1882 an air of permanence began to signal the Whites were here to stay. Fort Spokane was decreed a permanent military post and the name was changed from Camp Spokane to Fort Spokane. By 1890 Fort Spokane consisted of approximately 50 frame and brick buildings occupied by six infantry and cavalry companies. At the height of army occupation over 300 soldiers, as well as many families and civilians, lived at the fort.

The soldiers trained and cycled in and out of Fort Spokane; mostly in vain as urgent needs for their services were infrequent. When the economic panic of 1893 resulted in nationwide labor unrest, many of the soldiers from Fort Spokane were assigned to protect and handle rail traffic throughout the Northwest. At the start of the Spanish American War in 1898, the garrison was called to action. One of the final military missions from Fort Spokane was in the spring of 1899 when soldiers were dispatched to the Coeur d'Alene mining district during the mining riots. Within months, the fort was turned over to the Indian Service and military occupation of Fort Spokane came to an end. The equipment and furnishings from the fort were moved by wagon to the newly established Fort George Wright in Spokane.

From 1899 to 1929, Fort Spokane served in varying capacities as an Indian boarding school, the headquarters for the Colville Indian Agency, a tuberculosis sanatorium and general hospital for the local tribes. In 1960 Fort Spokane was transferred to the National Park Service and became part of the Lake Roosevelt Recreation Area. A few of the original buildings are maintained by the Park Service, and a walking tour of the grounds is well marked with diagrams, photographs and historical documentation.

The Jerome Peltier Military Fort Spokane Photo Collection: A Tour of Activity

During his years as the owner of Clark's Old Book Store, Jerome "Jerry" Peltier specialized in old books and historical photographs of the Northwest. People would often sense Jerry's keen interest in the preservation of history and give or sell him many of their priceless books or photographs. The following pages of photographs were included in one of these albums, and were taken during the era of Fort Spokane's occupation by the Indian Service after the army abandoned the fort in 1899.

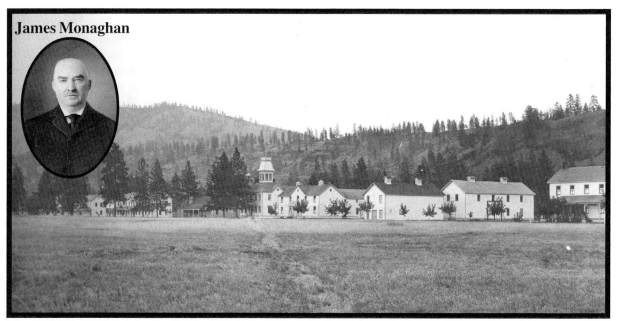

James Monaghan

The building with the tower, flanked by barracks, was the administration building at Fort Spokane. The company commander's residence was directly behind it. When the frontier post of Fort Spokane was established in 1880, James Monaghan *(Inset-NWD)* became the first post trader. In the early 1860s, he was employed in connection with the sailboats operating on the lower Columbia River. He also worked on the first steamboat, the *Colonel Wright*, from Wallula to Celilo. Monaghan was one of the most influential individuals in the early development of the Inland Northwest. *(All photos through page 34 courtesy Jerome Peltier.)*

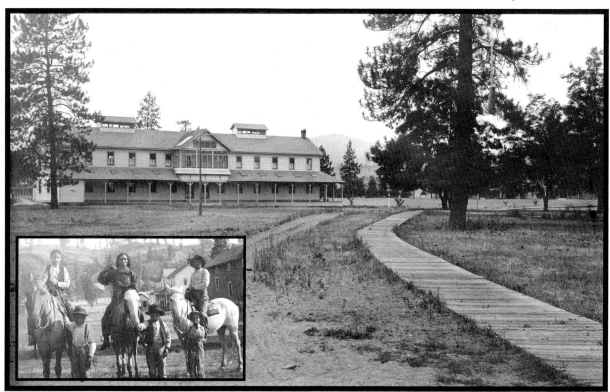

One of two horse stables at the fort (now gone). The quartermaster stable was restored. The old Fort Spokane site is now a popular tourist attraction and part of the Lake Roosevelt National Recreation Area.

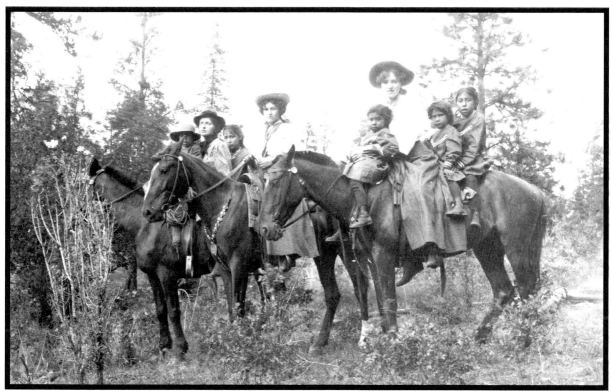

Even very young Indian children were taken from their families to be enrolled at the boarding schools. The purpose of the school was to remove the children from their "barbarous life" and teach the white man's ways.

The officers' quarters were later occupied by the Indian school staff. Nellie Miller Smith (above) was Indian Agent A.M. Anderson's personal secretary. Anderson was removed in 1904 after growing criticism against him.

Fort Spokane's marshal and his deputies. It was the duty of the fort police under Agent Anderson to retrieve children who ran away from the boarding school. Truant children would then be placed in solitary confinement in the guard house (used as a prison during the army's occupation of the fort) for several days.

In the late 1890s, when women began to abandon the side saddle in favor of riding astride, pants were not socially acceptable, but long split skirts (culottes) that could be buttoned up the front to look like a skirt were.

A gathering of staff and children from the boarding school. There were some good times and many bonds were formed, but it was generally a traumatic experience for many of the Indian children.

A group of Indian teenage girls in their boarding school uniforms. The Indian boarding schools attempted to eradicate the children's native customs and would even punish them for speaking their native language.

A winter gathering of students at the Indian Boarding School. Children who escaped from the school were returned and placed in solitary confinement in the former army prison (the guard house) for several days.

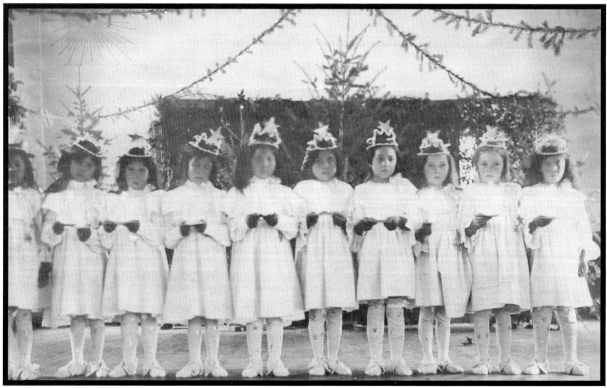

Young girls from the boarding school about to perform a Christmas song during the holidays at the fort. The empty sadness in their expressions is a dramatic reflection of the boarding school experience.

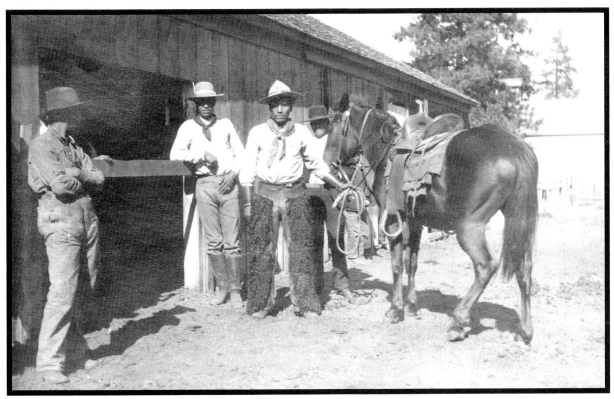

According to the sequence of photographs in the album, minutes after this photo was taken, the man on the right was bucked off this horse.

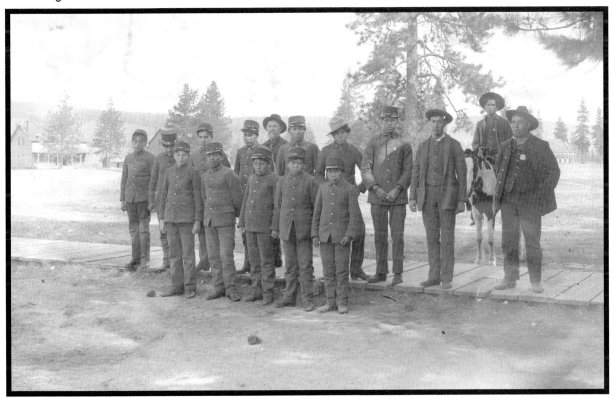

A group of teenage boys in their boarding school uniforms. Each boy was allowed three suits a year, including this uniform. The girls, who were taught to sew their own clothing, were allowed five dresses, one of wool flannel.

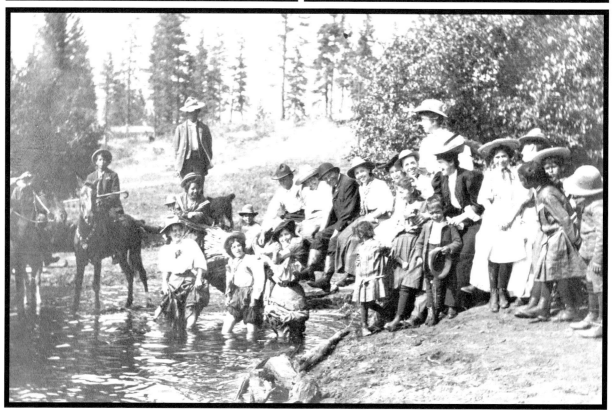

From this montage of photographs, it is obvious the white residents of the fort found plenty of ways to entertain themselves and enjoyed many good times.

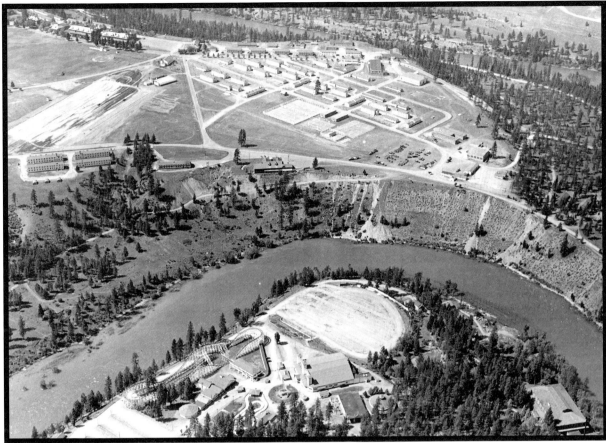

Aerial photo of Fort George Wright with Natatorium Park in the foreground. *(Photo courtesy Wallace Gamble)*

In 1894, when it became publicly known that the U.S. Government was considering establishing another army post in the Northwest, A.A. Newberry, a member of the Spokane Bureau of Immigration, traveled to Washington, D.C., for the purpose of securing that post for Spokane. Newberry spent six weeks in Washington, D.C. lobbying toward that goal. He returned with news that if Spokane donated 1000 acres with water and $15,000 cash, the fort would be located in or close to Spokane. This was accomplished through numerous fund-raising benefits, donations from private citizens and businesses. Approval was granted in 1895.

When Fort George Wright was opened in 1899, it officially replaced Fort Spokane, inconveniently located to the center of population. Consequently, all military activities in northeastern Washington were consolidated at the new fort, which consisted of a two-battalion permanent post (the majority of the buildings are of solid brick) on a plateau above the Spokane River, approximately three miles from the heart of Spokane.

Fort Wright served as a regular army post until 1941, at which time it was turned over to the Army Air Corps. During its tenure in that capacity, First Lieutenant Clark Gable trained there in 1943.

The fort remained an active post until 1958. It has since served in numerous private capacities. In 1990 Mukogawa Women's University of Kobe, Japan, purchased 92 acres. The Mukogawa Fort Wright Institute was established to provide an American cultural experience and extensive English instruction for Japanese women students. It houses several hundred students each quarter.

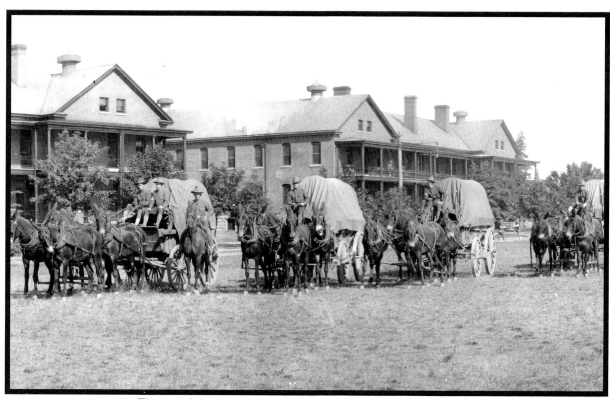

The 21st Infantry wagon train at Fort George Wright in 1919.
(EWSHS, Libby-Graff photo. Detail of L87.1-16408.19)

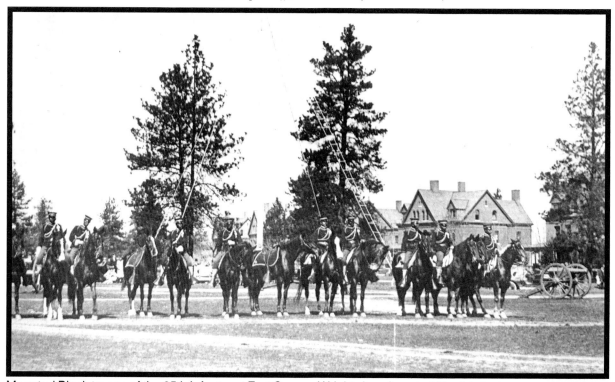

Mounted Black troops of the 25th Infantry at Fort George Wright. A regiment of Black infantrymen were among the first troops assigned to the fort in 1899. They were soon dispatched to the Coeur d'Alene Mining District in response to labor disputes and the explosion of the Bunker Hill Mill. *(Photo EWSHS, L94-40.55)*

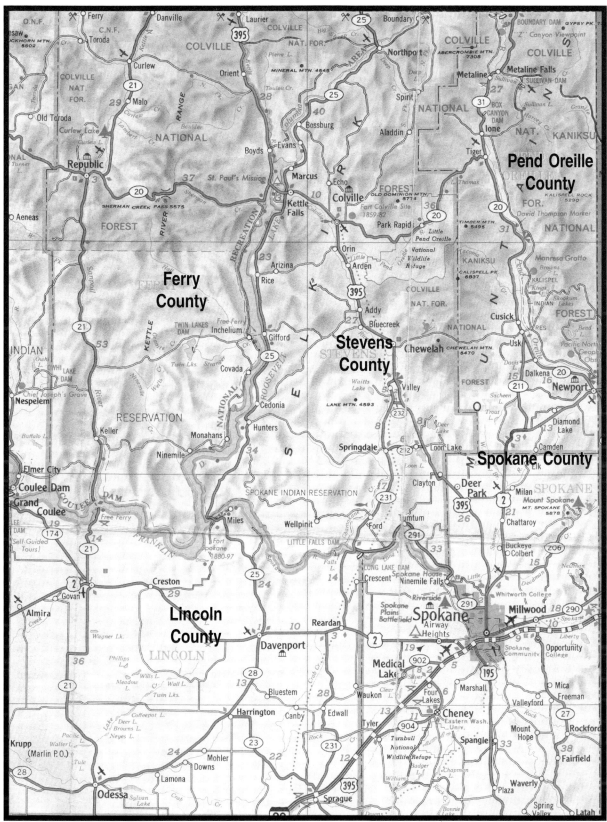

This map illustrates the Washington counties covered in the following five chapters:
Ferry, Stevens, Pend Oreille, Lincoln and Spokane.

Chapter 4

Ferry County

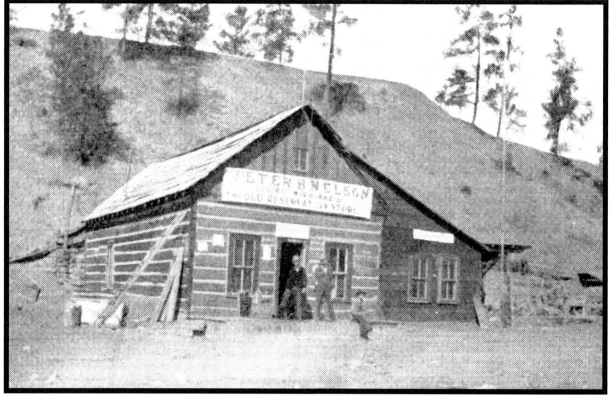

Nelson (later renamed Danville) the first town of record in Ferry County.
(Photo from "History of North Washington," Western Historical Publishing Co. 1904)

The history of the white settlers in Ferry County began with brothers O.B. and Peter B. Nelson. Around 1890, the Nelsons opened the first store in what was to become Ferry County. Situated on the Colville Indian Reservation, their trade was mostly with the Indians for the first few years. When the north half of the reservation was opened to prospectors in 1896, the townsite of Nelson was patented as a placer claim. Portions of this claim were sold to other investors, who also built on the site. The Nelsons seized the opportunity to capitalize on the needs of the massive rush of gold prospectors without having to pay duties. They built a store on the U.S.-Canada boundary line in order to trade in both countries. Of course, this arrangement was not met with approval by either country, and the store was soon moved back to the town of Nelson.

In 1897 Nelson was designated as an official post office site (the first on the Colville Indian Reservation) and Peter Nelson was appointed postmaster. With the coming of the railroads and close proximity to Nelson, British Columbia, the town of Nelson, Washington, became Danville when the town was platted in 1902. The change was made to remove the confusion of mail destined for Nelson, B.C., and Nelson, Washington. In 1900 the United States Customs Office officially designated Danville as a border crossing. Today it remains one of three official ports of entry in Ferry County. Laurier and Ferry are the other two.

Danville got its name from Dan Drumheller, who owned many mining claims in Canada and a large number of claims adjacent to Nelson, Washington. Drumheller, who might best be remembered from his Spokane notoriety, became one of the largest cattle operators in the Inland Northwest. After settling in Spokane in 1880, he engaged in the wholesale meat business and founded the city's first meat-packing company. He also was involved in banking, mining and real estate businesses. In May of 1883, Dan became a murder suspect in Spokane for the death of an Indian he had quarreled with earlier in the day. Although a prime suspect, he was cleared. In 1892 he was elected mayor of Spokane.

In April 1872, the Colville Indian Reservation was established. Three months later the boundaries were changed to include all of the future Ferry County. With the earlier discovery of gold in the upper reaches of Washington state and lower British Columbia, eager prospectors were already combing the area. A determination that valuable ore lay throughout the region spurred the U.S. Government to negotiate the purchase of the north half of the reservation from the Indians for $1,500,000 (about $1.00 an acre) on July 1, 1892. The purchase price was to be paid in annual installments of $300,000. However, the Indians had to incur $60,000 in legal fees in their fight to receive payment from the government.

Four years later, on February 21, 1896, the "north half" was opened to prospecting. The first mining claim staked in what is now Ferry County was the Black Tail claim. It was staked on February 20, 1896 by John Welty, the first white man to reside in what is now the town of Republic. Two years later, the south half of the reservation was also opened to mineral entry causing an even larger stampede than the opening of the northern region. By 1900 approximately 12,500 mining claims had been staked in Ferry County.

With an increasing population, a movement was initiated in 1899 to carve Ferry County from the once-massive Stevens County. The proposed name for the new county was "Eureka" (a word used to describe the triumph of discovery), but when the bill passed, the name "Ferry" was given in honor of Elisha P. Ferry, the first governor of Washington State. Being the largest settlement, Republic was designated as the county seat.

On October 10, 1900, the northern half of the Colville Reservation opened to timber harvesting and homesteading, granting 160 acres to white adult claimants. As a means of protecting established homes and farms, 80-acre allotments had been made to 660 Indians residing on the "north half" prior to the official homestead opening. But by opening day, numerous sites had already been staked out or squatted on by white settlers and towns had been built on placer mining claims. (The "south half" subsequently opened to homesteading on July 1, 1916.) In a further restructuring of the former reservation land in northern Ferry County, President Theodore Roosevelt set aside nearly 870,000 acres as the Colville National Reserve on March 1, 1907.

A franchise had been granted in March 1898 for the building of a railroad through northern Ferry County, but the train did not arrive until the summer of 1902. Two railroads reached Republic about the same time. The Kettle Valley Railroad (commonly referred to as the "Hot Air Line") made a connection with the Canadian Pacific at Grand Forks, B.C., while the Washington & Great Northern (a branch of the Great Northern) connected with the Spokane Falls & Northern (originally D.C. Corbin's line, but part of Great Northern by this time) in Stevens County. The arrival of the railroad was met with great celebration. For one reason, the Granby Smelter had begun operations at Grand Forks in 1900. This more efficient means of transportation provided a welcomed boost to Ferry County's economy. Although the interior of Ferry County was now connected to the outside world and great wealth was extracted from the ground and the forests, it has remained to this day a sparsely populated region of relatively unspoiled beauty.

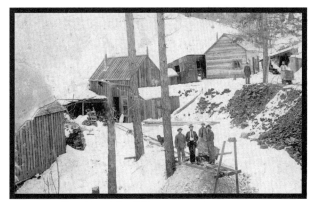

The Ben Hur Mine around 1900.

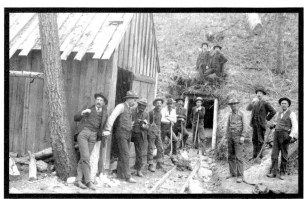

The Lost Lode Mine.

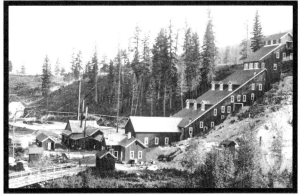

Patsy Clark's mill at the Republic Mine, 1898.

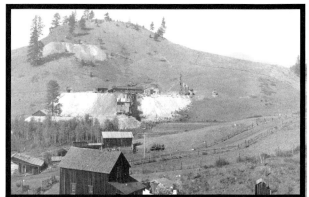

The Knob Hill Mine, circa 1910.

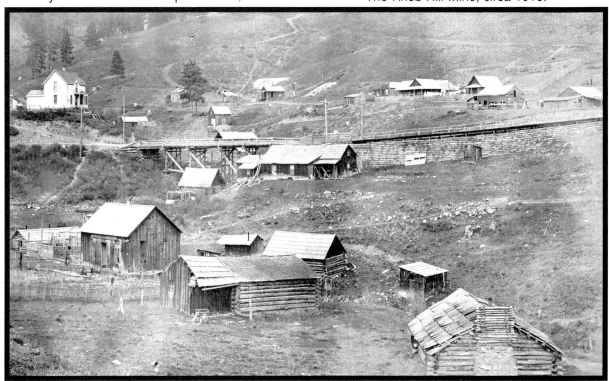

Eureka Camp, circa 1910, slightly northwest of the present town of Republic. The majority of the area's mining operations, including those shown above, were located in Eureka Gulch, the site of some of the richest gold-bearing ore in the world. *(Photos courtesy Ferry Co. Historical Soc., except upper left, Stevens Co. Historical Society.)*

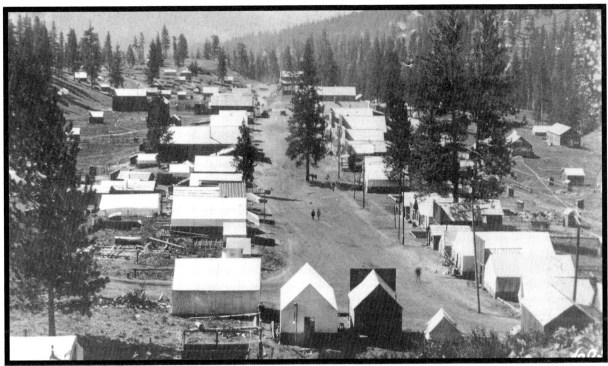

Republic in 1898, when the post office was established. The name was changed from Eureka to Republic, after the Republic mine, as there was already a Eureka, Wash. post office. *(Photo courtesy Dean Ladd & Larry Elsom)*

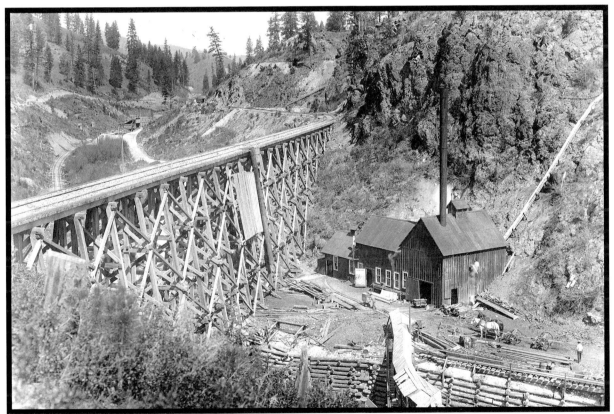

The power plant and adit (entrance) to the Quilp Mine in Eureka Gulch and the Great Northern Railroad trestle, circa 1904. *(Frank Palmer photo courtesy Ferry County Historical Society)*

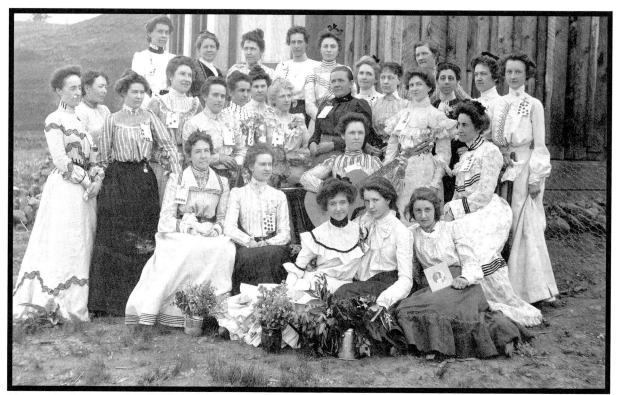

Marguerite O'Keefe, standing to the right of the woman playing the guitar, had a dressmaking and millinery shop in Republic. This gathering of women was at the S.G. Dewsnap home, circa 1900. *(Photo courtesy Ray O'Keefe)*

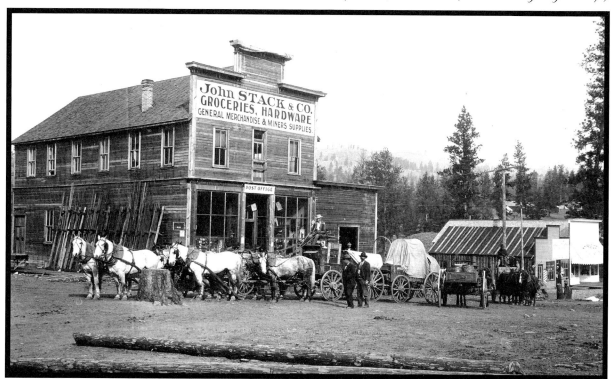

John Stack & Company, circa 1899. Stack opened this general merchandise store on October 30, 1897. The following year, it also became the post office and Stack was appointed postmaster. His sister Mary married mining magnate Patsy Clark, who financed the Republic mine and mill. *(Photo courtesy Ferry Co. Historical Soc.)*

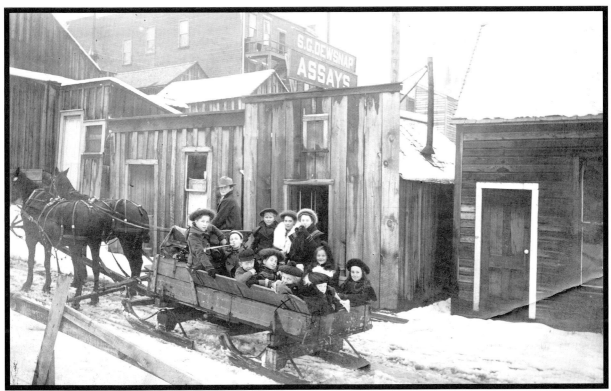

A sleighing party celebrating Dean H. Smith's tenth birthday. The location is Republic's 6th Street, between Clark and Keller. Earl O'Conner was the driver. *(Photo courtesy Ferry County Historical Society.)*

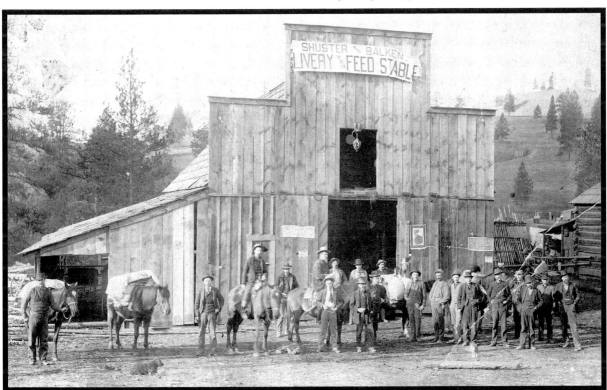

Shuster-Balken Livery Stable in 1897. Until the railroad arrived in 1902, all freight to and from Republic was hauled by horse or mule trains. Livery stables were key businesses. *(Photo courtesy Ferry Co. Historical Soc.)*

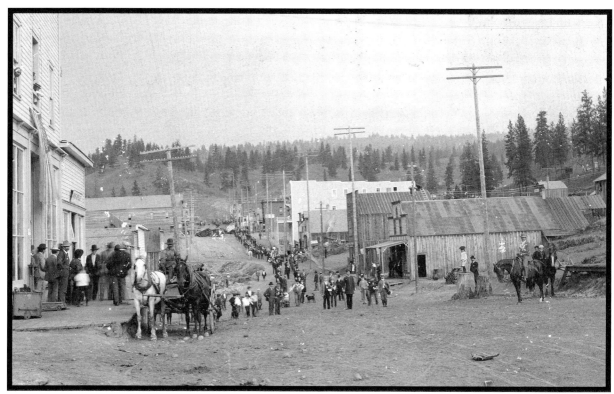

A Fourth of July parade through the town of Republic, looking north, circa 1913.
(Photo courtesy Ferry County Historical Society)

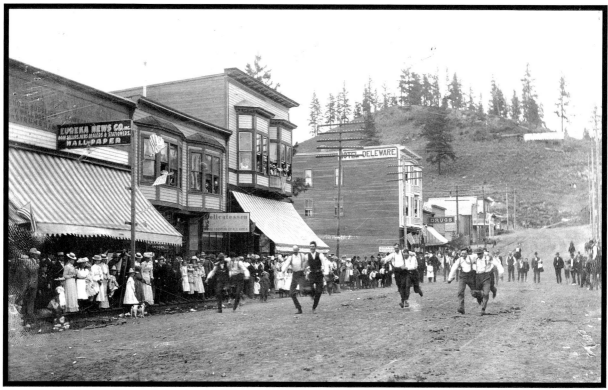

Three-legged races through the town of Republic added to a Fourth of July celebration, circa 1903. View is to the north. *(Photo courtesy Ferry County Historical Society)*

Curlew is situated at the confluence of Curlew Creek and the Kettle River, about 20 miles north of Republic, in some of Ferry County's richest agricultural land. Before the arrival of the white settlers, the location was a popular crossroads for the native tribes. The east-west route was used by placer gold prospectors in the 1850s and was followed by Colonel W.T. Sherman and his party through the Pacific Northwest in the 1880s. The Indians operated a flat-boat ferry at a point just above the eddy of the Kettle River. The current would carry the boat downstream to several convenient landings located on the other side.

The town's first building was a log cabin owned by Chief Alec Long. In 1896 Guy S. Helphrey, a Spokane real estate dealer, and his partner, Mr. Walters, (later bought out by Guy's brother John) purchased the cabin and some property for $100 and opened a mercantile store. This store and others that followed supplied the prospectors during the boom days. The post office was established in 1898 and Helphrey became the post-master. In 1902 Curlew became a stop along both the Washington & Great Northern and Kettle Valley rail lines, and Helphrey was forced to move his store. The store, built at the new location in 1902, still exists today.

During the early 1900s, Curlew's population averaged about 200 people plus numerous businesses. Many historic buildings still remain today. During Prohibition, bootlegging and liquor smuggling operations abounded in Curlew. The typical mainstays of the community, however, were mining, logging and agriculture.

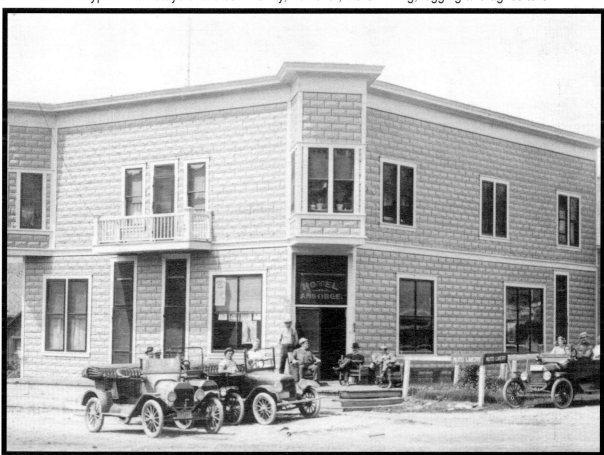

Ansorge Hotel, circa 1920. Built in 1903, it was the first building in Ferry Co. to be placed on the National Historic Register (1979). According to the hotel's records, Henry Ford from Detroit, Mich., was a guest on July 31, 1917. He was en route to visit relatives in the Toroda Creek area. Until 1956, the Ansorge had the only telephone in Curlew. The hotel is now a museum. *(Photo courtesy Stevens Co. Historical Society)*

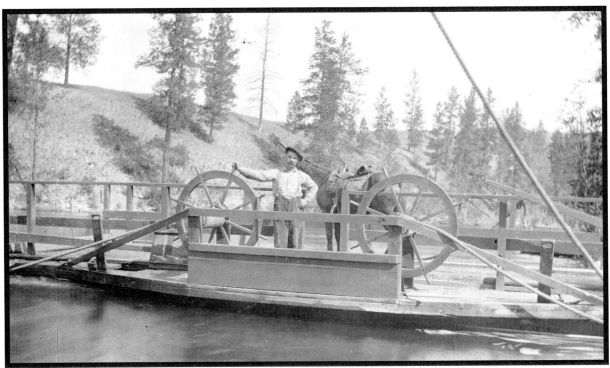

In 1897 this cable ferry across the Kettle River to Curlew replaced the Indians' flat boat ferry. A corduroy bridge took its place in 1901. In 1908 another bridge was built when floods washed out the first one. That bridge still exists and is on the National Historic Register. Photo 1899. *(Photo Courtesy Ferry County Historical Society.)*

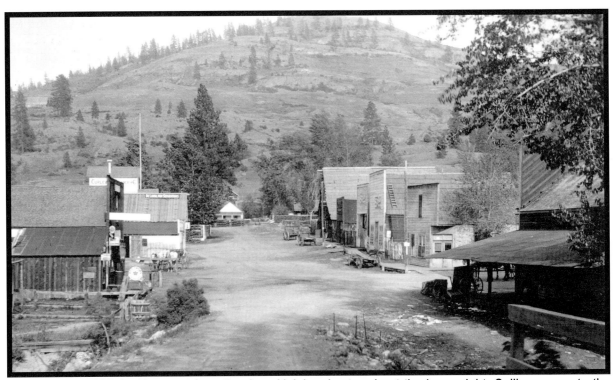

Curlew, circa 1908, looking east from the river. Helphrey's store is at the lower right. Selling cream to the Curlew Creamery (highest building on the left) was a major source of local income. It later located its main offices in Spokane. *(Photo EWSHS, L86-1311.17)*

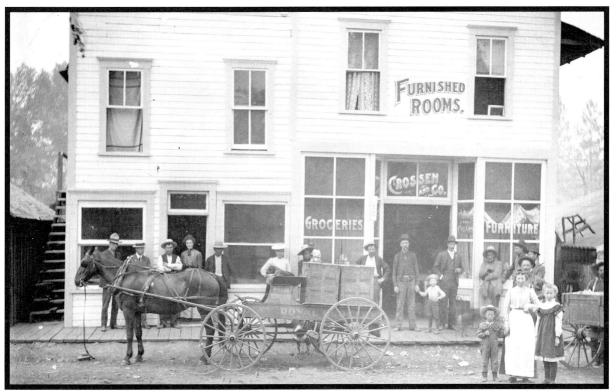

Crossen's store in Curlew.
(Photo courtesy Ferry County Historical Society)

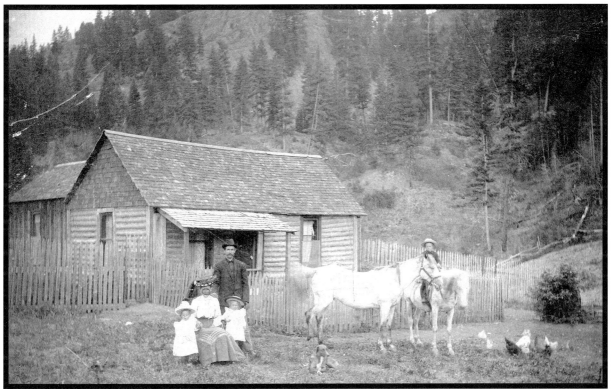

The Seiver house at the base of Gibraltar Mountain near San Poil Creek, south of Republic, circa 1904. It was typical of the early homesteads in the area. *(Photo courtesy Ferry County Historical Society.)*

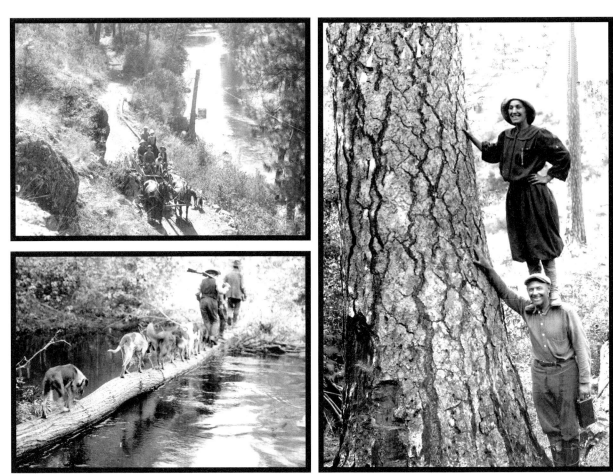

Mr. & Mrs. Gocke (right) and their hunting party camped at Devil's Elbow along the San Poil River, ca. 1910.

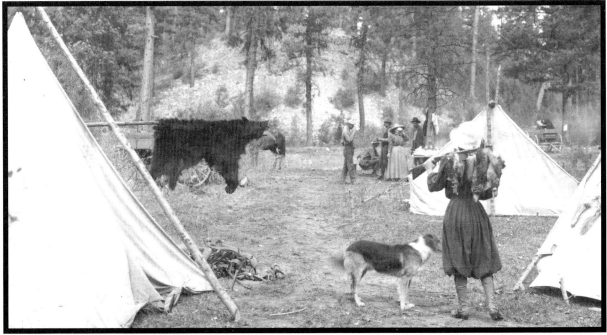

(EWSHS, Frank Palmer photos, Jerome Peltier collection.
Clockwise from upper right: L84-327.1935, L84-327.1936, L84-327.1925 and L84-327-1906)

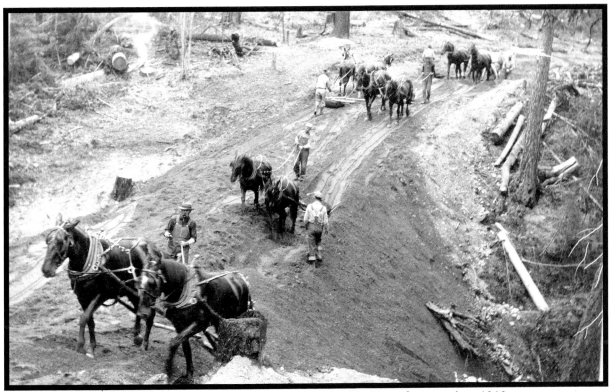

A road construction crew grading a road bed in Ferry County, circa 1910.
(Photo courtesy Ferry County Historical Society)

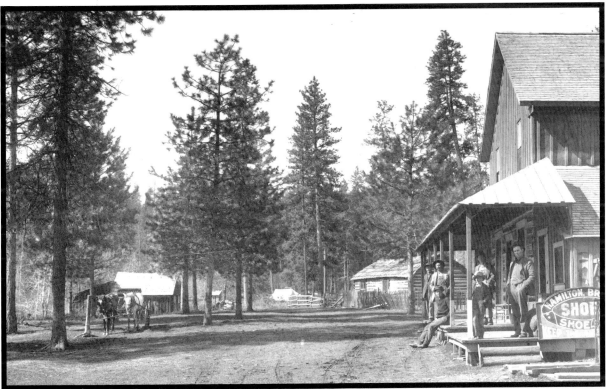

A store at Meteor around 1908. Meteor lies between Twin Lakes and the Columbia River on the Colville Indian Reservation. *(EWSHS, Frank Palmer photo, L84-327.1086)*

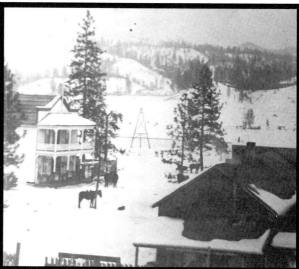

Left: The Ferguson home on Cobbs Creek near old Inchelium, circa 1915. (From L to R) Tom, Esther, Annie (mother), Helen, Ed and Bill Ferguson, and Ed Zeller. **Right:** Old Inchelium before construction of Grand Coulee Dam forced the town to move to higher ground.

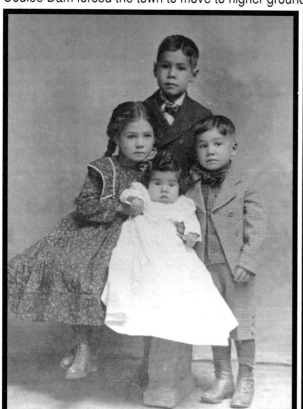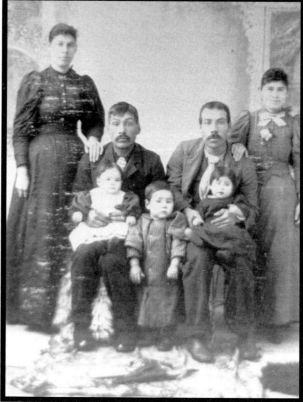

Left: Four of Joseph and Annie (Etue) Ferguson's children (clockwise from top): William (Bill), Joey, Mae and Mabel, circa 1900. **Right:** Annie Etue (upper left) married Joseph Ferguson (seated left). Joseph's brother Todd (seated right) married Annie's sister Julia Etue (standing right). Joey Ferguson is the little boy in the center. Circa 1898.

(Photos courtesy Jennifer Ferguson, granddaughter of Esther Ferguson and great-granddaughter of Joseph and Annie Etue-Ferguson. From the Esther Ferguson-Mason-Coe collection, Colville Tribe)

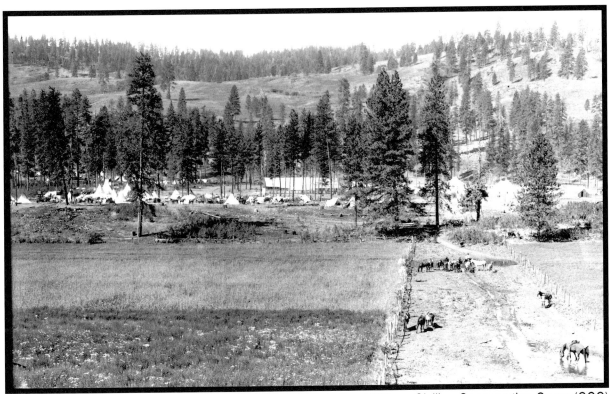

Town of Covada on the Colville Reservation, circa 1908. In the 1930s, a Civilian Conservation Corps (CCC) camp was located here, providing employment during the Depression. *(EWSHS, Frank Palmer photo, L84-327.1117B)*

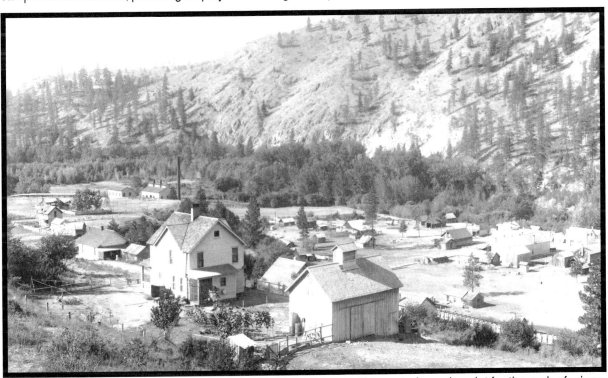

The town of Keller on the San Poil River in 1908. Keller became the central supply point for the rush of miners into the south half of the Colville Reservation in 1898. In 1939, before the flood waters from Grand Coulee Dam covered this townsite, the town moved a few miles north. *(EWSHS, Frank Palmer photo, L84-327.1947)*

I n 1940 the backwaters from Grand Coulee Dam created 151-mile Lake Roosevelt from the dam to the Canadian border. Thousands of acres were flooded, displacing some 3000 people from their homes and submerging towns under 30 to 235 feet of water. The towns of Peach, Gifford and Gerome faded into the pages of history. Thousands of homes and other buildings from Boyds, Marcus, Inchelium, Lincoln, Keller and Daisy were removed to higher ground, where the towns struggled to start anew. The town of Kettle Falls moved in with Meyers Falls, and the name was changed to Kettle Falls. It was a traumatic time for many people, but none were more deeply affected than the native tribes of Indians who had inhabited the banks of the Columbia River for thousands of years. Much of the Indian history, lore and tradition had centered on the Kettle Falls island (Hayes Island) located above the present highway bridge. It was also a primary burial ground. For centuries, the Kettle Falls had been a traditional gathering place and prime fishing site for local and distant tribes. Thousands of artifacts recovered before the waters flooded the area indicated a network of Indian trade that reached as far as Montana, the Upper Fraser River country of Canada, California and the Pacific Coast.

In 1939, as completion of the dam approached, the Bureau of Reclamation contracted with Ball and Dodd, undertakers from Spokane, to remove graves from along both sides of the Columbia River reservoir. Contractor Harold T. Ball hired over 100 Indians, who labored diligently on every phase of the project. He worked closely with Pete Gunn, a Colville tribal council member, who was the government inspector on the job. Gunn conferred with elders of the tribes, including Augusta Williams, a Colville Indian who was well over 100 years old, and studied tribal records to locate many of the graves. Louis Egger, who later owned the funeral home in Colville, also assisted in the removal of the graves. In all, about 1400 graves were removed to newly-established burial grounds located on the Colville and Spokane Indian Reservations in Ferry and Stevens Counties.

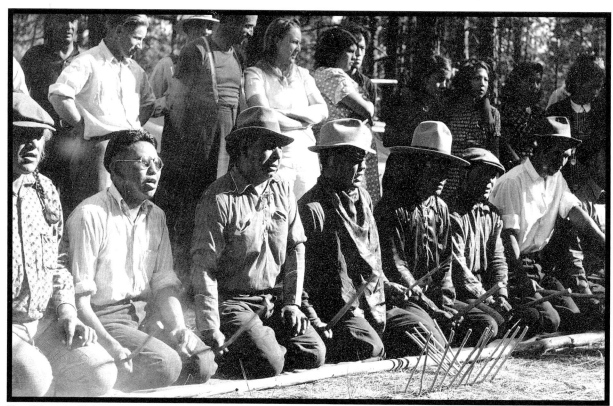

Traditional stick games were part of the final farewell, known as the "Ceremony of Tears," to the tribal fishing grounds when the backwater from Coulee Dam covered the Kettle Falls. *(Photo courtesy Wallace Gamble.)*

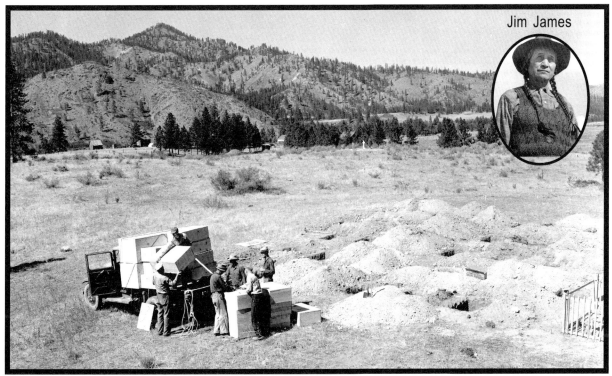

Jim James

Harold Ball, contractor for the project, said his panel truck covered 9000 miles in nine weeks locating grave sites. The boxes on and beside the truck were used for the remains prior to re-interment. The dignified Chief Jim James (inset) of the San Poil Tribe led the farewell ceremony at the Kettle Falls.

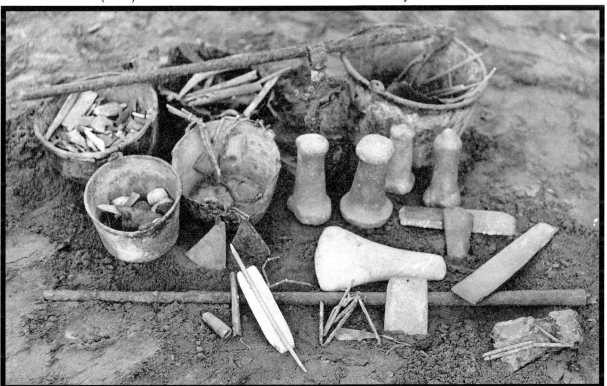

A sampling of artifacts recovered from the graves along the Columbia River reservoir. Many of the relics were found on Hayes Island (the Kettle Falls island). Photo taken in 1939. *(Photos courtesy Wallace Gamble)*

Chapter 5

Stevens County

John and Lena Walsh, shown with their children Maggie, Mabel, John and Bob, built one of Colville's first homes. Colville and Colville Mountain are in the background. Colville's first school was built on this property, and later moved to the Stevens County Museum. *(Photo courtesy Stevens Co. Historical Society.)*

The county's official recorded history dates back to the legislature of 1857-58, when most of it was originally in Spokane County, a territory covering roughly 76,000 square miles. The early territorial legislatures mapped out the interior of Washington Territory even before many towns or crossroads had come into existence or the natural geography of the land was known. Early counties often existed only on paper, as was the case with the first Spokane (Stevens) County. The few scattered settlements in the county were located in the Colville Valley. Many of these first settlers were former employees and relatives of the Hudson's Bay Company's fur trading post, Fort Colvile, located on the flat below the old town of Marcus.

Prior to the arrival of the fur traders, the region had long been a cultural crossroads and trade center for numerous Inland Northwest Indian tribes. The Kettle Falls was the second most significant salmon fishery along the Columbia River (Celilo Falls was the largest). It was primarily the domain of the Colville Tribe, but people came from great distances to fish here. Farther south, the Spokane Indians were joined by neighboring tribes at their fishing sites on the Spokane River. However, the native tribes' lifestyle was forever changed with the gold discovery in the early 1850s in Canada and the northern reaches of Washington Territory. With the depletion of the precious metal in the California gold fields, new sources were being sought and found in this area, initiating the first major influx of white settlers.

This influx stimulated the legislature into an attempt at establishing local government. Public officials were appointed (the board of county commissioners, sheriff, and auditor), but there was little political interest among these early settlers. They failed to qualify or organize the county government. A second attempt was made the following year. On January 18, 1859, the legislature again appointed new officials. This effort also failed.

Among the major contributing factors to these failures were Indian uprisings and hostilities due to the recent encroachment on their native lands. In 1858 the United States Government began a military campaign to subdue the resistance of the Indians. This campaign was conducted by Colonel George Wright. It was swift and cruel. As discussed in chapter 3, the military post of Fort Colville (originally Harney's Depot) was established on Mill Creek in the Colville valley. Its purpose was to promote a peaceful coexistence between the Whites and Indians. By 1860 Colonel Wright's military campaign against the Indians and the military presence at Fort Colville had given the newcomers a sense of security about this region. Coinciding with the recent discoveries of gold along the rivers, the added security resulted in a major population increase.

In January of 1860, the legislature made a third attempt and passed another act to reestablish the county of Spokane. The same boundaries were outlined as in the first two acts, which were (roughly) the Columbia River on the west, Snake River on the south, Rocky Mountains to the east and the Canadian border to the north. Neither of the first two acts specified a location for a county seat, but named "Colville" in the 1860 act. However, as there *was* no town of Colville (only Fort Colville), Pinkney City, the town built adjacent to Fort Colville when the fort was established, became the temporary county seat. Pinkney City was a small town, but still the largest in the region. To help ease the confusion, the name of the town, given in honor of Fort Colville's commander, Major Pinkney Lugenbeel, was used interchangeably with "Fort Colville" and "Colville."

Almost immediately after successfully establishing the county, the boundaries began to change. Discovery of gold along the Clearwater River in (what is now) Idaho, brought an influx of people who needed their own local government. The Washington Legislature created some new counties in what is now Idaho and Montana, removing them from Spokane County. In 1864 the legislature annexed what was left of Spokane County with the newly-formed Stevens County, which was bounded on the east by the Columbia River. The only land it had in common with the Stevens County of today is what lay between the Columbia River and the Kettle River's extension from Canada to the Columbia River. In the annexation, Spokane County (covering both present-day Stevens and Spokane counties – and beyond) acquired the name Stevens, in honor of Washington's first territorial governor. Although the formation of the county is complicated, the best indication of Stevens County's original size can be illustrated through its process of dismemberment. The following counties were cut away from Stevens County (in chronological order): Whitman County, November 27, 1871; Spokane, October 30, 1879; Kittitas and Lincoln, November 24, 1883; Adams, Franklin and Douglas, November 28, 1883, Okanogan, February 2, 1888; Ferry, February 21, 1899; Chelan, March 13, 1899; and Pend Oreille, June 10, 1911.

The significance of Isaac I. Stevens to the county warrants a brief history of his life. Stevens was born in Andover, Massachusetts, in 1817. He graduated at the head of his class in the U.S. Military Academy in 1839 and entered the army as a second lieutenant of engineers. During the Mexican War, he was appointed brevet major for gallantry. Upon his return, he was selected chief of the coast survey to find the most direct route from the Mississippi to the Pacific Coast for a northern transcontinental railroad. In 1853 he resigned his commission in the army. He became governor of Washington Territory and served as its delegate in Congress for two terms. During the Civil War, he was commissioned a brigadier-general of volunteers and on July 4, 1862, was promoted to major general. He was killed in battle in September 1862, near Chantilly, Virginia.

Fort Colville was closed in the early 1880s and the town of Pinkney City shriveled. As there was still no town of Colville, local residents platted a site on land owned by John Hofstetter, the "Father of Colville," and dedicated the new town in 1883. The new site was about three miles southwest of the old fort at a more suitable location. County records were moved and the county seat at Colville became official. Several subsequent attempts were later made to relocate the county seat, but it has remained at Colville.

The earliest major mineral discoveries in northeastern Washington were in Stevens County. In 1885 the discovery at the Old Dominion Mine by W.H. Kearney, A.E. Benoist and E.E. Alexander, about five miles east of Colville, quickly caught the attention of capitalists in Spokane, who also recognized the value of the rich agricultural land and the timber. They began organizing the Spokane Falls and Northern Railroad Company, and recruited D.C. Corbin to supervise its construction. Stevens County residents celebrated the end to their isolation and the means to transport the ore to smelters and other products to larger markets. The train was met by a forty-two gun salute in Colville in October 1889. The line reached Marcus the following spring and Northport in 1892. The railroad prospered as additional mineral deposits were discovered in north Stevens and Ferry Counties and Canada. A stampede of prospectors streamed through Stevens County in search of their fortunes, greatly boosting the local economy and development of the county into what it is today.

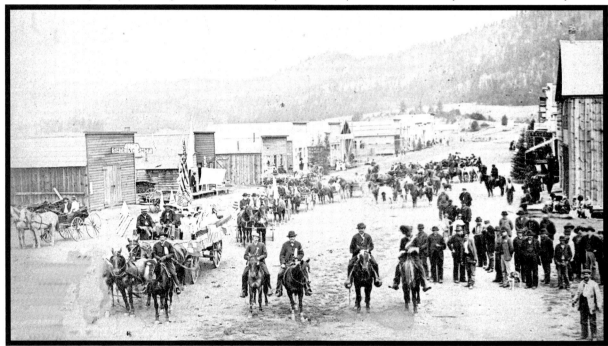

Colville's Fourth of July celebration started at daybreak with the "sounding of the anvil" (gunpowder charges placed in the small square at the butt end of an anvil and set off). By the time all the anvils scattered around town had been fired, there was no doubt what day it was. In the early days, there was always a Fourth of July parade. The "Liberty Wagon" (above left) was a major attraction. It consisted of a horse-drawn wagon with seats on all sides, filled with young girls in white dresses. The liberty wagon drivers on this July 4, 1886 were John Hofstetter (left) and French Rickard (right). The riders leading the parade (left to right) were C.A. (Kit) Ledgerwood, Al Benoist, Fred Rice, E.L. Larios, G.B. Ide. In the carriages behind the wagon were Mr. & Mrs. Sam Vinson (left) and Mr. and Mrs. L.W. Meyers (right). Other typical 4th of July festivities included foot races, horse races, a band concert in an eight sided wooden bandstand on the courthouse lawn (after it was built in 1897), and a baseball game.

(Photo courtesy Stevens County Historical Society.)

The Colville Valley Corridor,
North to South

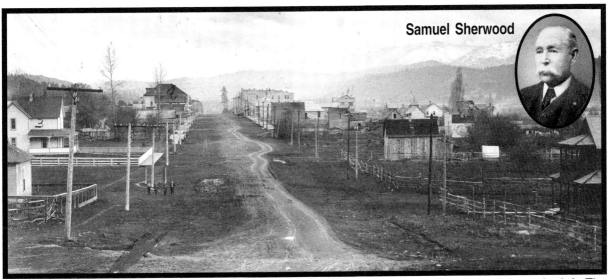

Samuel Sherwood

Looking south on Colville's Main Street in 1903. Meyers Opera House (with the hip roof) is on the left. The three-story brick building on the right is the Rickey Block. Samuel F. Sherwood was mayor of Colville at the time of this photo. He also served several terms as county auditor. *(Inset-History of North Washington.)*

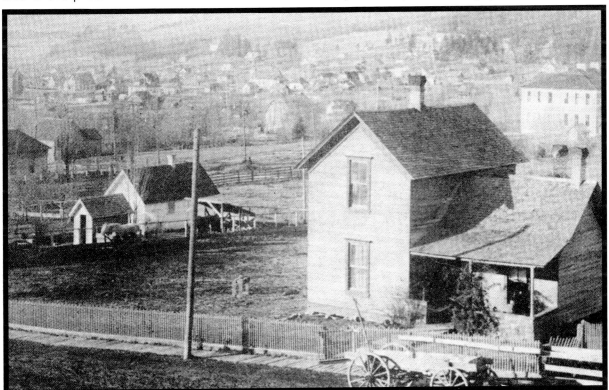

Looking northwest (left) toward downtown Colville and Main Street from the Hofstetter home on East Columbia, circa 1900. Eells Academy is the two-story building on the right. *(Photos courtesy Stevens Co. Historical Society.)*

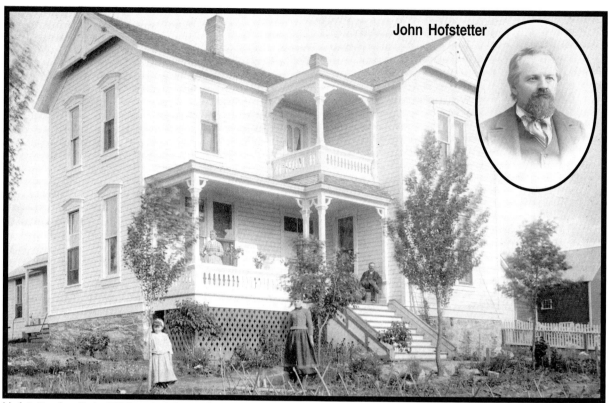

John Hofstetter

Hofstetter family in 1899 at their home located below the present hospital. John W. Hofstetter (inset) is considered the "Father of Colville." The Hofstetters were known for their hospitality to people passing through the valley.

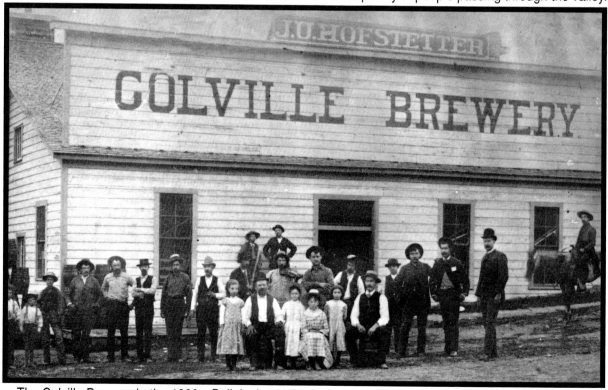

The Colville Brewery in the 1880s. Built in the 1870s by John Hofstetter, it was Colville's first business.

(Photos courtesy Stevens County Historical Society)

Mrs. Jane Hofstetter with (left to right) Hugh Thompson, grandson Harry Rice, granddaughter Jessie Rice (Webb) and Herbert Thompson, circa 1901. *(Photo courtesy Stevens County Historical Society.)*

Two of J. Fred and Lillian (Hofstetter) Rice's children, Jessie and Tom, around 1904. Fred was a Colville pioneer. Lillian was born on the Hofstetter homestead in 1873. *(Photo courtesy Stevens Co. Historical Society.)*

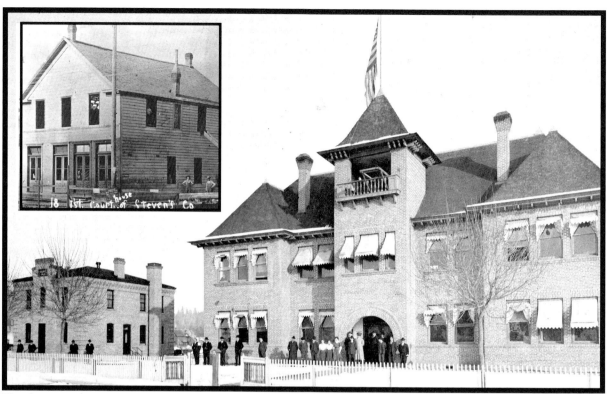

The Stevens County jail and courthouse, built in 1898, was torn down in 1939 to build the existing one. The first courthouse in Colville (inset) was established in 1886. *(Photos courtesy Stevens County Historical Society)*

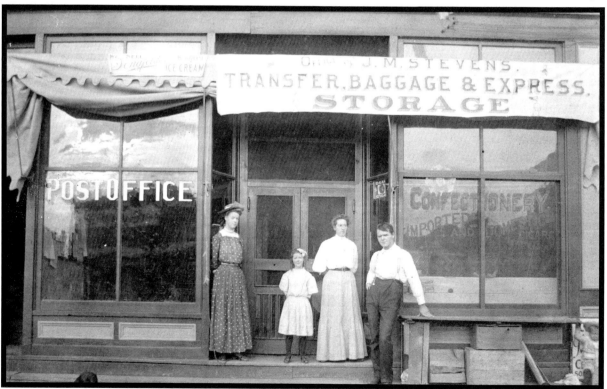

W.L. Terry's confectionery store and the post office on Main Street, circa 1908. Right to left, William Terry, his wife Vernilla, and their daughters Irene and Hazel. *(Photo courtesy Stevens County Historical Society.)*

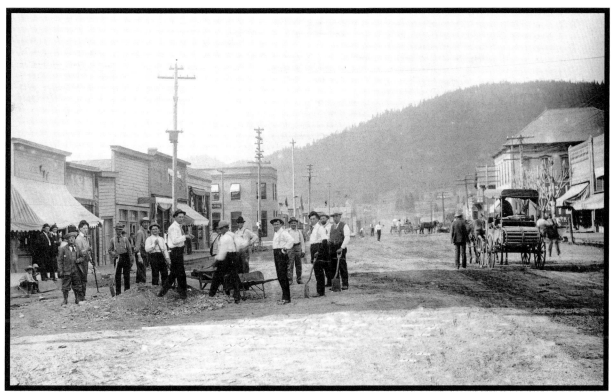

The Colville Improvement Club on Main Street (looking north) on May 25, 1909.
(Photo courtesy Stevens County Historical Society)

Leo Gordon's tack shop on East First in Colville in 1910. Leo was also an artist and later displayed his oil paintings of western scenes in his shop. *(Photo courtesy Stevens County Historical Society.)*

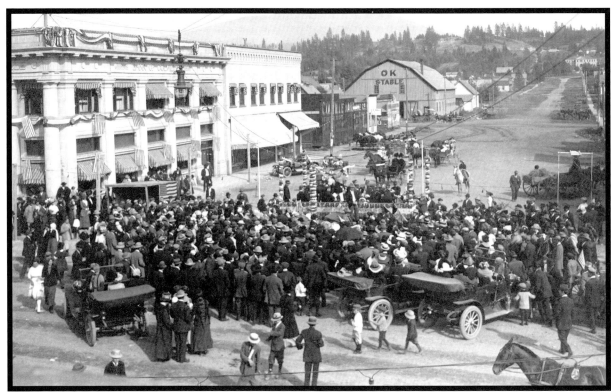

Armistice Day celebration in Colville in 1918, looking east on Aster (called Janet Street before 1911) from Main. Bank of Colville (left) is now Happy's Hallmark Shop. The OK Stable was at the site of the present library. Eells Academy is at the upper right corner. *(Photo courtesy Stevens County Historical Society.)*

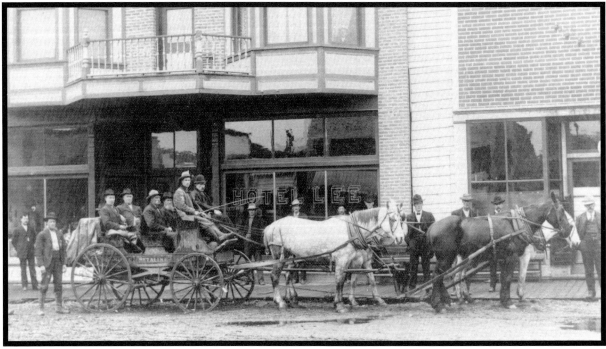

Colville-Metaline stage, driven by Gary Lane, at the Lee Hotel (now the House of Music) in Colville in 1906. Andrew J. Lee built the hotel in 1903, the second one in Colville. Mr. Lee (far left) is standing slightly behind Manford Daggy, auctioneer. Pat Grace is at the far right. *(Photo courtesy Stevens County Historical Society.)*

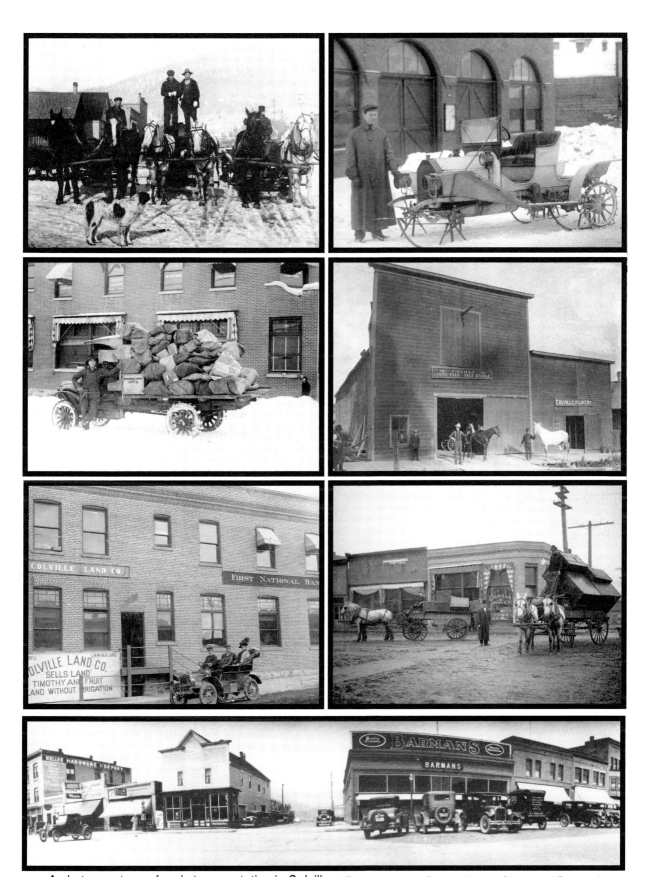

A photo montage of early transportation in Colville. *(Photos courtesy Stevens County Historical Society.)*

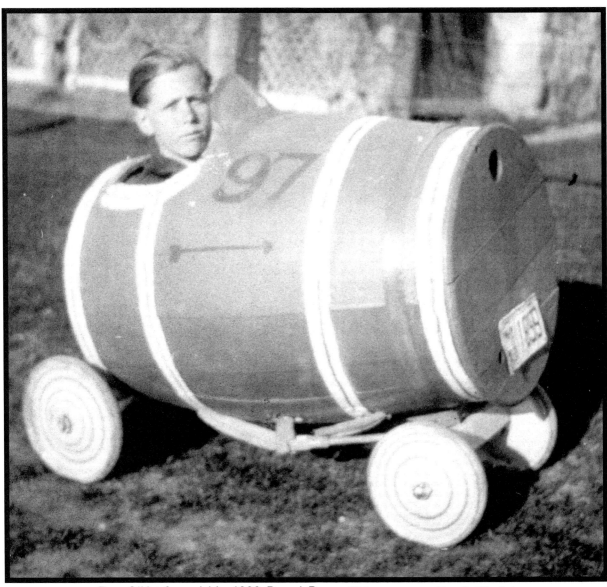

Ray O'Keefe and his 1930 Barrel Bug. *(Photo courtesy Ray O'Keefe.)*

n 1930 Ray O'Keefe, while living in Colville, constructed this vehicle from parts he found in his father's barn. In 1993 O'Keefe won an essay/photo contest "My First Car," held by the Cheney Cowles Museum, with the following essay:

Growing up during the Depression in a large family there was little or no money for toys or entertainment, so I learned early to make my own.

On finding an empty wooden barrel, I rolled it home, sure that I could find a proper use for it, and soon decided to build a car with an open cockpit similar to the airplanes of that era. I devised a lever for steering, which was successful, and a paint job complete with red stripes and the number "97" in honor of the Steam Locomotive immortalized in a ballad.

I soon learned when coasting down hill, at a good rate, to pull my head in like a turtle, turn sharply and roll the car, sometimes even coming back to rest on its wheels! When a young acquaintance begged me to drive it, I checked him out thoroughly on its operation including the proper procedure for rolling, but when rolling the car, he neglected to retract his head. Fortunately, it resulted in no damage to the car and only the loss of a considerable patch of hair and a little skin from the side of his head. I don't remember him ever pestering me to ride in my "Barrel Bug" again!

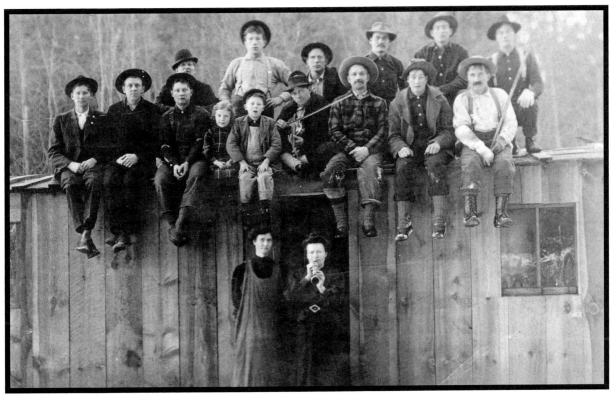

A group enjoying a little music on a neighbor's roof. Note the fiddler, horn player and lone singer. This picture postcard was sent January 20, 1910 by Roy Galbreath, the fiddler. *(Photo courtesy Stevens Co. Historical Soc.)*

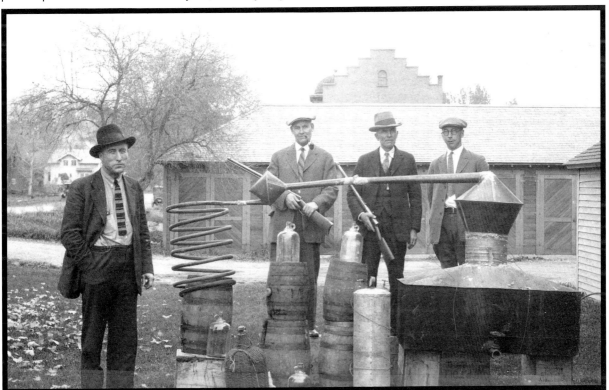

A still seized in Colville during a law-enforcement raid in 1930. Bootlegging and liquor trafficking across the Canadian border were lucrative operations during Prohibition. *(Photo courtesy Ray O'Keefe.)*

Dr. Lee B. Harvey built the hospital on North Main in 1905. He also had one of the first cars in Colville and often took children for rides after work. Note the hairstyle. *(Photo courtesy Stevens County Historical Society)*

The Colville Harvey Hospital operating room in action. In 1908 Dr. Harvey spent several weeks with the Mayo Brothers of the famed Mayo Clinic in Rochester, Minnesota, observing their methods and learning the latest and most successful surgical techniques. *(Photo courtesy Stevens County Historical Society.)*

A salmon caught in the Columbia River around 1935 by Gus Lundin (center rear). The children (L to R) are ? Lundin, Rodney O'Keefe, ? Lundin, Sid Lundin, Kelly and Lois O'Keefe. *(Photo courtesy Ray O'Keefe.)*

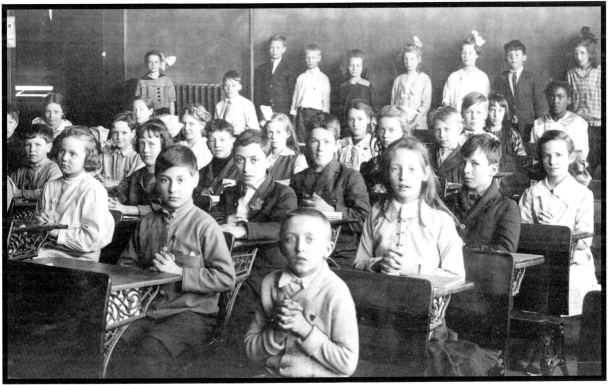

One of the area's schools during a time when prayer was acceptable and encouraged.

(Photo courtesy Stevens County Historical Society.)

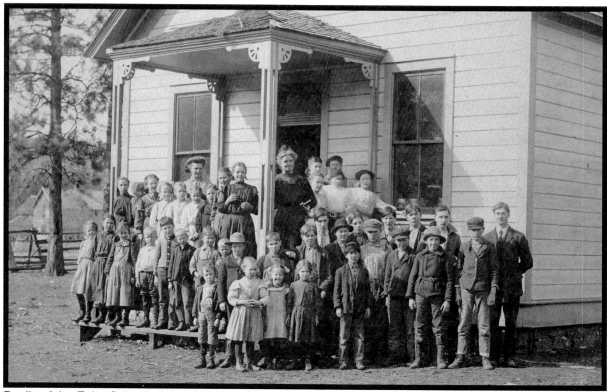

Pupils of the Echo School, circa 1909. Mrs. Wood was the teacher. The name "Echo" came from being able to hear echoes from various sawmills throughout the valley. *(Photo courtesy Stevens County Historical Society.)*

Leland Wilson and his "catalo" named Jumbo, the only living male offspring from a bison bull and domestic cow, in 1929. From his Grand View Ranch near Colville, he travelled the country selling postcards of this animal and touting the superior qualities of this breed of livestock. *(Photo courtesy Stevens Co. Historical Society.)*

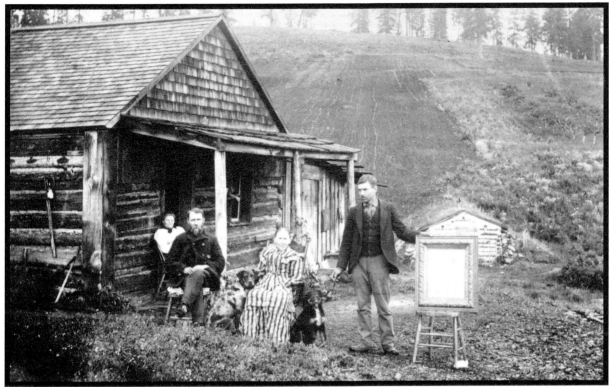

The Keough homestead in 1905 near White Mud Lake, a good farming area southeast of Colville. Frank and Elizabeth Murray are sitting in front. Their son Johnny is standing. The woman on the porch is unidentified.

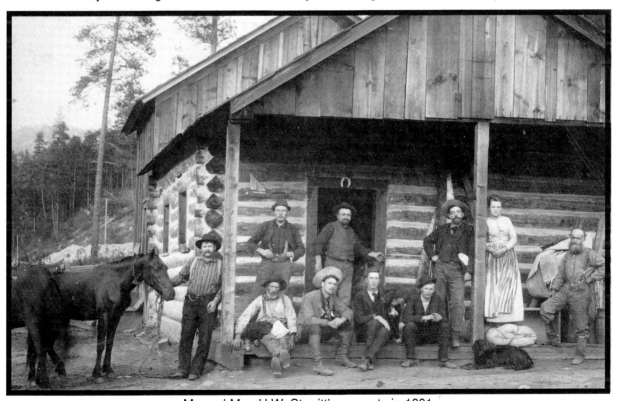

Mr. and Mrs. H.W. Sterritt's property in 1891.

(Photos courtesy Stevens County Historical Society.)

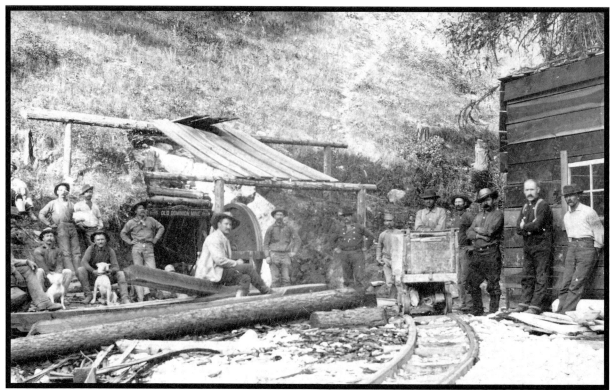

The Old Dominion Mine, discovered in 1885, was Washington's greatest lead-silver producer. The claim was once jumped by five men, one of whom was the infamous Wyatt Earp. *(Photo courtesy Stevens Co. Historical Soc.)*

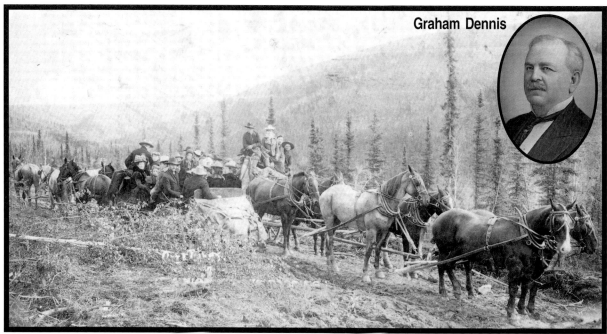

Graham Dennis

Stages passing on the Old Dominion Mine road, which was actually little more than a trail. The mine's large crew required a continual flow of supplies. Graham B. Dennis *(Inset-NWD)* was instrumental in organizing and developing the Old Dominion Mining & Milling Company, and was first president of the Northwest Mining Association, formed in 1895. He also served on the Spokane City Council from 1886-88, and organized and was the first vice president of the Spokane Industrial Exposition of 1890. *(Photo courtesy Stevens Co. Hist. Soc.)*

This is a photo from the Lambert family album. Note the man on the gate post. Sometimes it takes a lot to win the girl. *(Photo courtesy Stevens County Historical Society.)*

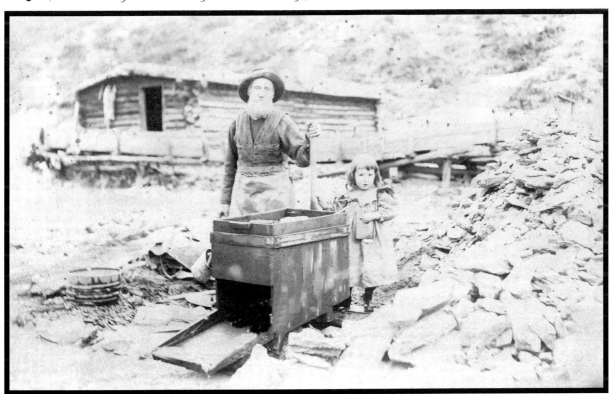

A gold placer miner and his daughter operating a "gold rocker table," which was a crude early device used to separate gold dust from sand and gravel. *(Photo courtesy Stevens County Historical Society.)*

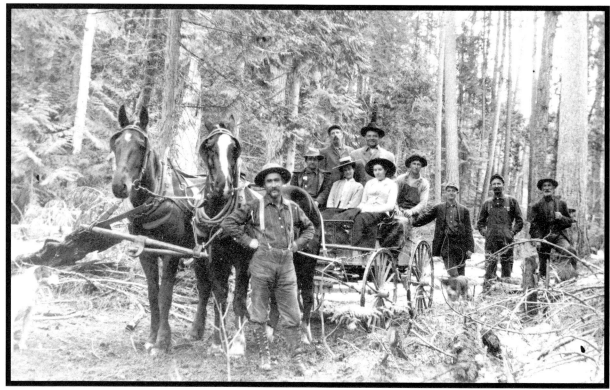

A Sunday outing near Starvation Flats, southeast of Colville.

(Photo courtesy Ray O'Keefe.)

Left: The Palmer children at their home near Orin, circa 1924. From left to right, Fay, Rose, Fern and Richard. The little boy in the wheelbarrow (center) is unidentified. **Right:** Bessie (Hawkins) Palmer, Fay and baby Fern near Orin in 1921. The sawmill community of Orin is about four miles south of the town of Colville on the Colville River. The Orin post office was located at the Winslow Sawmill.

(Photos courtesy Joan Sorensen, daughter of Fay (Palmer) George.)

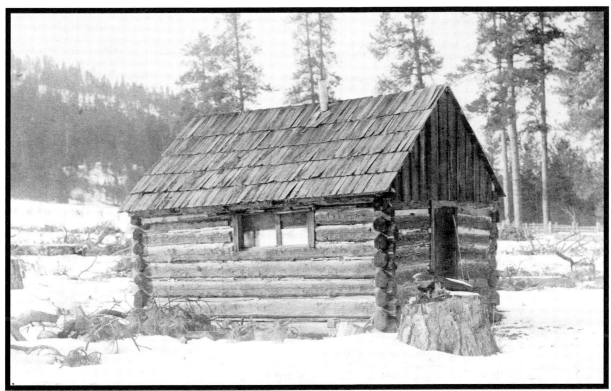

Schoolhouse, built on Gilbert Aubin's property in 1889, was across the valley from Orin. Mrs. Harriet Aubin, who became the first Stevens County superintendent, taught here. *(Photo courtesy Stevens Co. Historical Society)*

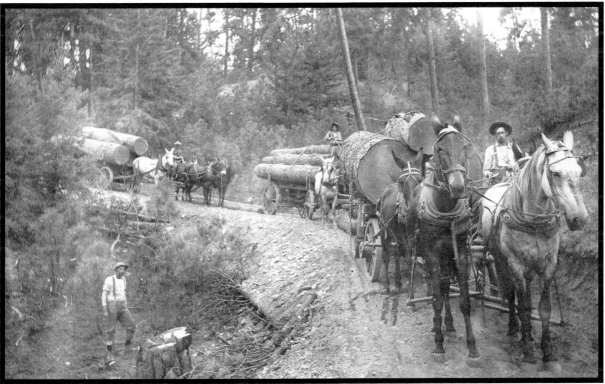

An early log hauling operation. Note the size of the logs and the four-horse teams used to pull the wagons. *(Photo courtesy Ray O'Keefe.)*

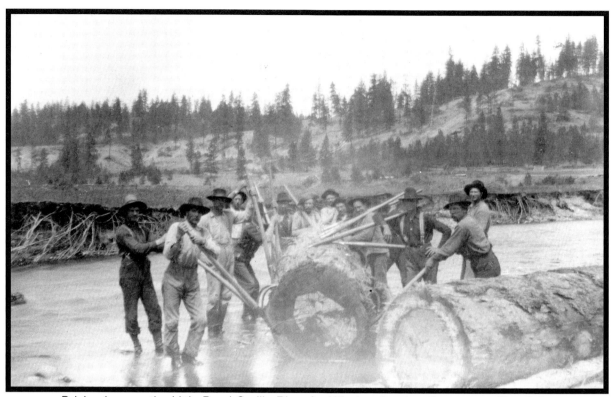

Driving logs on the Little Pend Oreille River for Winslow Lumber Company mill at Orin.
(Photo courtesy Ray O'Keefe.)

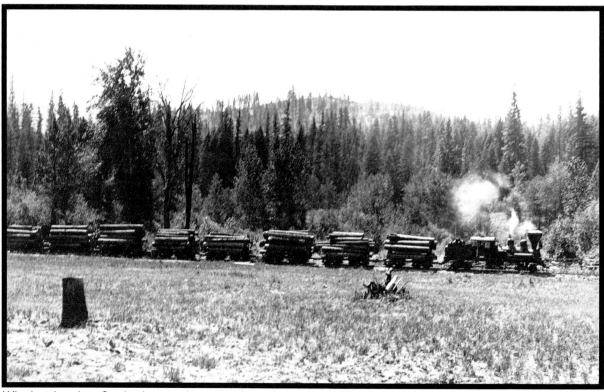

Winslow Lumber Co. had several camps along their railroad line from Arden to Starvation Lake. Logs were pulled to Arden by a Shay engine, dumped in the water and floated to Orin. *(Photo courtesy Stevens Co. Historical Soc.)*

The Winslow Sawmill at Orin, which was named for Orin Winslow. This mill was one of the largest operations in the region until it was destroyed by fire in 1938. *(Photo courtesy Stevens County Historical Society.)*

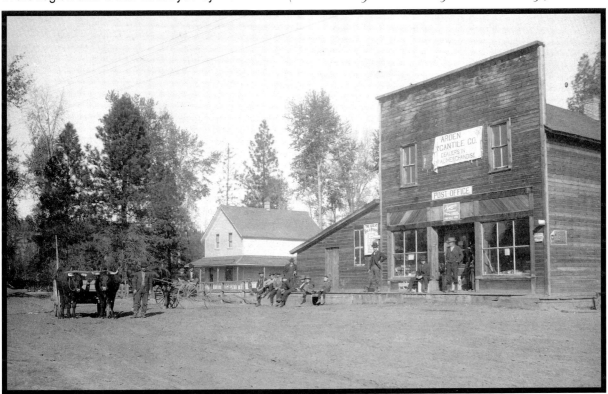

The Arden post office and store. A popular recreation area near Arden, between Colville and Chewelah, was enjoyed by people from nearby communities. *(Photo courtesy Ray O'Keefe.)*

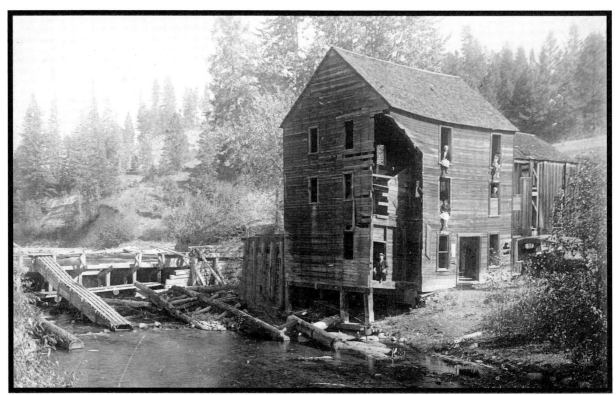

The remains of the old Oppenheimer grist mill near Arden. In the windows are: Mrs. Bell, Ollies Bell, Thelma Dorman, Roland Dupuis and Ruth Moore. *(Photo courtesy Stevens County Historical Society)*

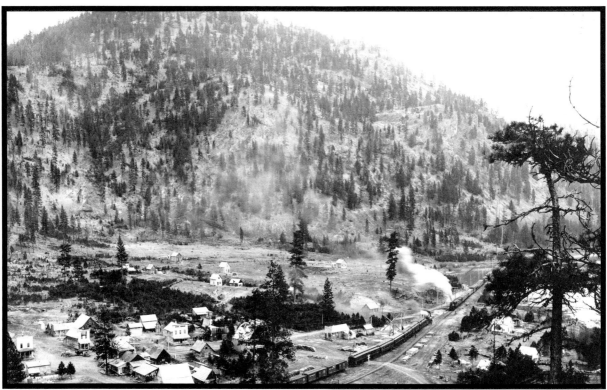

The town of Addy in 1904. Addy was as a primary shipping point on the S.F. & N. Railroad for goods to the Le Roi mines in British Columbia in the late 1800s. *(Photo courtesy Stevens County Historical Society.)*

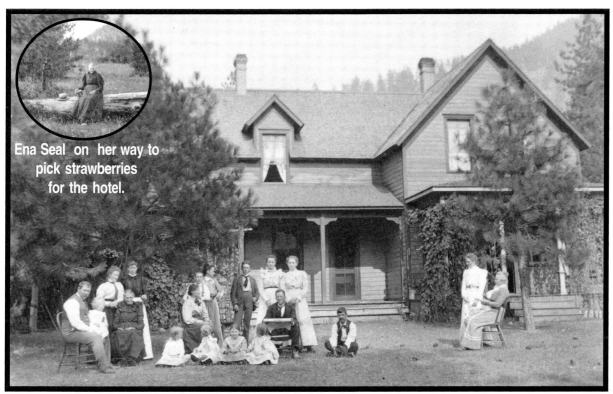

Ena Seal on her way to pick strawberries for the hotel.

In 1893 John and Ena Seal started the Addy Hotel next door to son George's store (below). After Mr. Seal's death in 1899, Mrs. Seal and Alice Plowman operated it until 1902. *(Photo courtesy Stevens Co. Historical Society)*

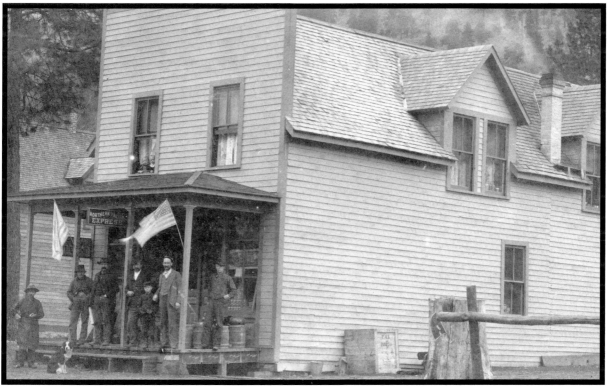

George W. Seal (4th from left) and Elias S. Dudrey, the first postmaster, started Addy's first store in 1890. The town was named for Seal's sister and Dudrey's wife, Addy. *(Photo courtesy Stevens County Historical Society.)*

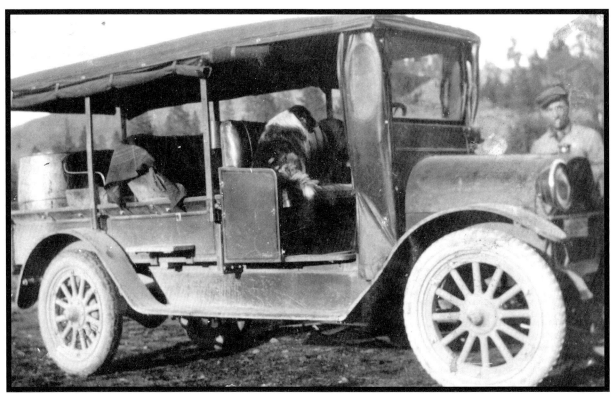

Walt Woodward and his trusty companion sometime in the 1920s. Woodward's truck carried passengers and freight between Addy and Gifford. *(Photo courtesy Stevens County Historical Society.)*

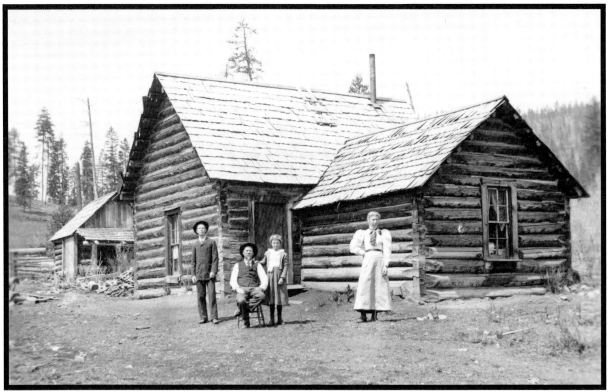

The Anderson homestead west of Addy (now the Summit Cemetery) around 1898. (L to R) Edwin, Charles, Bertha and Minnie Anderson. The Andersons had a sawmill at Addy. *(Photo courtesy Stevens County Historical Society)*

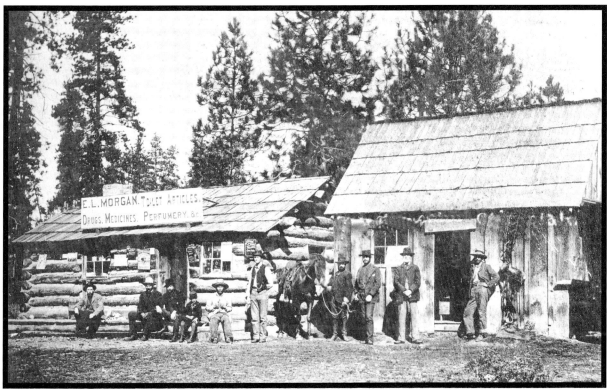

Chewelah's first post office and drug store, located on the west bank of Chewelah Creek north of Webster Street, was built in 1880. This also served as part of the Indian Agency *(Photo courtesy Chewelah Historical Society)*

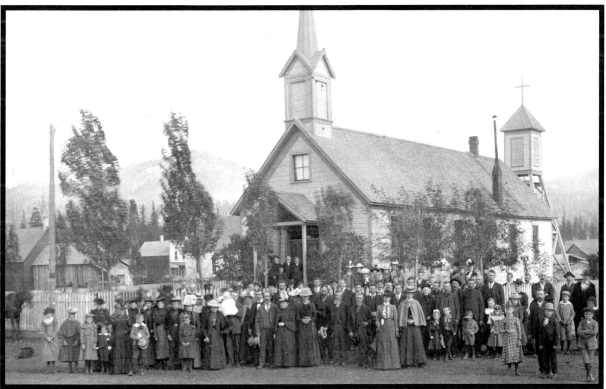

The Chewelah Catholic Church, circa 1900, was near the site of the present American Legion hall. A new church was constructed in 1908 and this building was then used as a school. *(Photo courtesy Chewelah Historical Soc.)*

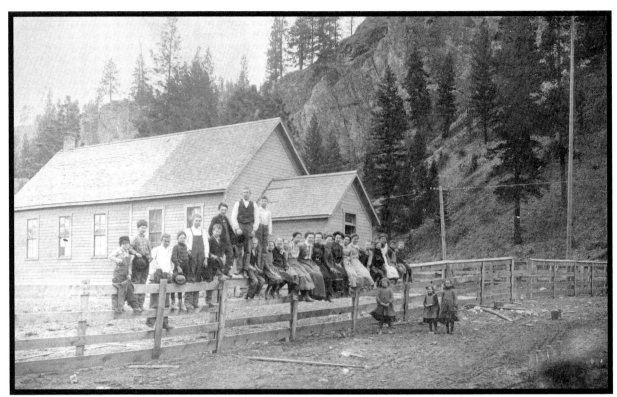

The Blue Creek School, generally known as the Graham School, in March 1902. It was built about 1895 along the main road near the Duncan Road turn off. It was used until 1919. *(Photo courtesy Chewelah Historical Society)*

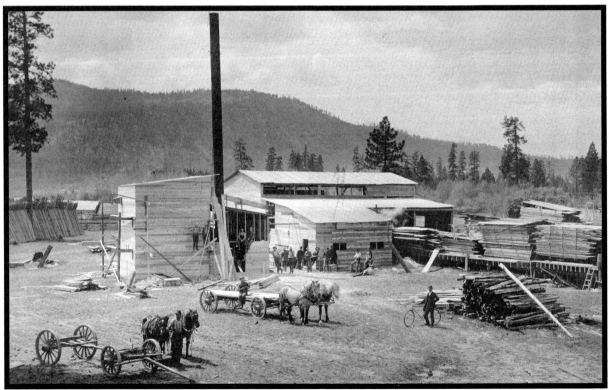

The Smith and Houston Planing Mill at Chewelah in 1902. Mr. Steelhead, the only local photographer in the area at the time, is the man on the bicycle. *(Photo courtesy Chewelah Historical Society)*

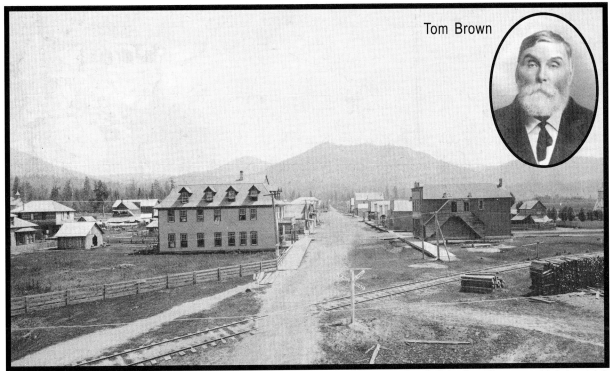

Tom Brown

Chewelah's Main Street looking east in 1903. The large building on the left is the Pomeroy Hotel, which burned in 1904. The drug store on the right burned in 1906. Tom Brown (inset), who is considered the "Father of Chewelah," moved his family to this part of the county in 1859. *(Photos courtesy Chewelah Historical Society.)*

The Club Bar and Cafe (the Nett Block) was built in 1907 by John Nett. It served for many years as the Union Hall and more recently the Golden Age Hall (with the top story removed). *(Photo courtesy Chewelah Historical Soc.)*

The Chewelah cemetery during Cemetery Decoration Day on May 30, 1907. Many of Chewelah's well-known pioneers are buried here. *(Photo courtesy Chewelah Historical Society)*

The 5th grade school room in Chewelah during the 1908-09 school year. Note the abnormal concentration span of all the students. *(Photo courtesy Chewelah Historical Society.)*

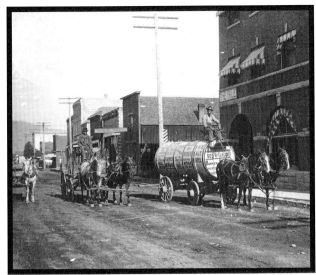 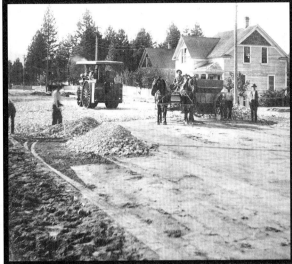

Left: Chewelah's city dray sprinkler in 1910. **Right:** Improving Webster Street at First in 1912.

Left: Arrival of the Copper King traction outfit in 1905 to haul ore to the railroad en route to the smelter. **Right:** Ella Diedrich Potter, operator at the old Chewelah Telephone Company Exchange.

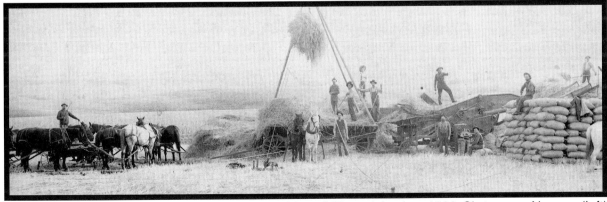

A horse-powered threshing machine on the outskirts of Chewelah, circa 1900. Six teams of horses (left) traveled around the capstan to provide the power to run the separator. The straw was stacked manually.

(Photos courtesy Chewelah Historical Society)

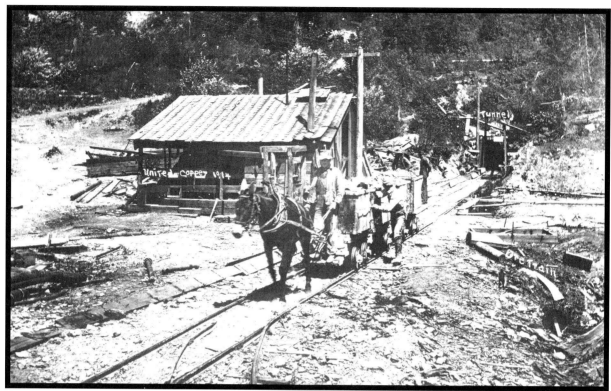

The ore train leaving the portal of the United Copper Mine on its way to the mill in 1914. The main adit of this mine extended over 4200 feet into Eagle Mountain. *(Photo courtesy Chewelah Historical Society)*

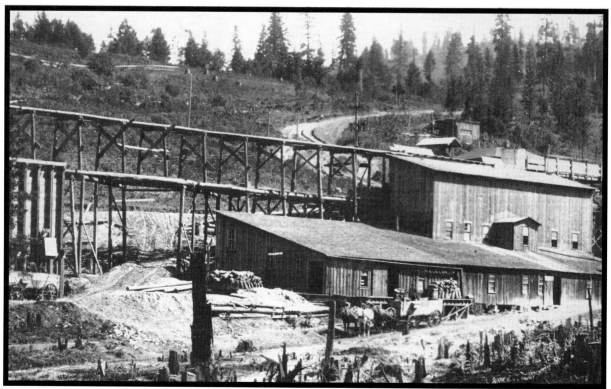

The United Copper concentrator mill in 1914. The concentrates were sacked and shipped by teams and wagons to the railroad at Chewelah to be shipped to the smelter. *(Photo courtesy Chewelah Historical Society)*

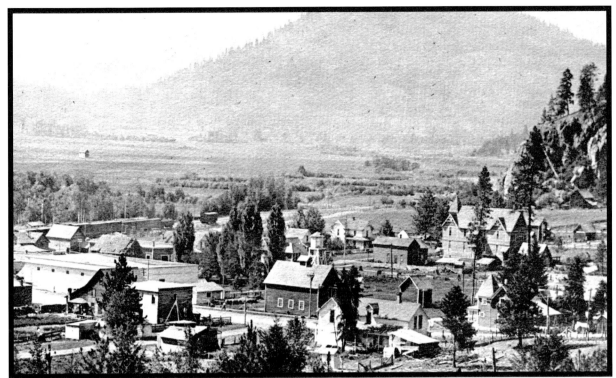

A view of Valley looking northwest, circa 1912. Valley was first called Kulzerville after the Kulzer family, the first settlers there. They owned a general store. The flat roofed building to the far left is the Kulzer Block, which was built in 1908, and today is the Valley General Store. *(Photo courtesy Stevens County Historical Society.)*

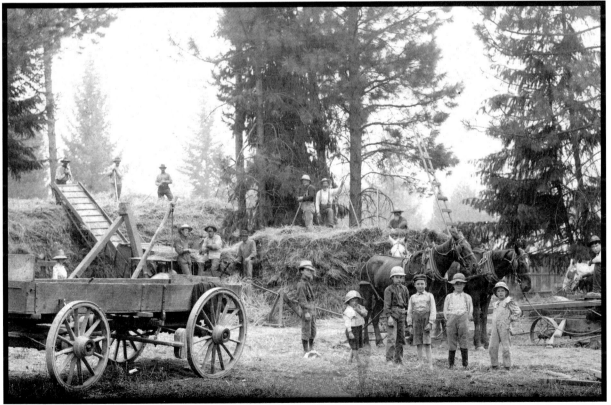

Harvesting hay in Stevens County, circa 1900. *(Photo courtesy Stevens County Historical Society.)*

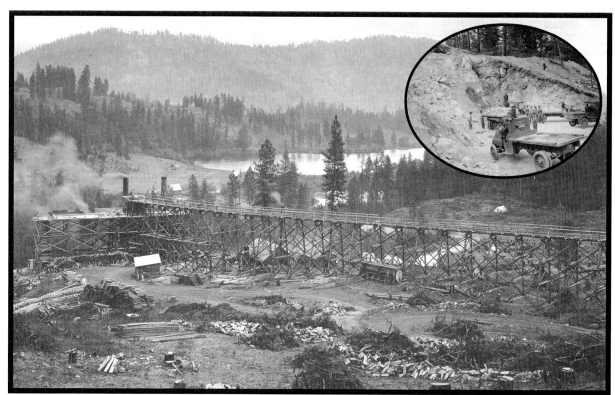

The American Mineral Company magnesite plant (Allen Camp) at Valley. Photo taken in August 1917. Inset is the magnesite quarry. *(Photos courtesy Stevens County Historical Society)*

Camp at the U.S. Marble Company's quarry, circa 1899. This was located on Greenway Mountain near Valley.
(Photo EWSHS, L89-183.7)

The town of Springdale, circa 1915. It came into existence with the construction of the Spokane Falls & Northern Railroad in 1889. Prior to its arrival, C.O. Squires homesteaded the land on which the town of Springdale now stands. The inset photo of Ada and Mellie Brown, with their dog Jack, was taken in Springdale in 1906. *(Springdale photo courtesy Thelma Shriner. Inset courtesy Stan Williams, son of Mellie (Brown) Williams.)*

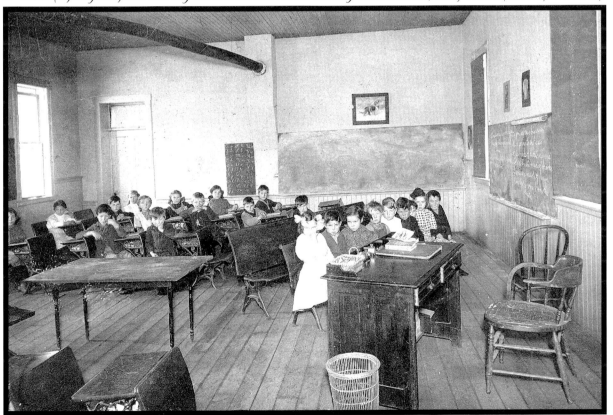

The first and second grade classes at the Springdale school in 1911. *(Photo courtesy Stan Williams.)*

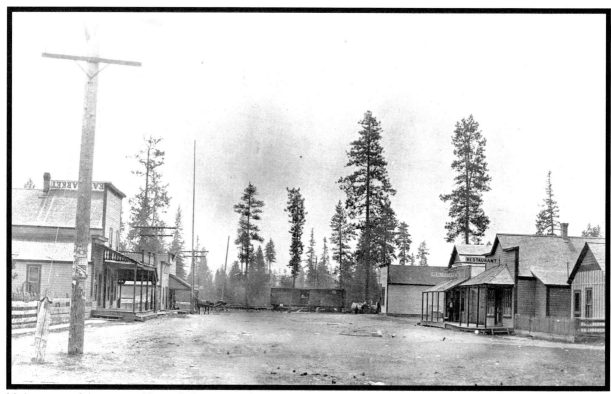

Main street of the town of Loon Lake, a popular summer resort area, in 1907. In the early days, lumbering and flourishing ice businesses were the main industries supporting the town. *(Photo EWSHS, L86-4814)*

Autos and ferris wheel at Loon Lake in 1920. After the S.F.& N.R.R. was built in 1889, D.C. Corbin owned and operated a park at the lake, a destination point for special excursions. *(EWSHS, Libby photo, L96-1.380)*

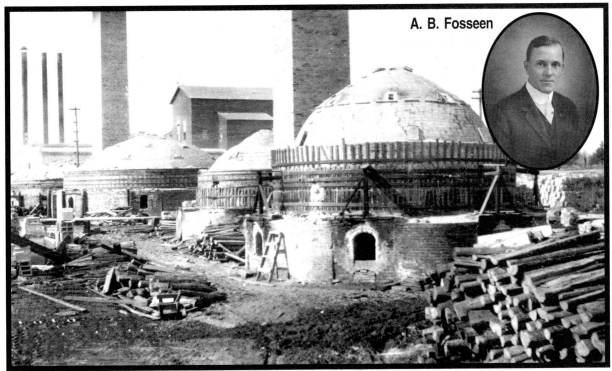

A. B. Fosseen

Kilns at the Washington Brick, Lime and Manufacturing Company in Clayton, circa 1900.

(Photo courtesy Stevens County Historical Society.)

The town of Clayton got its start when the railroad came through in 1889. Until its closure in 1957, the brick and terra-cotta plant was the lifeblood of the town. Washington Brick, Lime & Mfg., the largest brick manufacturer in the Inland Northwest, was established by industrialists from Ohio in 1893. As the owners reached retirement age, they offered to sell the business to Arthur B. Fosseen, whose building material agency in Yakima had been a major distributor of the company's product for years. In 1919 Fosseen and his associates purchased the company and operated it for the next 38 years. Around 1927 a young man by the name of Leno Prestini hired on. He was a talented terra-cotta sculptor, whose creations can still be seen on many local buildings. When new building codes, which prohibited sculptures from extending over sidewalks by more than two inches, undercut the demand for this artwork, Prestini transferred his talents to painting.

In 1924, during his early teen years, Neal Fosseen went to work for his father at the brickyard, which began shaping the work ethics of one of Spokane's most popular leaders. The Fosseen legend began at the age of 12, when he became the youngest Eagle Scout in the world. He later served as president of the Boy Scouts Inland Empire Council. He was elected as Spokane's mayor for two terms before resigning and transferring the office to Mayor David Rodgers. During his tenure, he made some of the most significant contributions of any mayor in Spokane's history. He was involved with the development of Spokane International Airport, Expo '74 and instrumental in establishing an excellent sister-city relationship between Spokane and Nishinomiya, Japan. As a result, he was named to the Order of the Rising Sun by the emperor of Japan. In 1936 Neal married Helen Witherspoon, whose grandfather was both a chief of police and fire chief in early Spokane. Her father and brother were chairmen of the Old National Bank.

Helen & former Mayor Neal Fosseen, 1999

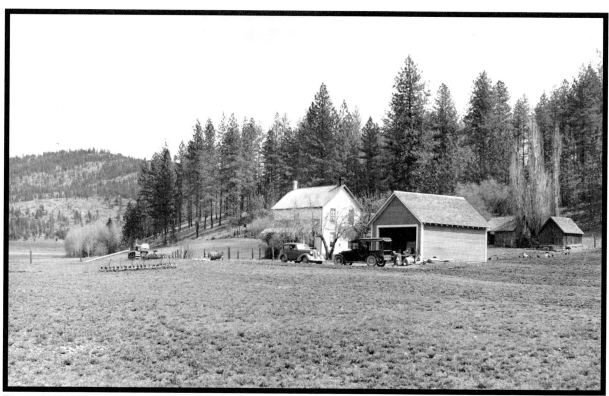

These buildings are located at the former site of the Tshimakain Mission, established north of Ford in 1838-39 by the Revs. Elkanah Walker and Cushing Eells. *(Photo courtesy Spokane Public Library Northwest Room.)*

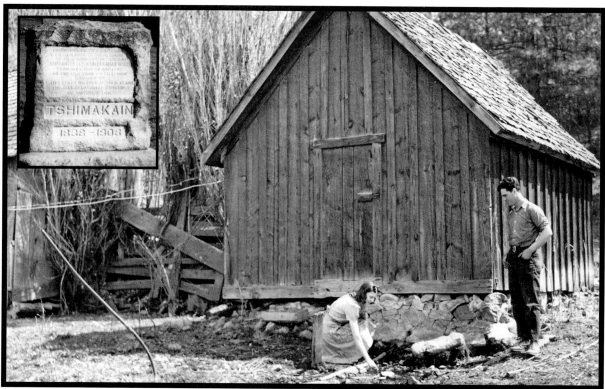

The old spring house in 1940, which covered the spring that furnished water to the Tshimakain Mission. The inset is the present-day roadside marker near the mission site. *(Photos courtesy Spokane Public Library Northwest Room.)*

The Columbia River Corridor
North to South

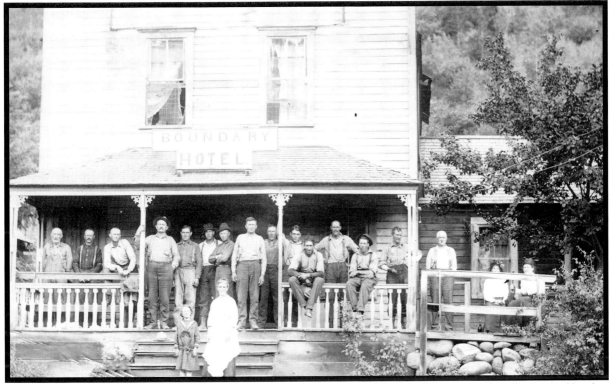

The hotel at Boundary, just south of the Canadian border, in 1915. The hotel was owned and operated by Joe Klass (3rd from right) and his wife, Elizabeth (standing below the stairs). *(Photo courtesy Stevens Co. Historical Soc.)*

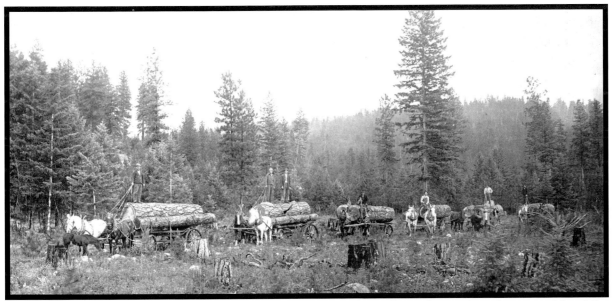

Hauling logs from white pine forests to Orr's Mill in 1916. The mill was located on the west side of the Columbia River across from Northport. *(Photo courtesy Stevens County Historical Society.)*

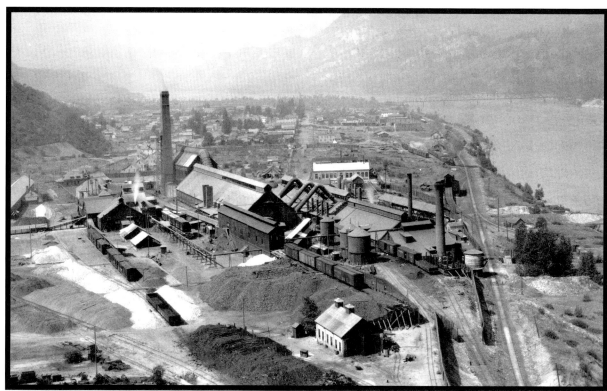

Northport smelter and the once-booming town of Northport in the background, June 1918. The smelter was only in operation from January 1898 until the early 1920s. (*Photo courtesy Stevens County Historical Society*)

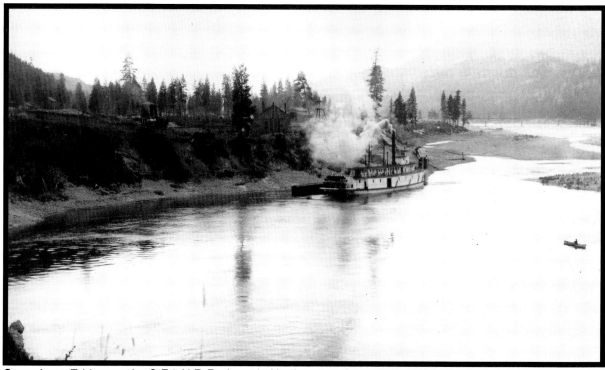

Steamboat *Eddy* near the S.F.& N.R.R. depot in Northport on August 25, 1897. The first steamboat to run the Columbia in northeastern Washington was the *Forty-Nine,* built by Captain Lew White at the town of Marcus. It was launched on November 18, 1865 and made its first run the following April. (*Photo EWSHS L95-107.3*)

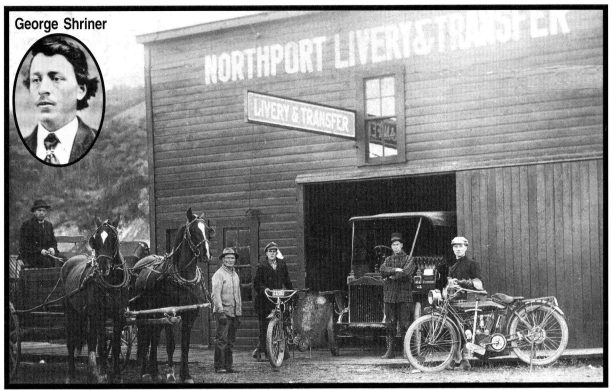

George Shriner

George W. Shriner's (inset) livery and blacksmith shop, circa 1916. Pictured (L to R) are George Willey, George Simpson, George Goodwin, Wade Thompson and the owner's son Earn Shriner. *(Photos courtesy Thelma Shriner.)*

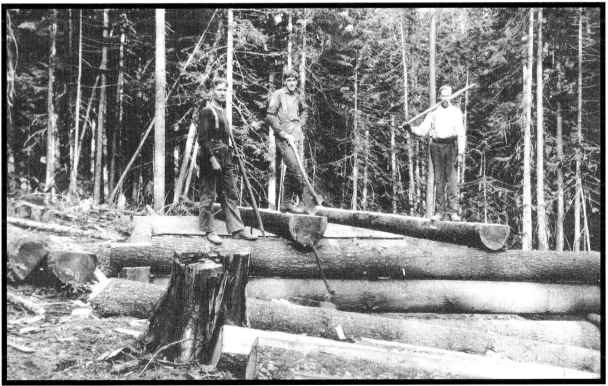

Whipsawing lumber in 1911 for Clyde (center) and Jessie O'Keefe's log home on their homestead at Sherlock Creek, halfway between Leadpoint and Deep Lake. *(Photo courtesy Ray O'Keefe, son of Clyde and Jessie O'Keefe.)*

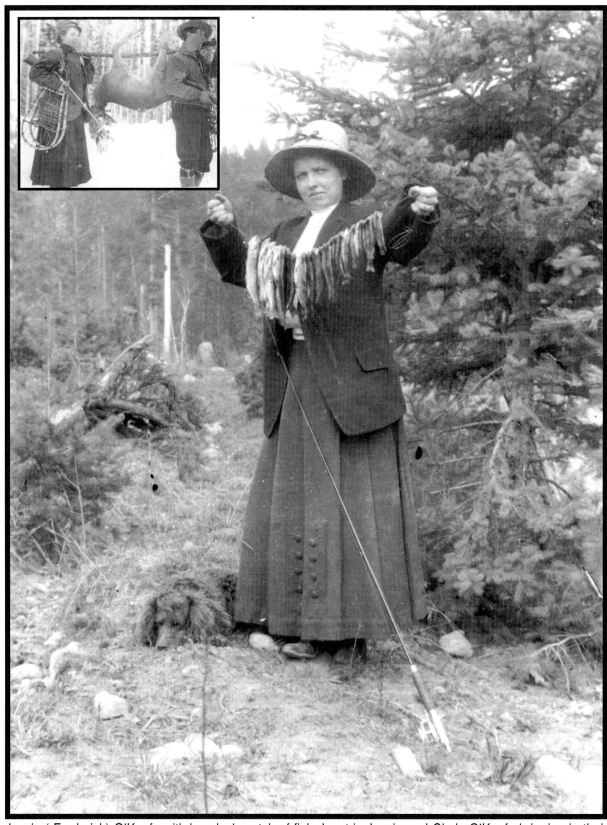

Jessie (Frederick) O'Keefe with her day's catch of fish. Inset is Jessie and Clyde O'Keefe bringing in their game supply. Photos taken about 1911 near their Sherlock Creek homestead. *(Photo courtesy Ray O'Keefe)*

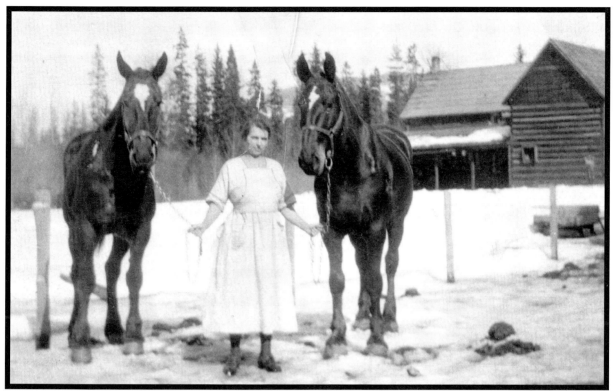

Jessie O'Keefe with the family horses at their home near Cedar Creek, between Leadpoint and Boundary in the early 1920s. *(Photo courtesy Ray O'Keefe.)*

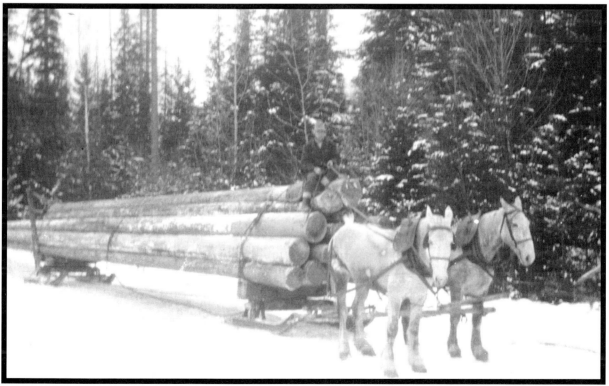

Clyde O'Keefe had a cedar pole business. He is shown here hauling cedar poles to Boundary by sled during the winter in the early 1920s. *(Photo courtesy Ray O'Keefe)*

A typical scene on many of the early homesteads. Kindhearted settlers often raised orphaned fawns. Although these acts were well intentioned, the consequences were often traumatic. *(Photo Stevens Co. Historical Society.)*

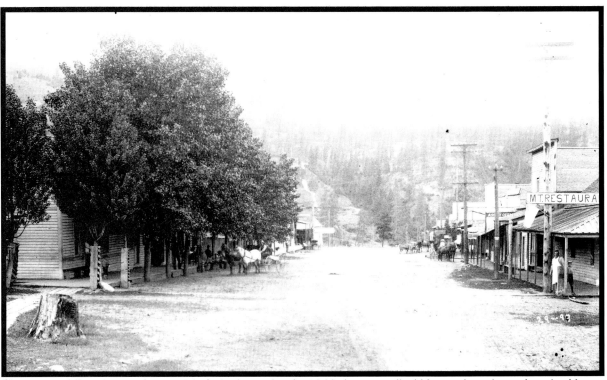

The town of Bossburg, circa 1908. At its inception in 1888, it was called Young America, after the Young America silver mine. Before the town was finally named for C.S. Boss and John Berg who platted the town in 1892, it was called Millington for its stamp-type mining mill. *(EWSHS, Frank Palmer photo, L84-327.411c.)*

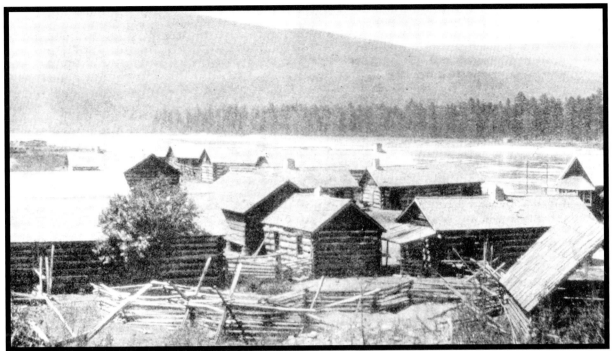

After the British Boundary Commission completed its survey in 1862, their buildings (above) became the town of Marcus. When the Spokane Falls and Northern Railroad arrived and the town was platted in 1890, it was named for Marcus Oppenheimer. Oppenheimer was an early homesteader who arrived in the area in September 1863 and operated a store in one of the buildings. *(Photo courtesy Spokane Public Library Northwest Room.)*

Marcus resident Andrew Edward "Ed" Pelissier at his fishing site. He was instrumental in building the Kettle River Road, the first road from Marcus to the boundary line. *(Photo courtesy Stevens County Historical Society.)*

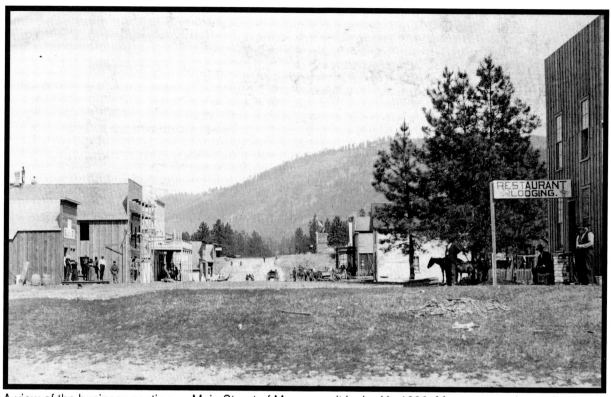

A view of the business section on Main Street of Marcus as it looked in 1896. Marcus came into existence in 1862 and was one of the first towns in Stevens County. *(Photo courtesy Spokane Public Library NW Room.)*

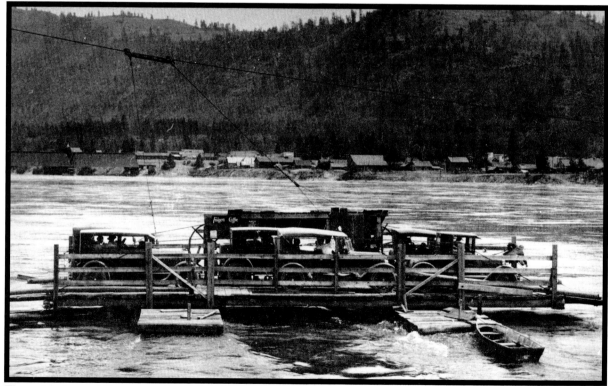

The cable ferry at Marcus on the Columbia, about 1925, was powered by the river's current and could carry six cars. The old town of Marcus, now under water, is in the background. *(Photo courtesy Stevens Co. Historical Soc.)*

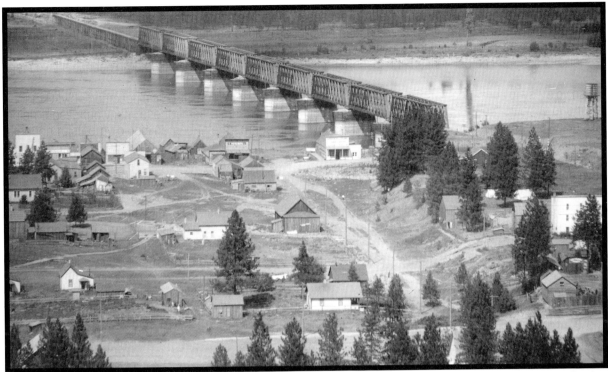

Marcus in 1911. This was the largest town forced to move or be flooded by the backwaters of Grand Coulee Dam. Many of the buildings were moved to a higher bench in 1939, but foundations and sidewalks, normally under 50-60' of water, are still visible when the river is low. *(Photo courtesy Stevens County Historical Society.)*

In 1925 Marcus had a girls – but no boys – basketball team. Dora (Brittain) Smith, first on left, recalled a most embarrassing moment when her bloomers fell down during a game. *(Photo courtesy Patricia Smith Goetter.)*

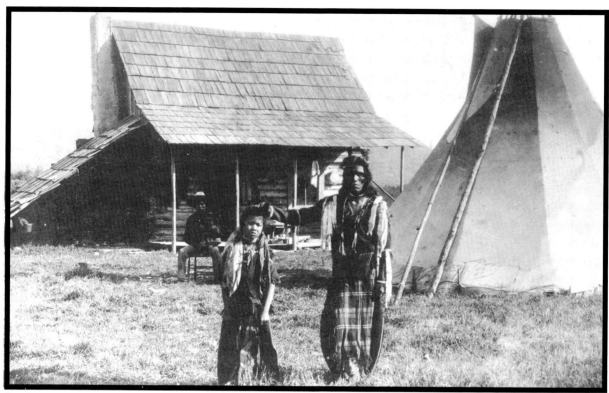

Colville Indians at old Fort Colvile on the Marcus flats above the Kettle Falls. When the fort was established in 1826, many Indian families camped close to the fort to work odd jobs. *(Photo courtesy Stevens Co. Historical Soc.)*

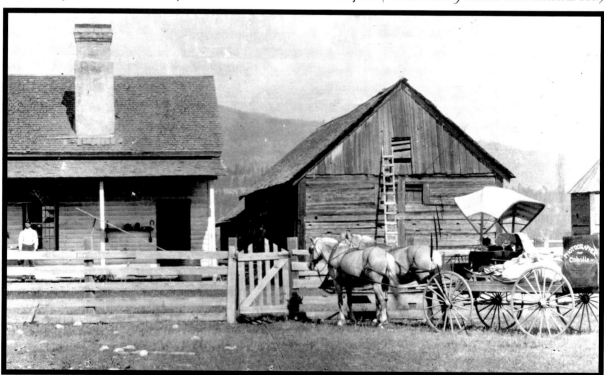

Frank Palmer's photography wagon in 1900 at the old Hudson's Bay Fort Colvile. The buildings (L to R) were the officers' quarters, storehouse and blockhouse. Frank Palmer took thousands of photos of the Inland Northwest, documenting its early development. Many of his photos appear in this book. *(EWSHS, Frank Palmer photo, L86-666)*

The Marcus ferry washed up on the rocks above the Kettle Falls on the Columbia River after it broke loose and floated down the river. Lower center, an Indian woman is spearing fish. *(Photo EWSHS, Magee Album, L83-132)*

A Lambert family outing along the Columbia River, circa 1900. This scenic area was a popular picnic spot. *(Photo courtesy Stevens County Historical Society.)*

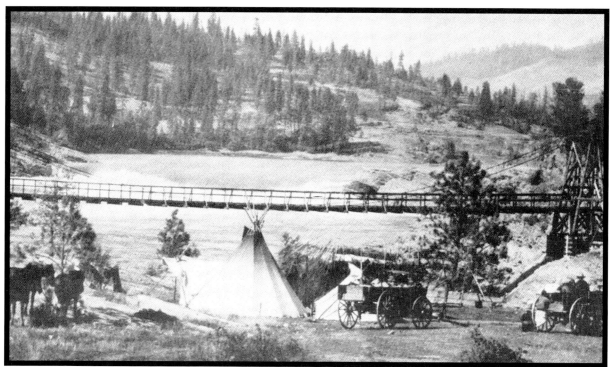

Indian fishing camp at the Kettle Falls. When the fur trappers arrived, the main Colville Indian village was located at this site. Their homes were communal lodges and tepees (as shown above). Every year numerous tribes gathered during the fishing season, but a salmon chief controlled the catching and distribution of the fish to insure it was divided fairly among everyone at the camp. As the men caught the fish, the women prepared and dried them on dome-shaped willow racks located on the river bank. Washington Water Power built the footbridge (center of photo) and planned to build a dam but abandoned the idea. *(Photo courtesy Stevens County Historical Society.)*

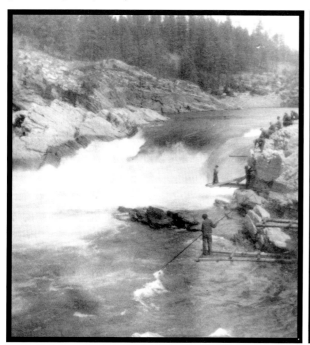

Left: Indians fishing at the Kettle Falls was a common site in earlier times. *(Photo courtesy Ray O'Keefe.)*
Right: Charles Curtis proudly displaying the fish he caught at these falls, circa 1936. *(Photo EWSHS, L85-278.2)*

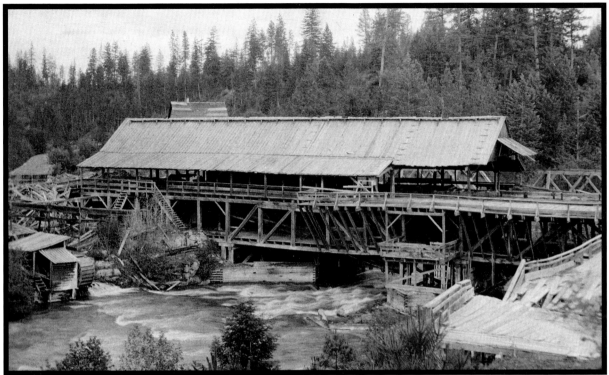

Meyers Falls Lumber Co. in the early 1900s. L.W. Meyers owned the sawmill and a flour mill at the falls named for him. At that time, Meyers was the largest individual holder of improved property in Stevens County. In the early 1800s, the Hudson's Bay Company built a grist mill at Meyers Falls, the first in Stevens County.

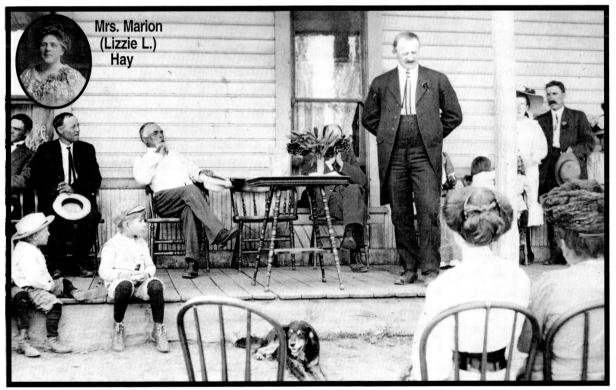

Mrs. Marion (Lizzie L.) Hay

Governor Marion Hay on the front porch of the Gordon Hotel at Meyers Falls on June 1, 1910. The beautiful townsite was platted in 1891 and is now the town of Kettle Falls. (*Photos courtesy Stevens County Historical Society.*)

St. Francis Regis Mission, circa 1880. In 1869 Father Urban Grassi, S.J., purchased 40 acres east of present-day Kettle Falls to establish the second St. Francis Regis Mission (the first was in existence for a few years in the mid-1800s near present-day Chewelah). The Sisters of Charity opened the Sacred Heart Academy (not shown), a school for Indian girls, in 1873, which continued until 1921. The Jesuit priests conducted one for the Indian boys (building with the steeple) from 1878 until 1908. After extensive remodeling, the former girls' school later became a convent. Today, it is a bed and breakfast called "My Parents' Estate." *(Photo courtesy Stevens Co. Historical Society.)*

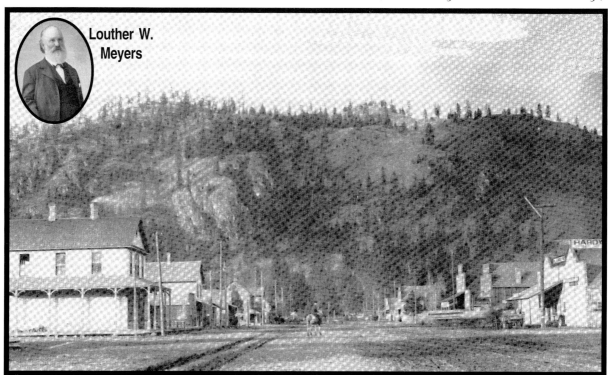

Meyers Street, the main street of Meyers Falls, looking north toward Gold Hill, circa 1910. The homestead of L. W. Meyers, the town's namesake, included the falls and surrounding property. He also owned about a third of the original Colville townsite. *(Photo courtesy Stevens Co. Historical Society. Inset from "History of North Washington.")*

Aerial photo of Kettle Falls on March 16, 1930. Grand Coulee Dam flooded old Kettle Falls in 1940 but not before the town moved in with Meyers Falls, changing its name to Kettle Falls. *(Photo courtesy Stevens Co. Historical Soc.)*

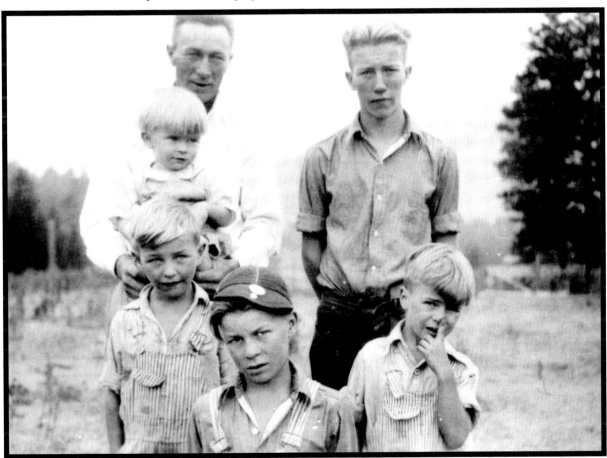

Walt Clemons and his family at Pleasant Valley in 1936. They survived tough times share farming in Rice, Arzina and Pleasant Valley. He received as much as one-third of the profits. *(Photo courtesy Tamara (Clemons) Clemson.)*

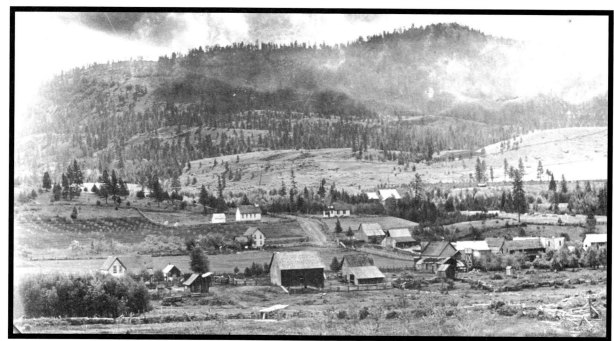

The town of Rice in 1908. It was named for William Rice, who owned a store and became the postmaster when the post office was established in 1883. *(Frank Palmer photo courtesy Jerome Peltier.)*

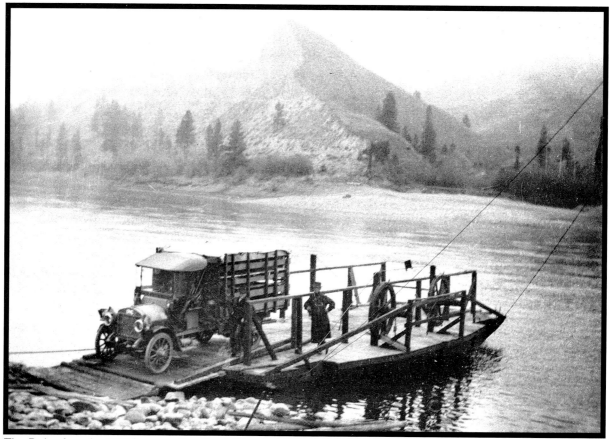

The Daisy ferry in 1917 transporting the 1.5 ton truck owned by A.B. Nickens of Covada, which he used to haul merchandise between Spokane and Covada on the Colville Indian Reservation. *(Photo courtesy Thelma Shriner.)*

The Engstrom family ran the ferry across the Columbia River from Gifford to Inchelium (now a free ferry run by the state). This little girl at Gifford is believed to be an Engstrom. *(Photo courtesy Stevens Co. Historical Society.)*

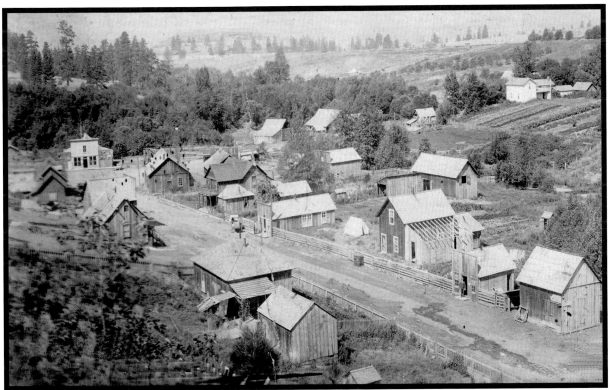

The town of Hunters, early 1900s, named for James Hunter, a pioneer who settled here in 1880. When the town was platted in 1890, lots sold for $5 to $25 apiece. *(Photo courtesy Stevens County Historical Society.)*

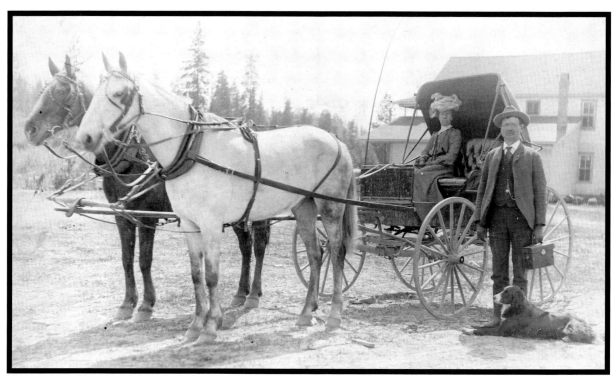

Dr. and Mrs. Roderick McRae of Hunters. Dr. McRae once had a horse who knew the route so well, he automatically stopped at each farm along the road, allowing the doctor to nap between visits. After finishing his rounds and turning for home, the horse proceeded without stopping. *(Photo courtesy of Stevens Co. Historical Society.)*

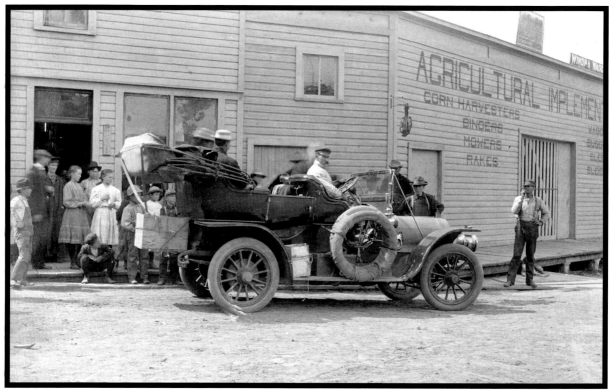

Charles White's grocery store in Hunters. This store, founded by Frank Donley and a Mr. Smith, was the first one in Hunters. *(Photo courtesy of Stevens County Historical Society.)*

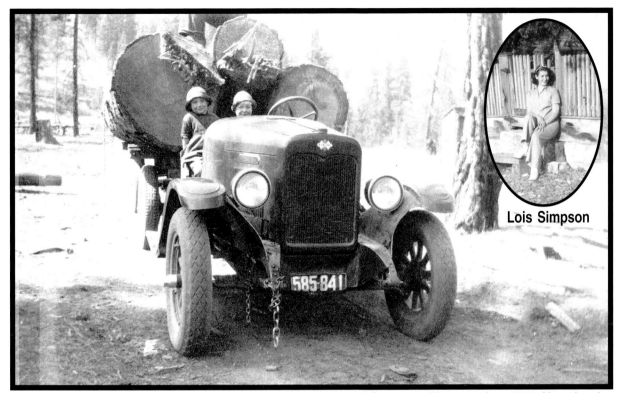

Pete Simpson's truck with a load of logs and his children Lois and Gene near Hunters, circa 1929. Note the size of the logs. The inset is Lois Simpson (Randall) as a teenager at the Crystal Hotel in Miles, circa 1940.

(Photos courtesy Lila Krueger, daughter of Lois Randall.)

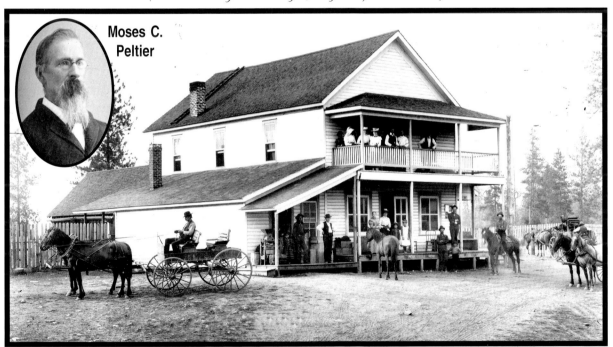

Moses C. Peltier's hotel at Fruitland, circa 1900. Peltier also owned and operated a commercial farm, a general merchandise store with a post office, blacksmith and carpenter shop, feed barn and various warehouses. Upon his arrival in 1886, he gave Fruitland Valley its name as he recognized its fruit growing potential.

(Frank Palmer photo courtesy Jerome Peltier. Inset from "History of North Washington.")

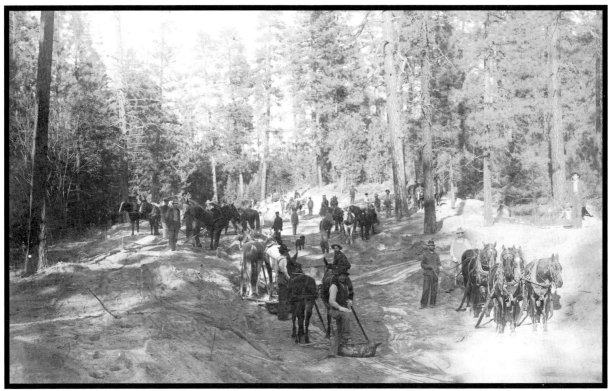

Building the Fruitland Irrigation Co. ditch from the Colville River along the Columbia River to Daisy, circa 1907. Hundreds of acres of orchard land were irrigated from this ditch. J.S. Lane was in charge of the operation.

Inspecting the Fruitland Irrigation Company ditch. County Commissioner William Sax is in the lead buggy. The ditch was ready for use in 1908 but was not very successful. The water delivery system was not efficient enough to carry the necessary volume the full length of the ditch. *(Photos courtesy Stevens County Historical Society.)*

The Spokane Indian Reservation was created in January 1881 by President Rutherford B. Hayes. This was the first mission at Wellpinit on the reservation, circa 1900. *(Photo EWSHS, L90-237)*

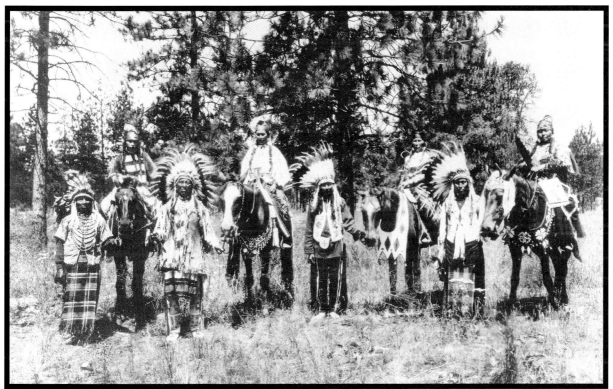

Members of the Spokane Tribe (L to R), Joe Robinson and his wife, Lott and Lucy Lowley, John and Minnie Stevens, Joseph Levi and his wife. Photo was taken at Indian Canyon in August 1935. *(Photo EWSHS, L98-1.23)*

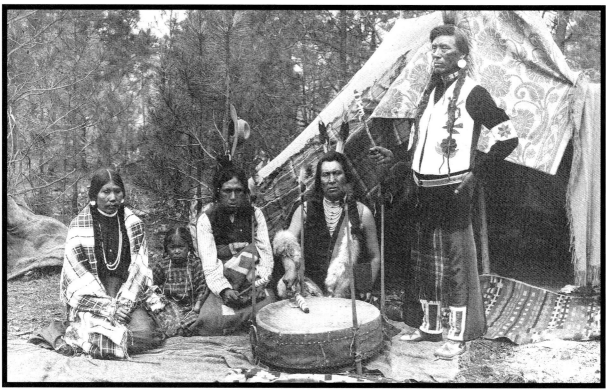

Members of the Spokane Tribe at Indian Canyon in 1935. (L to R) Martha Joshua Pierre (Sin Taque), Mi Mi Stevens (John Stevens's daughter), Jackson Eliga, Paul Oyachen and John Stevens. *(Photo EWSHS, L98-1.21)*

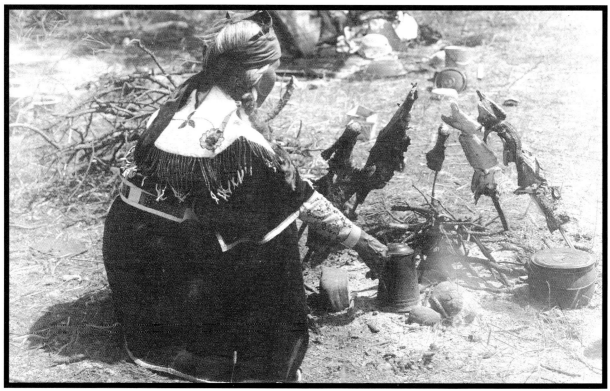

Lucy Lowley (Chi Lo Ta) smoking salmon at Indian Canyon in August 1935.
(Photo EWSHS, L98-1.18)

Chapter 6

Pend Oreille County

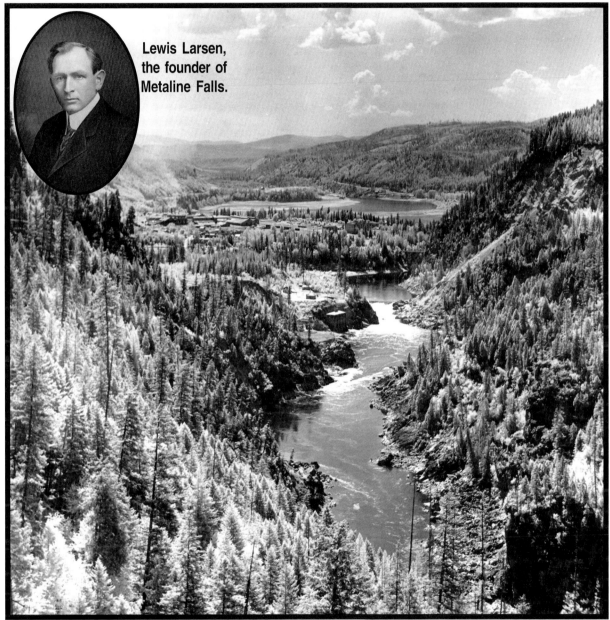

Lewis Larsen, the founder of Metaline Falls.

The Pend Oreille River looking south toward the town of Metaline Falls. *(Photo courtesy Wallace Gamble.)*

Pend Oreille County was the last settled region of Washington State and is the state's youngest county. But for a single Executive Order signed on July 2, 1872, its brief history nearly unfolded in an entirely different manner. On April 9, 1872, President U.S. Grant established the Colville Indian Reservation for the Colvilles, Lakes, Spokanes, Okanogans and other non-treaty tribes east of the Columbia River. The reservation was bordered by the Columbia River to the west, the Pend Oreille (Clark Fork) River to the east,

Canada to the north, and Spokane and Little Spokane Rivers to the south. The entire area of Pend Oreille County west of the Pend Oreille River lay within these boundaries. However, strong pressures upon President Grant resulted in restoring this land to the public domain and reducing the reservation boundaries.

When the early settlers began arriving in the mid-1880s, present-day Pend Oreille County was part of Stevens County. There were only trails through the rugged Selkirk Mountains that separated the Pend Oreille Valley from the county seat at Colville. Even with the coming of the railroad, a train trip from Newport to Spokane, with connections to Colville took at least four days. By the early 1900s, the population throughout the Pend Oreille Valley had increased sufficiently to make the inaccessibility of the county seat more than just an inconvenience. Local residents appointed two prominent individuals – Fred Wolf of Newport, editor of the *Newport Miner,* and Fred Trumbull, an attorney from Ione – to circulate petitions and lobby for a new county.

The move to further divide Stevens County was met by strong resistance. As fate would have it, State Senator Oliver Hall, a powerful senator from Colfax, had an affinity for the Pend Oreille Valley, where he enjoyed hunting and fishing, and had built a lodge at Sullivan Lake. He sympathized with the problems facing the residents of the valley and took special interest in their bill. His efforts were successful. The bill creating Pend Oreille county was passed by the legislature and signed by Governor Marion E. Hay. It went into effect on June 10, 1911. Newport was named the temporary county seat, with a provision for the permanent selection to be made by the voters within a year. Four contenders – Newport, Cusick, Usk and Ione – vied for the position. However, Newport had (and still has) the largest population of the county's towns and, with its proximity to Spokane and the major towns in northern Idaho, it had a definite advantage. With the vote, it retained its position as the county seat.

The county's name and its origin have been sources of controversy. Senator Hall proposed the name Allen in honor of John B. Allen, the state's first United States Senator, arguing that Pend d'Oreille was too difficult to spell and pronounce. Local representatives convinced him the Pend d'Oreille name already had familiarity from advertising publicity being given the area. Theories about the origin of the name range from the plausible to the farfetched. The most logical theory comes from the translation of the French phrase *pend d'oreille* (meaning "to hang from the ear") that was used by the French-Canadian fur traders and explorers to describe the native Indians who wore elaborate ear pendants of decorative shells. The *d'* was officially dropped from the spelling by the United States Board of Geographic Names around the time the county was formed.

Pend Oreille County, located in the northeast corner of Washington State, is bordered by Idaho, Canada, Stevens and Spokane Counties. It is approximately 67 miles long and averages 22 miles in width. The Pend Oreille River enters Pend Oreille County from the east at Newport and flows north through the center of the county into Canada. It is bordered on both sides by the Selkirk Mountains (mostly National Forest land), which become progressively higher and more rugged farther north. The highest mountain is the 7309-foot Gypsy Peak.

Tucked away in this mountainous region were vast stores of lead and zinc deposits. The mountains themselves were covered with huge quantities of virgin timber. Between 1928 and the 1950s, the Metaline Mining District in the northern reaches of the county was the most significant mining district in the state of Washington. Sawmill operations were located throughout the county, with four major mills located at Ione, Dalkena, Cusick and across the river from Newport (in Idaho). The largest industrial operation, which played a major economic role in the history and development of Pend Oreille County, was the Lehigh Portland Cement Plant in Metaline Falls. It began producing cement in 1911 and was a mainstay of the economy until its closure in 1990.

The first Whites known to have traveled the Pend Oreille River were David Thompson and his party of explorers searching for a shorter route to the Columbia on behalf of the Canadian-based North West Company. Between 1809 and 1812, Thompson led three exploratory journeys. The first trip north on the river was from the Cusick area in a leaky pine-bark canoe. A local Kalispel Indian guide accompanied him on this trip. At the beginning of the trip, the river was wide and placid, but as they proceeded toward Box Canyon, the river narrowed and picked up great speed. When Thompson asked how far it was to the falls, the guide confessed

114

he had never been on this stretch of water before. Because of the immediate turbulence of the river and unknown dangers, they reluctantly turned back. The following spring, with a different Indian guide, Thompson attempted a second trip north. This time they portaged around Box Canyon. Continuing north, they were thwarted again by the sudden drop of the Metaline Falls. This was the farthest north he traveled on the Pend Oreille.

Prior to David Thompson's arrival, the Pend Oreille Valley had been occupied for thousands of years by native Indian tribes, known in recent times as the Kalispels and Pend Oreilles. (They are now *officially* one tribe. Although related by bloodline and intermarriage, they were originally two tribes with different dialects.) The Kalispel Reservation, located across the river from Usk, is the smallest reservation in the state of Washington.

During the settling of Pend Oreille County, most of the towns and homesites were located on or near the river, convenient to the main source of transportation. Steamboats began to ply the waters of the Pend Oreille in the late 1880s from Newport to Ione (the treacherous passage through Box Canyon just below Ione restricted river travel farther north until the channel was widened and deepened in 1907). Competition from Frederick Blackwell's Idaho and Washington Northern Railroad, completed to Metaline Falls in 1910, eliminated the steamboat traffic along the river. The railroad opened up vast opportunities to transport the valuable natural resources from the northern portion of the county and brought about significant growth and development. Unfortunately for the county, much of the wealth from the stores of natural resources has been funneled out of the county, with little invested in the local communities. With the closure of the mines, sawmills and the cement plant, many local residents struggled to survive. But current indicators hold promise for the reopening of the Pend Oreille Mines, the county's largest, and the paper mill at Usk provides a solid component to the economy.

Today, the nearly 55-mile navigable stretch of river between Box Canyon and Newport is similar to a lake. Both riverbanks are becoming populated with many expensive homes. Since the construction of Seattle City Light's Boundary Dam just south of the Canadian Border in 1967, the breathtaking stretch of river between Box Canyon and Boundary Dams is now navigable part of the year. In spite of its scenic beauty, Pend Oreille County remains rather sparsely populated and one of Washington State's last frontiers.

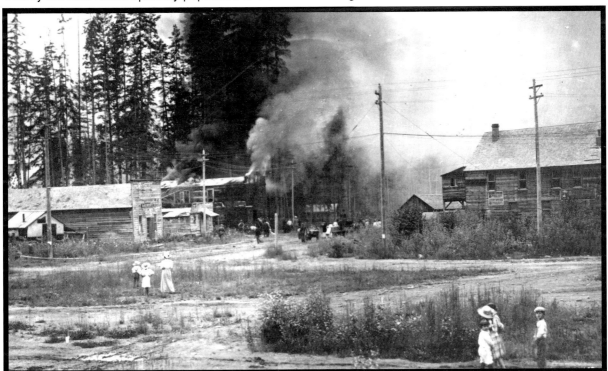

A fire in the town of Metaline Falls in its early days, circa 1909.

(Photo courtesy Pend Oreille County Historical Society.)

115

The Bamonte children (L to R): Star, Dale and Tony at the old Red Rooster, originally built as a roadhouse during Prohibition in the late 1920s. The house in the background was a dance hall. It was one of the few buildings around the area with hardwood floors. In the inset above, Tony, Dale and Star are seated on King, the workhorse. The Bamonte children lived with their father, Louie, in the old dance hall and later moved to the smaller house pictured in the inset. There was also a small log cabin on the site (at the left in the inset), but it had not been occupied since the early 1930s. Photos taken in 1948. *(Bamonte photos.)*

Mae
Schaeffer

Alfred
Schaeffer

Bill Schaeffer

Lehigh Portland Cement Company's plant and the northern terminus of Frederick Blackwell's Idaho and Washington Northern Railroad at Metaline Falls, circa 1912. Insets are Mae and Alfred Schaeffer, circa 1939. Al was the longest tenured plant manager (1947-1969) in the company's history. Lehigh, headquartered in Allentown, Pennsylvania, was the town's economic mainstay for many years. An early prospectus of the town revealed expectations of a booming metropolis but it never materialized. *(Photos courtesy Al and Mae Schaeffer.)*

The "Can Can Dancers" waiting to perform (left) and, on the right, displaying their talent (?) at a benefit gathering to raise funds for a new hospital (Mt. Linton) in Metaline Falls, circa 1955. They are (left to right): Dr. Frank Hammerstrom, Barney Olson (proprietor of Olson's Grocery Store), Wayne Shields (school superintendent) and Alfred Schaeffer (Lehigh Cement Company plant manager). *(Photos courtesy Al and Mae Schaeffer.)*

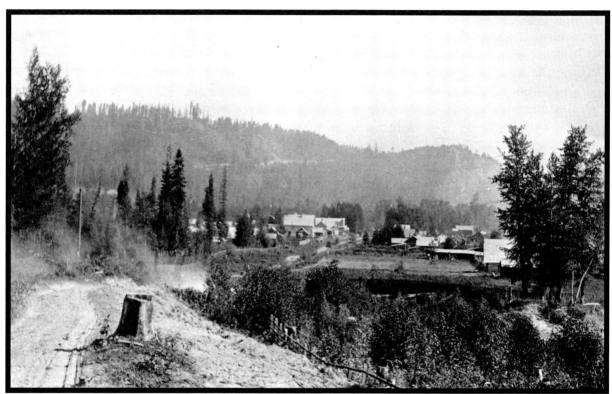

Metaline, the oldest town in Pend Oreille County, became active as a mining camp in the mid-1850s. It is situated directly across the river from Metaline Falls. *(Circa 1910. Photo courtesy Pend Oreille County Historical Society.)*

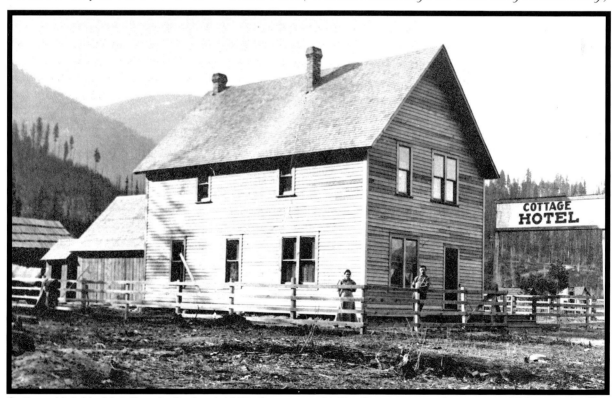

Cottage Hotel in Metaline, built about 1908. George and Lillie Samms were the owners. This was the first building to have running water in Metaline. *(Photo courtesy Pend Oreille County Historical Society.)*

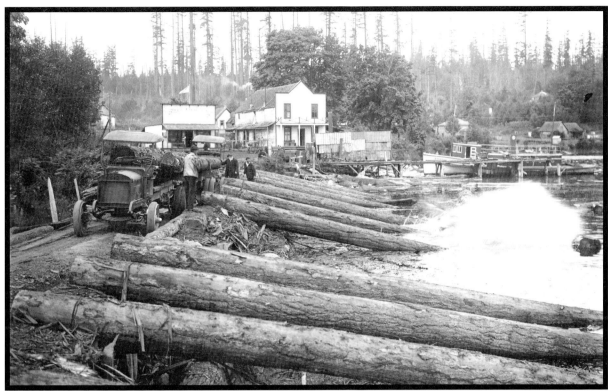

A GMC truck unloading logs into a millpond for a sawmill, circa 1910. This was a typical scene around the county. Storing the logs in water kept them from cracking when sawn into lumber. *(Photo courtesy Thelma Shriner.)*

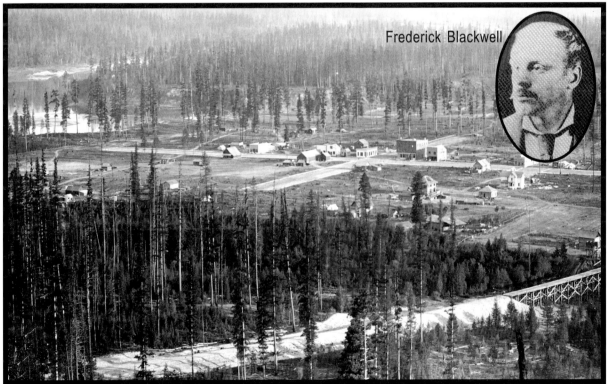

Frederick Blackwell

The town of Ione looking southeast, circa 1909. Ione was founded by Frederick A. Blackwell and built around the Panhandle Lumber Company. The first homesteaders arrived in 1894. *(Photos courtesy Pend Oreille Co. Historical Society.)*

Edward R. Murrow in Ione for the wedding of his brother Dewey, who married Donna Jean Trumbull, a native of Ione. The woman with Murrow is Hermine (Duthie) Decker who was romantically involved with Murrow for a number of years. Love letters from Murrow to Decker, written from 1930 to 1932, in Decker's possession at the time of her death in 1996, were kept secret until the death of Murrow's widow in 1998 (and subsequently donated to WSU). After they graduated in 1930 from Washington State College (now WSU), where they met as drama students, Decker wanted to marry and start a family. Murrow was not ready to settle down and Decker subsequently married another classmate from WSC. However, she continued to keep close track of Murrow's career until his death in 1965. Inset is Decker, Murrow and Mrs. Fred (Bess) Trumbull, circa 1930.

Edward R. Murrow, one of WSU's most famous graduates, gained national fame as a news commentator during WWII. During his career, he became Vice President of Public Affairs and served on the Board of Directors for CBS. Between 1961 and 1964, he was the head of the U.S. Information Agency. *(Photos courtesy Marse Dressel.)*

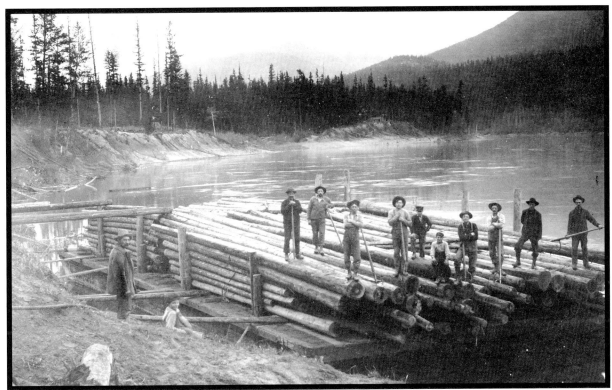

Load of hand-peeled cedar poles at the Tiger landing. Before the railroad's construction to the north end of the county, barges were used to transport freight to and from Newport. *(Photo courtesy Pend Oreille Co. Historical Soc.)*

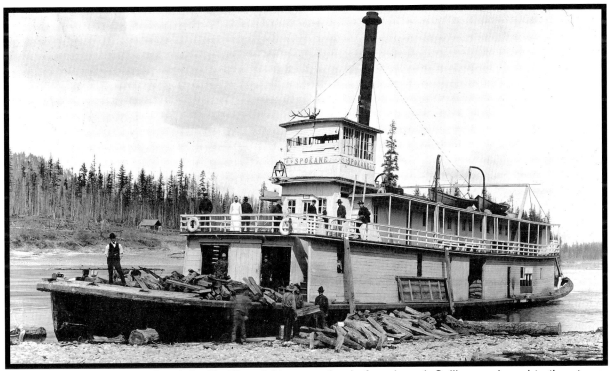

Steamer *Spokane* on the Pend Oreille River taking on a load of cordwood. Selling cordwood to the steamboats to run the steam engines was an important source of income for homesteaders along the river. The steamboats were in operation from 1888 until about 1910. *(Photo courtesy Pend Oreille County Historical Society.)*

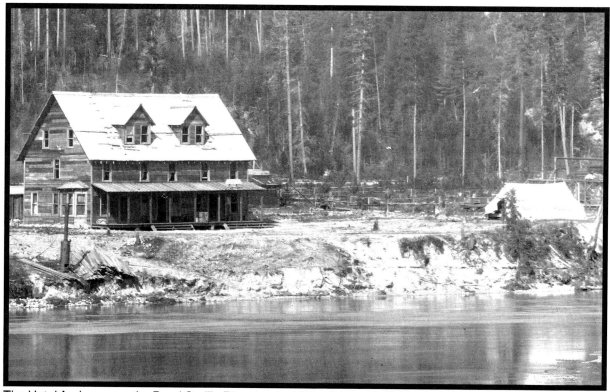

The Hotel Anderson on the Pend Oreille River bank at Blueslide in 1905. This hotel served many of the loggers and sawmill employees during its boom years in the early 1900s. *(Photo courtesy Pend Oreille Co. Historical Soc.)*

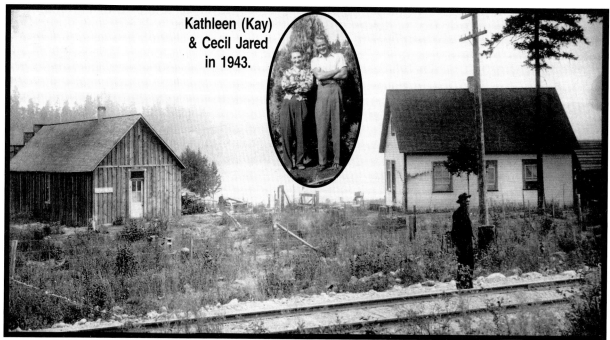

Kathleen (Kay) & Cecil Jared in 1943.

Jared Store (left) and Robert P. Jared standing on the Idaho & Washington Northern Railroad tracks in front of his and wife Sarah's homestead at the former town of Jared, circa 1910. Note the "Store" sign and the false storefront facing the Pend Oreille River, which for many years was the main highway to the north county. Cecil Jared (inset), grandson of Robert and Sarah Jared, and his wife Kay founded the Hangman Valley Greenhouse business in Spokane in 1972. Cecil began in that line of work in 1938. *(Photos courtesy Kay & Cecil Jared.)*

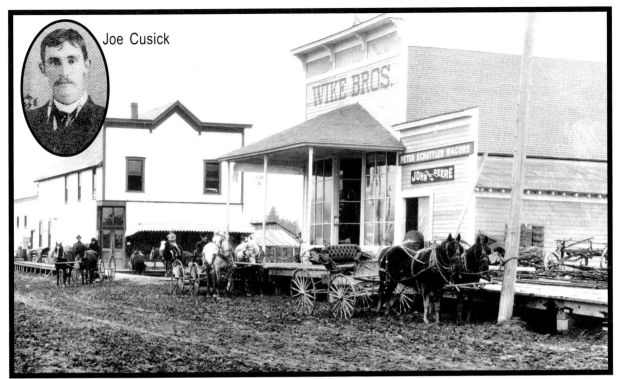

Joe Cusick

The town of Cusick, circa 1907. Joe and Ella (Rusho) Cusick homesteaded near the mouth of the Calispell River. Joe platted the town of Cusick on their homestead in 1902. The Wike Brothers built the first store (above) in 1906. Note the John Deere sign. *(Photo courtesy Pend Oreille Co. Historical Soc. Inset courtesy Helen Bond, Joe Cusick's niece.)*

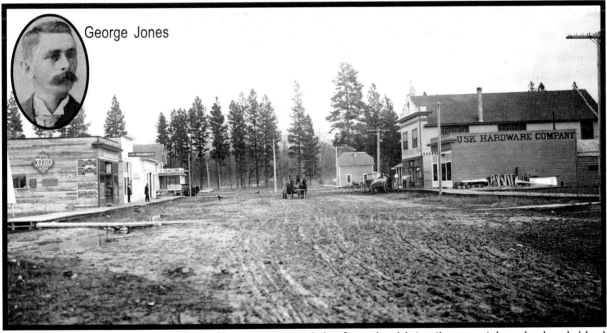

George Jones

The main street of Usk in 1909, looking east toward the ferry (and later the county's only drawbridge) across the Pend Oreille River. George Jones (inset), the earliest settler in this area, received the first homestead patent issued in Pend Oreille County (1895). He platted the town and named it after the village of Usk in his native Wales. His list of business ventures in Usk included the first store in 1886, the post office in 1892, a creamery in 1895, and a riverboat business. *(Photo courtesy Pend Oreille County Historical Society.)*

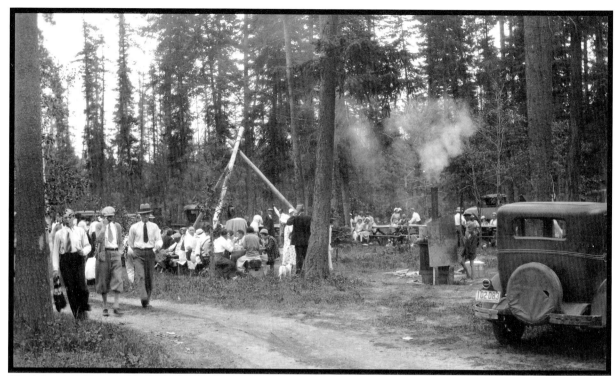

Picnickers at Diamond Lake in 1932. Once a popular recreation spot for school and company picnics (bus loads came from Spokane), it is now the county's most densely populated region. Many Spokane residents own summer homes here and numerous local residents commute to jobs in Spokane. *(Photo courtesy Sonny Poirier.)*

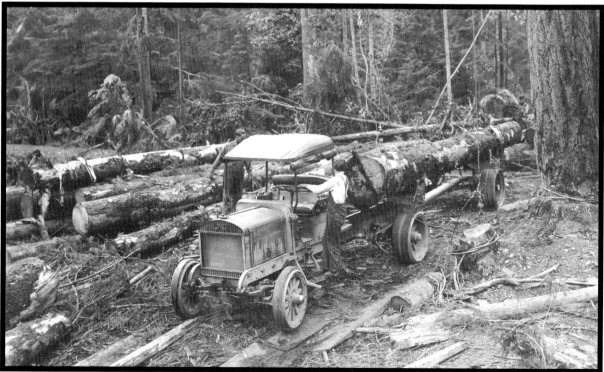

A GMC hard-rubber tire logging truck taking on a load, circa 1918. An early Pend Oreille County lumberjack's reaction to the first logging trucks was, "When you hear them, they're stuck and when you don't hear them, they're broke down." This was about the time trucks began replacing horses. *(Photo courtesy Thelma Shriner.)*

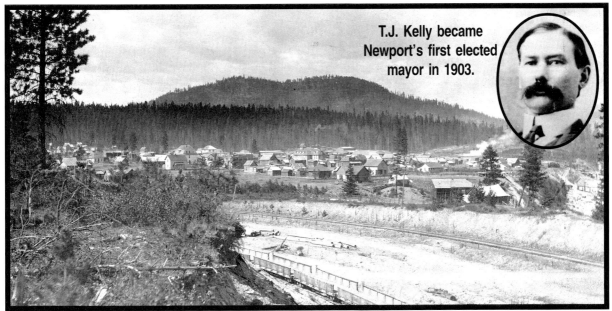

T.J. Kelly became Newport's first elected mayor in 1903.

Newport, Wash. and Newport, Idaho, in 1904. The town's origin was along the Pend Oreille River, just inside the Idaho line. From its early inception, as the town grew, a controversy developed over the location of the post office, then located in Newport, Idaho. By 1901, because the population on the Washington side was greater, the U.S. Postmaster General issued an order requiring the post office to be moved to the Washington side of Newport. This move eliminated the post office at Newport, Idaho, but the town continued to be indicated on maps under that name until it incorporated as Oldtown in 1947. *(Photo courtesy Pend Oreille County Historical Soc.)*

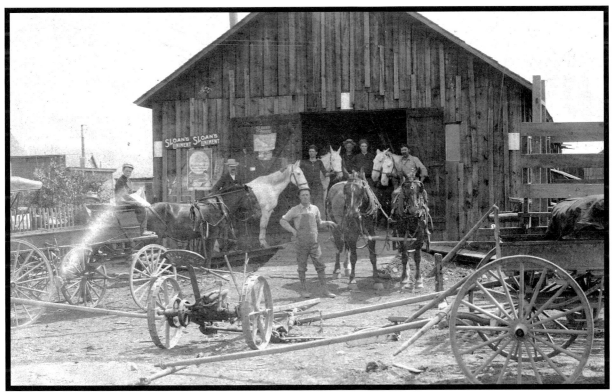

Bennett's blacksmith shop in Newport, circa 1910.
(Photo courtesy Pend Oreille County Historical Society.)

The Lear family, circa 1919: (L to R) George, William "Pup", Doris, Lucille "Susie", Helen and Alfred "Poly". This photo was taken by their mother, Roberta Boyer Lear. She titled it, "Just Kids." *(Photo courtesy Doris Underwood.)*

The Newport boxing team, identified only with last names: Tarbet, Powell, Amburgh, McMillian, Bridges, Jones and Vincent, circa 1920. *(Photo courtesy Pend Oreille County Historical Society.)*

The Pend Oreille State Highway (now U.S. 2), circa 1940, near Pend Oreille State Park. This stretch of high-way, from the Spokane County line to Highway 211 (the Sacheen cut-off) southeast of Newport, is now re-ferred to as "The Four Lane" as it is the county's only four-lane highway. *(Photo courtesy Wallace Gamble.)*

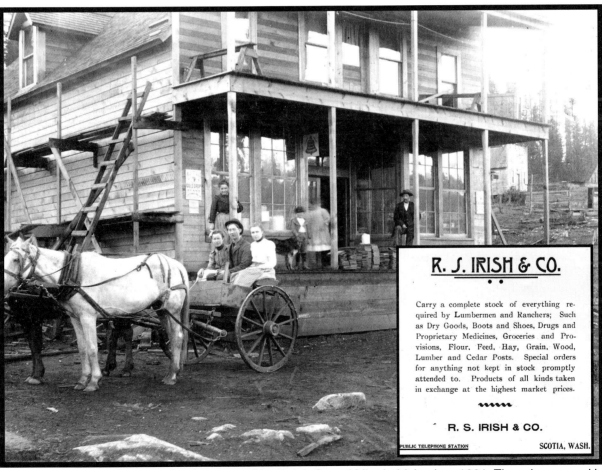

The Scotia General Store, at the time owned by Ralph S. and Minnie Irish, circa 1901. The ad appeared in the *Newport Miner* on June 1, 1901. Note the two-wheel horse cart. *(Photo courtesy Joan and Larry Reuthinger.)*

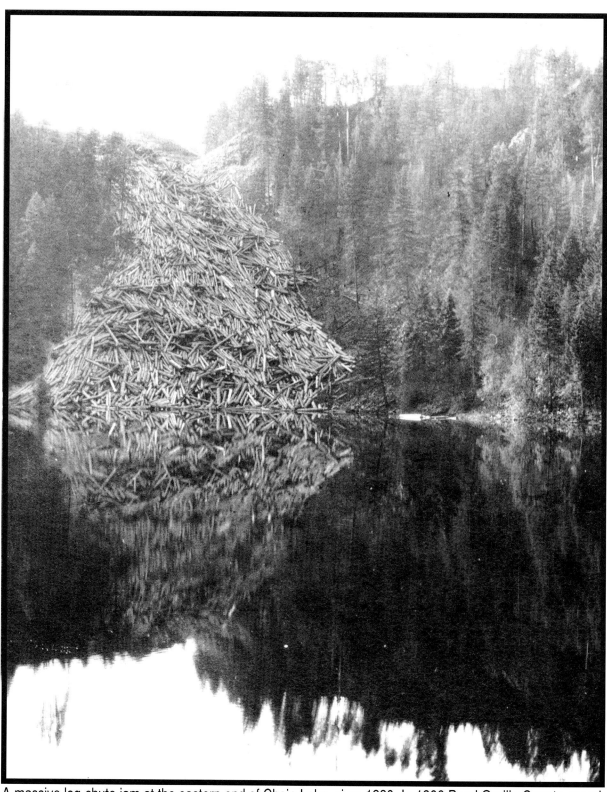

A massive log-chute jam at the eastern end of Chain Lake, circa 1930. In 1906 Pend Oreille County experienced its worst tragedy when a westbound Great Northern Railroad train jumped the track in the upper area of Chain Lake, two miles east of Camden, and plunged into the water resulting in numerous deaths and injuries.

(Photo EWSHS, Magee Album, L83-132)

Chapter 7

Lincoln County

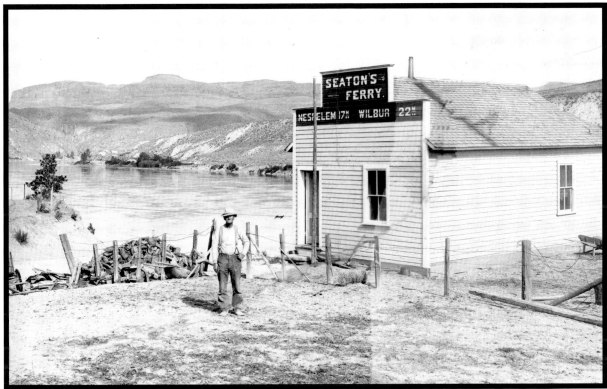

Seaton's Ferry, circa 1908. Located near the northwest corner of Lincoln County, it was operated by Sam Seaton, who had a ranch on the far side of the river. The ferry was propelled by the current pushing against its angled side. Seaton owned and later sold much of the land used for the Grand Coulee Dam site. He operated the ferry at this location for many years. Part of the core drilling for the Grand Coulee site was conducted from the deck of Seaton's ferry. *(EWSHS, Frank Palmer photo, L84-327.1359)*

Prior to the arrival of the white settlers to what is now Lincoln County, this area was intersected from east to west by one of the most popular Indian thoroughfares in eastern Washington. A frequent resting or camping spot was at present-day Davenport. A clear, cold water spring (now called Cottonwood Spring) and abundant bunch grass at this site created an oasis in the middle of a region the military denounced as a "howling desert." Although the first settlers to arrive in Lincoln County initially homesteaded along the creeks, they soon discovered the value of the uplands. This "howling desert" proved to be some of Washington's richest agricultural and most productive land for growing cereal grains.

Lincoln County was originally part of the immense Walla Walla County, formed in 1854, which encompassed all of eastern Washington, northern Idaho and part of Montana. As the population increased, further subdivision produced smaller and smaller counties. In 1883, four years after Spokane County separated from Stevens County, Lincoln County was carved from the western region of Spokane County. When the county

was formed, residents of the town wanted Sprague to be the county seat and for the county to be named Sprague in honor of John W. Sprague, the general superintendent and agent of the Northern Pacific Railway. The name was rejected because the legislative body reasoned it was not prudent to use the name of a living person. The rationale was the risk of that person, during his lifetime, bringing disgrace to the county. When the governor approved the bill on November 24, 1883, Lincoln County was named for President Abraham Lincoln and Davenport was chosen as the temporary county seat.

The election in 1884 to select the permanent county seat drew three candidates: Davenport, Harrington and Sprague. The question of location was hotly contested and violent at times. Sprague was the logical choice being the only town in the county along a railroad line, which cut across a small corner in the southeast part of the county; the other towns were fairly isolated. Sprague won the distinction at the polls, but it was accompanied by accusations of corruption and ballot tampering. Allegations were made of gravestone names appearing on ballots, children voting along with their parents, and the intimidation of nonresidents on passing trains to vote. There may have been some merit to these allegations as the final vote for the town of Sprague was substantially larger than the number of legitimate voters. Purity did not appear to characterize the county's first election. Finally, the November general election of 1896 permanently settled the ongoing 12-year battle amongst numerous interest groups for the county seat. On November 20th, the Lincoln County Commissioners convened at Sprague and issued an order to remove the county records from Sprague to Davenport by December 14th. In 1897 a new county courthouse was built in Davenport at a cost of $12,000.

In 1887 a new telephone line linked Spokane, Davenport and Fort Spokane. Two years later, the railroads were operating through Lincoln County. During the late 1880s and early 1890s, the discovery of silver in the Salmon River district in Okanogan created a much traversed route of travel through Lincoln County, revealing its beauty and potential to those passing through. The most active early boom years were between 1889 and 1893 when the county's population doubled in size.

The economy of Lincoln County was built primarily on raising livestock and the production of wheat and other grains. Especially in the early years, farmers were plagued by cricket and squirrel infestations, harsh winters and flooding that destroyed crops and livestock. A bumper wheat crop in 1897 heralded another boom and growth in population. Providing most of the supplies for Fort Spokane was a major source of income for the county.

The fort began in 1880 as Camp Spokane. By 1882 the United States Government began an expansion program to make it a permanent post and renamed it Fort Spokane. This led to the construction of over 45 structures within the next 12 years. In April of 1899, Fort Spokane was officially abandoned by the Government after the troops were called out to fight in the Spanish-American War. Its departure was met with resistance. Since its inception, the surrounding population had profited from every phase of its existence. (See chapter 3.)

Abundant water power and recreational opportunities provided by the Columbia and Spokane rivers are also economic mainstays in Lincoln County. These rivers run the distance of the county's northern boundary line. Grand Coulee Dam, just beyond Lincoln County's northwest corner, created the expansive Franklin D. Roosevelt Lake. Prior to construction of the dam, fruit production along the rivers was significant. Unfortunately, the water submerged the orchard land. It also covered Hell Gate, previously one of the most scenic attractions in Lincoln County. At Hell Gate, the river rushed through a rock gorge, whose perpendicular walls jutted high above the water level. Today, Roosevelt Lake offers a recreational paradise embraced by scenic beauty.

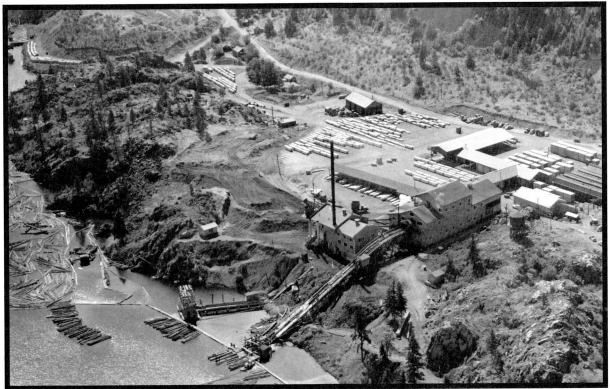

Lincoln Lumber along the Columbia in 1948. In 1938 the mill near the original town of Lincoln relocated to this spot in anticipation of the rising backwaters from the construction of Grand Coulee Dam. *(Photo EWSHS, L94-31.12)*

The town of Peach, circa 1905, located at the confluence of Hawk Creek and the Columbia River before Grand Coulee Dam's reservoir submerged it under 235 feet of water. This was one of the most ideal locations for growing fruit in the state. Surrounded by orchards, it was originally known as Orchard Valley. Peach was said to have been one of the most picturesque towns along the Columbia. *(Photo courtesy Lincoln Co. Historical Soc.)*

A Typical Relocation Project from the Columbia Valley

In the late 1930s, during the construction of the Grand Coulee Dam and the raising of the water level of the Columbia River, many of the small towns along the Columbia were forced to relocate. The occupants had a choice of moving their homes to higher locations or having them demolished on site. These photos depict the relocation of the Pete Simpson family home from Lincoln to Miles, a distance of approximately three miles. The government paid $500 for this house and sold it back to the Simpsons for $50. It was common for owners to buy back their homes at a fraction of what the government paid on the condition they remove them above the rising water level. Simpson, who built the house in 1932, was a logger and owned the equipment necessary for the move. Three generations of Simpsons have lived in this house. *(Photos courtesy Lila and Chris Krueger.)*

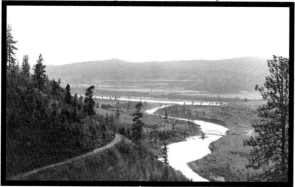

The Spokane and Columbia Rivers and Nee Bridge. The winding mountain road (left) was the route taken.

Preparing for the trip. Pat, the dog, is ready for the trip, waiting in his usual place on the top of the truck.

The house is suspended on logs between two trucks – Simpson's and Sanford Holbrook's – and tied down.

On the steeper grades a little help was needed. Note the Caterpiller straining on its back tracks.

The worst part of the trip is over. Note the narrow road and the tight surroundings they encountered.

Following the Simpson's home to its new location. Daughter Lois Simpson (Randall) is second from left.

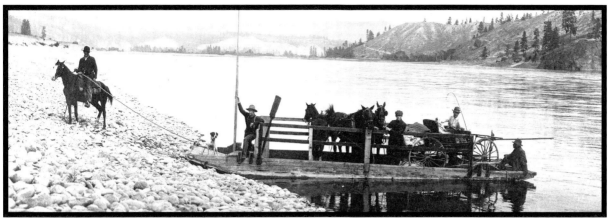

Ferry at Miles on the Spokane River in 1921.
(EWSHS, Frank Guilbert photo, L88-136.)

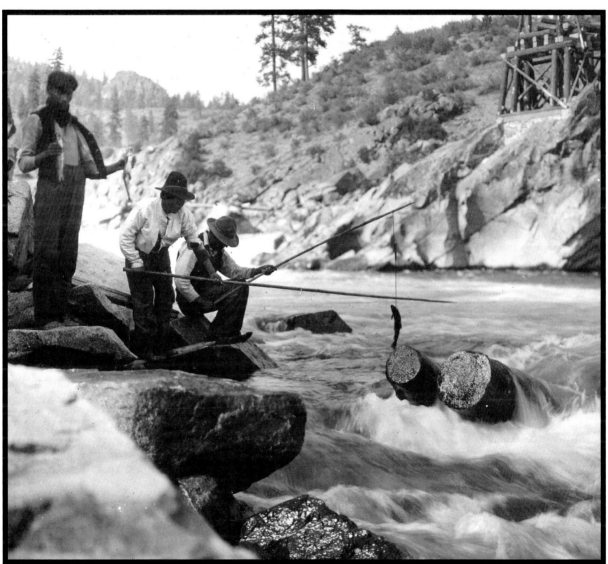

Indians fishing at Little Falls around the 1890s. Fish was a staple in the diet of the native tribes. These falls were covered by water after the construction of Little Falls Dam in 1910. *(Photo EWSHS, L92-86.5)*

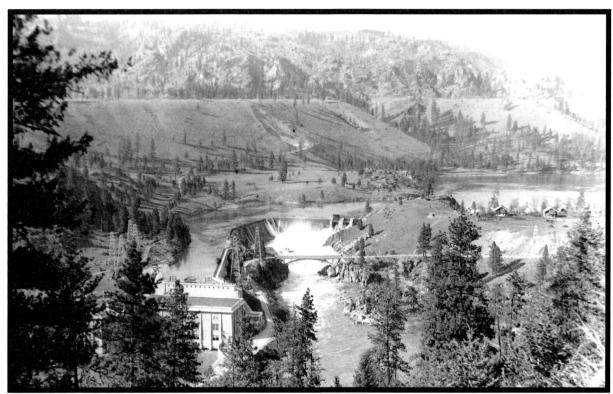

Little Falls Dam on the Spokane River in 1940. This dam was critical to the Washington Water Power Company's development as a regional utility. It was also destructive to the Indians' way of life. *(Photo courtesy Wallace Gamble.)*

The future site of the Long Lake power plant, September 13, 1910. Washington Water Power began construction of Long Lake Dam in 1915. *(Photo courtesy Spokane Public Library Northwest Room.)*

Early settlers camping between Deep Creek and Reardan. *(Photo EWSHS, L94-24.269)*

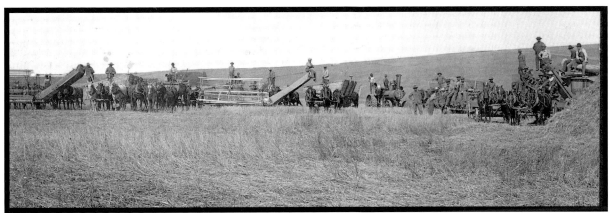

Threshing outfit, a familiar sight during wheat harvest near Reardan. *(Photo courtesy Lincoln Co. Historical Society.)*

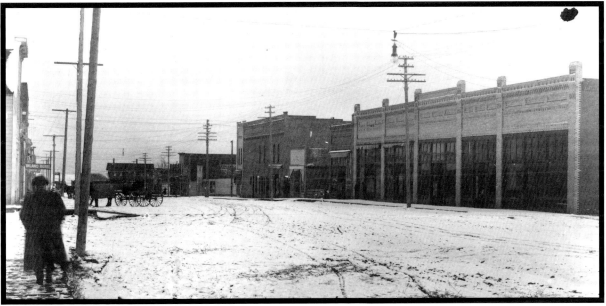

The town of Reardan, looking north on Lake St. from Spokane St., circa 1910. On the right is the John W. Raymer building where automotive and farm equipment were sold. The bank is at the end of the block (center) and the Inland Hotel is across the street. The town was named for the construction engineer of the Central Washington branch of the Northern Pacific Railroad, the first railroad through Reardan. *(EWSHS, Reeves photo L86-17.3)*

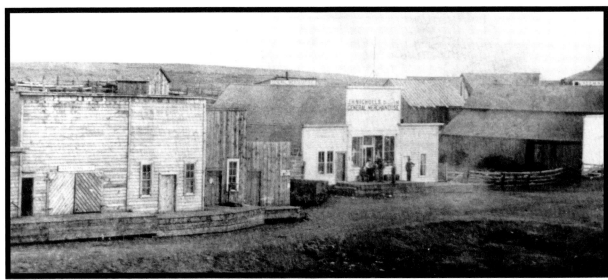

One of the oldest photos of Davenport, taken in the 1880s. The first settler in this area was Harry Harker, who arrived about 1880. In 1881 John H. and Emma Nicholls established the first permanent buildings on Harker Street in what became known as Cottonwood Springs. The first building (at the center of this photo) served as a store, post office, hotel and the Nicholls residence. It was followed by a livery stable (right) and a saloon. In 1883 John C. Davenport started a rival town named Davenport on the hill above Cottonwood Springs. The next year, a fire broke out in Davenport and it was not rebuilt. Saloon owner Richard Traul moved his saloon to the lower town and resumed business. With Traul came the Davenport name. A fire in 1903, which started at Spring and Harker, destroyed many of the original buildings. *(Photo EWSHS, L88-455.13)*

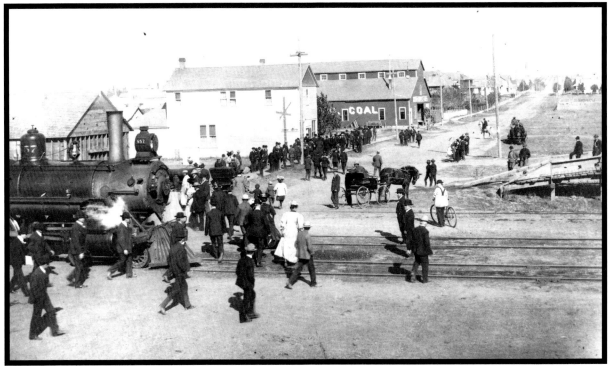

The first railroad to reach Davenport, the Central Washington branch of the Northern Pacific, arrived in early 1889. It is apparent by the number of people meeting this train, circa 1900, how important the railroads were to the town's existence and livelihood. The cross street shown is Seventh Street. *(Photo EWSHS, L88-455.5)*

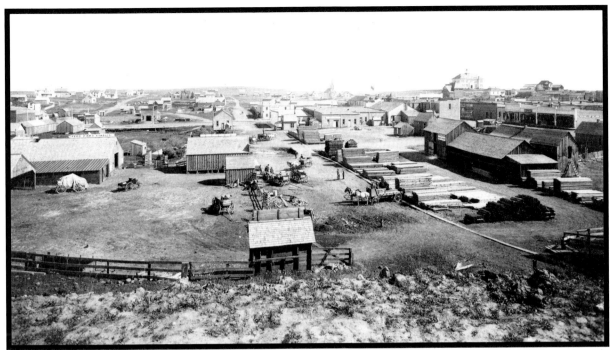

Davenport in 1898 looking north along Seventh Street. Henry Kahse's feed business and lumber yard are in the foreground. On the crest of the hill in the distance is the Methodist Church (center), built in 1892, and the courthouse (right), built in 1897. At the center of the photo, across the Cottonwood Creek bridge, is a horse-drawn watering tank used to wet the streets and control the dust. *(Photo courtesy Lincoln Co. Historical Society.)*

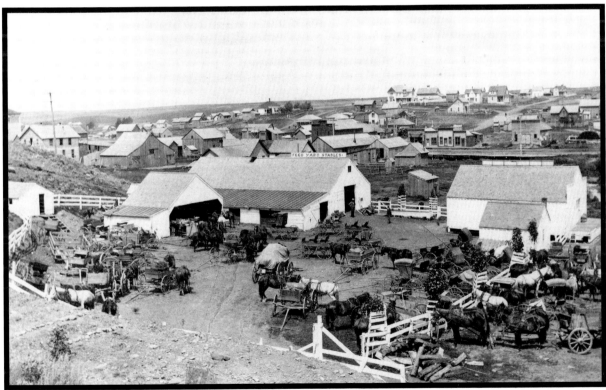

Davenport in 1900 looking northwest from Merriam Street. Henry Kahse's feed yard in the foreground was located just west of the present-day Lincoln County Museum. *(Photo courtesy Lincoln County Historical Society.)*

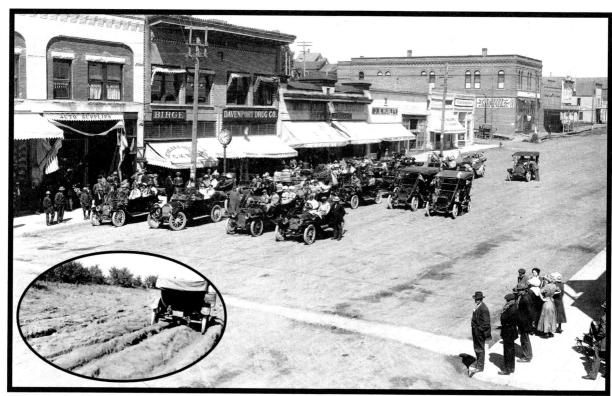

The first pilgrimage to Spokane by automobile. Every car in Lincoln County is lined up on Morgan Street in Davenport during a road rally, circa 1908. Inset photo, about a mile out of Davenport, is an example of the road conditions of the times. *(Photo courtesy Lincoln County Historical Society. Inset EWSHS, L83-10.3)*

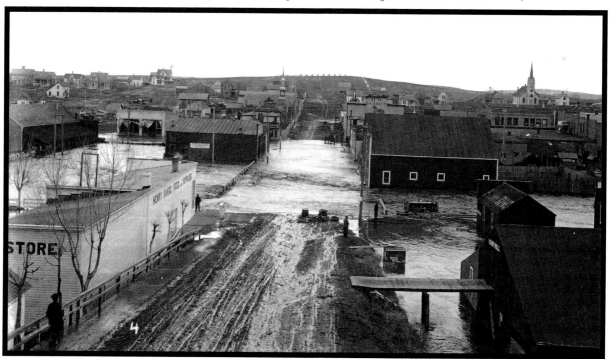

Looking north on Seventh Street after Cottonwood Creek flooded Davenport's main business section in 1910. The location of the footbridge is now the entrance to the Lincoln County Museum parking lot. The feed store on the left is still standing and is part of Kahse Park. *(Paige photo courtesy Lincoln County Historical Society.)*

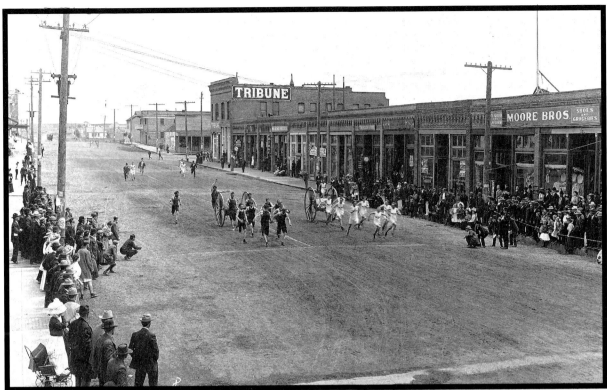

A fire hose brigade footrace between the volunteer firemen in downtown Davenport, circa 1908.
(Photo courtesy Lincoln County Historical Society.)

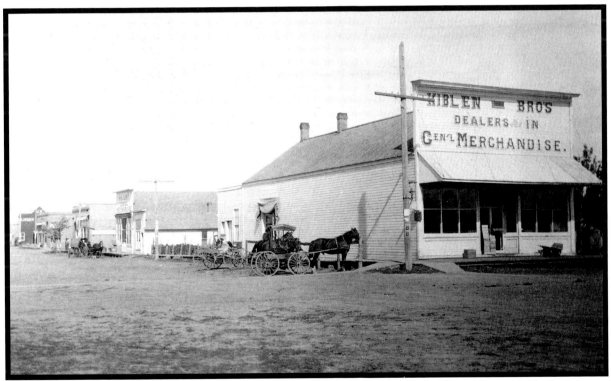

Creston's Main Street, looking north, circa 1913. Creston got its name from being the highest point in the area on the Central Washington Railway. It became known throughout the country as the place where Harry Tracy, one of the Northwest's most notorious outlaws, met his death in 1902. *(Purl Foote photo courtesy Lincoln Co. Historical Soc.)*

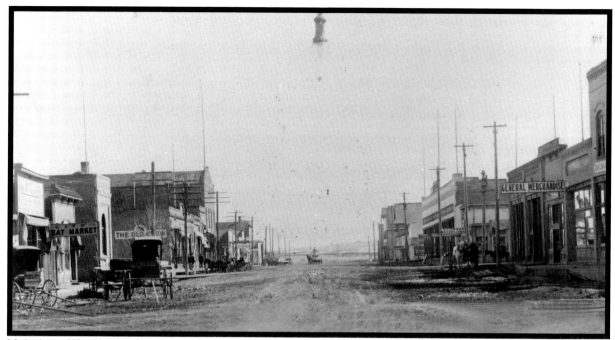

Main (now West Main) Street of Wilbur looking east in 1907. The tallest building on the left is the VFW, built in 1902. Wilbur took its name from Samuel Wilbur Condin, the first settler near present-day Wilbur. Condin was more widely known as "Wild Goose Bill." His colorful legend arose from a hunting expedition in his early years in which he single-handedly killed a large flock of geese that he presumed to be wild. Upon retrieving his trophies, he was met by an irate woman demanding to know what right he had to kill her pets! *(Photo EWSHS. L86-48.91)*

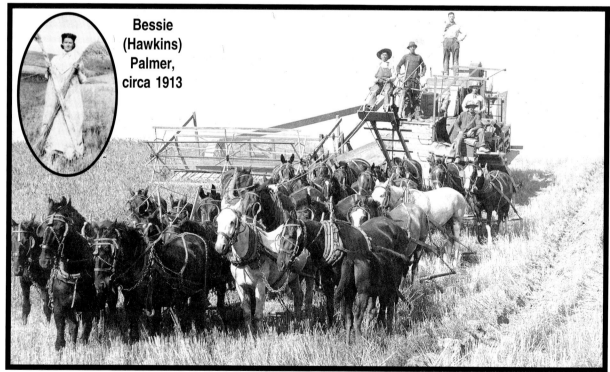

Bessie (Hawkins) Palmer, circa 1913

Erie Hawkins is driving Robert B. Hawkins's combine near Govan in 1908. Nate Palmer, who married Robert Hawkins's daughter Bessie (inset, holding sample stalks of wheat), is standing on top. Lincoln County is one of the top wheat producers in the world. *(Photo courtesy Joan Sorensen, granddaughter of Nate & Bessis Palmer.)*

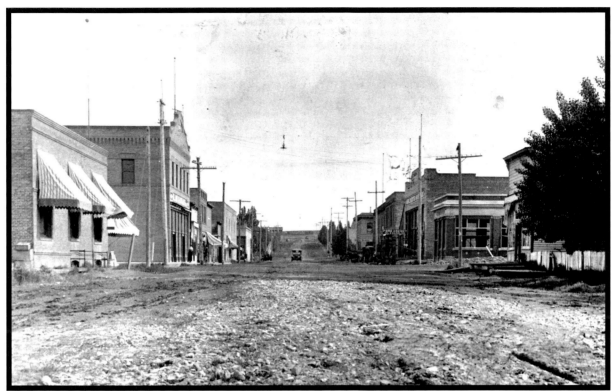

Main street of Almira, circa 1906. Almira was named for the wife of the original owner of the land upon which Almira was built, C.C. Davis. He was a pioneer merchant who built Almira's first store. *(Photo EWSHS, L86-93)*

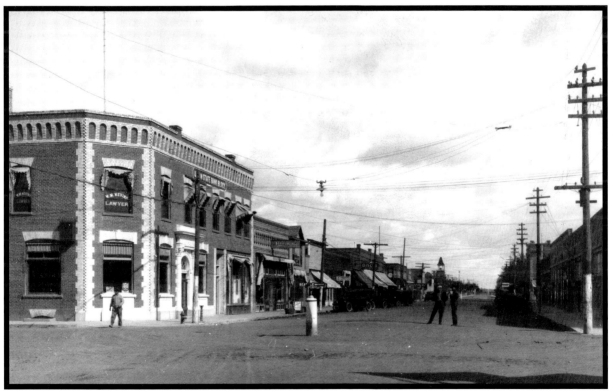

Odessa in 1920. Odessa was originally settled in 1886 by a group of German immigrants from South Russia, who named it after a prominent Russian wheat shipping center. *(EWSHS, Libby photo L86-588.191)*

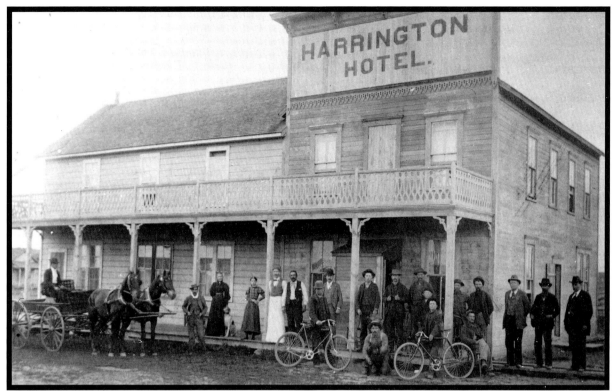

The Harrington Hotel, circa 1905. Harrington is one of the oldest towns in Lincoln County. It became a stop on the Great Northern Railroad in 1892, when the railroad was built through the area. *(Photo EWSHS, L85-261.11)*

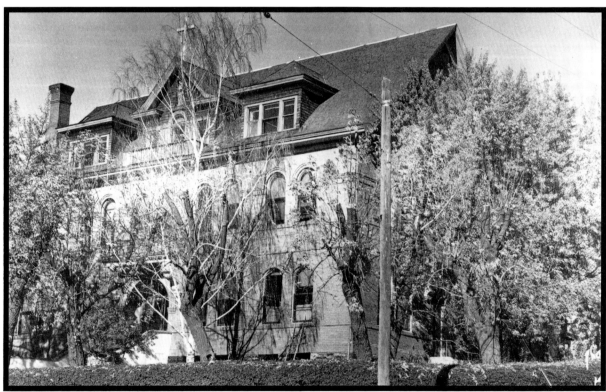

First Lincoln County Courthouse in Sprague in 1938. The county seat moved to Davenport in 1896. In 1905 this building, built in 1886, became St. Joseph's Academy. It was torn down in 1966. *(Photo EWSHS, L94-24.297)*

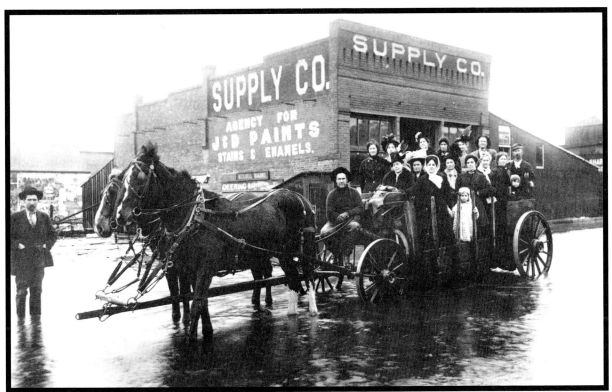

The 1909 flood in Sprague (originally Hoodooville). The first settler in the area was Patrick Cumasky (1869). The Northern Pacific Railroad stimulated the town's development with the construction of a grain storehouse and commissary in 1880. It later made Sprague its division headquarters. *(EWSHS, T.T. Richardson photo, L85-261.2)*

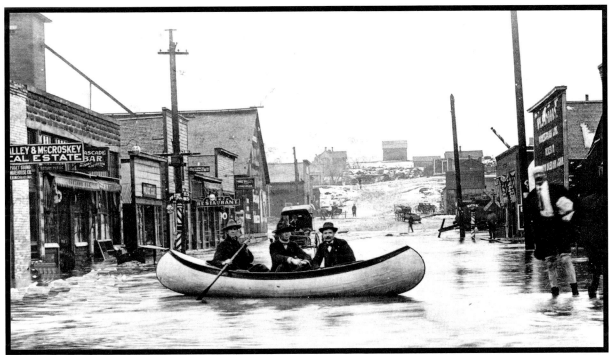

Boating in Sprague on January 18, 1909. Not only a victim of floods, in 1895 the town was also the victim of one of the most destructive fires in Eastern Washington. The fire reduced most of Sprague to ashes, which may have contributed to its loss of the county seat the following year. *(Photo EWSHS, L86-346.18)*

Chapter 8

Spokane County

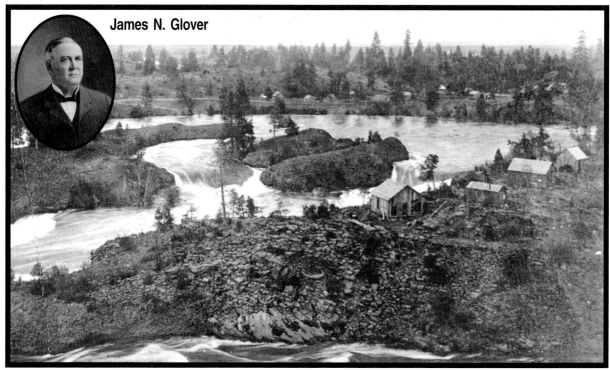

James N. Glover

Spokane Falls in 1880. James Glover *(Inset-NWD)*, regarded as the "Father of Spokane," arrived in 1873. He was one of Spokane's first permanent settlers and its first merchant. He purchased the land on which the townsite of Spokane began. *(G.W. Bechtel photo courtesy Spokane Public Library NW Room.)*

As early as 1805, the British infiltrated the region that now includes the states of Oregon, Washington, Idaho and Montana with hunters, trappers and traders. The first commercial entity to gain a foothold in the Inland Northwest was the Canadian-based North West Company, who consummated their interest with the establishment of trading posts. Two of its posts were located within the heart of the Inland Northwest and predated all other posts in both Washington and Idaho. These were the Kullyspell House near Hope, Idaho, and the Spokane House just north of Spokane. Of these two, the Spokane House was the most important and of greatest significance to Spokane County, as the Kullyspell House was in use for less than two years.

The security of these posts and the commerce between the trappers, traders and Indians set the stage for the development of the Inland Northwest. It is significant to note that the Spokane House was the first fur trading post in what is now Washington State. Most importantly, the Spokane House was the first commercial enterprise in the Inland Northwest and only a short distance from where Spokane, northeastern Washington's largest city, would be established.

The North West Company merged with the British Hudson's Bay Company in 1821. Hudson's Bay abandoned the Spokane House (old Fort Spokane) in 1826 for a more favorable site along the Columbia River near the

Kettle Falls. For the next three decades, most of the newcomers' activities and settlement in the Inland North-west centered around the Hudson's Bay's new Fort Colvile and the Colville Valley. During this time, interaction between Whites and Indians had been mostly favorable. However, that began to change in mid-1850s. [Note: The generally accepted spelling for the British holdings is *Colvile*, while the United States spelling is *Colville*.)

As discussed in chapter 3, the Steptoe and Wright campaigns dealt a severe blow to the Indian tribes of the Inland Northwest, culminating in numerous hangings in what is now Spokane County. Although the report Wright prepared in 1858 at the termination of his campaign stated there were 11 Indians hanged, one of his former soldiers, John O'Neil, contradicts that number. In fact, the exact count is a question raised by many historians. Some of the confusion and contradictions may have arisen from interviews many years after the event occurred. Excerpts from two such interviews are included below. Although short of establishing a precise count, they do offer some interesting information surrounding the event.

The first quotation is from reminiscences of Thomas Beall, Colonel Wright's hangman, published in the *Washington Historical Quarterly* (Volume 8, April 1917):

> The way I happened to be selected to hang the first Indian and the Indians whose execution [*sic*] led to Latah Creek receiving the gruesome title of Hangman Creek was this: At the camp on the Spokane, afterward known as "Horse slaughter camp," one of the officers inquired of us whether we knew how to tie a hangman's noose. I knew how to tie this knot and upon answering that I could tie that kind of knot was informed that I was detailed to act as hangman, and it thus happened that I tied the knot and placed the rope about the neck of all the Indians hanged by Colonel Wright's command in the Spokane Country. There is nothing in the gossip reported by my good friend, John Smith, to the effect that I received $20 for each Indian hanged, as I never received any reward for obeying the commands of my superior officers in assisting in the execution of these Indians.

The second article pertaining to the hangings was an interview with John O'Neil, an army veteran who fought with both Steptoe and Wright in the Palouse and Spokane battles. He was with Wright during his entire campaign, including the slaughter of over 800 horses near the present Idaho-Washington state line. The following statement, which appeared in the April 2, 1905, *Spokesman Review*, details O'Neil's account of the hangings:

> Mr. O'Neil says there were, all told, 27 Indians executed at different points on Hangman creek and the country round about. Among them was the red-shirted warrior [believed to be referring to Qualchan] who shouted so lustily for peace. A roadometer, a two wheeled vehicle, provided with an attachment for measuring the distance traveled, in charge of John Mullan of "Mullan Route" fame, was used as a scaffold from which the greater number of hangings were made. Of the total number of Indians thus executed not one showed the white feather. [It is believed he refers to none of the Indians showing cowardice.] Some did not wait for the roadometer to be moved from under them, but leaped off as soon as the noose was adjusted around their necks.

Following the end of the Wright Campaign and the establishment of military Fort Colville, which created a sense of security, settlers began to trickle into what is now Spokane County. In 1859 the government began building the Mullan Road from Fort Walla Walla to Fort Benton in Montana and improving the old pioneer trail between Walla Walla and the Colville Valley. The Colville road crossed the Spokane River west of the present Long Lake Dam. The Mullan Road crossed the Spokane River at Antoine Plante's ferry, east of present-day Spokane, until the Spokane Bridge was built in 1864 near the Washington-Idaho border. The discovery of gold in the northern part of the state brought eager prospectors who were inclined to follow the easiest, quickest routes. Consequently, most north-south travel, which was further hampered by the difficulty of crossing the Spokane River near the Spokane Falls, bypassed the central portion of Spokane County. However, for over

An early photo of Civil War veterans, circa 1900. Thomas Beall (front row, second from left) was the hangman for Colonel Wright during his "Campaign of Terror" (as it came to be known by the Indians) against the Indians in 1858. Beall also fought in the battles of Four Lakes and Spokane Plains and was with Colonel Steptoe during that command's defeat. During his time as a soldier in Wright's campaign, his official assignment was as a packmaster for one of the pack trains. Thomas Beall was 26 years old at the time he carried out the duties as Wright's hangman. *(Photo courtesy Jerome Peltier.)*

two decades before a railroad finally reached Spokane in 1881, the promise of a transcontinental line through this region captured the interest of recent settlers as well as many residents from the eastern states who dreamed of owning their own land and building a life in the West. Settlers slowly filed into Spokane County.

The formation of Spokane County involved a complicated chain of events. (For more detail than the following summary, see pages 54-55.) The first legislative act toward the creation of Spokane County from the larger Walla Walla County was in 1858. However, the new county officials failed to organize and send a representative to Olympia until 1860. The original Spokane County encompassed a large portion of eastern Washington and extended into what is now Montana, an area of about 76,000 square miles. In the early 1860s, the legislature created four new counties in what became Idaho and Montana, greatly reducing Spokane County's territory. In 1864 the legislature annexed what remained of the county with the newly-formed Stevens County. (This Stevens County encompassed a region west of the Columbia River, with only a small section in common with the present Stevens County.) In October 1879, the Territorial Legislature, with Spokane's Francis Cook as president, created Spokane County from a portion of Stevens County.

After the county's official formation, a conflict over the location of the county seat erupted between Cheney and Spokane. Cheney was chosen initially, but following some high-spirited competition, the city of Spokane won out. Spokane County held its first election on December 8, 1879. At that time the following officials were elected: Probate judge, J.E. Labrie; auditor, J.M. Nosler; sheriff, N.M Tappan; treasurer, Anthony M. Cannon; superintendent of schools, Miss Maggie Windsor; and commissioners, John Roberts, V.W. Van Wie and T.E. Jennings. J.T. Lockhart was also elected as the clerk of the district court for Spokane and Stevens counties.

Until the 1860s, Spokane County's history had little to do with white settlement. It was centered around early explorations, the Indians, the missionaries who came to minister to them, and the Indian wars. By 1879, when Spokane was officially declared a county, there were small but numerous settlements throughout the area. The city of Spokane had a population of about 300. Because of its centralized location and the availability of immense water power to run the sawmills, flour mills and provide the necessary utilities demanded by a growing metropolis, Spokane began developing as the axis of activity for the Inland Northwest.

As promised, the Northern Pacific Railroad built its transcontinental line across the northern United States, which was completed in 1883. As it reached Spokane from the west in 1881, Spokane quickly became the axis for railroad lines servicing nearly every region of the Inland Northwest, resulting in rapid population growth. In the mid-1880s, towns and settlements began developing throughout the county. By 1900 Spokane County was booming and the following towns and settlements had been established: Medical Lake, Cheney, Rockford, Fairfield, Latah, Deer Park, Marshall, Hillyard, Mead, Deep Creek, Chattaroy, Milan, Wayside, Wild Rose, Darts Mill or Dartford, Trent, Orchard Prairie, Pleasant Prairie, Spangle, Waverly, Plaza, Stevens and Mica. Spokane had grown to a city with a population of nearly 37,000, almost doubling in size in a ten year period. The county's population was over 57,500.

The prosperity of early Spokane County and the Inland Northwest was founded largely upon the mining industry. Each new mineral discovery brought large influxes of settlers and prospectors. Many intended to take their share of the wealth and move on, only to discover a new-found desire to make the beautiful Inland Northwest their home. The tremendous mineral wealth stimulated the building of the railroads and, thus, the development of the overall economy, which soon included the timber industry, agriculture, water generated power, and diverse industrialization. By the turn of the century, Spokane was being referred to as the "Hub of the Inland Empire." It had, in fact, become the commercial and transportation center of the Inland Northwest, with the majority of its resources coming from the adjacent mining, timber and agricultural districts.

The early mining history of the West began with the discoveries of minerals in California, Nevada, Colorado and the Pacific Northwest, mostly within the Inland Northwest. Although Spokane County covers 1,134,700 acres of land, there were never any mineral discoveries of significance made within its boundaries. However, by the early 1920s, virtually all mining business activities of northeastern Washington, southern British Columbia and the Idaho Panhandle were centered in the city of Spokane.

The origin of the name *Spokane* was derived from the Anglicized translation and interpretation of the native Salish language as spoken by the Spokane Tribe. When the first Jesuits and Protestant missionaries arrived, the chief of the Spokane Tribe was Illim-Spokanee. The translation of *Illim* is "chief" and *Spokanee* refers to "the sun." The tribe became known as the "Children of the Sun." In time, the second "e" was dropped, as was the long "e" sound at the end, resulting in *Spokane* as we know it today.

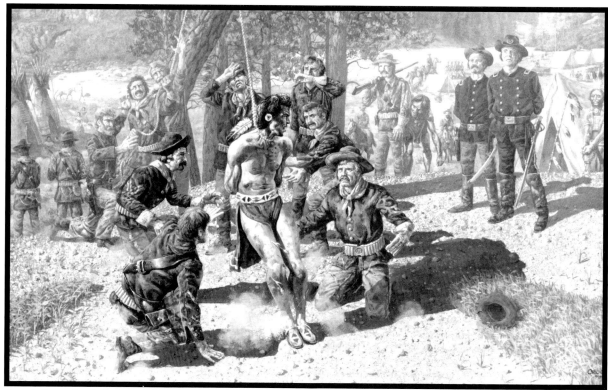

A painting depicting the hanging of the sub-chief Qualchan in 1858. This and other Native American slaughters in the Inland Northwest allowed the United States to gain control of the Indians' land.

(Painting courtesy of the artist Don Crook and the Spokane Public Library Northwest Room.)

The Last of the Hangings in Spokane County

Following the hangings of Native Americans by Colonel Wright, there were still more hangings to come. However, these would not be carried out by the military and the victims would not all be Indians.

During the late 1800s to early 1900s, vigilante hangings were common throughout the nation. Several of these also occurred in Spokane County, the first of which was in Rockford, south of Spokane. The following excerpts were taken from the *Northwest Tribune* reports about the mob hanging of Alday Neal:

> . . . the looseness with which criminals have been dealt with in Spokane county, would almost seem to justify the people taking the law in their own hands if they expect to bring criminals to justice. But the summary lynching of Alday Neal [second excerpt had "Neil"], at Rockford, last week, has every appearance of being a cold blooded murder. (June 2, 1882.)

> . . . We published yesterday an account of a particularly barbarous mob murder committed in Washington Territory. A man of bad reputation, but against whom no specific crime seems to have been charged, committed the offense of returning to the neighborhood he had left some time before. It does not appear that he had any other purpose than to visit a sister who lives there; but the law-abiding and respectable citizens were so determined not to endure his presence that they assembled in force, took him out of his sister's house, and incontently [sic] hanged him to a tree. (June 16, 1882 *Northwest Tribune* quoting an article printed in the Sacramento, California, *Record Union*.)

The next recorded mob action came at Cheney during the first week of September in 1884. A crowd of about

30 men tore down the fence which enclosed the jail at Cheney, broke down the door to the jail and subsequently hanged the lone inmate, an Indian. This story appeared in the September 13, 1884 issue of *The Review*. Although the article describing this action was quite lengthy, there was no mention of the crime for which the Indian was jailed, other than the mob had "absolute knowledge that the identical man guilty of such a monstrous crime had been hung [*sic*]."

A reference to another vigilante action in Cheney also appeared in the same article describing the Indian hanging event. It read as follows, "Swung him into the air under the command of the captain, with a sailors chorus of 'hoist away.' The gallows selected is a tree standing near the jail, which, they say, has been used before to answer the same purpose at the death of a Chinaman."

Spokane County's Official Hangings

On September 6, 1892 at 8:06 a.m., Spokane County carried out it first official execution with the hanging of Charles Brooks. Up until the mid-1900s, county officials were mandated to provide for their own justice, including executions. Courts and juries handed down verdicts and sentencing, and the county sheriff carried out the sentences. Early law books containing "sheriff duties" included directions for erecting hanging scaffolds and the procedures accompanying the hangings. These included the proper format for invitations and who should be invited to attend.

Spokane County would conduct two more hangings before the laws were changed, mandating that all hangings be conducted at the Washington State Penitentiary at Walla Walla.

Charles Brooks, Spokane County's first official hanging victim, and his wife Christina. Brooks, a black man, was tried and convicted for the murder of his estranged wife, whom he shot and killed after she filed for divorce. Before his marriage, he was known to have told friends he wanted to marry a white woman. Christina, a Swedish immigrant, was quite a bit younger than Charles, but married him after he deceived her into believing he had a lot of money. They had only been married about a year when she filed for divorce. Charles sought her out, gun in hand, to plead with her to change her mind. When she refused, he shot her. (At the time of the hanging, the above sketches were used in newspapers due to the unavailability of photographic options.)

FATAL DROP

The Negro Wife Murderer, Charles Brooks, Expiates His Cowardly Crime.

DEATH FEARLESSLY MET

In a Long Speech Upon the Gallows He Proclaims Forgiveness for All His Enemies.

BUOYED BY RELIGIOUS HOPE

He Denounces "The Spokesman" for the Exposure of His Brutality—A Hanging Without Blunders.

STORY OF BROOKS' LIFE AND CRIME

Charles Brooks was hanged in the county jail yard yesterday morning. At six minutes past 8 o'clock Sheriff Pugh touched the button, the trap doors dropped, and the wife murderer's neck was broken. He fell and bounded about a foot in the air, and then was within a few yards of where a deed of death was being enacted. To this curious, surging crowd, the fortunate ones who had pre-empted the telegraph poles communicated the proceedings in the jail yard below.

At the conclusion of the first execution in Spokane county a wonderfully quiet and peaceful dispersion took place. There was scarcely any discussion of the affair. Justice had been vindicated, the driveling sentiment that had sought to save Brooks' neck had been rebuked, and no fault was to be found with any of the proceedings of the day.

HE SLEPT LIKE A PICANINNY.

Without Fear or Regret and Confident of a Welcome to Heaven.

Brooks slept soundly the night preceding the execution. He lay stretched out on the cot in his cell in all the peace and tranquility of the slumbers of his picaninny days. His glossy brown visage betrayed no evidence of the dreams of a cold-blooded murderer. He lay on his back with one arm thrown up around his head in the attitude of a peaceful sleeper. He would have been apparently as inanimate as he was a few hours later after Sheriff Pugh had sprung the drop had it not been for the squeaking, screeching sound that escaped his lips at intervals. The murderer was gritting his teeth. Was it in the agony of apprehension over his approaching death? Was it despair over his foul crime? Not at all. Brooks felt no fear, no regret. He had during his last days drank in so much spiritual consolation from the big bible in his cell that he was thoroughly intoxicated with the idea that Jesus and the angels were waiting for him on

T he above is a portion of the front page article in *The Spokesman* on Wednesday, September 7, 1892. This article illustrates the typical attitude of the times toward minorities. The hanging of Brooks received over a dozen pages of press coverage during the last week of his life. Brook's final words were, "A man that loves a woman will kill her. If I hadn't loved her I wouldn't have killed her. If you love a woman you will go through fire for her."

Interestingly, in all three of Spokane's official hangings (from 1892 to 1900), the justice system completed the entire process, including the appeals, within three years (each of the first two only took about a year).

Gin Pong

To Mr. *D. D. McPhee*
Pursuant to the Statute,
you are respectfully invited to
attend the Execution of
Gin Pong,
at the Spokane County Jail,
Friday, April 30, 1897, 12 o'clock noon.
C. C. Dempsey
SHERIFF SPOKANE COUNTY, WASHINGTON.

Until the 1900s, it was typical for sheriffs to send invitations to the influential individuals in the community. It was also considered an honor to receive one of these invitations. Invitations were given out for all three of Spokane County's official executions.

Gin Pong, the second person in the history of Spokane County to be officially hanged, met his fate at 12:03 p.m. on April 30, 1897, for the murder of a fellow countryman, Lee Tung, in downtown Spokane.

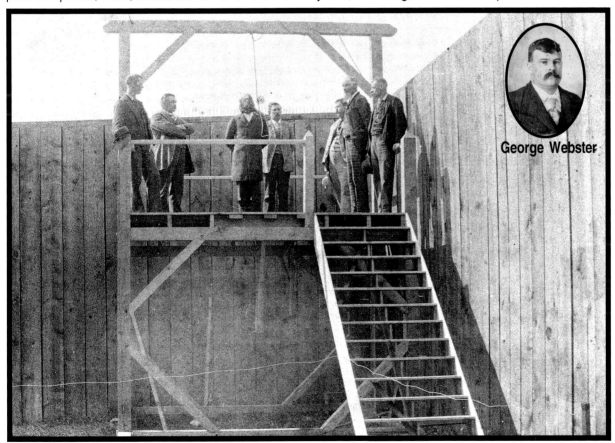

George Webster

Spokane County's third and final execution. George Webster, shown on the gallows, was hanged at 11:07 a.m. on March 30, 1900, for the murder of Lize Aspland, whom he killed while in a drunken state in May 1897.

(Gallows photo courtesy Spokane Public Library. George Webster inset, Gin Pong photo and invitation courtesy Jerome Peltier.)

Spokane's Premier Photographers: Charles A. Libby & Son
A Glimpse of the Charles A. Libby Jr. Family Album

Charles A. Libby Sr.

Charles A. Libby Jr.

In the late 1890s, after the death of Charles A. Libby Sr.'s father, his mother moved the family to Spokane. Charles's older sister, Addice set up a photography and art studio. Charles joined her in the business. Within a few years, he opened his own studio specializing in commercial photography. Addie continued in her portrait and art studio. In 1907 Charles Libby Jr. was born. As a teenager, he began working in his father's business. During the Libbys' careers, from 1898 to 1969, they recorded and documented the history in and around Spokane with over 200,000 photographs. The majority of this collection consists of 8"x10" negatives (both glass plates and nitrate film). Libby Sr. retired in 1962 at the age of 82. Libby Jr. continued the business until 1969 when he sold the firm to Keith Henry. Henry subsequently sold a majority of the collection to the Eastern Washington State Historical Society.

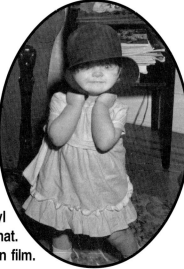

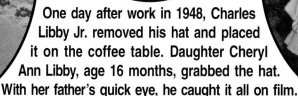

One day after work in 1948, Charles Libby Jr. removed his hat and placed it on the coffee table. Daughter Cheryl Ann Libby, age 16 months, grabbed the hat. With her father's quick eye, he caught it all on film.

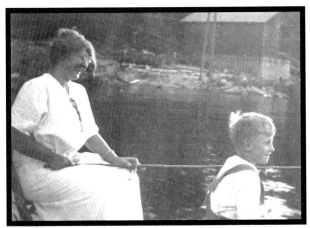

Charles Jr. with his mother, Gretchen, at the lake.

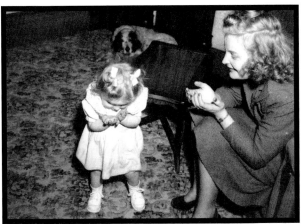

Cheri Libby and her mother, Betty.

Charles Libby Jr. with his mother Gretchen Libby.
Inset is Charles A. (Cal) Libby III, as a teenager.

Rich and Cheri Chapin on
their wedding day in 1968.

Industrious and dedicated photographers, the Libbys were among the best in their profession. On weekends during the 1920s, while Charles Jr. was still in high school, father and son would board an early morning train to Liberty Lake, photograph whatever picnics or functions were taking place, then rush back to Spokane to develop the film. Upon their return in the afternoon, proofs were passed around the tables and anyone wanting copies could write their name on the back. At the time, this provided a good source of income for the studio.

The Libby photographs document a diverse range of topics covering the evolutionary changes in Spokane from 1898 to 1969. Examples of this diversity are Spokane's first aerial photographs. These were taken by Charles Jr. To accomplish this, he designed special harnesses for himself and his camera.

Charles Libby Sr. passed away in 1966 and Charles Libby Jr. in 1982. However, their legacy will live on in perpetuity, providing an invaluable resource and treasure to Spokane and the Inland Northwest. Numerous Libby Studio photos are included in this publication. *(All photos on pages 152-153 courtesy Rich & Cheri (Libby) Chapin.)*

Fishtrap Falls, southwest of Tyler and Cheney, circa 1930.

(Magee photo courtesy Spokane Public Library Northwest Room.)

Fishtrap Lake Resort in the 1920s. Most of Fishtrap Lake is in Lincoln Co., but a small portion of it and the resort lie in Spokane Co. The resort opened in 1902. The building to the far right was originally a dance hall with frequent live music. The present store, built about 1912, was also a hotel. Current owner, Jim Scroggie, bought the resort in 1952. His grandfather was the first private owner of the land but sold it in 1902. *(Photo EWSHS, L97-19.52)*

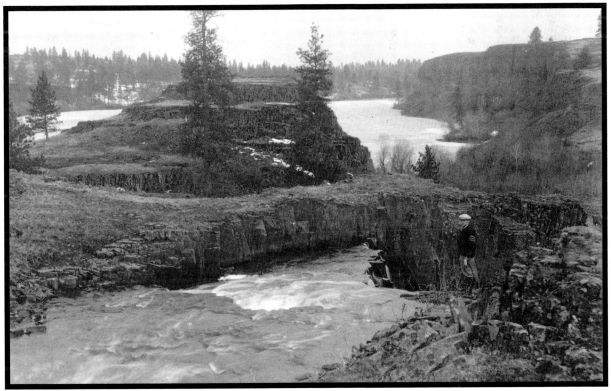

Hog Lake (also known as Deep Lake) above Fishtrap Lake, circa 1930.
(Magee photo courtesy Spokane Public Library Northwest Room.)

The town of Medical Lake, circa 1930. Andrew Lefevre, the first white man to settle in this region, was one of the earliest settlers in Spokane County. He arrived around 1859. *(Magee photo courtesy Spokane Public Library.)*

Medical Lake High School football (?) or basketball (?) players in 1913. Note the condition of the street. *(Photo EWSHS, L86-458)*

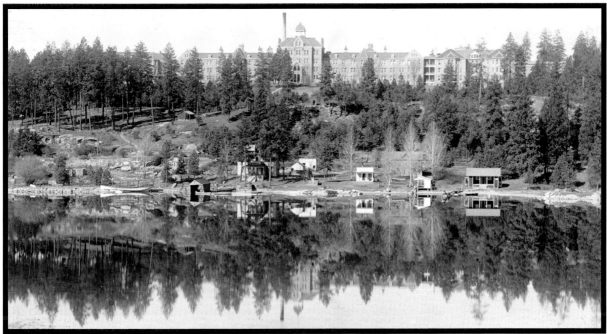

Eastern State Hospital "for the insane" (as it was called until 1918) located above Medical Lake. The first building opened for patients in 1891. In the early days, it was seen as a place to conveniently discard people with all sorts of societal problems, including alcoholics and the criminally insane. Over the years, treatment at the hospital has reflected evolving treatments and attitudes in caring for patients with mental problems. Lakeland Village, a school for the developmentally disabled, opened in 1906. *(Magee photo courtesy Spokane Public Library.)*

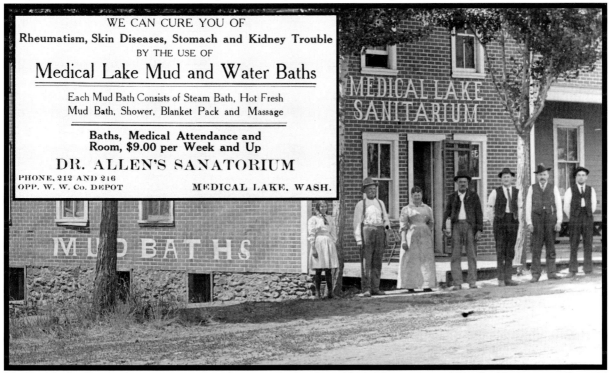

Medical Lake Sanitarium and an advertisement for it, circa 1908. The waters of Medical Lake were thought to have medicinal properties. The original owner of the townsite, Stanley Hallett, developed an evaporation process to condense the medical properties (mostly salt), which he marketed. *(Photo EWSHS, L86-57.11)*

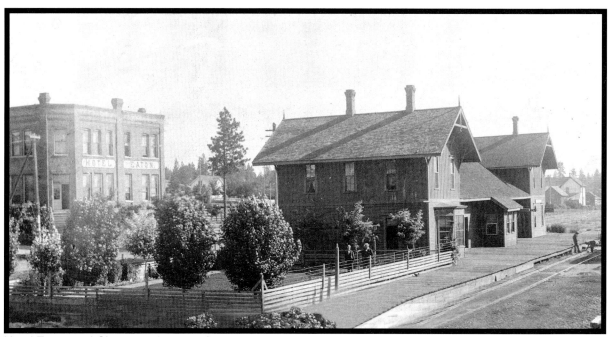

Hotel Eaton and Cheney train depot (built in 1881) in 1893. Cheney began as a trading point known as Depot Springs. The Northern Pacific Railroad, primarily through the efforts of Franklin Billings, laid out the townsite of Cheney. The town was then called Billings. When it incorporated, the name was changed again, this time in honor of Boston capitalist Benjamin P. Cheney, who was the N.P.R.R. director. Cheney donated $10,000 to build the Cheney Academy (forerunner of E.W.U.) on land donated by the railroad. *(Photo EWSHS, L94-9.226)*

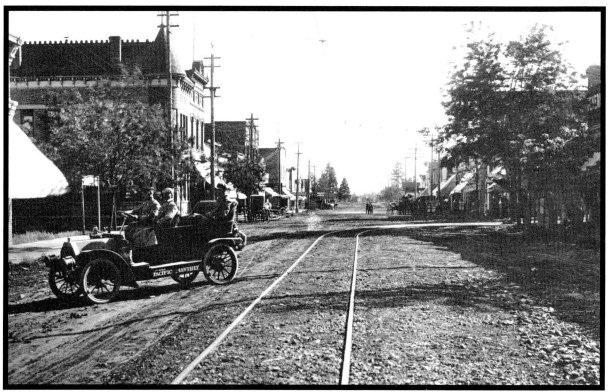

Washington Street in Cheney, circa 1910. Cheney aspired to become the Spokane County seat which it achieved for a brief period of time before losing it to the city of Spokane in a heated contest. *(Photo EWSHS, L94-24.48)*

Cheney Jail, built in 1881, was Spokane County's first jail. According to newspaper accounts there were two separate incidents of inmates being taken from this jail and hanged by vigilantes. *(Photo EWSHS, L94-24.46)*

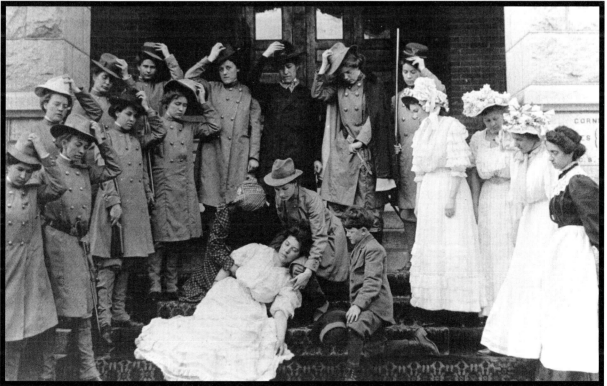

A play cast on the front steps of the State Normal School building in Cheney. The normal school, now Eastern Washington University, opened in April of 1882 as a teachers college. *(Photo EWSHS, L93-18.194)*

In 1890 this smelter was built in what is now Riverside State Park, just beyond the Bowl and Pitcher. Mining activity in the Coeur d'Alenes was booming and this project promised to be a great economic resource. In spite of the construction of 12 buildings and a graded right of way for a railroad spur, it was never fired up. Lawsuits developed soon after its construction, which continued for over a decade. Despite revival efforts, it fell into ruin. In 1926 the smelter burned down, leaving only the tall stack, which was dynamited. Considering the smog and toxic pollution emitted from a smelter, and the potential damage to the river and future state park, this outcome was probably in Spokane's best interest. *(Magee photo courtesy Spokane Public Library NWR.)*

An outing at the Bowl and Pitcher on the Spokane River in the 1920s. The only individuals identified were Beatrice Barnhart (top left), Gloria Hope (top right), and Lucy Hughes (far right, middle row). *(Magee photo courtesy Spokane Public Library Northwest Room.)*

"The Pyramids" above the Bowl and Pitcher at Riverside State Park on the Spokane River, circa 1930.
(Photo EWSHS, Magee Album, L83-131)

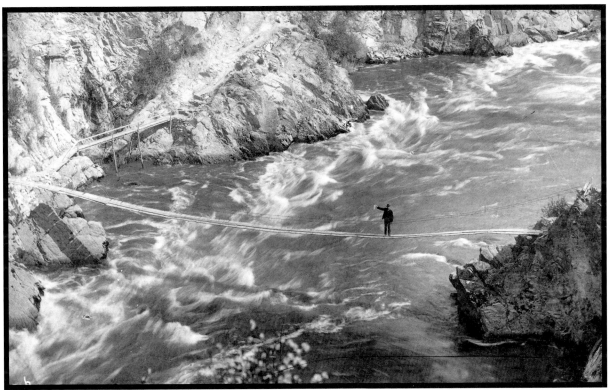

The Spokane River Narrows, circa 1900.
(Frank Palmer photo courtesy Spokane Public Library Northwest Room.)

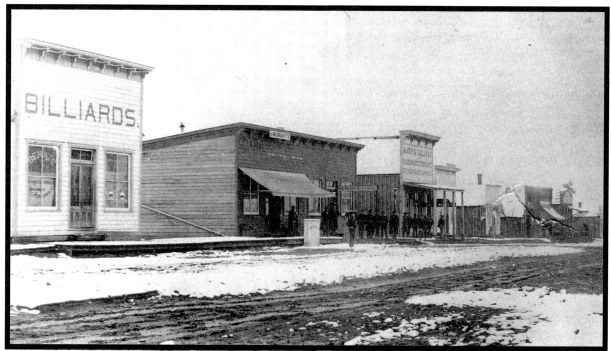

The west side of Spangle's Main Street after a snowstorm on May 8, 1891, taken by local photographer H.W. Green. William Spangle deeded a section of his homestead, which he staked in 1872, for the town of Spangle. The buildings (first three, from L to R) are the Senate Saloon, J.M. Grant's general merchandise store and a new drug store opened by W.E. Hoxsey, and the Ames and Calavan Hardware. *(Photo EWSHS, L94-24.131)*

The Spokane County poor farm at Spangle, circa 1925, was established in 1888. The farm was intended to be largely self-supported by its gardens, orchards and livestock. The original two-story building, designed to house about 60 residents, was soon overcrowded and in 1900 a second building was added. The poor farm (known as Broadacres) was sold to the Seventh Day Adventists in 1945. *(EWSHS, Frank Guilbert photo, L88-80)*

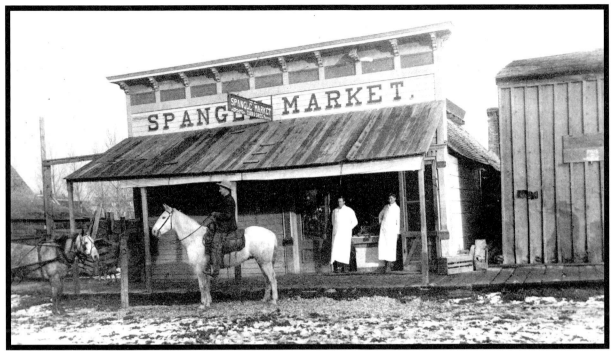

The Spangle Market, circa 1900. When the Spokane & Palouse branch of the Northern Pacific Railroad was constructed in 1886, the town quickly grew up on both sides of the tracks. Some years earlier, the N.P.R.R.'s survey party reported the land in this area to be worthless for farming. It later proved to be one of the richest agricultural regions in eastern Washington. *(Photo EWSHS, L94-24.95)*

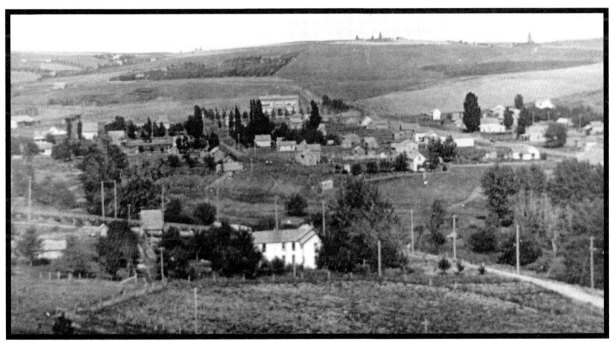

The town of Waverly looking north, circa 1900. In 1899 a huge sugar beet factory, which was promoted by Colonel Edward H. Morrison of Fairfield, was built in Waverly. Financial backing came from D.C. Corbin of Spokane. Although the first settlement in the vicinity of Waverly began in the 1870s, the town grew slowly until the sugar beet industry took hold. Waverly then became a true boom town. However, due to a number of factors, the Washington State Sugar Company only survived about a decade. *(Photo EWSHS, L94-9.123)*

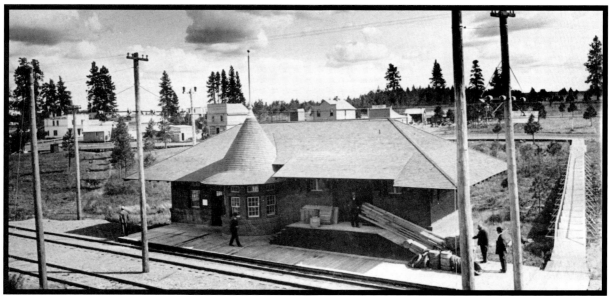

Spokane and Inland Empire Interurban station at Valleyford, circa 1900. *(Photo EWSHS, L86-202)*

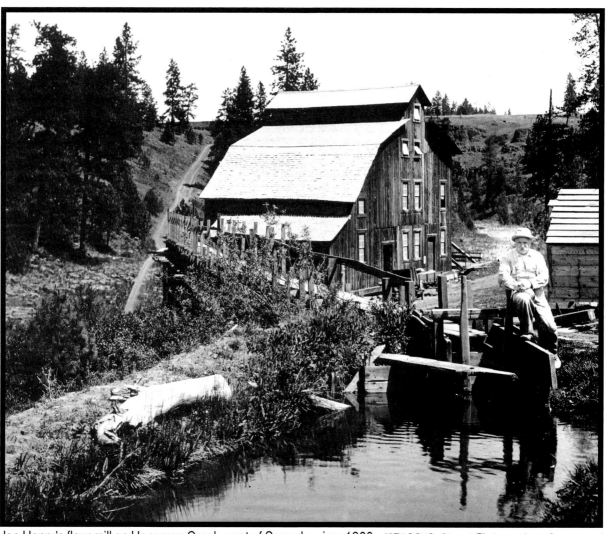

Joe Henry's flour mill on Hangman Creek, east of Spangle, circa 1900. *(EWSHS, Frank Palmer photo, L93-17.154)*

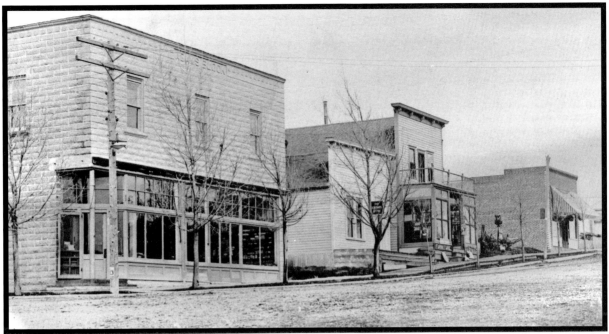

Looking east on Fairfield's Main Street, circa 1900. Fairfield got its start in 1888 when the railroad arrived. It was called both Truax and Regis until the post office was established the following year, securing the name Fairfield. Since the mid-1930s, Fairfield has been home to Ye Galleon Press. At age 87, founder Glen Adams continues to operate the printing business though confined to a wheelchair since 1983. Ye Galleon Press has released over 650 titles, the majority of which are on Northwestern history. *(Photo EWSHS, L86-48.82)*

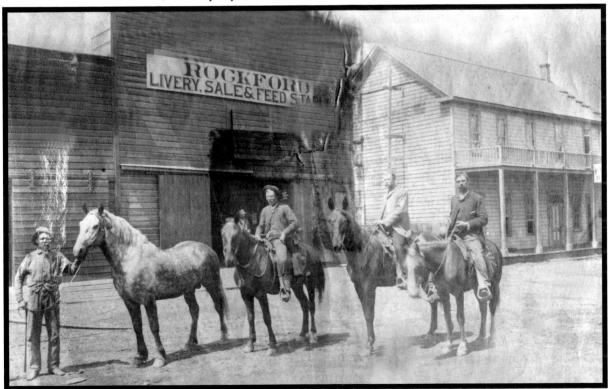

The Rockford Livery, Sale & Feed Stable and the Palace Hotel in 1885. The Palace was operated by I.O. and E.F. Smith. Rockford got its start in 1878 with the Farnsworth & Worley sawmill. *(Photo EWSHS, L87-245.35)*

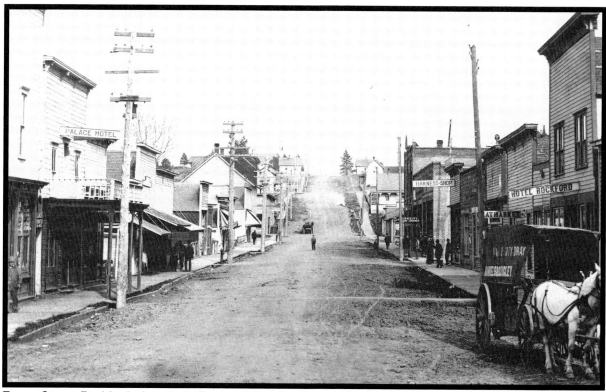

Emma Street, Rockford, circa 1910. Daniels & Quigley dray on the right. An agricultural center with a productive flour mill, Rockford was one of the most important stations along the O.R.&N.R.R. *(Photo EWSHS, L83-249.2)*

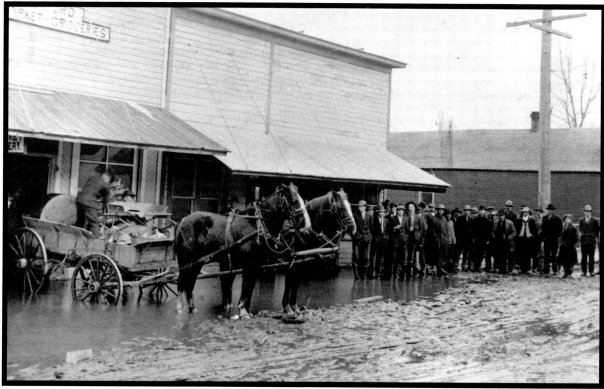

Flood in downtown Rockford March 9, 1910. Rockford is situated at the confluence of Mica and Rock Creeks. *(Photo EWSHS, L86-551)*

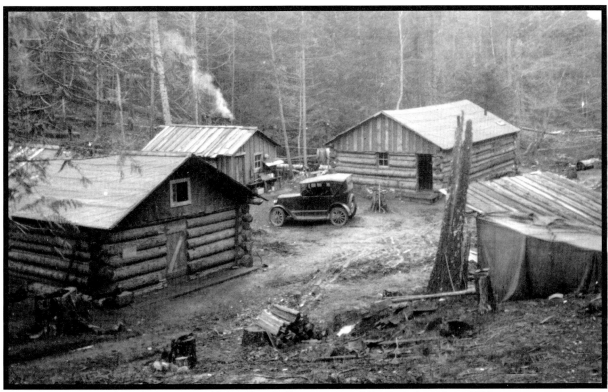

Logging camp at Kalez Creek Canyon near Liberty Lake, circa 1930.
(Magee photo courtesy Spokane Public Library Northwest Room.)

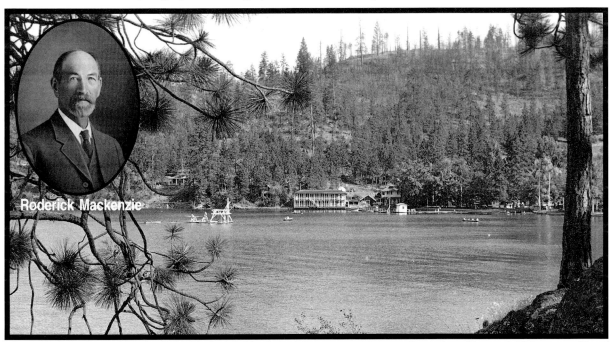

Roderick Mackenzie

Liberty Lake, circa 1930. In 1890 Roderick Mackenzie *(Inset-NWD)* purchased and farmed 860 acres of land on the west side of Liberty Lake. He also built a hotel and kept a fleet of boats for his guests. His resort (not shown) was the first at Liberty Lake. The lake became one of the most popular areas in the county. In 1903 the Spokane and Inland Empire Railroad Company built an electric line through the Spokane Valley to Liberty Lake and Coeur d'Alene. By 1909 it owned and operated a busy resort at the lake. *(Photo courtesy Wallace Gamble.)*

Willie Wylie at Liberty Lake, circa 1930. Wylie was a well-known character who lived most of his life in the Spokane area. He wore only shorts and shoes, even in winter. *(Magee photo courtesy Spokane Public Library.)*

The Charles Libby family and friends enjoying an outing at Liberty Lake in 1914. Young Charles Libby Jr. is seated in front of his father Charles Libby Sr. (third from left). *(Photo courtesy Cheri (Libby) and Rich Chapin.)*

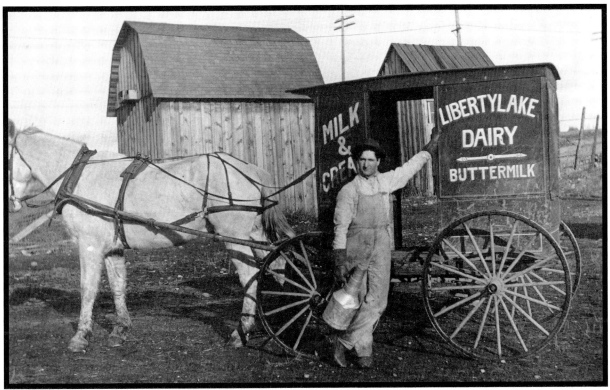

A delivery wagon for the Liberty Lake Dairy, circa 1908.
(Photo courtesy Spokane Public Library Northwest Room.)

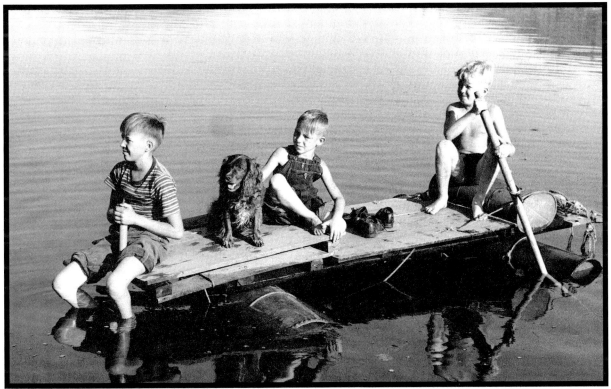

Rafting on Newman Lake, circa 1940. In 1903 the Spokane Canal Company used a canal, dug by property owners for draining the lake's overflow, to irrigate orchards in Otis Orchards. *(Photo courtesy Wallace Gamble.)*

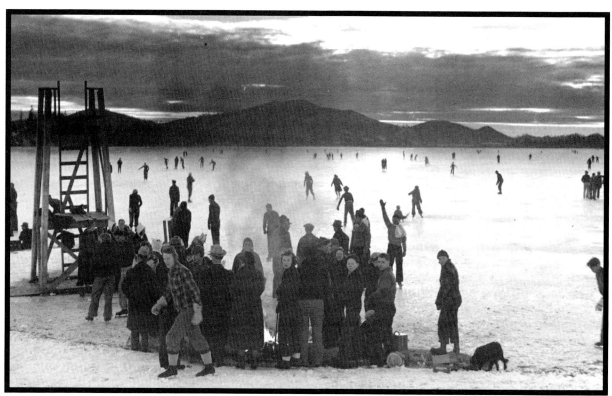

Ice skating at Newman Lake, circa 1940.
(Photo courtesy Wallace Gamble.)

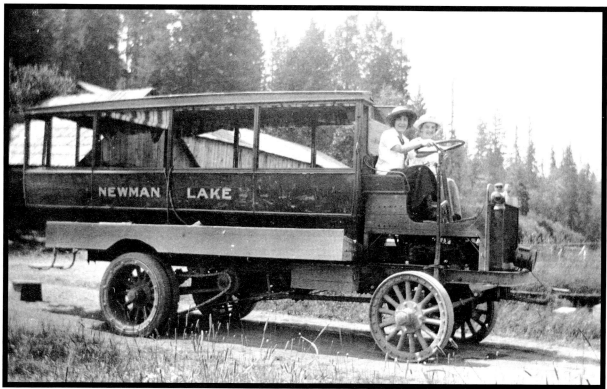

The Newman Lake bus, circa 1910. In 1864 William Newman became the first settler on the shores of the lake which bears his name. He originally came to the area with the boundary surveyors. *(Photo EWSHS, L94-19.15)*

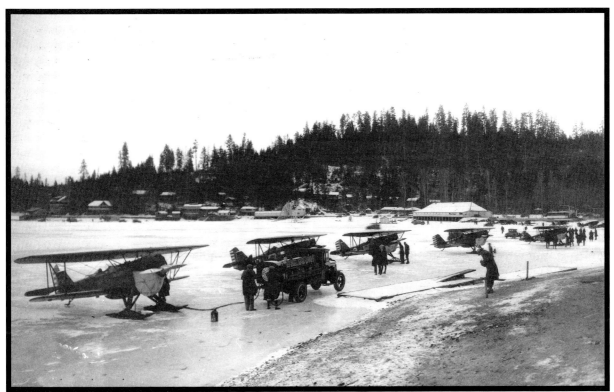

Small military planes on frozen Newman Lake in 1930.
(EWSHS, Libby Studio photo, L87.1-41389.30)

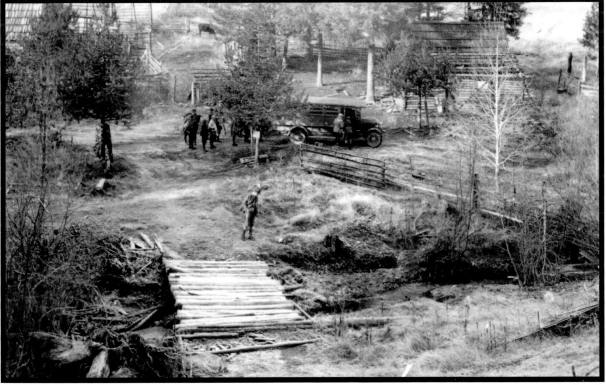

The Spokane Trail Club at Thompson Creek, north of Newman Lake. Thompson Creek was named for Louis Thompson who came to Newman Lake in 1884. *(Magee photo courtesy Spokane Public Library Northwest Room.)*

A 1941 Plymouth on the road to Mt. Spokane. Note the rumble-seat car with the skis in front of the Plymouth. The original road to the summit of Mt. Spokane was built by Francis Cook and his son Silas. Beginning in 1909, they spent years painstakingly surveying and building the road by their own physical labors, using road plows and old-fashioned graders. In 1912 the former Mt. Carlton was officially changed to Mt. Spokane. Governor Marion Hay and "Miss Spokane" Marguerite Motie were among those attending the name-changing celebration. In later years the Civilian Conservation Corps widened the road built by the Cooks. *(Photo courtesy Wallace Gamble.)*

Wallace Gamble, at age 97.

Fritz Babcock at the Vista House on Mt. Spokane, circa 1942. The Vista House, designed by Spokane architect Henry Bertleson, was dedicated in 1934. This photograph was one of countless images of the Inland Northwest taken and developed by Wallace Gamble, a Spokane cab driver with an eye for photography. Before becoming a cab driver, he was the personal chauffeur for timber tycoon T.J. Humbird for five years and then for Mrs. August Paulsen. Gamble, who was born in 1901, still lives in the South Hill home he and his wife Pearl built in 1937.

The first Mt. Spokane ski lodge on the west side of the mountain, circa 1940, was completed in 1937. Additions were later added, but all was destroyed in a fire on January 23, 1952. *(Photos courtesy Wallace Gamble.)*

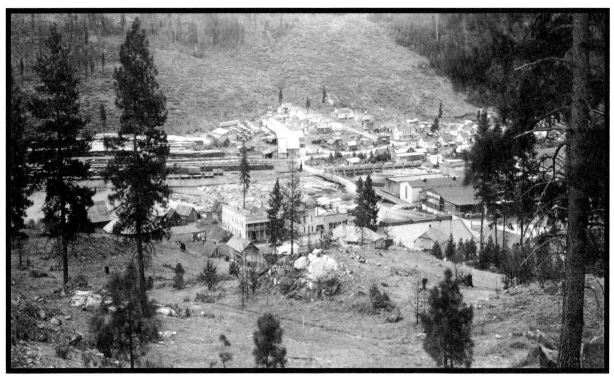

The town of Elk, circa 1905. Located on the Little Spokane River, it was once a busy sawmill town. Home-steaders were already staking out their claims when the G.N.R.R. came through in 1892. The post office was established that same year and the first store built in 1897. *(Photo courtesy Pend Oreille Co. Historical Society.)*

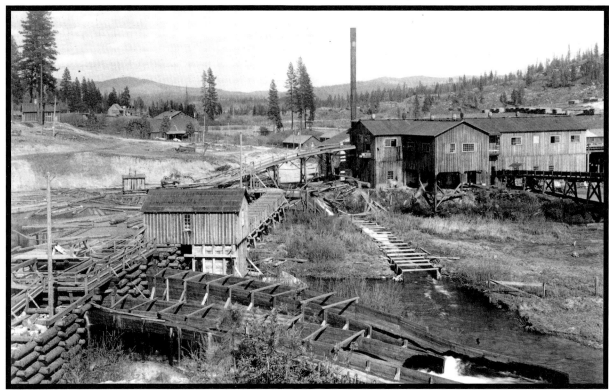

Milan mill on the West Branch of the Little Spokane River, one mile north of Milan, circa 1920. Logging operations and sawmills prospered in this area in the early part of the century. *(EWSHS, Magee Album, L83-132)*

Mt. Spokane Power Company below Milan in the 1920s.
(EWSHS, Magee Album, L83-132)

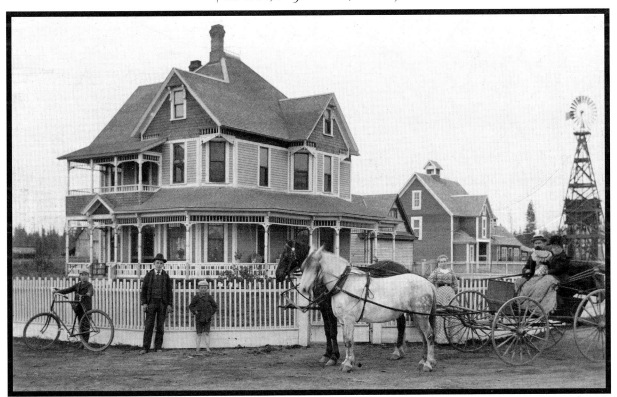

The Kelly home in Deer Park. Peter J. Kelly was one of the pioneers of Deer Park, arriving in 1889. Soon after his arrival, he built the first store and helped organize the First State Bank. *(Photo courtesy Joan & Larry Reuthinger.)*

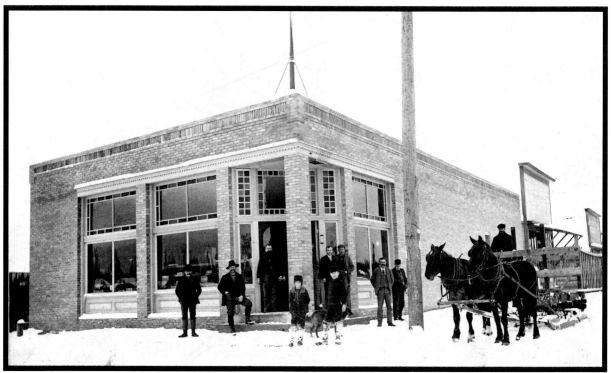

People's Supply on January 11, 1902 at the northwest corner of First and Crawford in Deer Park. The store was later enlarged (see following page). The bearded man in the doorway is founder and owner Peter J. Kelly. To the right of the column is co-owner Joseph A. Reuthinger. *(Photo courtesy Joan and Larry Reuthinger.)*

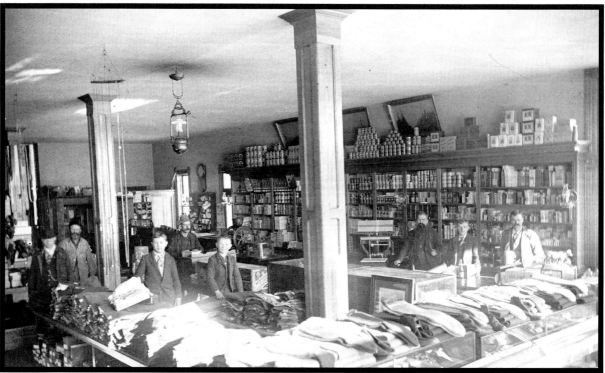

The interior of People's Supply store on January 11, 1902. P.J. Kelly is behind the counter (third from left). Joe Reuthinger is standing next to him. When Kelly passed away in 1908, son Oscar F. Kelly became his successor.

(Photo courtesy Joan and Larry Reuthinger, grandchildren of Joseph A. and Jennie Reuthinger.)

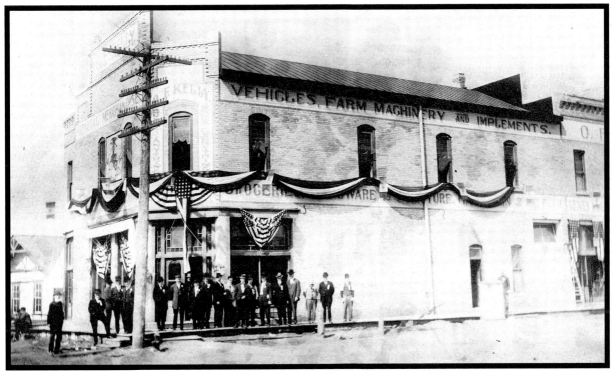

The People's Supply Store, circa 1909, owned by Oscar F. Kelly. This photo shows the store after it was enlarged in 1903, which included the addition of a second story. *(Photo courtesy Joan and Larry Reuthinger.)*

Joseph A. and Jennie (Irish) Reuthinger's first house in Deer Park, circa 1905. The home was located next to the Olson Hotel, at the southeast corner of First and Crawford, which is now an apartment building. Reuthinger's father donated land across the street for the Catholic Church. *(Photo courtesy Joan and Larry Reuthinger.)*

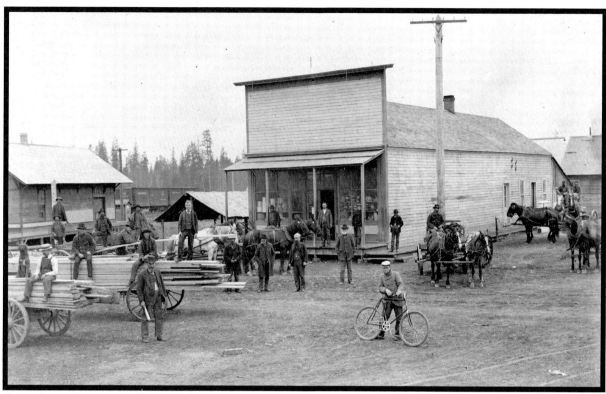

Deer Park, circa 1900. Deer Park was the supply point for the area's numerous sawmills and farms. The Standard Lumber Company's mill was the town's main industry. *(Photo courtesy Joan and Larry Reuthinger.)*

Unidentified loggers posing on a stump in 1909.
(Photo courtesy Spokane Public Library Northwest Room.)

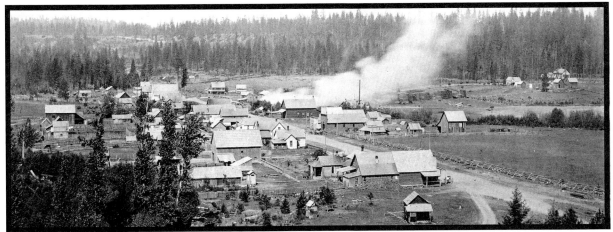

The town of Chattaroy in 1900. Dr. J.L. Smith's store is at the lower right. The Little Spokane River provided water power for the sawmill. Chattaroy was formerly called both Kidd and Cowgill. *(Photos courtesy Bob and Alice Owen.)*

Alice and Bob Owen in 1949

Members of the Owen family at the opening of the Owen Pioneer Museum near Chattaroy in 1949: (L to R) Elsie, Donnie and Forrest Owen; Walter and Bertha (Owen) Beyersdorf; Genevieve and Robert T. Owen; Estelle Owen; Lawrence Owen. Robert and Lawrence started the museum in some of the original buildings erected in the late 1800s on the family homestead, purchased by Alexander and Alice Owen in 1886. Lawrence Owen's store, the first one at Denison, was relocated to become a part of the museum. The museum is presently maintained by Bob and Alice Owen, son and daughter-in-law of Robert and Genevieve. *(Photos courtesy Bob and Alice Owen.)*

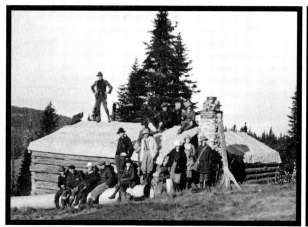

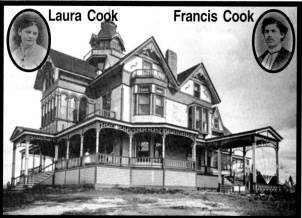

Laura Cook Francis Cook

Francis Cook was deeply involved in the early development of Spokane and the surrounding area. He was President of the Washington Territorial Legislature of 1879-80, which created Spokane County from Stevens County. His enterprises included: publishing the first newspapers in both Tacoma and Spokane; organizing Spokane's first annual county fair in 1886 (held on the South Hill); building and operating Spokane's first motorized trolley, which shuttled between downtown and Mirror Lake (now the Duck Pond at Manito Park); developing a fish hatchery and lake, now called Wandermere Lake; constructing the first road to Mt. Spokane, where he had a farm. The photo at the upper left is the Spokane Trail Club at Francis Cook's cabin on Mt. Spokane in 1923. Upper right is Laura and Francis Cook shortly before their marriage, and the Cook family's home on Spokane's South Hill, located within 10 feet of the present Cathedral of St. John, circa 1894. Cooks owned over 600 acres of land on the South Hill and their house was the first significant one built in that area. The bottom photo is the Spokane Trail Club at Cook's (now Wandermere) Lake in the 1920s.

(Photos, clockwise from upper left, courtesy Spokane Public Library (Magee Album); Adi Song, great-granddaughter, and Lolita "Corky" Knight, granddaughter of Laura and Francis Cook; EWSHS, Magee Album photo, L83-132)

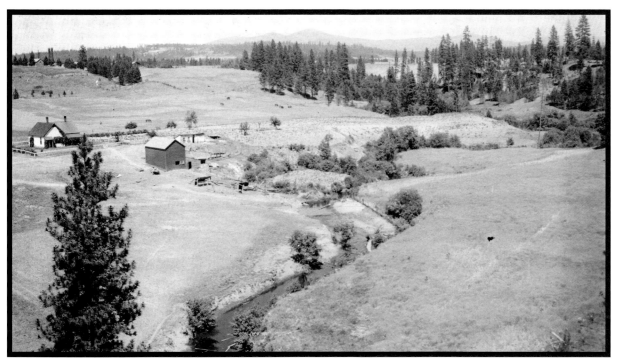

Deadman Creek from the Mead Bridge, circa 1930. The creek meanders through Peone Prairie, a fertile agricultural area, named after Baptiste Peone. *(Magee photo courtesy Spokane Public Library Northwest Room.)*

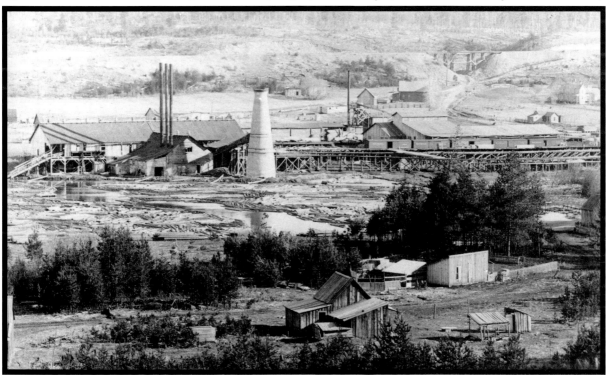

The Buckeye Mill at the town of Buckeye, circa 1910. Prior to finally settling on "Buckeye" in 1903, the town had been referred to as the Little Spokane crossing, Dragoon and Hochspur. The first settler was James Walton, called Pea Vine Jimmie by his friends. It is said he acquired this name because he fed pea vines to his horses and cattle. He began farming at the site where Dragoon Creek flows into the Little Spokane River in 1882 and operated a Government Forage Station (a roadhouse) for the stagecoach lines. *(Photo EWSHS, L94-24.26)*

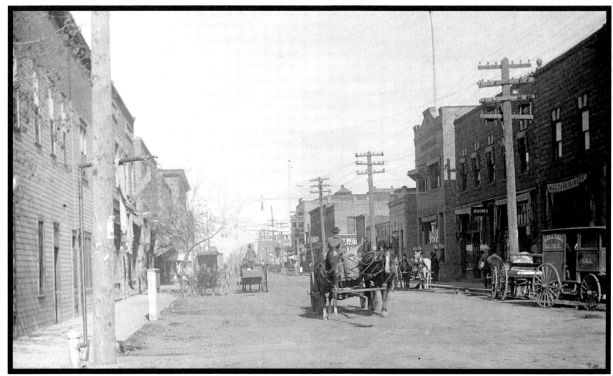

Market Street in Hillyard, circa 1910. The townsite was platted in October 1892 by Leland D. and Kate C. Westfall. Because James J. Hill owned the Great Northern Railroad, whose machine shops and railroad yards occupied this area, it became known as Hillyard. These shops were the best equipped in the West. *(Photo EWSHS, L86-248)*

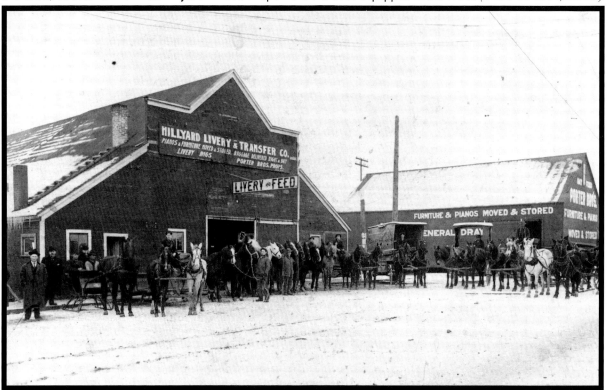

Hillyard Livery & Transfer Co. and Porter Bros. Furniture and Piano Movers in Hillyard, circa 1905. After much controversy, Hillyard was annexed to the city of Spokane in 1924. *(EWSHS, Kehoe photo, L87-9.2)*

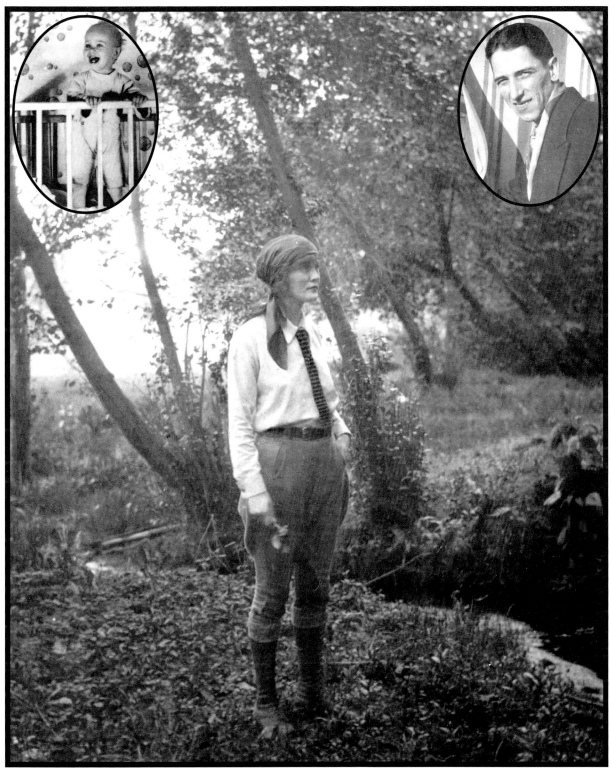

Freda Muller (Sligar) in 1928, dressed in the recreational fashion of the times. Inset at the upper left is a photo of daughter Gale taken by her father, Guy (right inset), in 1938. When the film was developed, a representative from the Kodak Company requested Sligars' permission to use the photo in the company's advertising promotions. The Sligar family lived at 10006 North Division in a two-story house. Today, that address is in a business district and the home of RV's Northwest, Inc. *(Photo courtesy Gale (Sligar) O'Connor.)*

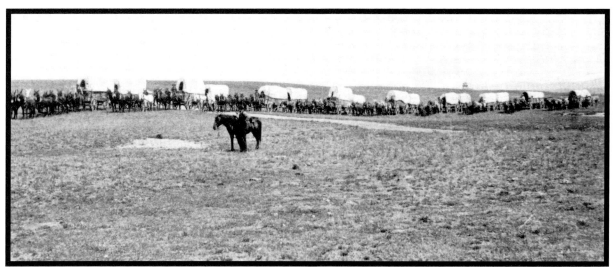

A column of freight wagons heading north on Spokane's Division Street, circa 1885. At this time, the street was called Victoria north of the river and Division south of the river. *(Photo courtesy Jerome Peltier.)*

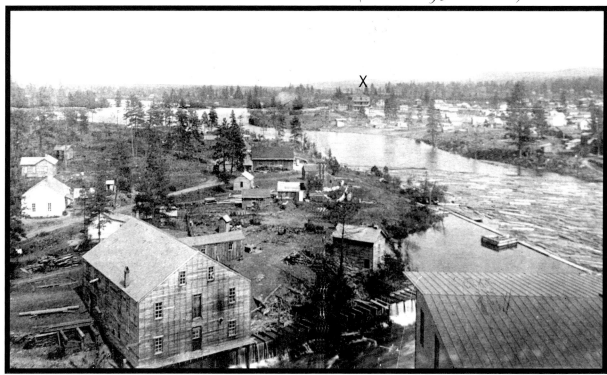

Early Spokane, when the downtown area was occupied by more homes than businesses, circa 1888. This photo from the roof of the Echo Mill on Howard Street (near the site of the present YMCA) is looking southeast across Havermale Island and the Spokane River (note the logs headed for the sawmill). In the foreground is a shingle mill (left) and the Oatmeal Mill (right). Spokane's first hospital, Sacred Heart (marked with the "X"), which opened on January 27, 1887, was at the approximate site of the present Doubletree Hotel on Spokane Falls Boulevard (then Front Street). The Sisters of Charity built it as both a hospital and a facility to care for the poor and homeless. The need was so great, new wings were added in 1889 and 1902. With the burgeoning railroad and industrial activity along the river, accompanied by a growing demand for a larger facility, the Sisters of Charity began searching for another location. In 1910 a new hospital was built on 8th Avenue, where it continued to expand and evolve into the present Sacred Heart Medical Center. *(Photo courtesy Jerome Peltier.)*

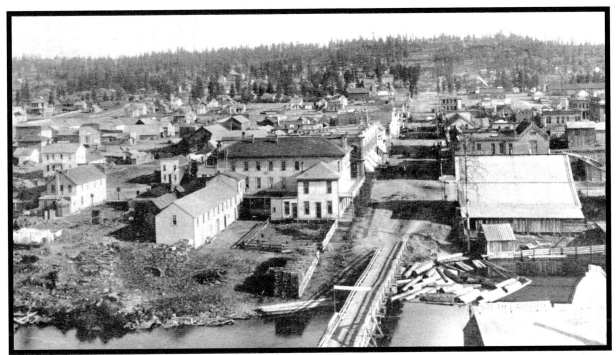

Looking south on Howard Street, circa 1888. The large building on the left side of Howard is the California House. To the right is the City Stable operated by John Glover, brother of James Glover. Front Street (now Spokane Falls Blvd.) intersects with Howard south of these two buildings. *(Photo EWSHS, Detail of L86-275.2)*

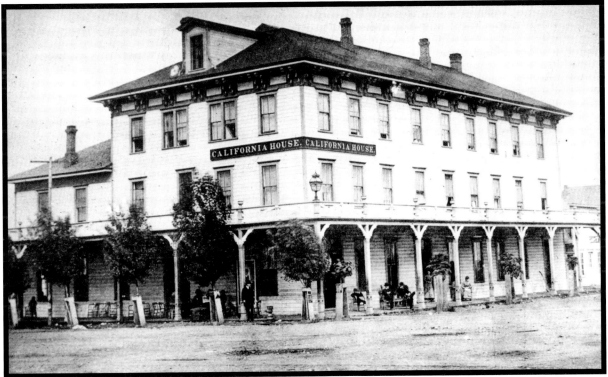

The California House, Spokane's first fine hotel, was built in 1878 and operated by W.C. Gray, his wife Clara and her brother Charles F. Smiley. After it was partially destroyed by fire in 1888, Gray rebuilt the hotel as the Windsor. The following year, it was completely destroyed in Spokane's "Great Fire." The hotel was located near the Spokane River at the approximate site of the Looff Carousel at Riverfront Park. *(Photo courtesy Jerome Peltier.)*

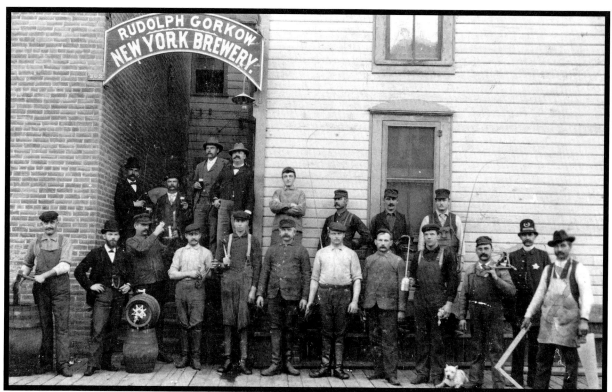

Rudolph Gorkow's New York Brewery, built in 1887 (northwest corner Washington and Spokane Falls Blvd.), was Spokane's first brewery. Joseph Kulhanek (front row, third from right), a brewmaster for Gorkow, and his wife Genevieve settled in the area in 1887. Bernhard Schade was also a brewmaster for Gorkow prior to starting his own brewery. Note the props the men are holding. *(Photo courtesy Sally Jackson, Kulhaneks' great granddaughter.)*

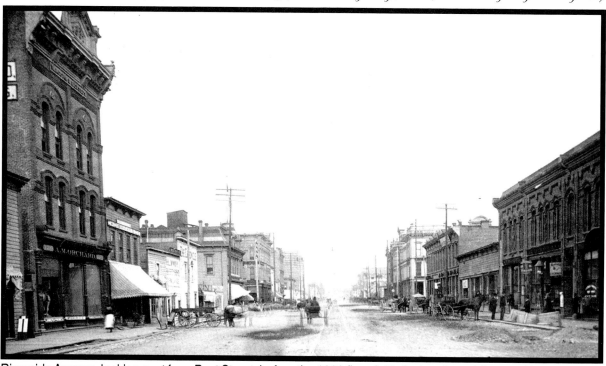

Riverside Avenue, looking east from Post Street, before the 1889 fire. A.M. Orchard's saddlery and harness shop was in the three-story building (left). All these buildings were destroyed in the fire. *(Photo courtesy Jerome Peltier.)*

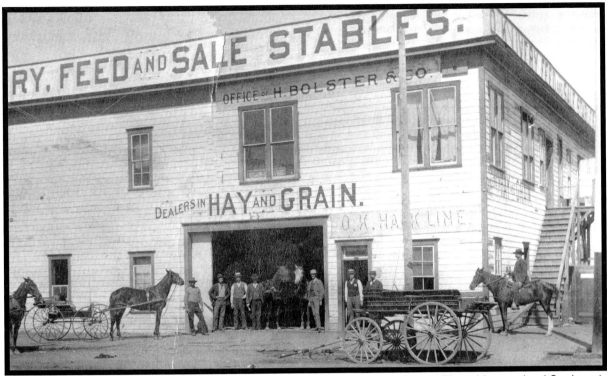

The O.K. Livery, Feed and Sale Stables at the northwest corner of Lincoln and Riverside, survived Spokane's big fire, but was only in existence from about 1889 until 1891. *(Photo courtesy Spokane Public Library NW Room.)*

Dutch Jake's band, circa 1900. Only known identities are Anna and Theresa "Racy" Kulhanek (middle row, 2nd and 3rd from right) and Carl Kulhanek (back row, 4th from right). Everyday at noon, the band paraded through town to drum up business for the Coeur d'Alene Theater/Hotel (southeast corner Spokane Falls Boulevard and Howard) owned by Jacob Goetz (who chose "Dutch Jake" due to frequent mispronunciation of "Goetz") and Harry Baer. They established the variety theater, complete with a restaurant, dance hall, saloon and game rooms, with their wealth from the Coeur d'Alene mines. *(Photo courtesy Sally Jackson, Theresa Kulhanek's granddaughter.)*

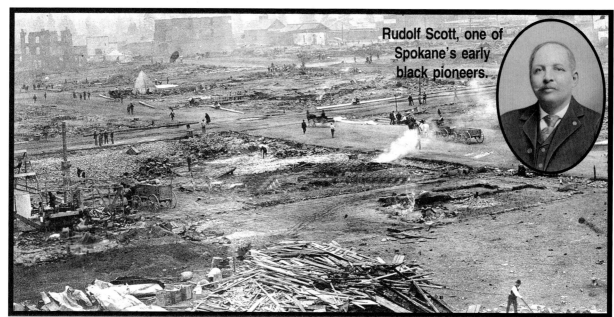

Rudolf Scott, one of Spokane's early black pioneers.

On August 4, 1889, thirty business blocks, the core of Spokane Falls, burned to the ground. The fire burned a swath nearly six blocks wide from the railroad tracks to the river, destroying everything in its path. Fortunately, only one life was lost. George Davis, a civil engineer, burned to death as he ran to his room at the Arlington Hotel. Rudolph Scott *(Inset-NWD)* established one of the first fire and life insurance agencies in the city. After the fire, the company covered all their claims. Scott was also a Spokane County delegate to the convention to organize the state of Washington. *(Photo courtesy Jerome Peltier.)*

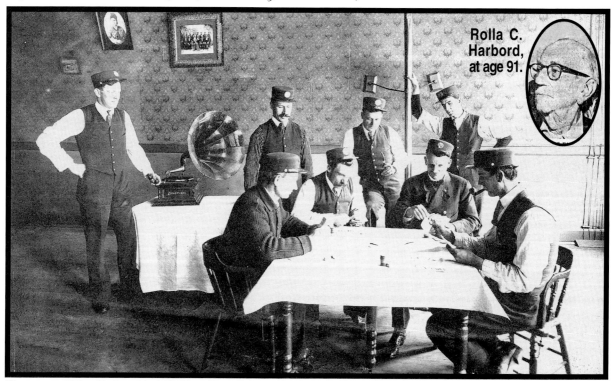

Rolla C. Harbord, at age 91.

The crew at Fire Station #1, 418 West First. Prior to Spokane's Great Fire, the fire department was on a volunteer basis. In 1890 a full-time paid fire department was established and this station was built. Rolla Harbord, who helped fight the fire of 1889, was Spokane's first paid fireman. He served until 1902. *(Photo EWSHS, L93-25.78.)*

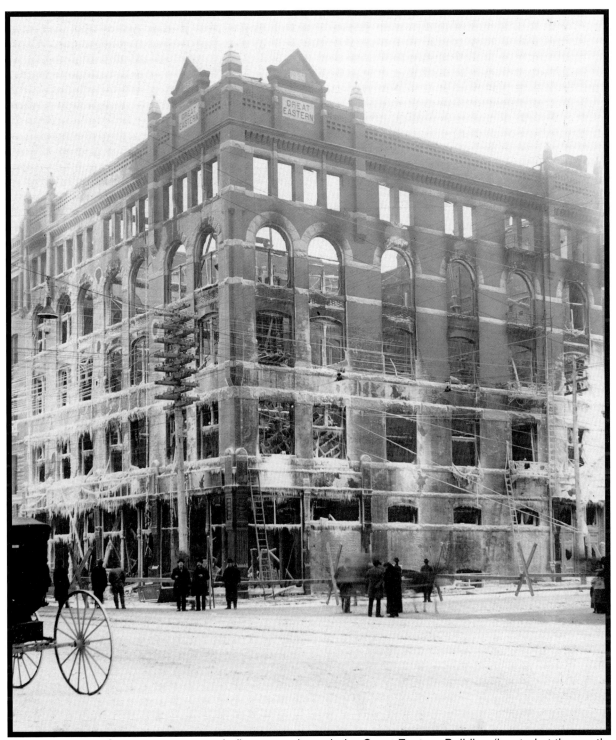

In January 1898, Spokane's most tragic fire swept through the Great Eastern Building (located at the southeast corner of Riverside and Post), leaving nine people dead. The building was rebuilt as the Peyton Block. It has since been enlarged, with two additional stories added. Although Spokane has had its share of devastating fires, the city's worst tragedy was not fire related, but caused by an accidental explosion of over 200 pounds of dynamite. On September 6, 1890, crews were drilling and blasting the rock cut at Sprague and Division in preparation for the Northern Pacific Railroad's new freight yard when the explosion occurred. Twenty four workers died in this accident. Most were buried at Greenwood Cemetery. *(Photo courtesy Jerome Peltier.)*

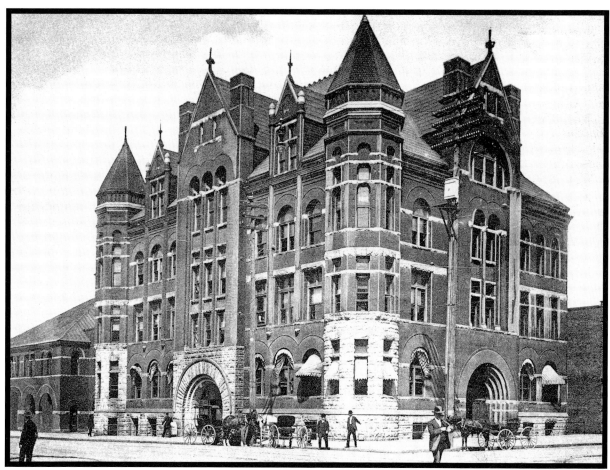

Spokane City Hall and Fire Station #5, the department headquarters (two-story building to the left). Construction of this city hall began in 1892 on the site formerly occupied by the California House (page 185). It was demolished in 1913 to build the Union Pacific Railroad Station. *(Photo courtesy Spokane Public Library NW Room.)*

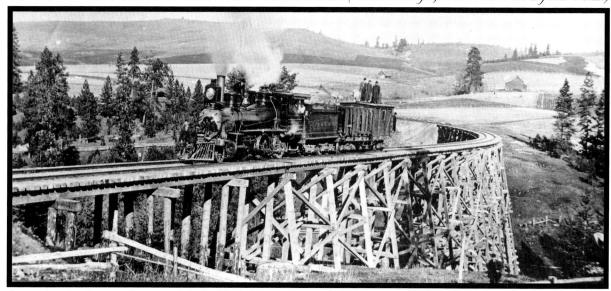

A construction locomotive crossing the Parkview Trestle on the Spokane & Inland Empire Railroad, the electric line owned by Jay P. Graves. The line connected Spokane to many of the outlying communities. This route, built in 1906, was to the Palouse. Hiram Ferris is on the engine holding onto the bell. *(Photo EWSHS, L94-24.142)*

Touring cars in front of the Interurban Terminal Building, located on the northwest corner of Main and Lincoln (now the site of the main branch of the Spokane Public Library). The terminal, designed by architect Albert Held, was built in 1905 primarily to serve the needs of the electric railway lines. *(Photo EWSHS, L93-18.178)*

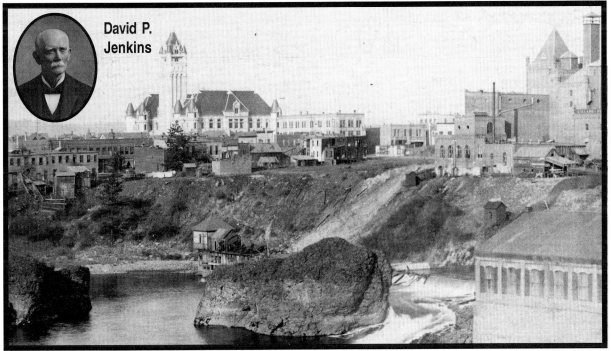

David P.
Jenkins

Looking west at the Spokane County Courthouse above the Spokane River, circa 1900. Colonel David P. Jenkins *(Inset-NWD)*, a veteran of the Civil War and an attorney, arrived in 1879. He was one of the principal property owners of early Spokane. He donated land for the courthouse (a full city block), Spokane College and the Plymouth Congregational Church (even though he was not a member). *(Photo EWSHS, L94-19.47)*

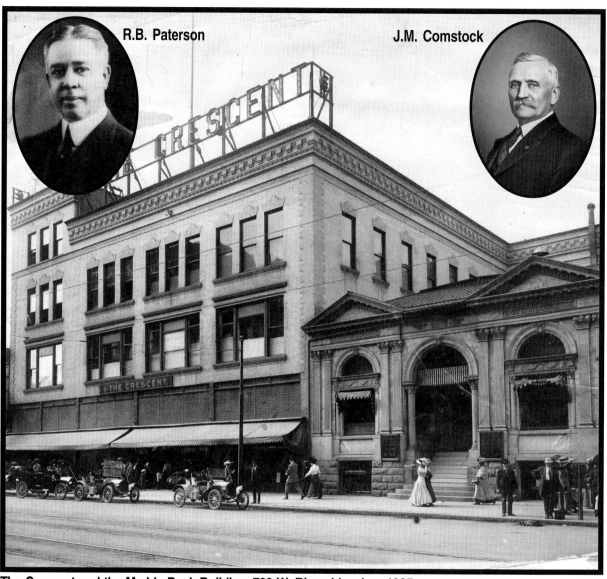

R.B. Paterson

J.M. Comstock

The Crescent and the Marble Bank Building, 700 W. Riverside, circa 1905. *(EWSHS, Libby photo, L85-79.181)*

The Crescent Store was scheduled to open for its first day of business on August 5, 1889. On the eve of August 3rd, James M. Comstock, a Civil War veteran who had attained the rank of captain, and Robert B. Paterson *(Insets-XWD & EWSHS)* stocked their rented space in the newly-erected three-story Crescent Block. The following day, most of the city's business section was destroyed by fire. The fire passed within two doors of the Crescent Block. The only surviving retail dry goods store in town, the new store's success was guaranteed. The Crescent Block, located on the south side of West Riverside next to the Review Building (see photo on page 225), conformed to the crescent-shaped curve in the street, giving rise to the name. The Crescent Store quickly outgrew its space and relocated the following year. Three moves later, the store settled into its own newly-constructed building (above) in 1899. As the Crescent grew and prospered, it built a big addition on Main and absorbed other buildings on the block, resulting in what is now the Crescent Court. One year short of a century in business, the Crescent Store was bought out by the Frederick and Nelson chain.

The Marble Bank (1892-1953), on the northwest corner of Riverside and Wall, was a marble-faced one- story building designed by architect Loren L. Rand for Anthony Cannon's Bank of Spokane Falls.

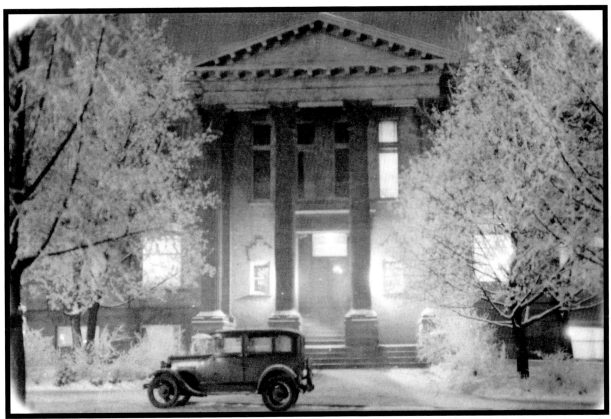

Spokane Public (Carnegie) Library, 1931. Andrew Carnegie donated funds in the early 1900s for libraries through-out the nation including this one. Preusse and Zittel were the architects. *(Photo courtesy Spokane Public Library.)*

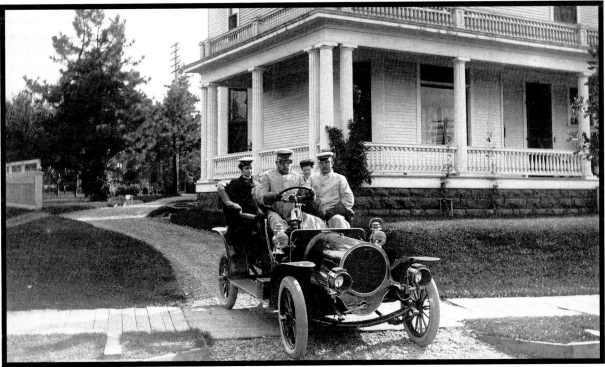

Arthur D. Jones, one of Spokane's early Realtors, driving his car from the driveway of his home at 1719 West Riverside Avenue in Browne's Addition, circa 1910. Note the caps on the women. *(Photo courtesy Jim & Milaine McGoldrick.)*

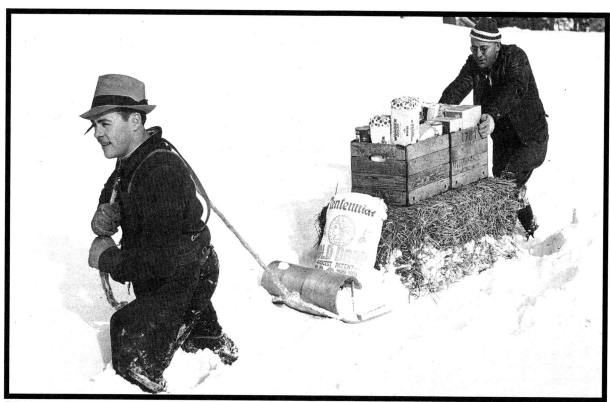

Bill Harrington, owner of Harrington's Mercantile in Lincoln Heights, and Sam Wood delivering groceries during the winter of 1936-37. Normal deliveries were made with a 1936 Dodge panel truck. *(Photo courtesy Bill Harrington Jr.)*

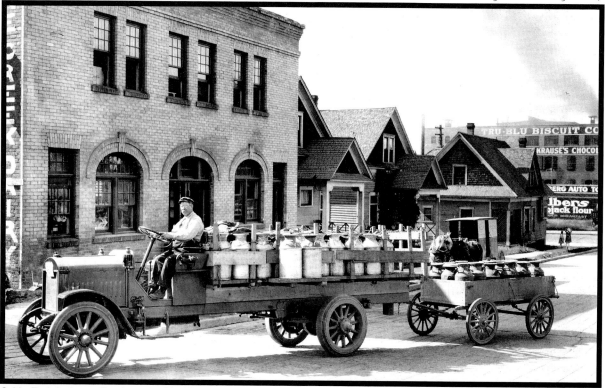

C.H. Reich from Spokane with his two-ton GMC truck and trailer used in hauling milk from Cheney to Spokane. This was taken in 1917 on Division Street near Sprague Avenue. *(Photo courtesy Thelma Shriner.)*

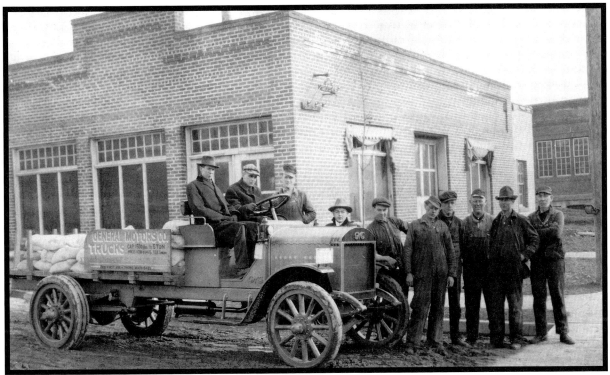

On March 16-17, 1917, the City of Spokane held a truck demonstration. The truck pictured above was the start of the demonstration. GMC won in every test over 12 different makes of trucks. The City naturally bought a GMC. Ten months later, the City figured the upkeep expense on the truck, which had been in service every day, amounted to $2.60. Three more trucks were immediately purchased. *(Photo courtesy of Thelma Shriner.)*

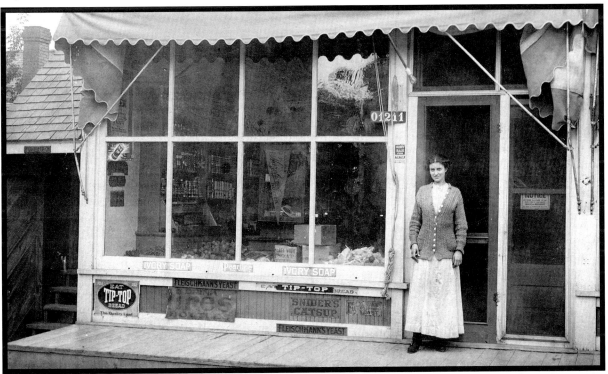

Theresa "Racy" Kulhanek (Estinson) in front of Anderson and Son's grocery store at 1211 N. Oak, circa 1911.

(Photo courtesy Sally Bigham Jackson, Racy Estinson's granddaughter.)

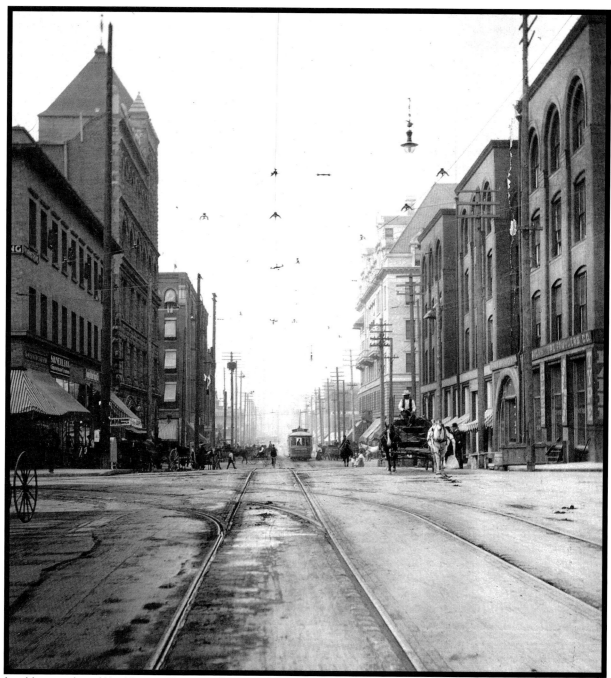

Looking north on Washington Street at Sprague Avenue in 1904. The rugged "wild west" town of Spokane was transformed as it rapidly arose from the ashes of the Great Fire. Many of the wooden-framed buildings were replaced by multi-storied brick structures, financed largely by the Dutch mortgage company Northwestern and Pacific Hypotheekbanks and wealth from the mines. The Armstrong Building (far left) is more commonly known as P.M. Jacoy's. Pete Jacoy opened his business at this location in 1903. The Granite Block (second left), built of large granite blocks, was demolished in 1928 to build the Paulsen Medical & Dental Building. The building with the awnings (center right) was the Spokane Club's headquarters, financed by F. Lewis Clark, when it opened in 1901. It later was known as the Chamber of Commerce building, the Metals building, and the American Legion. It is still standing, minus the top floor (which was removed after a fire), but is in a state of disrepair. Presently, a parking lot occupies the site of the buildings at the far right. *(Elsom photo courtesy Dean Ladd & Larry Elsom.)*

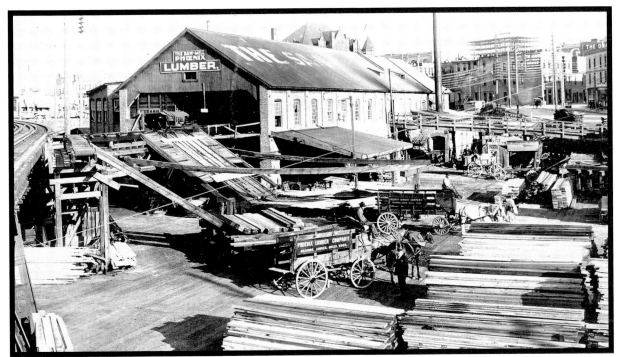

The Phoenix Sawmill was located at what is now Wall Street and Spokane Falls Blvd. There were eight separate sawmills at this site. The first owners were S.R. Scranton and J.J. Downing, operating from 1871 until James Glover bought them out in 1873. The Phoenix mill was the longest running, from 1898 to 1927. The last sawmill at this site was the Long Lake Lumber Company, 1927 to 1944. *(Photo courtesy of Jerome Peltier.)*

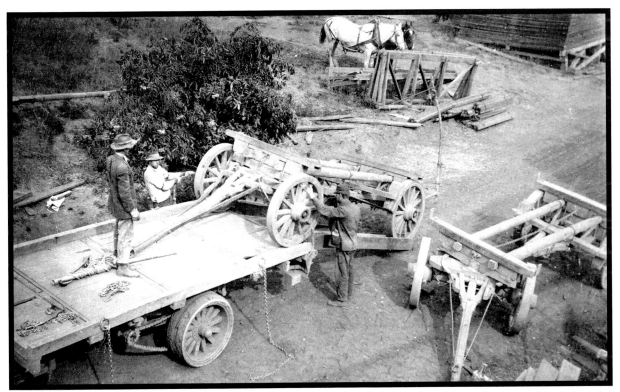

A flatbed truck and trailer used for hauling lumber. Following the delivery of lumber, trailers were loaded on the back of the truck to save wear. Note the hard rubber tires and chain drive. *(Photo courtesy Thelma Shriner.)*

Western Union Life Insurance Building (later the Sun Life Assurance Company Building, 1927-1966), at 1000 West Riverside, was designed by G.A. Pehrson in 1924. The original Western Union Life building at this site was designed by Cutter & Malmgren. In 1966 it became the Catholic Chancery. Barely visible below the roof line at the center are terra-cotta sculptures of Bacchus, the Greek god of wine. *(EWSHS, Libby photo, L94-10.209)*

The intersection of Howard and Riverside in downtown Spokane in the early 1920s. The Ziegler Building is in the foreground. The next large building to the right is the Sherwood Building. The tallest building in the background is the 15-story Old National Bank Building, built in 1910. For years it dominated Spokane as the city's tallest structure. The ONB was established in Spokane in 1890 as the Pacific Bank at College and Monroe. In 1892 it became the ONB. From 1895 until 1910, the ONB was in the Marble Bank Building (see page 192). Several interesting incidents have occurred at its premises. In 1892, when the bank was located on the southwest corner of Main and Howard, a gunfight took place over a gambling dispute. A man named Jack Delmore was shot. He fell into the Howard Street entrance of the bank and died. Another interesting incident occurred in August 1922. After obtaining permission from Mayor Fleming and the city council, Mink De Ronda, one of Spokane's early daredevils, parachuted off the top of the ONB Building. *(Photo courtesy of Jerome Peltier.)*

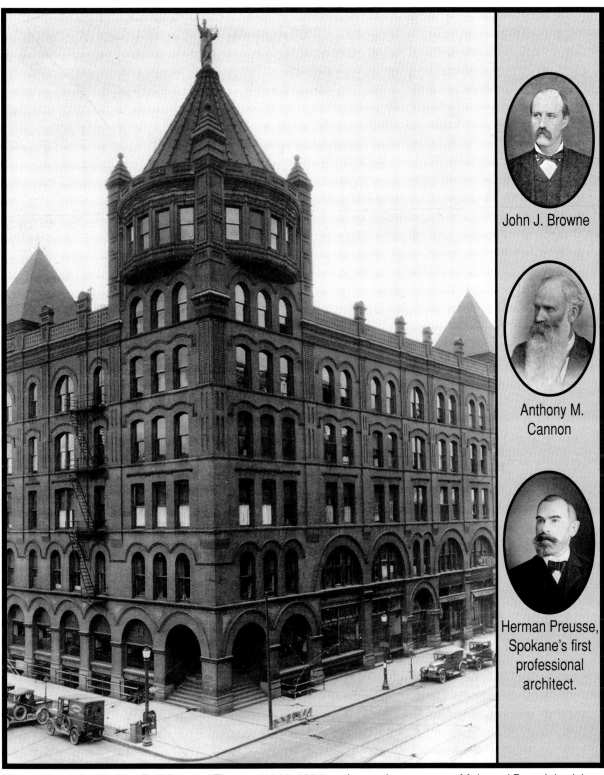

John J. Browne

Anthony M. Cannon

Herman Preusse, Spokane's first professional architect.

The red brick Auditorium Building and Theater, 1890-1934, at the northwest corner Main and Post. It had three balconies above the orchestra floor, a seating capacity of 1750 and the deepest stage in the world (intentionally built one foot deeper than the previous record holder in Chicago). During its era, all important functions were held here. The building was designed by Herman Preusse, and financed by owners A.M. Cannon and J.J. Browne. *(Photo courtesy Jerome Peltier; Insets of Browne and Cannon-"Spokane Falls and Its Exposition"; Inset of Preusse-NWD.)*

The Cutter-Corbin Photo Albums

Kirtland Cutter

D.C. Corbin

Among Spokane's most noteworthy men was Kirtland Kelsey Cutter, renowned architect and designer, whose fame began in the Northwest. Allegedly, his early architectural experience began as an employee for architect Herman Preusse in the early 1880s, although his formal training was as an artist rather than an architect.

Cutter's success and fame were largely through his social connections and artistic abilities. On October 5, 1892, he married Mary Corbin, a daughter of one of Spokane's wealthiest men, Daniel Chase Corbin. It was through his Uncle Horace Cutter, a Spokane banker, and an early friendship in Europe with Austin Corbin, that Kirtland found the opportunity and connections to design many of the homes for Spokane's wealthy. These same connections also led to his short-lived marriage to Mary Corbin.

During Cutter's era in Spokane, many industrial fortunes were made in and around the Inland Northwest. Consequently, there was a big demand to build expensive and showy homes. Spokane was the hub of this activity and, while this boom lasted, Cutter made a lasting mark in Spokane and far beyond. Even today "Kirtland Cutter" is one of the most recognizable names in Northwest architecture. There are numerous documents, records and memorabilia left from his legacy. A Cutter-designed home automatically commands more resale value.

Although much is known about Cutter's professional life, little is known of his personal life, especially the history and fate of his only child, whose birth name was Kirtland Corbin Cutter. In 1994 a local historian, Jean Oton, began a long and complicated search for more information. That search took her to 8621 Lookout Mountain Avenue, Los Angeles, California, the home of Corbin "Joe" Corbin Jr., the estranged grandson of Kirtland Cutter. At the time of Jean's contact with Joe Corbin, he was 68 years old and afflicted with cancer of the face. He had spent the majority of his life in California working in his swimming-pool maintenance business. During the following four years, a friendship developed. During that time Jean learned that Joe Corbin had met his grandfather several times, but was never informed who he was.

When Kirtland and Mary Cutter divorced, Mary raised their son. Her father, D.C., offered full financial support of his grandson provided his name be legally changed to Corbin Corbin. After graduating from the Naval Academy in Annapolis, Corbin Corbin worked as a banker in California and married Genevieve Willment, a silent movie actress. They had one son, Corbin Corbin Jr., who took the name Joe when he entered the navy. During the last four years of Joe Corbin's life, he learned more about his father's side of his family from Jean than he had from his own family. When he died on October 13, 1998, he left Jean three family photo albums and numerous memorabilia. The following photos are from those albums. Jean is planning to donate this collection to the Spokane Public Library's Northwest Room.

Jean Oton

The photograph on the left is Corbin (Cutter) Corbin Sr., son of Kirtland and Mary Cutter, born November 8, 1893 in Spokane. This photo was taken on October 25, 1918, while Corbin Corbin was attending the Annapolis Naval Academy. Corbin's future wife, Genevieve Willment (right), was born on February 1, 1895 in Delaware. This photo was taken for the Vogue Shopping Service on April 1, 1918. *(Photos courtesy Jean Oton.)*

Kirtland K. Cutter's grandson, Corbin "Joe" Corbin Jr., with his mother Genevieve (Willment) Corbin (right) and his grandmother Alice Willment (left). The inset is Joe Corbin as a baby. *(Photos courtesy of Jean Oton.)*

Corbin Corbin Sr. and Genevieve A. Willment, a silent movie actress, during their courting years (left), and shortly after their marriage in 1921 (right). They had been married 51 years at the time of Corbin's death on December 6, 1972. Genevieve died exactly two months later on February 6, 1973. *(Photo courtesy of Jean Oton.)*

The Spokane Club, on the northwest corner of Riverside and Monroe, circa 1940, before the addition of the athletic wing connected by a pedestrian bridge across Main Street. This Cutter-Malmgren design was completed in 1911. The first president of the Spokane Club, organized in 1890, was A.A. Newberry. It has also operated under the names "Spokane City Club" and "Spokane City and University Club." *(Photo courtesy Wallace Gamble.)*

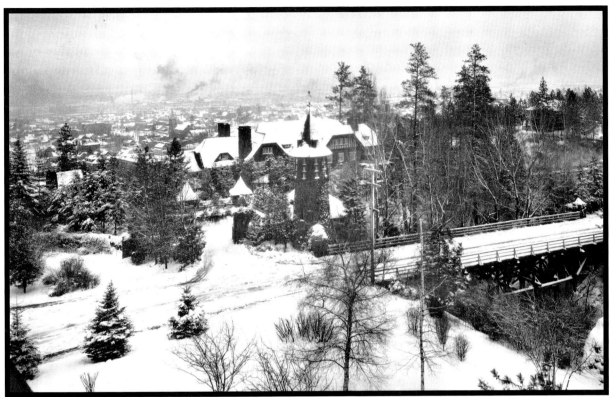

The Louis and Verus Davenport home in 1927. This Kirtland Cutter design built in 1908 at 34 West 8th was one of the most exclusive homes in Spokane. The landscape design was the work of the Olmsted Brothers, a famous landscape architectural firm from Brookline, Massachusetts. In the 1970s, the house was demolished to make way for an expansion of the Sacred Heart Medical Center. *(EWSHS, Libby photo, L94-10.30)*

Louis Davenport's son, Lewis, in his toy car at the entrance to his home on 8th. *(Photo EWSHS, L88-404.19.2.41)*

The Telephone Comes to Spokane

A SUPERINTENDENT OF CONSTRUCTION—1898

Thomas H. Elsom in his office at Spokane in 1898, when barbers did not do a rushing business.

This news clipping appeared in one of the early Spokane newspapers.

Thomas Elsom installed the first telephone set in Spokane in a grocery store owned by Walker L. Bean on the south side of Riverside at Howard in December 1886. Forty years later, he installed the first dial phone at that same location. Elsom arrive in Spokane Falls on November 11, 1886. He was hired by Charles B. Hopkins (founder of the first newspaper in the Inland Northwest at Colfax), who planned the use of the telephone for his newspaper. Hopkins was a pioneer developer of the telephone system in the Inland Northwest, who in 1884 began purchasing the military telegraph lines from Ft. Walla Walla to Ft. Missoula and Ft. Spokane.

Shortly after hiring Elsom, Hopkins sold the Spokane Falls lines to William S. Norman, who built Spokane's first exchange. Elsom began installing the first telephones and supervising the expansion of the early telephone system throughout the Inland Northwest. Norman's company was called Inland Telephone and Telegraph Company. Elsom retired on September 1, 1930, after 41 years of service with the telephone company. On December 15, 1953, Thomas Elsom passed away, leaving extensive documentation of these years of service, including over 1500 photographs, negatives and numerous diaries. In 1999 Elsom's grandsons, Dean Ladd and Larry Elsom, donated this entire collection to the Eastern Washington State Historical Society.

This illustrates how the early telephone workers installed telephone poles in 1899. About this time, Thomas Elsom designed an improved method for raising the poles. *(Elsom photo courtesy of Dean Ladd and Larry Elsom.)*

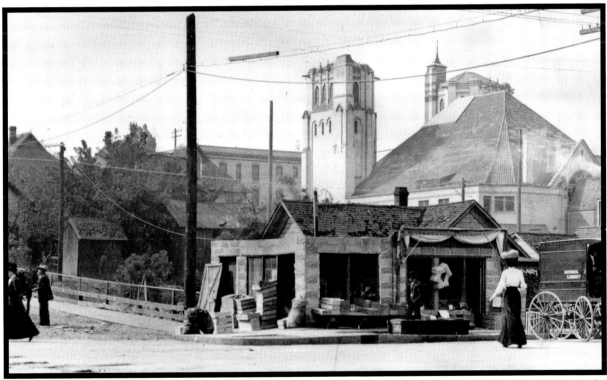

In 1910 the Pacific (formerly Inland) Telephone and Telegraph Company purchased this site at the southwest corner of Second and Stevens and began construction of an eight-story building, which became the Riverside exchange and the company's general offices. *(Elsom photo courtesy Dean Ladd and Larry Elsom.)*

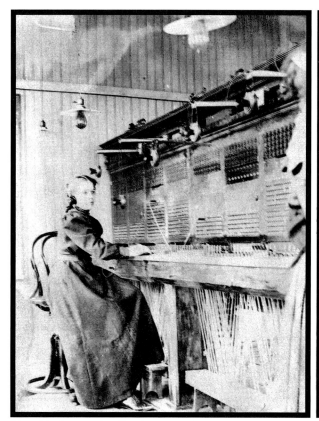

Mrs. Hodge at the Spokane exchange switchboard in 1899. Spokane's first exchange was established in the Hyde Block at Riverside and Wall in 1887. In 1892 the Inland Telephone & Telegraph Company built its own building on the west side of Wall south of Main. *(Elsom photos courtesy of Dean Ladd & Larry Elsom.)*

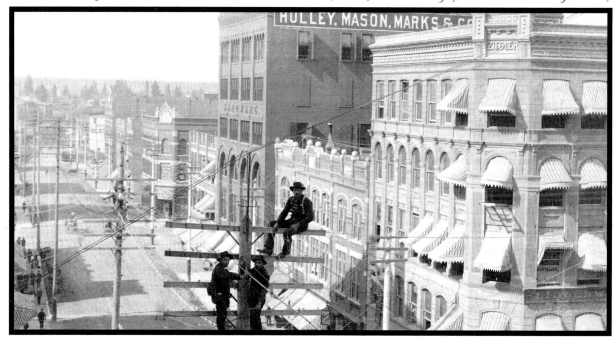

Elsom and workers on the phone lines, looking north on Howard at Riverside. The Ziegler Block (right) was built in 1889 and the Holley-Mason Building (center) in 1890. Holley-Mason moved farther south in 1906 and the building was converted into the Pantages Theater in 1908. *(Elsom photo courtesy Dean Ladd & Larry Elsom.)*

These photographs were from an album donated to the Northwest Room of the Spokane Public Library. None of the children were identified, but the photos represent some of the ways children in the early 1900s entertained themselves before television and electronics. *(Photos courtesy of Spokane Public Library Northwest Room.)*

The start of the gambling industry in this area . . . ?

In spite of early disadvantages, Carl Maxey acquired titles and awards too numerous to list. He began boxing in 1942 while attending Gonzaga University and won the NCAA light heavyweight boxing championship in 1948. He was the first Black to pass the bar exam in Eastern Washington and

**Carl Maxey,
1924-1997**

became the most recognized trial attorney in Spokane. He fought against injustice with great fervor, be it war, racism or poverty. He was a civil rights activist on a state and national level, and has been credited with single-handedly de-segregating much of the Inland Northwest. He sincerely tried to make the world a better place.

(Photo courtesy Wallace Hagin.)

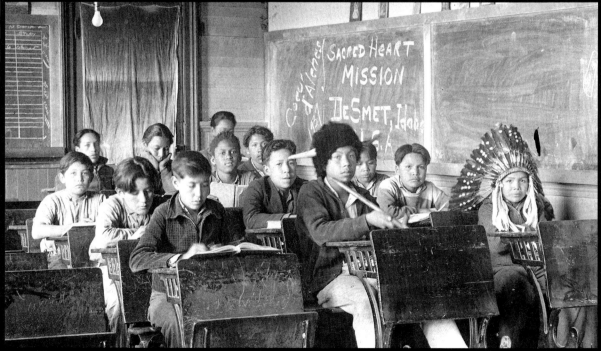

Top Left: Two unidentified boxers, circa 1900. *(Photo courtesy Spokane Public Library.)* **Bottom:** Fourth through eighth grade humanities class at the Jesuits' Sacred Heart Mission in De Smet, Idaho, circa 1935. Carl Maxey (center row, 3rd from front) was raised in orphanages and boarding schools. During the Depression, he was expelled from an orphanage and put in a juvenile detention facility strictly because of his race. The other known identities are: Herman Zachery (left row, 2nd), Bill Ignace (center row, 2nd) and (right row, front to back) Lawrence Aripa, Hank Aripa, unidentified, George Daniel and Luke Morrell. *(EWSHS, Edgar Dowd photo, L96-109.171)*

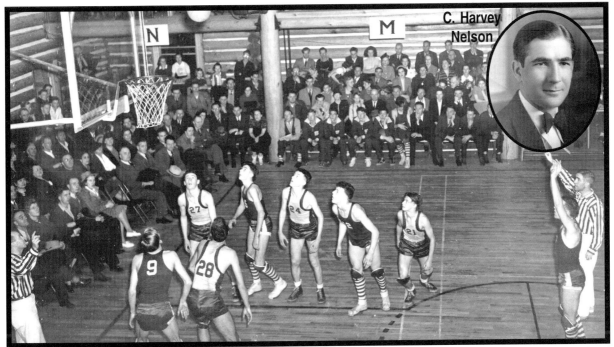

Until the Coliseum was built, sporting events were held at the Spokane Armory, the location for this high school game in the 1940s. C. Harvey Nelson (inset, circa 1930) was recruited to play for the Sparklers (below, far left) right after graduating from Lewis & Clark High School in 1926. He refereed on the local high school and college circuit. In the 1940s, he umpired for the Western International League and officiated at Spokane Indians' games.

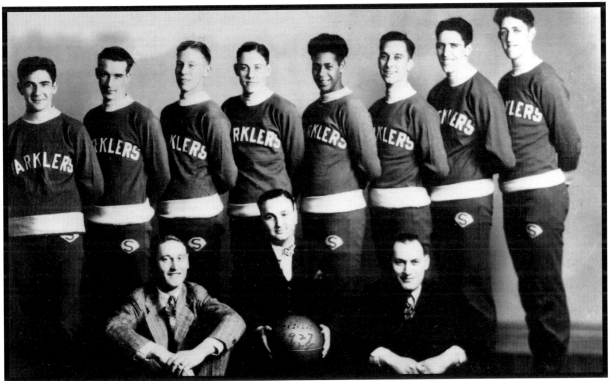

The Sparklers during the 1927-1928 season. They were a semipro team sponsored by Oscar Levitch, owner of Levitch Jewelers on Howard Street. During WWII, Oscar Levitch was known to have given servicemen wedding rings free of charge. *(Photos courtesy Dolores Cameron & Janet Matthews, daughters of C. Harvey Nelson.)*

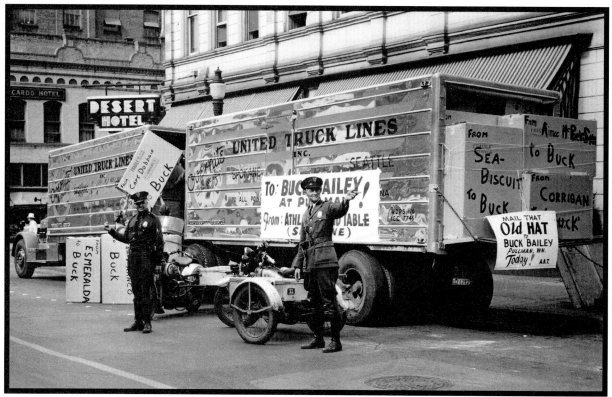

Spokane motorcycle police officers directing traffic around a United Truck Lines cargo drop of old hats being shipped to Buck Bailey, a coach at WSU, who liked hats, circa 1940. This was a prank being played on Bailey by the Athletic Round Table (ART), a group known for their humorous escapades as well as their good deeds for athletics. Officer Christian Luders is on the left; the other is unidentified. *(Photo courtesy Francis & Louise Carroll.)*

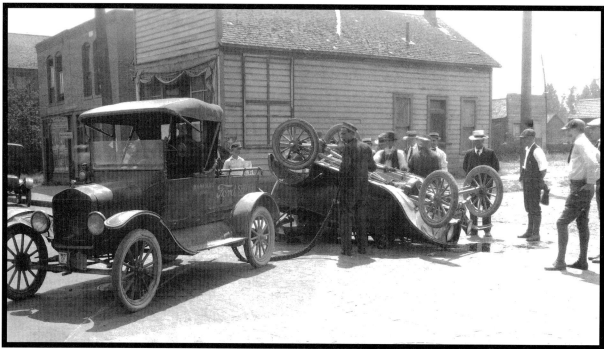

In the early days of the automobile, before tow-trucks, people had to be creative in dealing with wrecks. In this picture, everyone looks a little puzzled. The service truck is a circa 1919 Model-T. *(Photo EWSHS, L87-361.556)*

Spokane's Elegant Ambassadors

Marguerite Motie, the first Miss Spokane, served from 1912 to 1938.

(Photo courtesy Dorothy Marchi, niece of Marguerite (Motie) Shiel.)

As early as 1899, Spokane's leaders have turned to women to promote the city. The headlines in the local Spokane newspapers on October 3, 1899 touted the image of Miss Jean Goldie Amos as the "Goddess of Plenty" for Spokane's Industrial Exposition. From that point forward, Spokane has regularly placed women in positions as ambassadors for the city. These selections were honors to those being chosen and honors for a city accustomed to promoting itself.

An event in 1911 forever imprinted an image on Spokane's history: the Spokane Ad Club sponsored a contest to choose a symbol for the city. The initial competition solicited a drawing of an "ideal face and figure, with appropriate costumery to represent the metropolis of the Inland Empire." More than a hundred drawings were submitted. A sketch by Eleanor Gaddis was awarded first prize – a purse of $75.00 in gold coins. With this new

"ideal image," a second contest was held to select the first Miss Spokane. The rules for this contest required each contestant to submit a photograph of herself. Scores of young women submitted photos, most wearing braids. At the age of 17 years, Marguerite Motie was chosen to represent Spokane as its official greeter and representative. During the final judging of this contest, one of the main criteria was to demonstrate skills in public speaking. Marguerite was an excellent orator. In addition to her physical attractiveness, she was one of Spokane's South Central High School's most promising students, excelling in both academics and sports. She was a gracious city representative and set a high standard for future Miss Spokanes to emulate.

The costume Marguerite wore in her official capacity as Miss Spokane (previous page) was as depicted in Eleanor Gaddis's winning drawing. Marguerite's mother created a pattern and the costume was made of sheepskin by local furriers Bodeneck & Jacobs. Marguerite was featured in countless city promotional and publicity campaigns by the Chamber of Commerce and the Spokane Ad Club wearing this official Indian-dress costume. The costume was later donated to the Eastern Washington State Historical Society.

Marguerite Motie served as Miss Spokane for over 25 years. Even after she married her high school sweetheart Walter Shiel and moved to Seattle, she was regularly called back to participate in important functions for the city. During her lengthy reign, she came in contact with and endeared herself to more people than any other person in Spokane's history. To this day, she remains one of Spokane's most celebrated personalities.

Marguerite Motie and her seven sisters at their home at 614 W. 13th Avenue: (L to R) Vivian, Emily, Frances, Miriam, Ruth, Marguerite, Dorothy (Dodi) and Esther. *(Photo courtesy Dorothy Bayne Marchi, daughter of Emily.)*

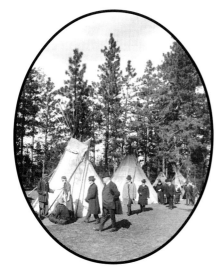

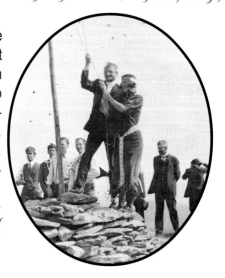

On the left, Marguerite Motie is shown with the Blackfeet Indian Tribe, who made her an honorary member. The photo on the right is from the dedication of Mt. Spokane in 1912. She is shown here with Gov. Marion Hay raising the American and Spokane city flags. *(Photos courtesy of Dorothy Capeloto, daughter of Walter and Marguerite (Motie) Shiel.)*

Catherine Betts (Williams), the second Miss Spokane, at age 20.

(Phelps photo courtesy Catherine (Betts) Williams.)

From 1912 to 1943, there were only two Miss Spokanes. Catherine Betts, granddaughter of pioneer fuel-oil businessman C.G. Betts, assumed the role from Marguerite (Motie) Shiel in 1939. Her costume (above) was created by some members of the Spokane and Coeur d'Alene Tribes. Among the highlights of her reign as Miss Spokane was accompanying New York's Governor Thomas Dewey, who was in town during his presidential campaign, to view Grand Coulee Dam. Henry Kaiser was their driver.

The Miss Spokane position was discontinued during WWII, but revived again in 1947 with the selection of Margel Peters who served until 1948 as the third Miss Spokane. Glenda Bergen, Miss Spokane IV, served from 1948 to 1951. Following Bergen's term, the position was limited to one year. In the 1940s, the Spokane Ad Club discontinued sponsoring the contest and the Spokane Chamber of Commerce assumed the role. During the late 1940s, two Miss Spokane contests ran simultaneously – one for the city and another for the county. The city's Miss Spokane wore the Native American costume while the county's wore a formal gown. The Chamber discontinued the city's Miss Spokane contest in 1977. The Miss Spokane contest continues today under the "Miss Spokane Scholarship Program." The following pages feature a random selection of other Miss Spokanes.

In 1949 Donagene Herr, an 18 year old senior from Rogers High School, was chosen Miss Spokane County by the Spokane Junior Chamber of Commerce. That same year, she was also crowned Queen of the Lilac Festival. She later entered the Miss Washington contest where she placed fourth, winning a scholarship to Whitworth College. During her years in Spokane, she won a number of other contests. Donagene grew up in the Lincoln Heights area of Spokane and later settled in Palm Springs, California. *(Photo courtesy Donagene (Herr) O'Dell.)*

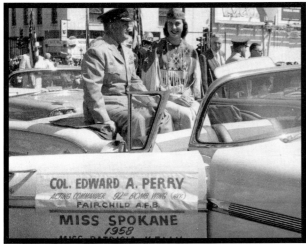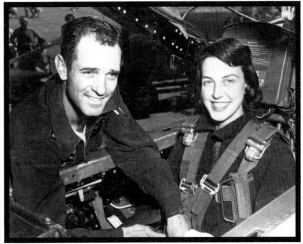

Left: Patsy Kelly (Eggers), Miss Spokane 1958, in the Lilac Parade with Col. Edward A. Perry from Fairchild Air Force Base. **Right:** In a T-33 jet trainer preparing for a flight with 1st Lt. William R. Fillingham of Geiger Air Force Base during the Armed Forces Day open house. For more than 45 minutes, they flew over points including Grand Coulee Dam and Mount Spokane and for a short time she was allowed to control the plane.

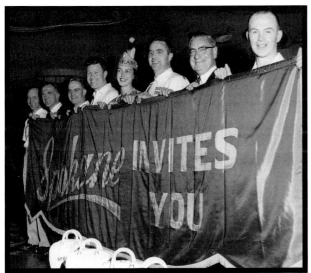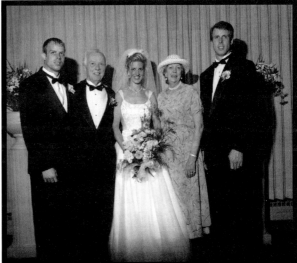

Left: One of many functions attended by Patsy Kelly as Miss Spokane. **Right:** The Eggers family at daughter Sarah's wedding in 1998 (L to R): Matthew, Arthur, Sarah, Patsy and David. *(Photos courtesy Patsy (Kelly) Eggers.)*

Patsy described her time as Miss Spokane as the honor in her life second only to her marriage and family. Her grandfather, Albert A. Kelly settled in Spokane in 1889, founding the Kelly Gardens on East Sprague. He was very active and civic minded, and served in the legislature in the early 1900s. Her father, Albert Kelly Jr., also served in the legislature during the 1930s.

In 1961 Patsy married Arthur Eggers and moved to Walla Walla where Art served as county prosecuting attorney for 25 years. She was active in the Junior Club and ran her own retail fresh-seafood market and gourmet restaurant. When her husband retired, they moved to Seattle and Patsy went to work as National Director of Marketing Services for Scanpan USA. She is now semiretired. They have three children: David is a corporate jet pilot and manages Aeroflight Executive Flight Services in Seattle, Sarah is a flight attendant with Continental Airlines, and Matthew is working towards his degree in physics in Seattle.

Left: Leilani "Lani" A. Wickline (Ellingsen), Miss Spokane 1970. During high school, Lani was a member of the Triple Trio (a singing group), a Girl's State Representative and a member of the National Honor Society. She is an accomplished singer and photographer. Note the change in the Indian dress from the original. This Miss Spokane program was discontinued in 1977. Top right: This photo was taken during the 1968 Lilac parade when Lani represented Rogers Highs School as its Lilac princess.

Left: Lani, as Miss Spokane, and Linda Wroe, Aqua Festival Queen from Austin, Texas, at the Lilac Festival parade in May 1970. Right: Lani, her husband Don Ellingsen, and their family in 1998. Lani and Don have three sons, one daughter and seven grandchildren. Don is a retired ophthalmologist. Both Don and his father Carl "Tuffy" Ellingsen are in the W.S.U. Athletic Hall of Fame. The Rogers High School field house was named in Tuffy's honor. Lani's namesake, niece Lani Elston, is following the family footsteps – as a Ferris H.S. sophomore, she has become one of the finest junior golfers in the Northwest. *(Photos courtesy Lani (Wickline) Ellingsen.)*

From Miss Spokane to Miss Washington

Anne S. Henderson (Anderson), Spokane County's 1958 Miss Spokane chosen by the Junior Chamber of Commerce. The above photos were taken when she won the Miss Washington contest and at age 5 (inset). Anne is the only Miss Spokane to ever win than honor. In 1958, as the first Miss Washington to compete in the Miss America contest, she placed 14th among contestants from throughout the Nation. Anita Bryant, Miss Oklahoma, was also a contestant, taking 3rd place. (Bryant is probably best remembered by her national television Florida orange juice commercials.) The 1959 winner of the Miss America contest was Mary Ann Mobley, of Brandon, Mississippi. *(Photo courtesy Anne (Henderson) Anderson.)*

Anne was born in Sacramento, California. At age six, she moved to Spokane with her parents Virginia and Bob Henderson, and brother Jim (who now resides in Mission Viejo, California). She started first grade at Finch Elementary, then completed her remaining education at Jefferson and Lewis and Clark High School. In her senior year at L.C., she was chosen Lilac princess. At this time, the Lilac Festival Court – Lilac queen and five princesses – were chosen and sponsored by the American Federation of Garden Clubs. While in high school, Anne developed a talent of pantomiming popular female recording stars. Being the first in the area to offer this type of entertainment, her performances were in demand throughout Spokane.

Anne enjoyed the innocence of growing up in the '50s. Her close-knit family encouraged her pursuits and aspirations. Even today, Anne lives only blocks from her youthful mother with whom she shares many of her daily activities. Anne has three children. Daughter Kristen Powell, a graduate from Gonzaga University, works in the financial field. Jeff graduated from the University of Washington and is in graduate studies at the University of Arizona. Steve is a graduate from Seattle University and is working in the computer science field. Anne has one grandchild, Kristen's daughter Anne "Annie" Elizabeth, who is her proud grandmother's namesake.

Following the Miss Washington contest, Anne gained national acclaim as one of the top models in the nation. The photo on the left was taken by *Life Magazine* during her years as the #1 rated model in San Francisco, Calif.

Four generations (L to R): Virginia (Mutch) Henderson, Anne (Henderson) Anderson, Kristen (Anderson) Powell and Annie Powell. In 1960 Anne was chosen as the National Wine Queen (right). *(Photos courtesy Anne Anderson.)*

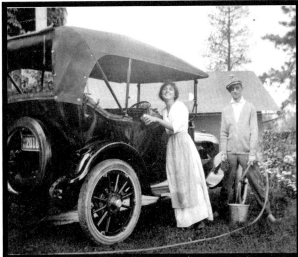

Left: Coronation of Miss Spokane, Jennifer Williams, in 1990. Jennifer was the first Miss Spokane following a 20 year lapse in the contest. From left to right are Jeff Anderson, Anne Anderson (Miss Spokane and Miss Washington in 1958), Steve Anderson, Jennifer Williams and Scott Bennett. The photograph was taken at the Queen's ball after the coronation. The three men provided the music for the occasion. *(Photo courtesy Anne Anderson. Steve and Jeff are her sons.)* **Right:** Marguerite Motie (Shiel), the first Miss Spokane, washing the family car with a friend, circa 1912. *(Photo courtesy Dorothy (Shiel) Capeloto, daughter of Marguerite (Motie) Shiel.)*

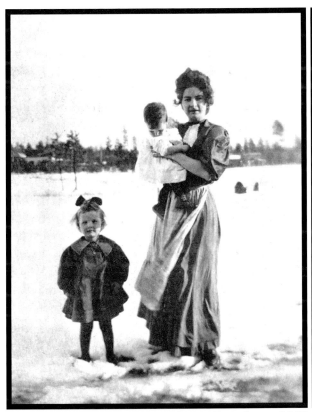

Left: Ada Mutch with her daughters, Dorothy and Milly, in front of their home at 4526 North Walnut in 1915. **Right:** The Mutch sisters, Virginia, Milly and Dorothy in 1933. Virginia's daughter, Anne Anderson, became the only Miss Washington from Spokane to ever win that honor. *(Photos courtesy Anne (Henderson) Anderson.)*

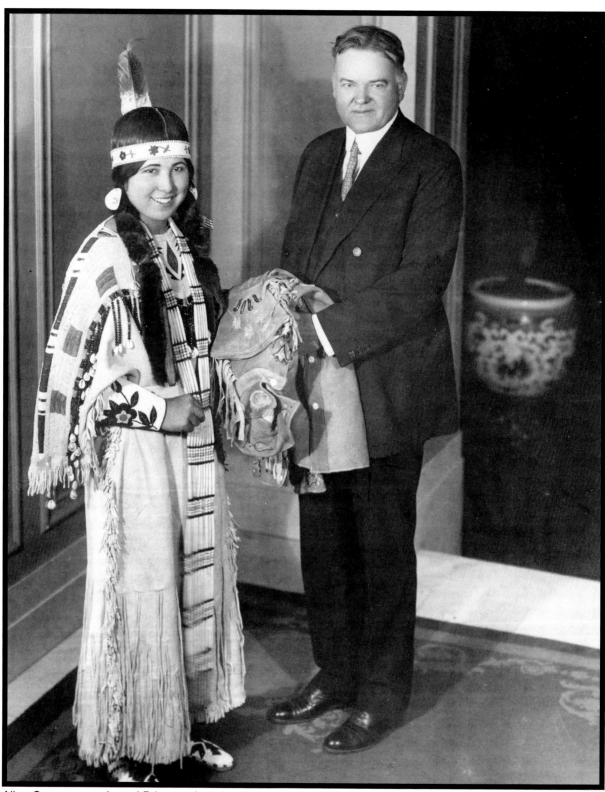

Alice Geary was selected Princess America during the 1925 Northwest Indian Congress, which represented 23 tribes. Although the early Miss Spokanes wore the costumes, none were Indian. Alice Geary, great-great-granddaughter of Chief Spokan Garry, was a true Indian "princess." During the 1926 Indian Congress, she presented Secretary of Commerce Herbert Hoover with an Indian hunting jacket. *(EWSHS, Libby photo, L93-68.10.92)*

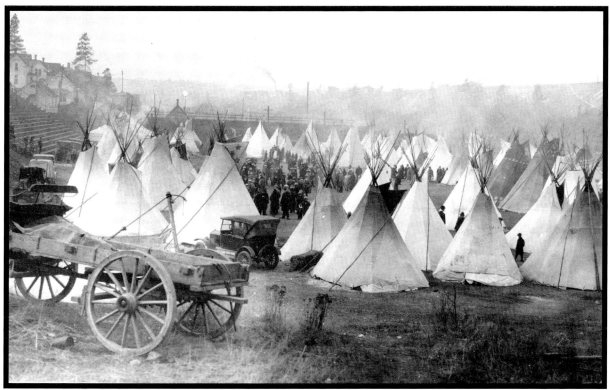

The first Northwest Indian Congress in Spokane, November 1925. This encampment was at Glover Field, the old fairgrounds in Peaceful Valley (see below). *(Photo courtesy Spokane Public Library Northwest Room.)*

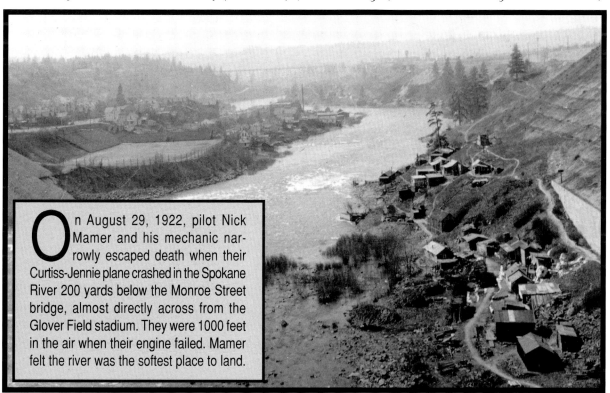

On August 29, 1922, pilot Nick Mamer and his mechanic narrowly escaped death when their Curtiss-Jennie plane crashed in the Spokane River 200 yards below the Monroe Street bridge, almost directly across from the Glover Field stadium. They were 1000 feet in the air when their engine failed. Mamer felt the river was the softest place to land.

Looking west from the Monroe Street bridge toward Peaceful Valley and Glover Field (left), circa 1930. The settlement to the right was known as Poverty Flats or Shantytown. *(Photo EWSHS, Magee Album, L83-131)*

Camping at Highbridge Park, on the upper banks of Hangman Creek, near the bottom of Sunset Hill in Spokane. When automobiles started becoming popular in the early 1910s to 1920s, designated automobile camping areas, such as this, began to spring up throughout the United States. *(Photo EWSHS, L83-113.96)*

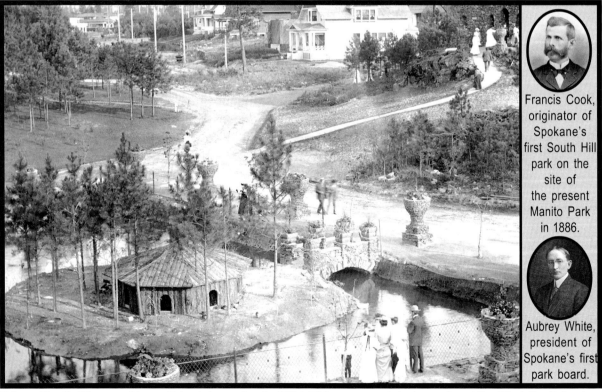

Francis Cook, originator of Spokane's first South Hill park on the site of the present Manito Park in 1886.

Aubrey White, president of Spokane's first park board.

Tekoa, Manito Place and Loop Drive intersection in 1904. This swan and duck pond and the "Owl Castle" aviary (upper right) were part of Manito Park's zoo. *(Photo EWSHS, Detail of L93-17.96; Insets-(top) Adi Song, (bottom) NWD.)*

222

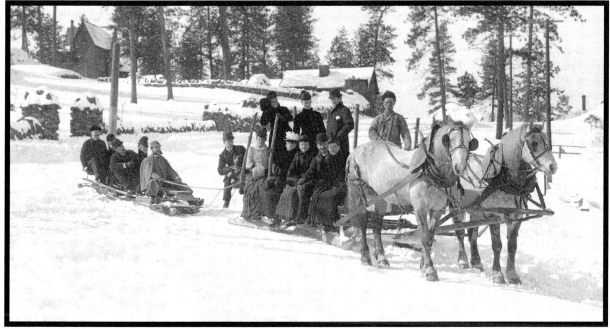

A winter sledding party on Seventh Avenue near Howard Street, circa 1888. The F. Lewis Clark gatehouse and home (a Kirtland Cutter design) are visible in the background. *(Maxwell photo courtesy Spokane Public Library.)*

John Fahey in front of his home at 2004 East 16th, posing in a goat cart owned by the photographer, in 1923. Fahey is a retired professor from Eastern Washington University, a noted author of numerous books, and among the most respected historians in the state. *(Photo EWSHS, L93-1.81)*

Saturday Evening Post delivery boys in 1920.
(EWSHS, Libby Studio photo, L94-9.235)

Profile of an Early Spokane Street Kid

Ben Miller moved to Spokane from Portland, Oregon, with his parents in 1916. Before moving, he sold newspapers on the streets of downtown Portland while ducking the truant officers because "you had to be 10 years old to sell newspapers." Ben's first job in Spokane was selling the *Spokane Press*. Within a short time, he was assigned to Main and Washington, Spokane's busiest corner, where he averaged sales of 300 newspapers a day.

Following his stint with the *Spokane Press,* Ben began working for the City Messenger Service. This was a small company which employed young boys to make deliveries by bicycle within the downtown area. The boys balanced their deliveries on their heads, dampening the tops of their caps to prevent slippage. Spokane was (in Ben's words) "a wide-open city" and many of the deliveries were to the "red-light" districts. Typical deliveries were trays of food from various downtown restaurants and, during Prohibition, bootleg liquor. One of Ben's most memorable deliveries was to a Vaudeville group performing at the Pantages Theater. They were staying at a downtown hotel with a flight of 40 stairs. When Ben arrived, they were amazed he had bicycled across town with their entire order balanced on his head. At their request, Ben descended the stairs with the order on his head, mounted his bicycle and gave them a demonstration. For his performance, the hat was passed and Ben received one of his largest tips while in that business.

Ben covered his college expenses at Washington State College by working the streets of Spokane. He became a pharmacist and eventually went into business with Ray Felt. The partnership of Miller and Felt owned two pharmacies in Spokane and lasted nearly 27 years. Ben served terms as president of the Temple Emmanuel and B'nai B'rith, a Jewish men's fraternal organization. In his later years, he did philanthropic work in the community and served as captain of the United Fund (forerunner of United Way).

Ben E. Miller in 1917.

(Photo courtesy Ron Miller, son of Ben Miller.)

Crowds at Riverside and Monroe for the Lincoln Statue Dedication at Main and Monroe, on Armistice Day, November 11, 1930. In the foreground is the statue of Ensign John R. Monaghan, who was killed in 1899 during military action in Samoa. The Review Building (center) has been Spokane's newspaper mecca since 1891. W.H. Cowles (inset), mainstay of Spokane's news industry, was the publisher of the Spokesman Review for over 50 years. *(EWSHS, Libby photo, L87.1-44009.30; Inset courtesy Jerome Peltier.)*

O n April 24, 1912, an angry Russian immigrant, Charles Aleck, stormed up to the second floor of the Review Building and into the editorial rooms of the *Spokane Chronicle*. He demanded to see the editor, Edward Rothrock. Aleck confronted Rothrock with, "You're the editor?" As Rothrock nodded, Aleck backed toward the hallway door with Rothrock following. Seconds later, Aleck fired two shots. Rothrock was mortally wounded and died within minutes.

It was learned Charles Aleck had been in the United States for only four years and was working as a logger at Bovill and Potlatch, Idaho. According to newspaper accounts, Aleck related he had been the object of harassment from fellow lumberjacks, who accused him of "unnatural practices." They joked that a story had been published in the *Spokane Chronicle* as big as the articles concerning the sinking of the *Titanic*. The workers had goaded him at every opportunity, until he was unable to tolerate their torments. He boarded a train for Spokane and checked into the Rochester Hotel. Later in the evening, he went to the *Chronicle* office to request a retraction of the story. He was told to write out his complaint and come back later. The following morning, after spending some time in the saloon at the hotel, he purchased a hand gun and proceeded to the *Chronicle* office.

The incident which sparked the murder of Edward Rothrock was the sinking of the *Titanic,* which claimed over 1500 lives on April 15, 1912. The magnitude of this headline, which coincided with false information and jesting directed at Charles Aleck, sparked his intense anger leading up to the shooting.

Ironically, Spokane's **South Monroe Street** was impacted twice by this disaster:

Edward Rothrock's address at the time of his murder was **1112 South Monroe.**

An employee of Fairmount Cemetery, John H. Chapman, took a leave of absence, returning to England to marry his childhood sweetheart. Upon traveling back to Spokane with his new bride, Elizabeth Chapman, aboard the *Titanic,* they both lost their lives. The body of John Chapman was recovered by the steamer *Mackay-Bennett.* The body of his wife was never found. Chapman's address was **609 1/2 South Monroe.**

Edward H. Rothrock

Members of the Durham family at Spirit Lake, Idaho, in 1927, (L to R): Nelson W. Durham; Nelson's daughter Mable (Durham) Sanders; Data (Rothrock) Durham, Nelson's wife and sister of Edward Rothrock (whom Nelson married after the death of his first wife); Nelson's son Wayne Durham and his wife Sue (Hanger) Durham. Nelson Durham was a former editor of the *Spokesman Review* and author of some of the finest Spokane history ever written, the three-volume set, *Spokane and the Inland Empire,* published in 1912.

(Photos courtesy Spokane Public Library Northwest Room.)

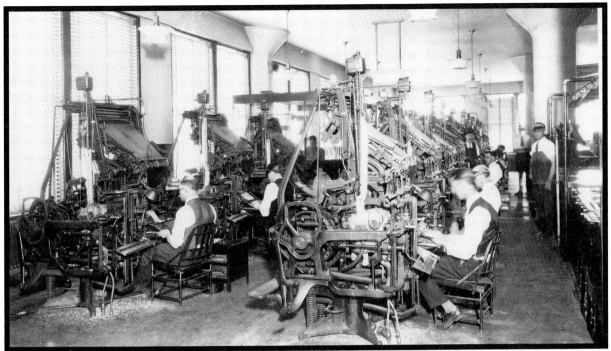

Linotype room at the *Spokesman Review*, circa 1920.
(EWSHS, T.W. Tolman photo, L86-219.550)

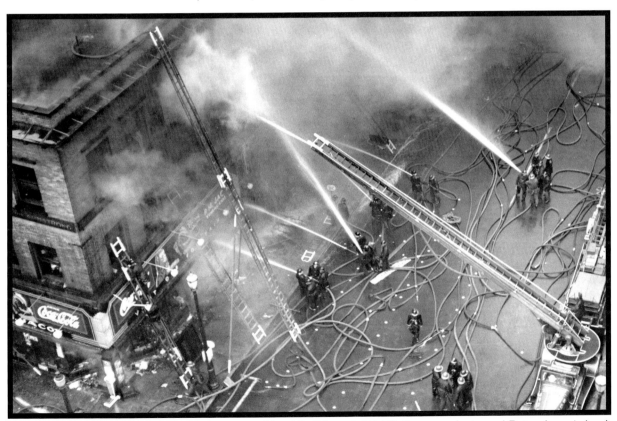

On November 8, 1939, a fire in the Armstrong Hotel Building at 402 W. Sprague destroyed Peter Jacoy's business, closed the hotel and injured five firemen. The *Spokesman Review* paid Spokane cab driver Wallace Gamble $3.50 for this front-page photo taken from the roof of the Hutton Building. *(Photo courtesy Wallace Gamble.)*

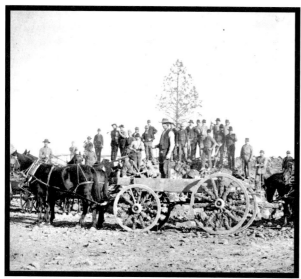

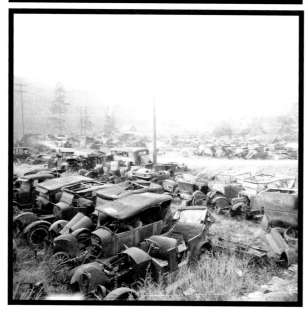

A montage of transportation related photos in the Spokane area. Upper left is the road grading crew for the Northern Pacific Railroad near First Avenue and Bernard, before the arrival of the first train in 1881. Upper right is a promotional shot for the new Overland Sedan taken in Peaceful Valley in 1920. Middle left is a U.S. horse mail cart in 1926. Middle right shows a 1929 streetcar-automobile accident at 14th Avenue and Grand Boulevard (in some shots of this accident, St. John's Cathedral is visible in the background). This was one of the first local photos of a car accident taken specifically for an insurance company. Lower left is an auto wrecking yard in 1931. *(Top left photo courtesy Jerome Peltier. The other four are EWSHS Libby Studio photos, in the order described above: L96-1.45, L87.1-10546.26, L87.1-39178.29 and L87-1.248.31)*

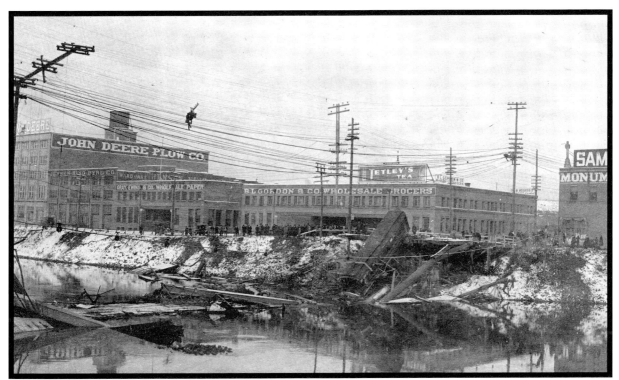

The Division Street bridge collapsed on December 18, 1915, killing five people and injuring others. Efficient means to cross the Spokane River were a pivotal factor in the city's development, but numerous lives were lost in the process. The first bridge in the city was constructed in the early 1880s. It consisted of three separate spans across the three river channels; the first span was at Howard Street. *(Elsom photo courtesy Dean Ladd & Larry Elsom.)*

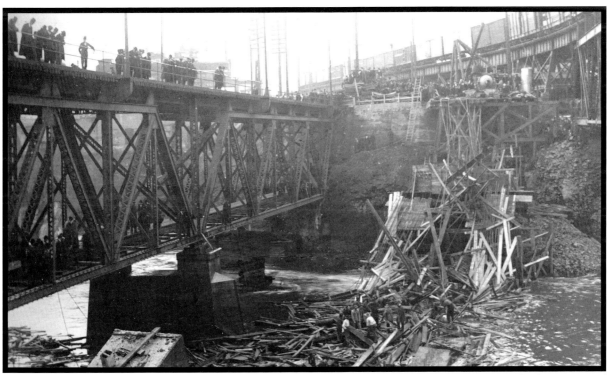

The unfinished Post Street bridge collapsed on February 6, 1917, plunging the work crew into the icy waters of the Spokane River. Three were killed and many injured in this accident. *(Photo courtesy Dean Ladd & Larry Elsom.)*

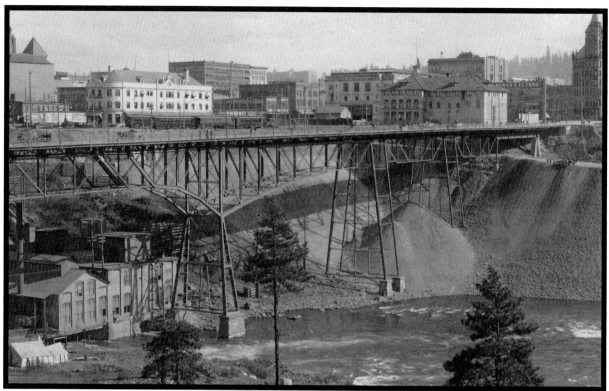

The second Monroe Street bridge, looking southeast, circa 1907. The first bridge, built in 1888, was wood construction, the second (1891) steel and the existing one (1911) concrete. *(Photo EWSHS, Magee Album, L83-131)*

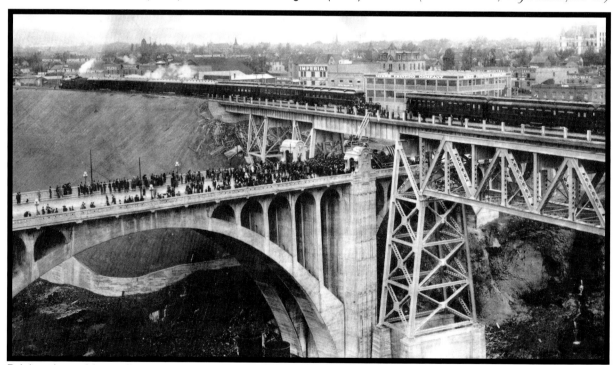

Driving-the-golden-spike ceremony on September 15, 1914 celebrating the completion of the Oregon-Washington Railroad & Navigation Co. bridge over the Monroe Street bridge and Milwaukee Railroad's entry into Spokane. Milwaukee signed a 99-year contract to use the steel trestle. The trestle was subsequently demolished during the preparations for Expo '74. The view is looking to the northwest. *(Photo courtesy Jerome Peltier.)*

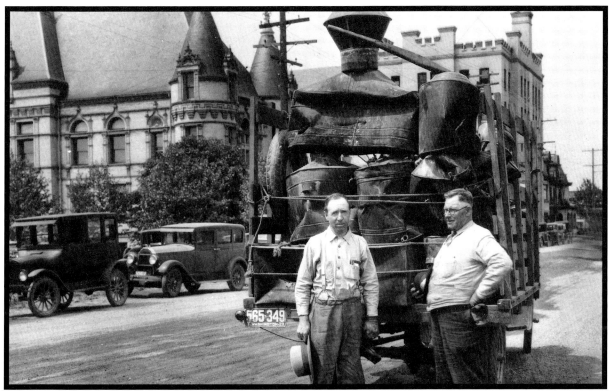

This still, loaded on the back of a truck in front of the Spokane County Courthouse, was confiscated during Prohibition. The photograph was taken on June 7, 1929. *(EWSHS, Libby photo, L87.1-39508-29)*

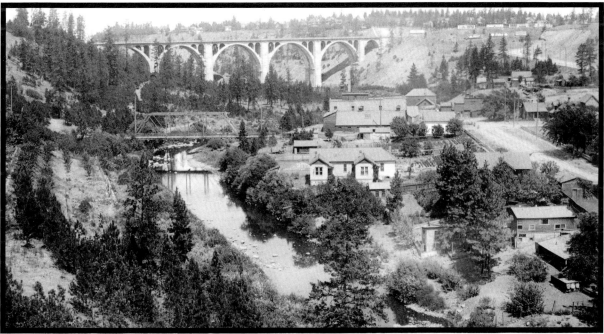

Hangman Creek as it flows past Vinegar Flats, located about one-half mile south of the junction of the creek and the Spokane River. The Keller-Lorenz Vinegar Works, founded in 1890, was located at 11th and Spruce for nearly 70 years, giving the area its name. The plant covered 1.5 acres and, before increasing the storage capacity over 50 percent in 1912, the Vinegar Works already had the largest capacity in the United States. Its primary sources of apples were from Moran Prairie and the Spokane Valley. *(Photo EWSHS, Magee Album, L83-133)*

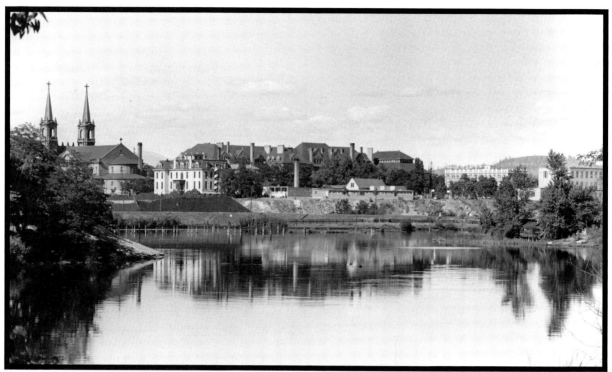

Gonzaga University, founded by the Jesuits, looking north from the south bank of the Spokane River, circa 1940. Although criticized for selecting Spokane, not Cheney, for his proposed school, Father Joseph Cataldo purchased the land in 1881. Construction commenced and the college opened in 1887. *(Photo courtesy Wallace Gamble.)*

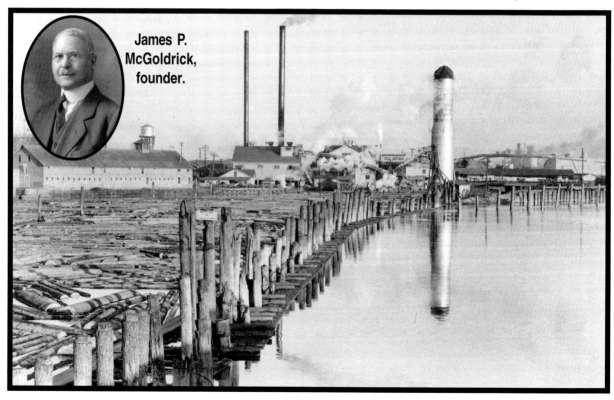

James P. McGoldrick, founder.

McGoldrick Sawmill on the north bank of the Spokane River at the southern end of Gonzaga University. It was operated from 1904 until the mid-1940s, and was one of the city's major employers. *(Photo Spokane Public Library. Inset-NWD.)*

State Patrol motorcycle officers at the Spokane Air Meet Derby in 1928.
(Photo EWSHS, L95-97.14)

Singer-actor Bing Crosby and his brother Edward J. Crosby at the Davenport Hotel, circa 1940. In 1906, at age three, Harry L. "Bing" Crosby moved to Spokane. A childhood friend nicknamed him after a comic-strip character they both enjoyed. Crosby attended Gonzaga High School and, for a few years, studied law at Gonzaga University, which named a couple buildings in his honor. Working backstage at the Auditorium Theater ignited ~ interest in the entertainment business. He headed for Hollywood in 1925, where he made a lasting mark. On October 14, 1977, he died on a golf course while enjoying his passion for golf. *(EWSHS, Forde photo, L93-66.89)*

The Spokane Interstate Fair in 1915, held at the Playfair grounds, located at North Altamont and East Main. Note the Indian camp to the right. During the 1930s and 1940s, the fair was not held consistently. In 1947 a permanent site (the present fairgrounds) was purchased and the fair was revived in 1951. *(Photo EWSHS, L93-17.102)*

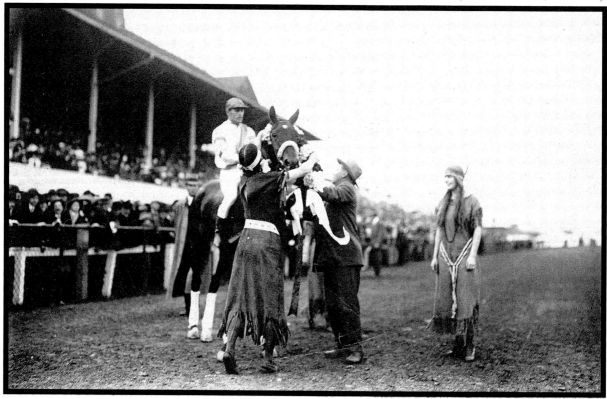

Miss Spokane, Marguerite Motie, and her court at Playfair Racetrack, circa 1912. *(Photo courtesy Dorothy Capeloto.)*

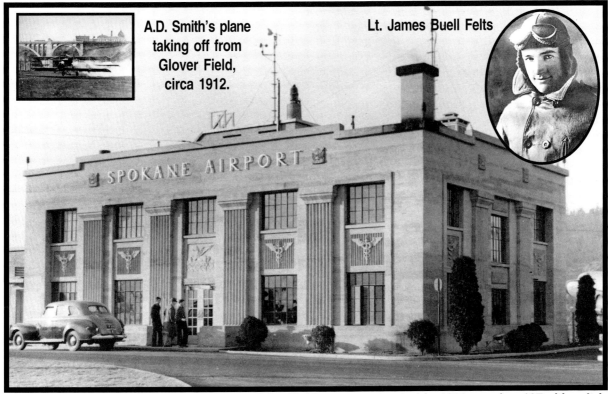

A.D. Smith's plane taking off from Glover Field, circa 1912.

Lt. James Buell Felts

The Spokane Airport terminal building at Felts Field was constructed in 1932, serving 137 cities. It is now on the National Historic Register. *(Photos courtesy (l) Jerome Peltier, (center) Wallace Gamble & (r) Jim McGoldrick.)*

Aviation history in Spokane began in 1911. One of the first landing strips was Glover Field located west of the Monroe Street bridge along the south bank of the river (left inset). It was originally built by the city as an athletic field. The old Spokane Interstate Fairgrounds (now Playfair) was also used as a landing strip. The first airplane to enter Spokane, landing at this strip in 1911, was piloted by Cromwell Dixon Jr. (see next page). Around 1913 Parkwater Field was established along the Spokane River east of the city. An enlarged, improved airfield was later built at that site by the city. Following the death of Lt. James Buell Felts (right inset) on May 29, 1927, the name was changed to Felts Field. Felts, a prominent National Guard aviator and WWI pilot, and his passenger, E.E. Baker, were killed when the engine of his plane stalled approximately 150 feet over Parkwater Field. They crashed near the old Diamond Match mill. Before his death, Felts was the publisher of the *Spokane Valley Herald* and active in the community. He was a graduate of WSC (now WSU).

Felts Field became the original home of the Washington Air National Guard. The War Department chose Spokane over Seattle and Helena, Montana, because of Spokane's commanding position over a vast expanse of territory. In 1927 the inspector and technician for the Army Air Corps declared Spokane's airfield "the best in the world." This compliment was partially due to three months of field cleanup labor by the work gang from the county jail. In the 1930s and 1940s, Felts Field served as Spokane's municipal airport.

Today, the Spokane area is serviced by two civilian airports and one military base: Felts Field, Spokane International Airport, and Fairchild AFB. Spokane International Airport began as Sunset Airport. With WWII looming, it became a military base and was renamed Geiger Field in 1941 in honor of Major Harold Geiger. In 1942 the War Department selected Spokane over Seattle and Everett to build an army air base (later named Fairchild AFB in November 1950) because it felt Spokane had better weather conditions and a safer inland location.

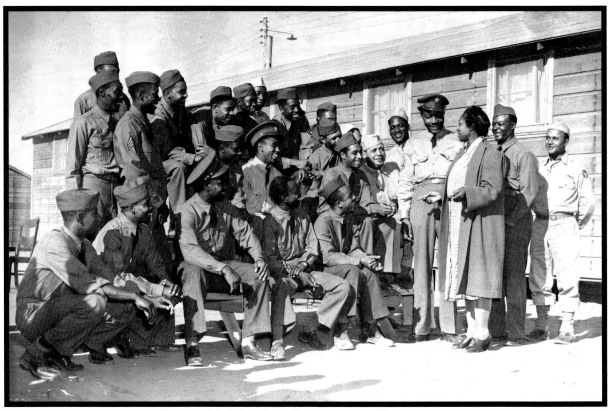

The 32nd Aviation Squadron at Geiger Field in 1942.

(EWSHS, Libby photo, L96-1.10)

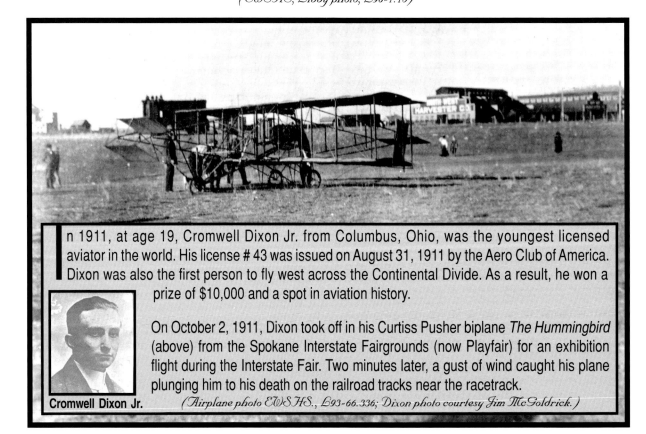

In 1911, at age 19, Cromwell Dixon Jr. from Columbus, Ohio, was the youngest licensed aviator in the world. His license # 43 was issued on August 31, 1911 by the Aero Club of America. Dixon was also the first person to fly west across the Continental Divide. As a result, he won a prize of $10,000 and a spot in aviation history.

On October 2, 1911, Dixon took off in his Curtiss Pusher biplane *The Hummingbird* (above) from the Spokane Interstate Fairgrounds (now Playfair) for an exhibition flight during the Interstate Fair. Two minutes later, a gust of wind caught his plane plunging him to his death on the railroad tracks near the racetrack.

Cromwell Dixon Jr.

(Airplane photo EWSHS., L93-66.336; Dixon photo courtesy Jim McGoldrick.)

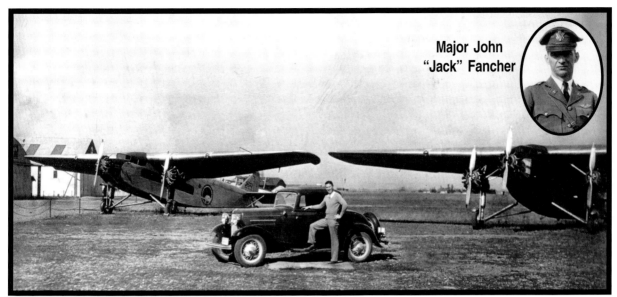

Major John
"Jack" Fancher

Felts Field (formerly Parkwater Field) in 1932. Nicholas B. "Nick" Mamer is standing beside his new 1932 Ford V-8 Coupe, just purchased from Phil Garnett, owner of Universal Auto Company. The Ford Trimotor aircraft in the background belonged to Mamer Air Transport (Nick's company). The inset is Major Jack Fancher, who was the first commanding officer of the Washington National Guard's 116th Observation Squadron (the third one to be organized in the United States). Fancher, who grew up in Espanola (near Medical Lake), was killed on April 28, 1928 by a defective bomb used in an air show at Wenatchee. From its inception, aviation in Spokane became one of the most popular vocations and pastimes in the Inland Northwest. Unfortunately, three of Spokane's most notable and talented pilots (Felts, Fancher and Mamer) died in airplane-related accidents. One of the most tragic early airplane accidents in Spokane killed four people on November 23, 1928. A Ford Trimotor plane, unable to locate Felts Field in heavy fog, attempted a forced landing on the South Hill, crashing in the area of 54th and Regal. *(EWSHS, Libby photo; Inset photos courtesy Jerome Peltier.)*

**Mamer and 1927 derby queen
Vera (McDonald) Cunningham**

On September 21-25, 1927, Spokane was honored to host the National Air Derby. One Derby originated in New York and another in San Francisco. Nick Mamer took third place in the Derby from N.Y. to Spokane. Two years later, he and copilot Art Walker set four world records during the 1929 Derby sponsored by the

**Nick Mamer's record setting
*Spokane Sun God***

National Air Derby Association. They flew nonstop from Spokane to San Francisco and New York and back to Spokane, the world's longest nonstop flight. It was also the first transcontinental refueling flight, the first night refueling flight, and the first aerial refueling conducted above 8000 feet. Mamer made this flight in the *Spokane Sun God*, a modified Buhl Airsedan provided by the Buhl Airplane Company specifically for this flight.

Another significant event in Spokane's aviation history was the visit on September 12, 1927 of world-famous Col. Charles Lindbergh in his *Spirit of St. Louis.* He was touring the United States to promote an interest in commercial aviation. Schools were closed so the children could also witness his landing and participate in some of the festivities, which included a parade, speeches and a banquet at the Davenport Hotel.

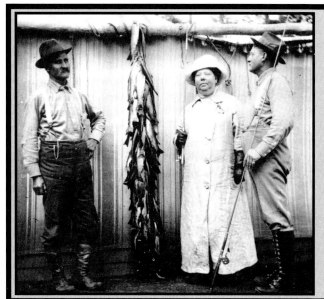

(L to R): Stephen Hutton, May Arkwright Hutton and Levi W. "Al" Hutton. Al and May Hutton made their fortune in the Hercules Mine above Burke in Shoshone County, Idaho. They were hard working individuals with a desire to make the world a better place. May was a leader in the women's suffrage movement campaigning for women's rights, the first woman delegate to a National Democratic Convention, and one of the original inductees into the Washington State Hall of Fame. After May's years of laboring in mining camps, running boarding houses and cooking for the miners, Al wanted to make a better life for her. He built her a beautiful home on East 17th, but, sadly, May's health failed and she died within a year.

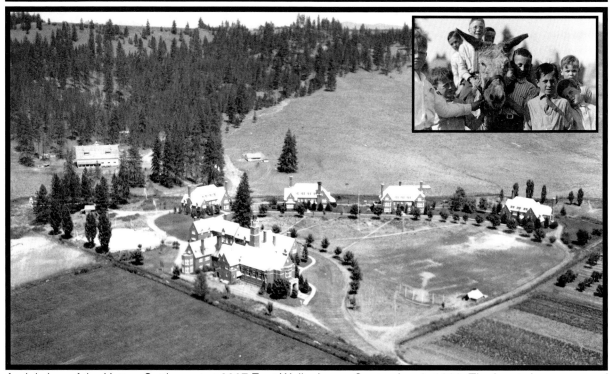

Aerial view of the Hutton Settlement at 9907 East Wellesley on September 8, 1933. The inset shows some of the children at the Hutton Settlement in the 1920s. Raised as orphans and having no children of their own, the Huttons dreamed of building a place where orphaned brothers and sisters would not have to be separated. Before their dream was realized, May passed away on October 6, 1915. Al proceeded with their plans, sparing no expense or detail to create a warm homelike setting on a 320-acre farm. It opened in 1920. It was unique in its day because the children were housed in cottages with house parents rather than in one large institution. The Settlement was the recipient of the Hutton's estate. Al and May never forgot their humble beginnings and the mark they left is a tribute to the difference wealth can make in the hands of the generous. The Hutton's legacy lives on in the hundreds of lives who have been touched by finding a home at the Hutton Settlement.

(Photos EWSHS, (top) L88-327, (bottom) Leo's Studio, L96-72.13, (inset) Frank Guilbert.)

Antoine Plante's cabin in the Spokane Valley on May 25, 1923. Erected in the 1850s, it was the meeting place of Governor Stevens and Spokan Garry (he spelled his name without an e on the end) on December 3 - 6, 1855. During this meeting, the decision was made by the Spokane Tribe to remain at peace with the Whites. Plante, a former fur trader, was part Indian and married to an Indian woman. He built a cable ferry across the river near his home, raised a garden and planted the first fruit trees in the Valley. The Mullan Road crossed the Spokane River at Plante's ferry, which also served as a supply point for passing travelers. The discovery of gold at Wild Horse Creek in British Columbia and Helena, Montana, made this the principal river crossing for people in the Inland Northwest. Plante vacated this site in 1872 when he settled on Jocko Creek to the west of Missoula, where he died in 1890. *(Photo courtesy Spokane Public Library Northwest Room.)*

The Dalles near Antoine Plante's old ferry crossing on the Spokane River at Myrtle Point.

(Photo EWSHS, Magee Album, L83-131)

Diners at the Oval Oasis of the Harlem Club (originally the Pirate's Den) on East 6th in the Spokane Valley, circa 1934. Seated at the table to the right (L to R): Joe Kulhanek, Gus and Theresa Estinson. The Estinsons owned a mink farm nearby. The Harlem Club was one of Spokane's hottest night spots, offering excellent food and entertainment (jazz was the main attraction), from 1929 until it was destroyed by fire in 1951. It was owned and operated by the first black family in the Spokane Valley, Ernest J. and Myrtle "Theo" Brown, and their seven children. The entire family was involved in the business; E.J. and Theo ran the kitchen while the children waited tables and entertained with song and dance. The Browns introduced Spokane to barbecued spareribs. Traveling black celebrities, such as Louis Armstrong, Nat King Cole, Cab Calloway, Pearl Bailey and Sammy Davis Jr., were guests of the Harlem Club. *(Photo courtesy Sally Jackson, Estinson's granddaughter.)*

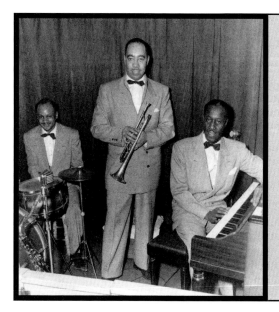

Wally Hagin Trio at Casa Bianca Club on Sprague Avenue in the Spokane Valley, circa 1980. "Bugs" Bradford is on the drums, Wally Hagin Jr. on trumpet and Lluvoyd Page on piano. Wallace H. "Wally" Hagin's passions are music and photography. He studied music at Gonzaga University under a full scholarship and for years has performed in dance bands, including engagements at the Harlem Club. Buck Campbell, a well-known local athlete, played alto sax in that band. Hagin has lived in Spokane most of his life and documented much of the black community's history since 1945 through photographic images (collection now owned by the Eastern Washington State Historical Society). Among his other accomplishments, he is a licensed mortician and the first licensed black pilot in Washington. *(Photo EWSHS, L97-56.255)*

Left: Wallace and Irene Hagin around the time of their move from Butte, Montana, to Spokane in 1918 to help their friend Rev. Emmett Reed reorganize the Calvary Baptist Church. Son Wally was three years old at the time. **Right:** Vernon Baker and Wally Hagin Jr., after Baker was belatedly given a Medal of Honor in 1997 for his outstanding courage and leadership during battle in WWII. His all-black division was one of the few to see combat. After risking his life, Baker's gallantry was belittled by superior officers determined to keep Blacks out of the spotlight. Baker was the only living black WWII veteran to receive this honor (six others received it posthumously). Both Baker and Hagin have experienced firsthand the sting and rejection from racial prejudice. Baker had to fight to join a segregated army in WWII and Hagin was denied entry into the Army Air Corps in 1941, being told the Army "had no room for Negroes." *(Photos courtesy Wallace Hagin Jr.)*

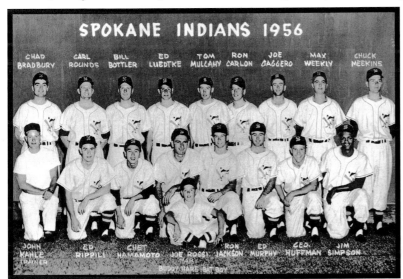

These pictures really do have something in common: the little girl on the right grew up to marry one of the Spokane Indian baseball players on the left and raise six children together. Ron and Sally (Bigham) Jackson have devoted most of their lives to sports and children. Ron played professional baseball for eight seasons, holding offensive and defensive records as a second baseman in the Northwest League, coached for Gonzaga University a couple years and American Legion teams in the Spokane Valley for 24 years. He is presently assistant coach to wife Sally for the Sunrise Elementary Midget team. Sally was the first woman baseball coach in Washington; founded the Spokane Valley Girls Softball Association; and has taught swimming lessons for 48 years. She has been a Guardian Ad Litem for 15 years and active in politics, serving as the chairman for the Democratic Central Committee for six years and as 4th Legislative District chairman. *(Photos courtesy Ron & Sally Jackson.)*

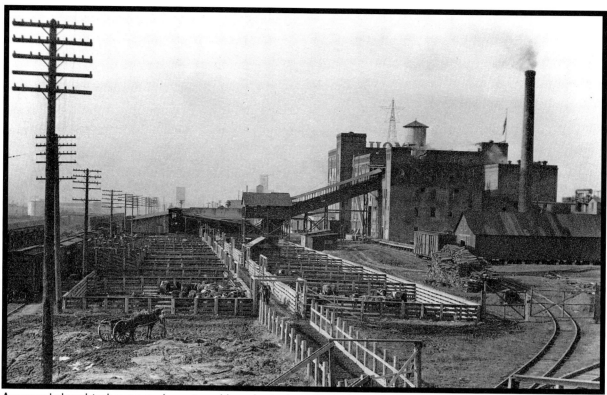

Armours' slaughterhouse and meat packing plant, circa 1940. Armours was established about 1910 at South Wall and Railroad. By 1923 they secured their site at 3306 East Trent Avenue. *(Photo courtesy Wallace Gamble.)*

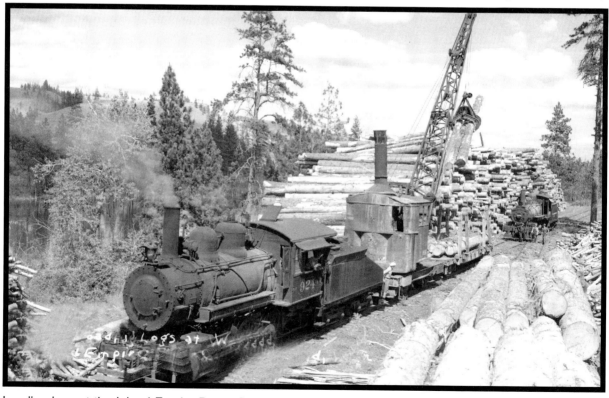

Loading logs at the Inland Empire Paper Company wood yard at Millwood, circa 1930. Jay P. Graves and William Cowles were among the initial investors in this paper mill. *(EWSHS, Leo's Studio photo, L83-152.162)*

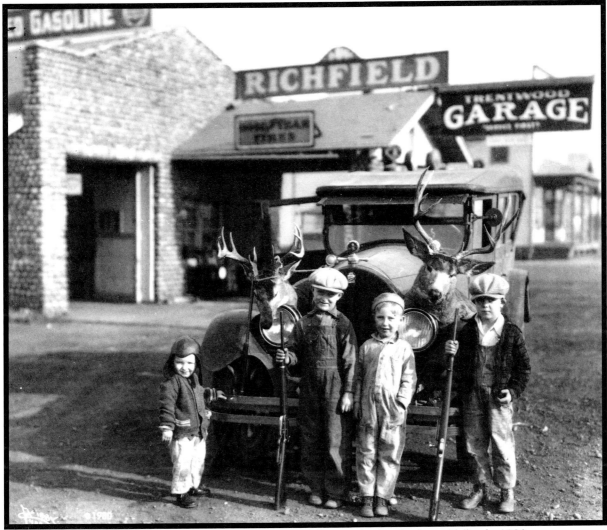

Hunting season in front of the Trentwood Garage in the Spokane Valley in 1929.
(EWSHS, Libby photo, L87-1.40949.29)

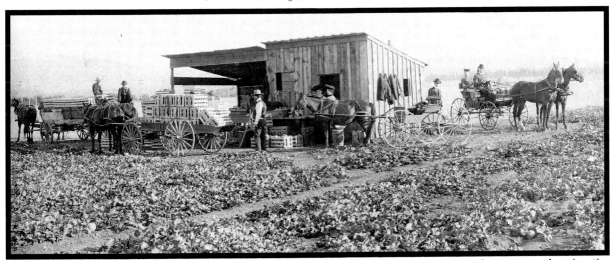

Riverside Avenue in Opportunity, circa 1900. About this time, local irrigation systems began transforming the barren plains of the Spokane Valley into rich, productive agricultural lands. *(Photo courtesy Patricia Smith Goetter.)*

Left: Looking south along Pines Road from Main Avenue at the town of Opportunity in 1908. **Right:** Looking south on Pines Road toward Broadway, circa 1908. The few scattered farms in the area had struggled to survive before irrigation became an option in the early 1900s. The irrigation system drew an influx of farmers, giving rise to such towns as Opportunity, Veradale, East Farms, Otis Orchards and Greenacres. In turn, the increasing population attracted the attention of public transportation entrepreneurs, especially J.P. Graves and his electric line, the Spokane and Inland Empire Railroad. Convenient transportation was accompanied by urban development, forever changing the scene above. Although towns developed throughout the Valley, the only one to incorporate was Millwood. To this day, community residents lobby for Valley incorporation.

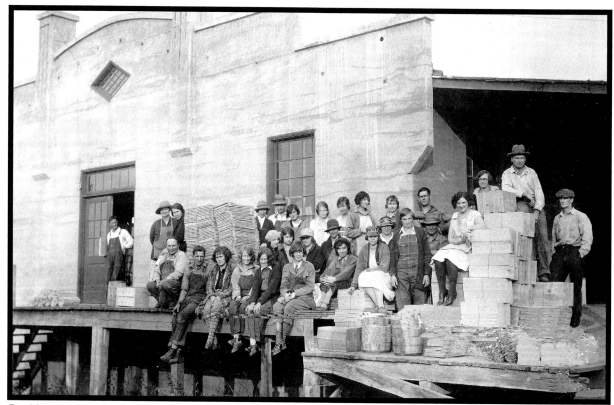

Packing crew at Spokane Growers Exchange Packing House in the Spokane Valley, October 16, 1929. After irrigation became available, apples were the principal crop from about 1910 until the early 1930s. Thousands of acres of apple trees drew sightseers during apple blossom time. This prompted the Spokane Valley to host an Apple Blossom Days Festival in 1921 and 1922. Prior to that, Spokane had an annual apple show with the festival's royalty, King Pip and his Court. *(All photos courtesy Patricia Smith Goetter. Pat's mother Dora (Brittain) Smith is pictured above, seventh from the left.)*

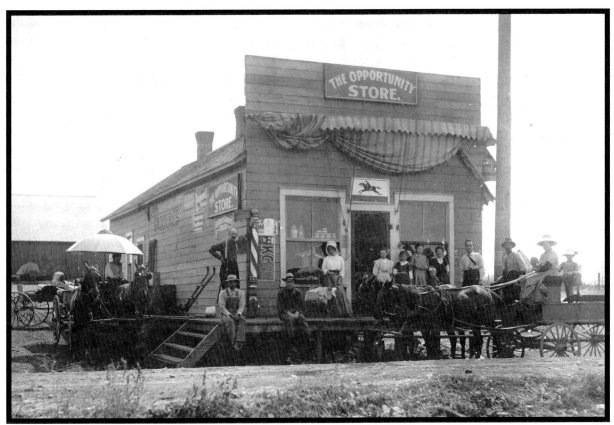

Opportunity Store on opening day in 1906 at the southwest corner of Appleway (now Sprague) and Pines, the hub of the town. The owners were John Janosky (left of utility pole) and John Allen (standing by the barber pole). A livery barn behind the store housed the horse and buggy used to deliver merchandise.

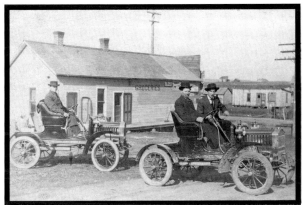

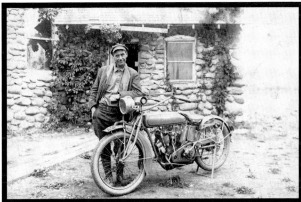

Left: The same store as above when automobiles started becoming popular, circa 1912. Eli Farr and his son-in-law, W.P. Myers, purchased the store in 1909. They soon demolished it and replaced it with a modern general store. Shelves of merchandise extended to the ceiling. The man on the left is believed to be Glen Downing, who operated the Washington Water Power substation across Pines Road from the store. **Right:** Roland T. Smith Sr. at the Vera Electric Water Co. District #1 pump house at 601 N. Evergreen, circa 1920. In 1908 Smith moved his family from Addy in Stevens County to work in a supervisory capacity for the Modern Irrigation and Land Company and the Vera Electric Water Company digging wells and laying pipelines. He also helped develop land around Opportunity and worked in the fruit industry. *(All photos courtesy Patricia Smith Goetter. R.T. Smith was Pat's grandfather.)*

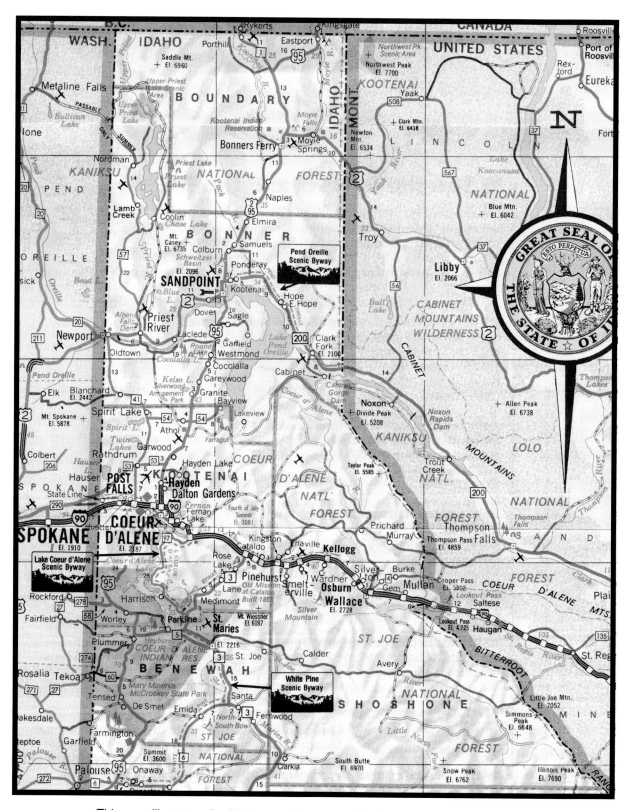

This map illustrates the Idaho counties covered in the following four chapters:
Boundary, Bonner, Shoshone and Kootenai.

Chapter 9

Boundary County

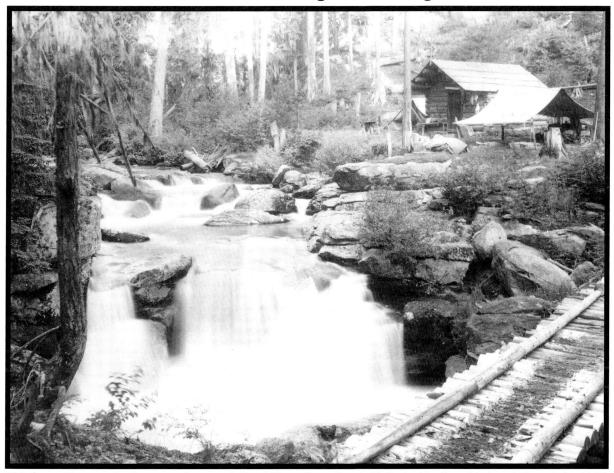

Dirt Oven Ranger Station, southwest of Porthill, at Cow Creek Falls in Kaniksu National Forest, in 1927.

(Magee photo courtesy Spokane Public Library Northwest Room.)

oundary County, Idaho's northernmost county, is situated within the Kaniksu National Forest. It is a scenic mountainous region bisected north and south by Highway 95. North of the Cabinet Mountain Range, which covers the southeastern quadrant of the county, the Kootenai River flows northwest from Montana into Idaho. At Bonners Ferry, the course changes to a more decidedly northern direction as it flows into British Columbia. The river is bounded on the west by the Selkirk Mountains and on the east by the Purcell Mountains. The county's tallest peak exceeds 7700 feet. Naturally, the timber industry has been Boundary County's economic backbone. The fertile Kootenai River Valley contributes a significant agricultural component to the economy. There has also been some mining activity.

The native people in this part of the country were the Kootenai Indians, whose ancestral lands covered northern Idaho, northern Montana and southeastern British Columbia. They lived mostly along the Kootenai River Valley. The village sites were chosen by the chief. When a chief died, the tribe would move to a new site

chosen by his successor. Their trademark sturgeon-nosed canoe provided efficient river transportation. They were also among the first northern tribes to have horses. (Note: Spellings vary from region to region. The Canadians favors *Kootenay*, the Idaho tribe and river is spelled *Kootenai* and the Montana tribe is *Kutenai.*)

The first documented non-native visit to this area was David Thompson's small party of explorers representing the North West Company. They set up a temporary camp near the present site of Bonners Ferry in the spring of 1808, during which time Thompson made the first known accurate maps and descriptions of this area (many of the place names he assigned have since changed). At that time, the future townsite of Bonners Ferry was the Kootenais' main village. The Kootenais already had traps when Thompson arrived, making it evident they had previous contact with trappers and traders (probably at the Rocky Mountain House on the Saskatchewan River in Alberta, Canada). The Hudson's Bay Company followed close on the heels of the North West Company, establishing a trading post, called Fort Flatbow, at the present town of Porthill.

According to Father Pierre Jean DeSmet's letters, his first visit to the Idaho Kootenais was in 1845. DeSmet highly praised this tribe for their kindness, hospitality and moral conduct. He found their honestly to be above reproach. So eager were they to follow the Jesuits' teachings, they constructed a little log church and faithfully attended to their new religion, even without the presence of a priest. Unfortunately, when the Indians were ceding their lands in exchange for reservations, the Idaho Kootenais essentially "slipped through the cracks." However, the government granted land allotments for the land on which they resided along the Kootenai River north of Bonners Ferry. These land allotments make up the nearly 4000-acre "reservation" as it exists today.

In 1863 gold was discovered on Wild Horse Creek in British Columbia. The route used by the early prospectors began at Walla Walla and proceeded through what is now Boundary County. The Wild Horse Trail, as it came to be known, crossed the Kootenai River at the present town of Bonners Ferry. The Kootenais ferried travelers across the river in their canoes. Four men from Walla Walla recognized an opportunity. After receiving permission from Chief Abraham of the Kootenai Tribe, they requested ferry rights from the Idaho Territorial Legislature, which were granted on December 22, 1864. This ferry was attached to a pulley and cable system that spanned the river near the present railroad bridge. It was named for one of the founders, E.L. Bonner. Although he was never a permanent resident, his name became one. About 1875 Richard Fry took over the ferry operation. His brother Martin soon joined him and together they ran the ferry, a trading post and post office near the ferry. Until 1884, the Fry brothers and their families were the only white people in present Boundary County.

In 1864 the extreme northern area of the Idaho Panhandle became one county – Kootenai. When it was established, Kootenai comprised what is now Boundary and Bonner Counties. The present Kootenai and Benewah Counties were soon annexed to the original Kootenai County. In 1907 Bonner County was formed from Kootenai and eight years later, in 1915, Boundary County was officially created when an act of the Legislature separated it from the northeast portion of Bonner County. Boundary County derived its name from its proximity to the British Columbia, Washington and Montana borders. Bonners Ferry became the county seat.

In the late 1800s, the Kootenai River provided the highway for commerce between Bonners Ferry and Nelson, British Columbia. Steamboats transported passengers and goods between the two locations on a regular basis. The first steamboat on the Kootenai was the *Midge*, which was launched at Bonners Ferry in July 1884. As with many river-frontage towns before dams were built, the town of Bonners Ferry flooded regularly during heavy snowpack years. Repeated attempts to curb the problem with the construction of dikes and drainage ditches failed. The completion of Libby Dam in Montana in the mid-1970s finally controlled the flooding problem.

With the arrival of the Great Northern Railroad in 1892, Bonners Ferry became a major shipping and supply point for Canadian mines. By 1899 the Great Northern's Kootenai Valley Railroad extended to Kootenay Lake in British Columbia, bringing an end to steamboat navigation along the river. In 1906 Daniel C. Corbin built the Spokane International Railroad. This line served the timber and farm industries, securing Spokane's position as hub of the Inland Northwest by linking Spokane, the Spokane Valley, Coeur d'Alene, Sandpoint, Bonners Ferry and points in between to the Canadian Pacific Railroad at Eastport in north Boundary County. It also made connections with the northern United States transcontinental railroad lines.

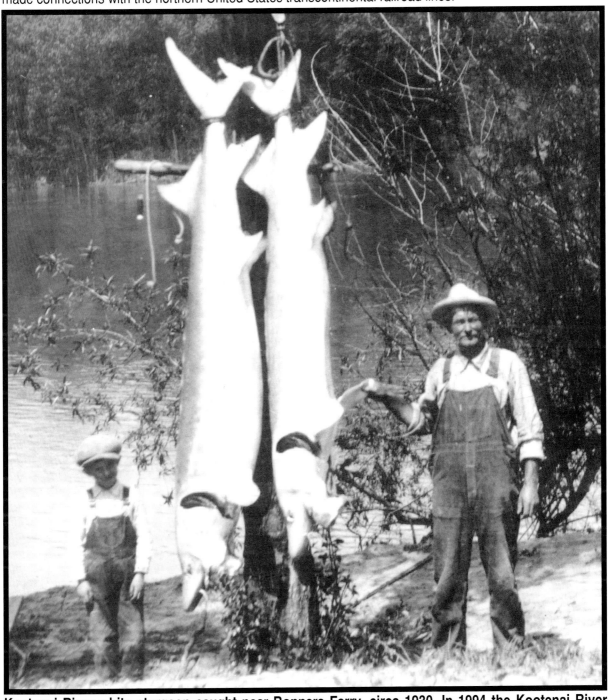

Kootenai River white sturgeon caught near Bonners Ferry, circa 1930. In 1994 the Kootenai River sturgeon were added to the endangered species list. *(Magee photo courtesy Spokane Public Library NW Room.)*

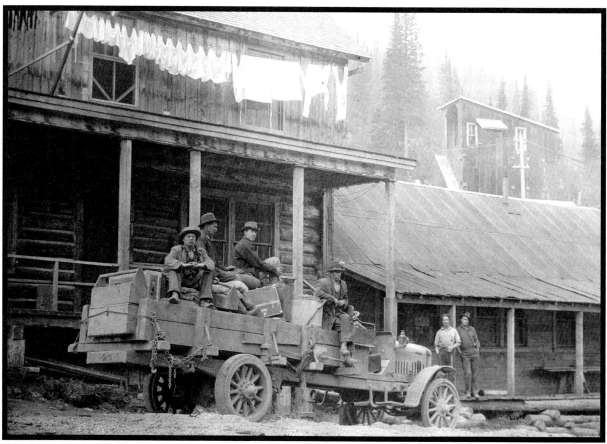

F.M. Maughan's two-ton truck at Porthill in 1917. This truck hauled silver-lead ore from the Continental Mines at the head of Boundary Creek. On this 26-mile trip, the average load was 6700 pounds. The largest single load weighed 10,117 pounds. The Continental was discovered around 1890 and operated into the 1980s. It was developed by Albert K. Klockmann, an astute German-born businessman. *(Photo courtesy Thelma Shriner.)*

The Porthill Ferry landing site on the Kootenai River in 1927. The cable tower is visible at the center of the photo and the ferry is pictured in the inset. Located at the United States-Canadian border, Porthill is one of two official ports of entry in Boundary County; the other is at Eastport. *(Magee photo courtesy Spokane Public Library.)*

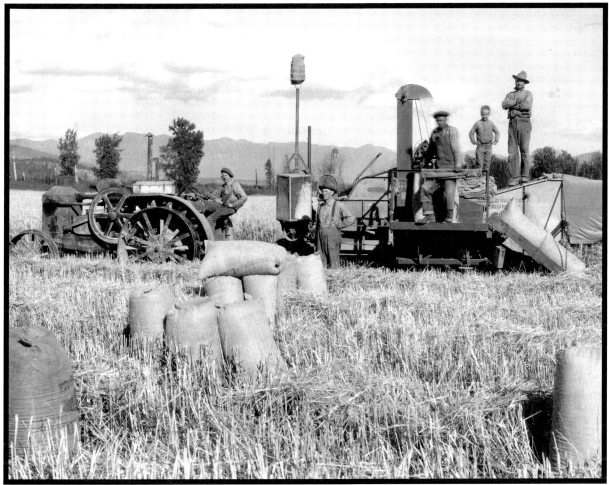

Harvesting and sacking wheat in the Kootenai Valley in the 1920s. The repeated flooding of the Kootenai River produced some of the most fertile soil in the state for growing wheat. *(Photo EWSHS, L84-286.72)*

Left: Kootenai Indian Village by St. Michael's Mission near Bonners Ferry. Although not protected by a reservation, land allotments preserved some of the ancestral lands in the Kootenai Valley where the small tribe of Idaho Kootenais resides. They have developed a fish hatchery to revive the sturgeon population, which suffered from low water conditions after the construction of Libby Dam. *(Photo courtesy Bonners Ferry Historical Society.)* Right: John S. Plato plowing his fields near Bonners Ferry. In 1900, at age 12, John came to Bonners Ferry from Iowa with his parents, Harry and Emma Plato, who homesteaded on the North Hill. *(Photo courtesy Wallace Gamble.)*

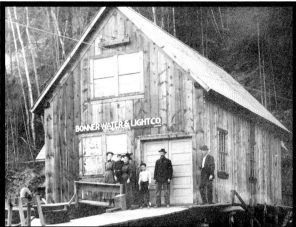

Left: Dr. E.E. Fry in front of his first office in Bonners Ferry on the horse he used to visit patients, circa 1903. His first hospital was established by the Spokane International Railroad during its construction. He built a new one in 1919, which eventually became the Community Restorium. Dr. Fry was very active in the community, even serving some terms as mayor as well as on the school board. *(Photo courtesy Bonners Ferry Historical Society.)* Right: Bonner Water and Light Company powerhouse on Myrtle Creek, west of Bonners Ferry, was the town's first hydroelectric plant. Construction of this plant, in operation by 1907, was supervised by Harrison (Harry) A. Gale (far right) and financed by Albert A. Featherstone. Harry's father Edward C. Gale is standing to the left of him. Edward's wife Ida is third from left. The Gale children are the others (left to right): Lura, Dewey and Clair. *(Photo courtesy Nancy Gale Compau, granddaughter of Harry and Harriet Gale.)*

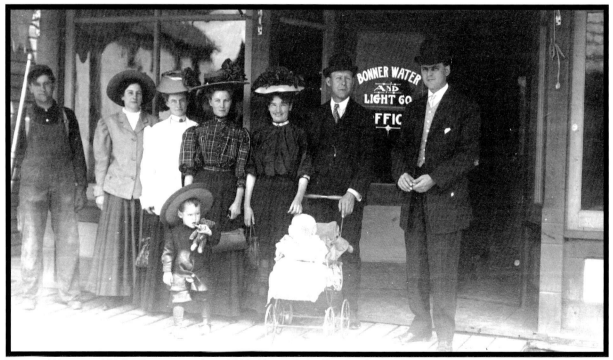

Bonner Water and Light Company, circa 1910. Harry Gale (far right) was the company's power plant supervisor. His wife, Harriet (Gray) Gale is in the center with son Clair. Their good friends, Belle and Bert Keaton and their baby, are between Harriet and Harry. The man on the far left (unidentified) was an employee. Rachel (Gray) Rosebaugh (second left), Harriet Gale's sister, was an observer for the Weather Bureau. For nearly two decades, she measured the river during flood season. The woman in white is unidentified. *(Photo courtesy Nancy Gale Compau.)*

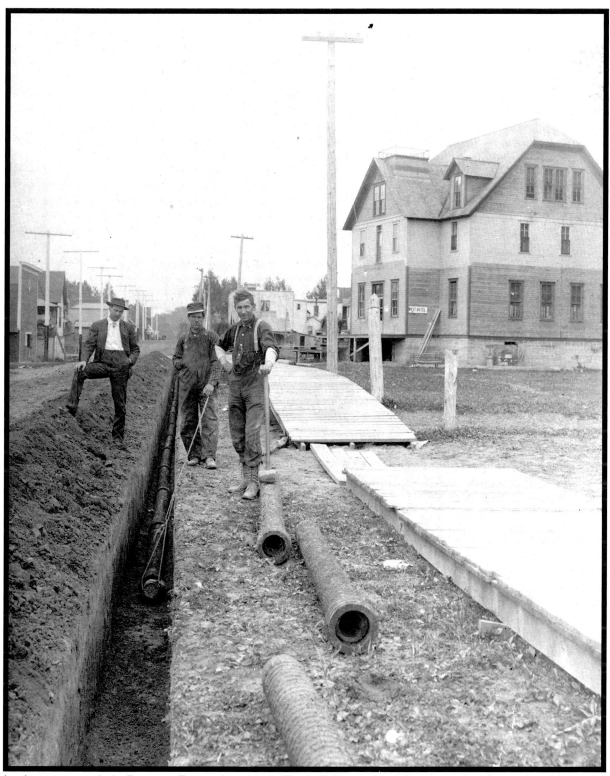

Laying water main in Bonners Ferry, circa 1907. The building at the right, situated at Second and Kootenai Streets, was built in the 1890s as a schoolhouse. A third story was later added and it became the West Hotel; the named was later changed to Idaho Hotel. When Boundary County was formed in 1915 and Bonners Ferry became the county seat, further remodeling converted the building into the county's first courthouse. It was torn down in 1939 after being replaced by the present courthouse. *(Photo courtesy Nancy Gale Compau.)*

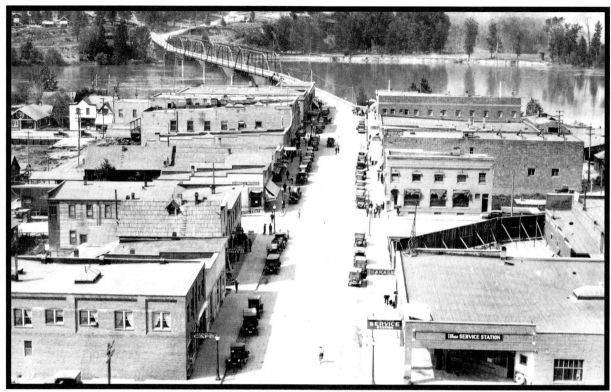

Looking north at Bonners Ferry and the Kootenai River, circa 1930. In 1905 the ferry was replaced with the first of four bridges. The bridge in this photo, built in 1910, was the second wooden bridge. It was replaced in 1933 by one of steel. The present concrete bridge was built in 1984. *(Magee photo courtesy Spokane Public Library.)*

Luciel and Gale Starmer (left) in Bonners Ferry in the late 1930s and (right) Camp Fire Girls on an outing in the early 1930s. The only known identification is Luciel Starmer (top row, 3rd from right). *(Photos courtesy Gale Starmer.)*

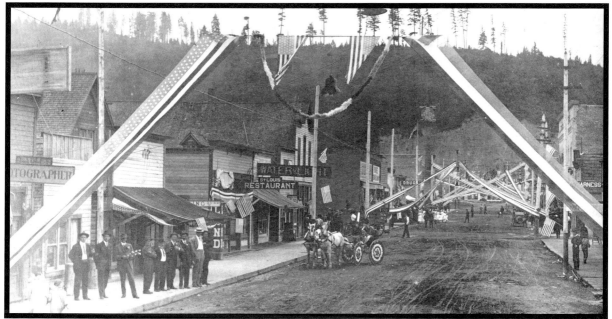

Fourth of July celebration in Bonners Ferry, circa 1900. When Richard and Martin Fry were operating the ferry and trading post in this area, a post office was established under the name Fry, with Richard Fry as postmaster. With the coming of the Great Northern Railroad, the community developed into two town sites – Bonner Port and Eatonville. They were later incorporated under the name Bonners Ferry. (*Photo courtesy Nancy Gale Compau.*)

Naples Store, built in the 1930s.

Naples junction, circa 1926. The little logging town of Naples is the southern gateway to Boundary County. The first store was built by Louis Popp to serve the railroad workers during the construction of the Great Northern in 1892. Naples gained notoriety during the deadly siege at Ruby Ridge in 1992 against white separatist Randy Weaver. (*Magee photo courtesy Spokane Public Library. Inset courtesy Bonners Ferry Historical Society.*)

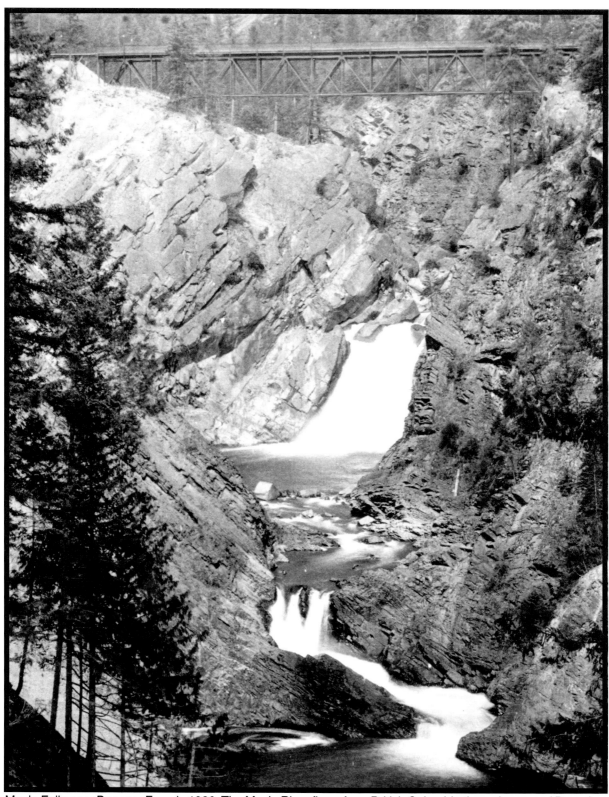

Moyie Falls near Bonners Ferry in 1926. The Moyie River flows from British Columbia through some of Boundary County's most scenic terrain. It enters the Kootenai River near the town of Moyie Springs. The first power plant on Moyie Falls, designed by H.H. Hughes, was built in the early 1920s. At the top of the photo is the old bridge along Highway 2 between Idaho and Montana. *(Magee photo courtesy Spokane Public Library Northwest Room.)*

Chapter 10

Bonner County

A cabin on the shore of Priest Lake in northern Idaho, circa 1910.

(EWSHS, Frank Palmer photo, L84-327.1046)

In February of 1907, an act by the Idaho Legislature, approved by Governor Frank R. Gooding, separated the northern half of Kootenai County into a new county. This new county was called Bonner, in honor of E. L. Bonner, who established the first ferry across the Kootenai River at the present site of Bonners Ferry. Sandpoint was established as the county seat. Eight years later Bonner County would itself be split when its northern portion would be formed into Boundary County.

Northern Idaho is endowed with resplendent scenery surrounding numerous lakes and waterways. Bonner County boasts two of the most beautiful and popular north Idaho lakes – Priest and Pend Oreille. The massive Lake Pend Oreille covers 148 square miles. The county is a recreational haven for the outdoors enthusiast.

Idaho and the Inland Northwest's first trading post, the Kullyspell House, was located about four and one-half miles from the present town of Hope on the shore of Lake Pend Oreille. This post was built in the fall of 1809 by David Thompson, a partner with the North West Company, which was absorbed by the Hudson's Bay Company in 1821. Kullyspell House consisted of two buildings, the first erected in Idaho by non-natives. One was a dwelling for Thompson's men and the other a storage building for the furs. The first commercial transaction in the Inland Northwest between Whites and Indians took place in one of these buildings: David Thompson bartered for more than 100 animal skins from the Indians. Kullyspell House was used as a trading post for only about a year and a half before it was abandoned for more favorable locations. During Thompson's travels through Idaho, he created the first reliable maps and written descriptions of what is now Bonner County.

In the 1840s, Father Pierre Jean DeSmet was a frequent visitor to the native Kalispel (Kullyspell) and Pend Oreille Indians (the latter are generally classified as Kalispels). The Kalispels were a nomadic tribe who inhabited the region of the Clark Fork and Pend Oreille rivers and Lake Pend Oreille. During his travels and missionary work in the Inland northwest, Father DeSmet created goodwill between the Indians and Whites, easing the way for settlement by non-native people. An excellent resource on the early development of the Inland Northwest is a four-volume set of books published in 1905 entitled *Father DeSmet's Life and Travels Among the North American Indians*.

In 1853 Congress appropriated funds for a survey to determine the most direct route west of the Rockies for the western link of a northern transcontinental railroad. Under the direction of Isaac I. Stevens, surveying parties crossed through the future Bonner County that year. Although this event began introducing outsiders to this area, the railroad was not built until almost three decades later, and few settlers arrived before the 1860s.

Several events occurring in rapid succession stimulated the first settlement in future Bonner County at Seneacquoteen. It was located on the south bank of the Pend Oreille River a few miles west of Lake Pend Oreille. For centuries, Seneacquoteen, an Indian word for "crossing," was widely used by the native tribes as the river's narrow channel at this point made it the easiest place to cross. The British and American boundary surveyors set up a camp at this spot in 1860-61 while establishing the international boundary line between the United States and Canada. In 1863, when gold was discovered on Wild Horse Creek in British Columbia, hordes of prospectors crossed the river at Seneacquoteen. The following year, the discovery of gold in Helena, Montana, increased the traffic. A mail and freight route was established across northern Idaho and Lake Pend Oreille. This route led from California up the Columbia River, overland to Lake Pend Oreille, across the lake and overland again to various points in Montana. Enterprising individuals, Whites and Indians alike, negotiated various fares to transport travelers across the river at Seneacquoteen to (what became) the town of Laclede. In 1863 the Washington Territorial Government (until later that year, this region was still in Spokane County in the Washington Territory) issued the first official ferry license at this location.

The difficulty with overland travel and the volume of traffic soon spawned steamboat construction at Seneacquoteen. The first steamboat to ply the waters of the Pend Oreille River, across Pend Oreille Lake and up the Clark Fork River was the *Mary Moody*, launched in 1866. Being the only settlement of any significance when the Idaho Territorial Legislature established the first county (Kootenai) in northern Idaho in 1864, Seneacquoteen was named the county seat; however, no county business was ever conducted there. As the county's population grew, a later amendment gave the commissioners the power to relocate the county seat. In 1881 they exercised this power and moved it to Rathdrum.

This activity and the Homestead Act of 1862, plus the construction of transcontinental railroad lines, precipitated a growing population in Bonner County. As the railroad built through the area in the 1880s, the town of Hope, which grew out of a Northern Pacific Railroad construction camp, boomed as the Rocky Mountain Division Point. The Great Northern came through the area with its transcontinental line in 1892. The Spokane International followed in 1906 with a line extending from Spokane to Eastport in Boundary County. The railroads brought people and served the growing timber, mining and agricultural industries in Bonner County.

Sandpoint, the county seat since the creation of Bonner County in 1907, grew slowly until the arrival of the Great Northern and Spokane International railroads. With the depletion of timber in the midwest and eastern portion of the United States, the demand for the virgin timber from the mountainous regions of the Inland Northwest attracted large lumber companies. The Humbird Lumber Company, whose owners came from St. Paul, Minnesota, acquired Sandpoint Lumber Company and Kootenai Bay Lumber Company. This became one of the region's largest sawmills, creating a stable economic base on which the area grew and prospered.

Left: The John Campbell Hotel in Laclede in 1910. **Right:** An outing near Laclede. Harriet (Florence) Mercer, wife of Bert Mercer, is at the left. Viva Durfey is on the horse, with Mary (Schaefer) Hodge and husband Bill Hodge standing on either side, circa 1915. *(Photos courtesy Bonner County Historical Society.)*

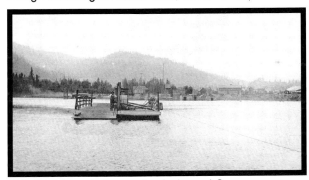

Left: The ferry between Laclede and Seneacquoteen with ferryman Henry Peterson, circa 1910. There were a number of ferry crossings on the Pend Oreille River, but the ferry at this location was the longest running. The first commercial ferry at this crossing began in Seneacquoteen in 1863. The Laclede ferry ran until 1957, shortly after the construction of Albeni Dam. **Right:** Laclede Railroad Station, circa 1910. Laclede was a busy logging community until A.C. White's sawmill was destroyed by fire in 1922. After the fire, White purchased a sawmill at Dover and moved the company. This included moving 57 company buildings and houses, which were put on barges and floated up the river. *(Photos courtesy Bonner County Historical Society.)*

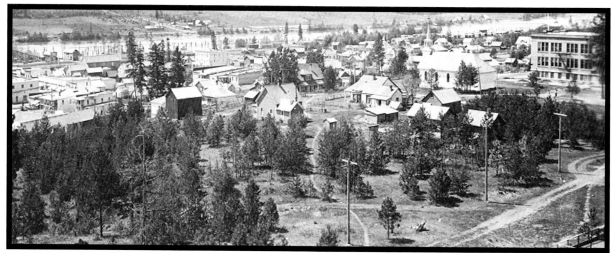

A bird's eye view of Priest River, looking southwest toward the Pend Oreille River (top of photo). Henry Keyser and his wife Emma arrived in the Inland Northwest in the early 1870s. They lived for a short time in Rathdrum and Spokane before settling at Trent in the Spokane Valley. Two years after Emma's death in 1883, Henry married Elizabeth Fuchs. They moved near the area where Priest River joins the Pend Oreille River in the late 1880s, becoming the first homesteaders at the present town of Priest River. The first post office, store and school were built in the early 1890s as construction of the Great Northern Railroad pushed westward through this area. The town originally was located about one mile east of the present townsite near Keyser's Slough, but was abandoned in 1894 due to severe flooding. The "Priest" name for the lake, river and the town stemmed from the Jesuit priests' involvement in the area beginning in the 1840s. *(Photo courtesy Bonner County Historical Society.)*

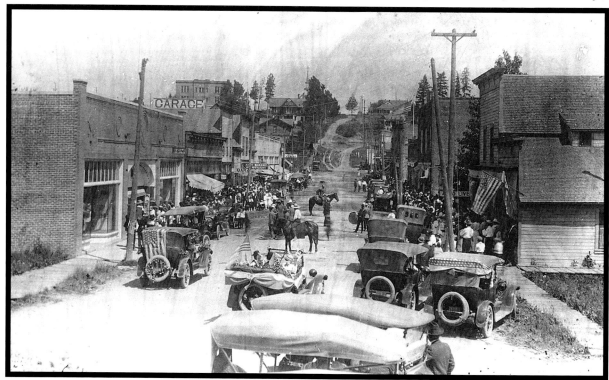

A Fourth of July celebration in Priest River, originally named Valencia, circa 1915. This view is looking north along Main Street from Montgomery toward the present Highway 2. A number of these buildings still exist, including the one on the left, which is now the Antique Mall. *(Photo courtesy Bonner County Historical Society.)*

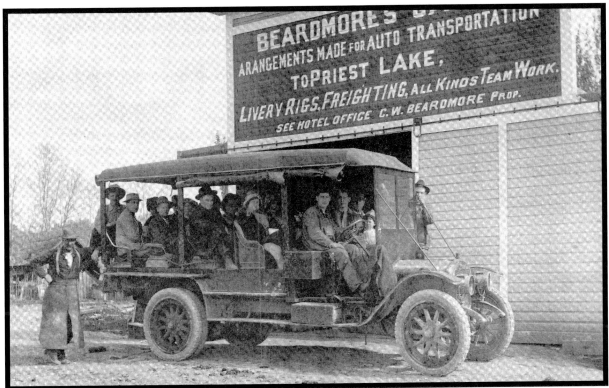

The Beardmore Stage Line from Priest River to Coolin, circa 1915. Charles Beardmore began homesteading north of Priest River in 1900. In 1902 he brought his new bride Lucy "Daisy" Gumaer to the St. Elmo Hotel, which he had recently purchased. This became their home for the rest of their lives. Beardmore purchased a sawmill in 1916, which would support Priest River's economy for the next 15 years. In 1922 he built the Beardmore Block on Main Street. It housed a number of businesses including the Beardmore Store and a theater. Both Charles and Lucy were active community leaders. Lucy became the first woman to represent Bonner County in the Idaho House of Representatives. *(Photo courtesy Pend Oreille County Historical Society.)*

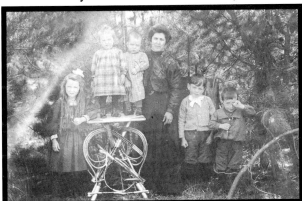

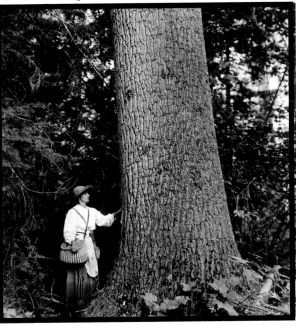

Above: The Tim Sullivan family in Priest River in 1910, (L to R): Emilie, Edna, Andy, Della, Pat and Cliff. *(Photo courtesy Bonner County Historical Society.)* Right: Unidentified woman standing beside a white pine tree near Granite Creek, circa 1911. White pine was the most valuable timber in the Inland Northwest, and North Idaho had the largest stands of white pine in the country. *(Frank Palmer photo courtesy Museum of North Idaho, Rec-9-53)*

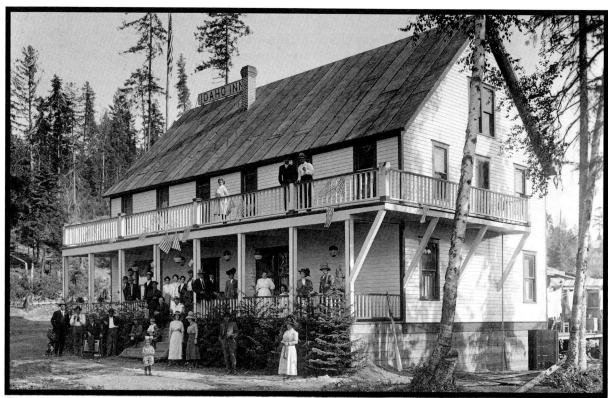

The Idaho Inn at Coolin in 1918. A popular resort area at the south end of Priest Lake, Coolin was named for Andy Coolin, who was the first to settle there. In the early 1920s, Nell Shipman, a Hollywood silent screen actress, built a film studio called Lionhead Lodge on the upper eastern shore of Priest Lake. One of the films, a full-length feature called *The Grub Stake*, was filmed at Priest Lake, near Tiger in Pend Oreille County and in Spokane. The company went broke and left the lake in 1925. *(Frank Palmer photo courtesy Museum of North Idaho, Plk-3-2)*

This photo from the Libby family's album was taken at Priest Lake by Charles Libby Sr., a professional photographer from Spokane. His wife, Gretchen, is second from the left. *(Photo courtesy Cheri (Libby) and Rich Chapin.)*

Albeni Falls on the Pend Oreille River was named for Peter Albeni Poirier, the first to homestead and establish businesses at this location. Poirier arrived in the Inland Northwest in 1883 from Montreal and moved to Albeni Falls in 1887. He built a boarding house (lower right), a saloon with a dance hall, large barn and blacksmith shop to accommodate newcomers. Shortly after his arrival, the first steamboat to navigate the river below Albeni Falls was launched. Albeni Falls Dam was constructed between 1951 and 1955. *(Photo courtesy Fielden Poirier Jr.)*

Mary (McGuire) and
Albeni Poirier
in 1894.

A Great Northern Railroad train crossing at Albeni Falls (note the smoke from the steam engine). After the railroad completed its line through this area, excursions from Spokane to Albeni Falls became popular. Albeni Poirier met his future bride, Mary Catherine McGuire, who came into his establishment during one of these excursions. They married in 1894, gave up the businesses, built a home overlooking the falls and began farming and raising cattle. *(Photo courtesy Pend Oreille County Historical Society. Inset photo courtesy Fielden Poirier Jr.)*

Oldtown, originally called Newport (see about name change on page 125), was the first settlement along the Pend Oreille River at the Idaho-Washington border. It got its start around 1890 as a new port (as the name implied) for river and overland travel. Tom Fea and John Cass had a restaurant and Mike Kelly built a general store (where he established a post office in 1892). Around 1905 the tall building with the dormers (left of center) was built as a hotel for the riverboat and lumber mill crews. *(Photo courtesy Pend Oreille County Historical Society.)*

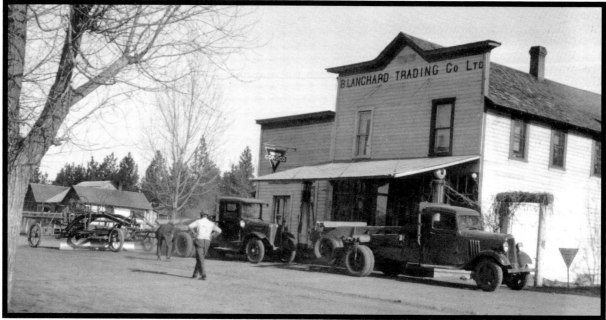

Blanchard Trading Company Store in 1934. The first settlers in the area were the Poirier brothers, Louis (age 17) and Albeni (age 22), in 1883. Oscar Melder, who had passed through earlier, was the next to settle there. In 1912 the Blanchard Trading Company was formed, of which Louis Poirier was a partner. The company bought out three existing stores that had been built about 1908. The store built by Charles Armentrout for R.R. Friend became the Blanchard Trading Company Store. Over the years it was enlarged and expanded. By the 1930s, Louis Poirier's son Fielden had become the sole owner. The store handled a wide variety of merchandise and was the focal point of the community. *(Photo courtesy Fielden Poirier Jr., who lived over the store while he was growing up.)*

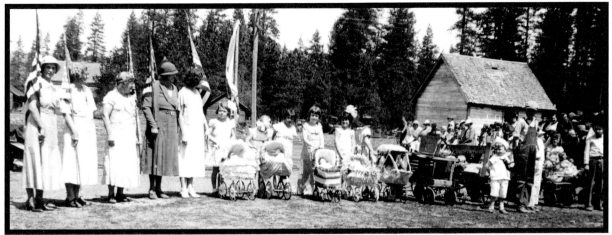

Lineup of baby buggies at Blanchard's 1933 May Day celebration.

Left: Irene Bakie (left) and Alice (Graham) Poirier (right) pulling Alice's daughter, Dolores Poirier, during the May Day celebration in 1933. **Right:** Mary Strong in front of her family homestead in the Blanchard area.

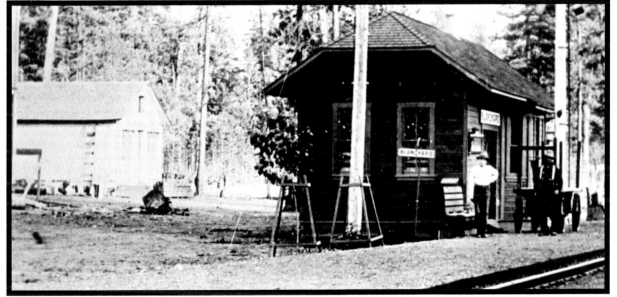

Idaho and Washington Northern Railroad Depot in Blanchard, originally called White for the first postmaster, Will White. When the railroad came through in 1908, the name was changed to Blanchard for Joe Blanchard, who was married to Louis Poirier's sister, Alde. Shipping logs and cordwood became a major source of income after the railroad was built. *(Photos courtesy Fielden Poirier Jr., son of Alice Poirier (shown above) and grandson of Louis Poirier.)*

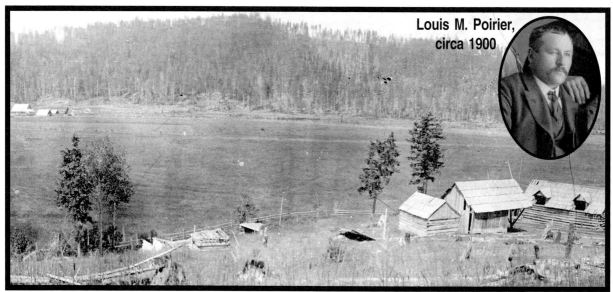

Louis M. Poirier, circa 1900

The Louis Poirier (inset) ranch in 1902, looking west from the original homestead buildings (right), the first in the Blanchard area. From 160 acres, the ranch grew to over 3000 and has been in the same family since 1884. Louis's son Fielden took over in 1927. Today, Fielden Jr. (Sonny) continues to manage it with his wife LaVonna.

Left: Louis Poirier in 1908 on the 12' x 24' hay wagon he built to haul hay from his meadow. **Right:** Effa (Rusho) Laidley (center) is flanked by her sons Edward F. Poirier (L) and Fielden L. Poirier (R). Fielden's future, wife Alice Graham (second from right) is standing next to Charles Olin and his future wife, Corenia Mace. Charles was a good friend of Fielden and worked for him for many years. Photo taken in June 1917.

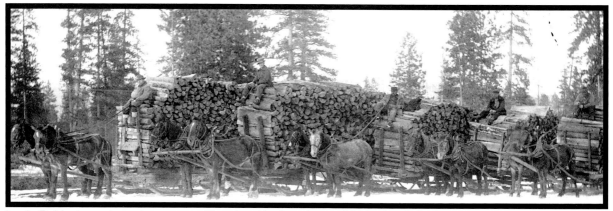

Louis Poirier's cordwood crew near Blanchard in the winter of 1912. Louis is the man on the middle sled. His sons Ed (far left) and Fielden (second from right) were also part of the crew. *(Photos courtesy Fielden Poirier Jr.)*

266

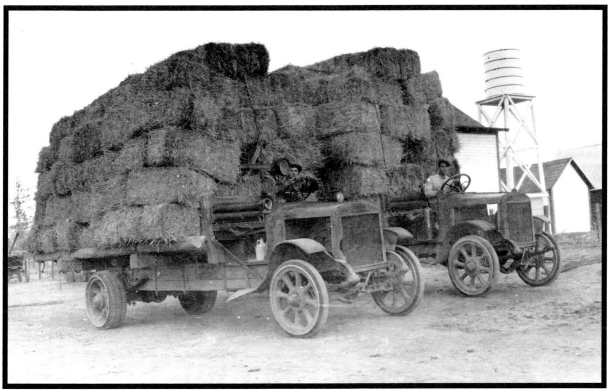

Ed and Fielden Poirier Sr. in front of the Blanchard Trading Company Store, circa 1920. Before the railroad came through the Blanchard area, their father Louis hauled hay by horse and wagon to a barn he had in Newport, Wash. When he had enough to fill a boxcar, he shipped it out by train. *(Photo courtesy Fielden Poirier Jr.)*

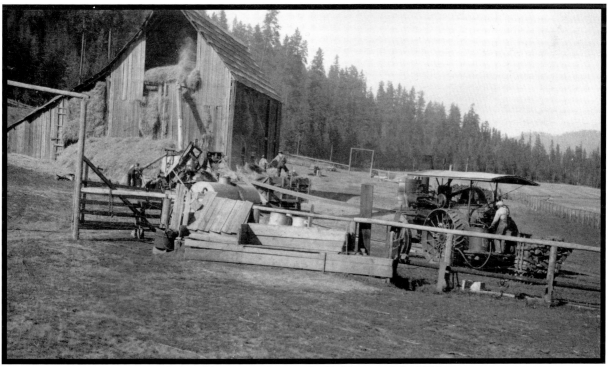

A threshing operation on the Poirier ranch in 1936.

(Photos courtesy Fielden Poirier Jr..)

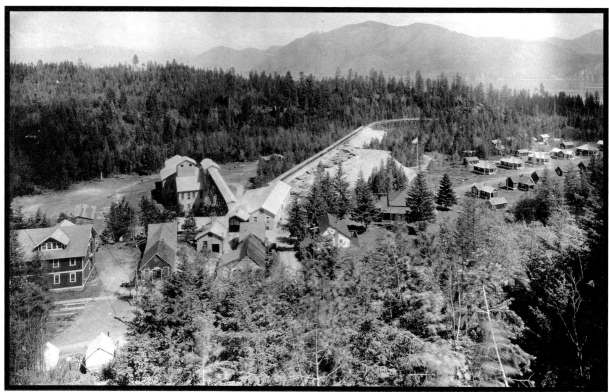

Talache silver-lead mine and camp near the town of Sagle, south of Sandpoint, in June 1923. The Talache mining district produced about $2,000,000 worth of silver and lead between 1919 and its closure in 1926.

(EWSHS, Department of the Interior Reclamation Service photo, L84-286.22)

Main Street of Sagle after a fire on August 21, 1910. Sagle got its start in 1884 when Mr. and Mrs. John Summers and their children settled there. Nate Powell opened a store and submitted an application for a post office around 1900 under the name Eagle. There was already an Idaho post office with that name so Powell changed the 'E' to an 'S' and registered it as Sagle. *(Photo courtesy Bonner County Historical Society.)*

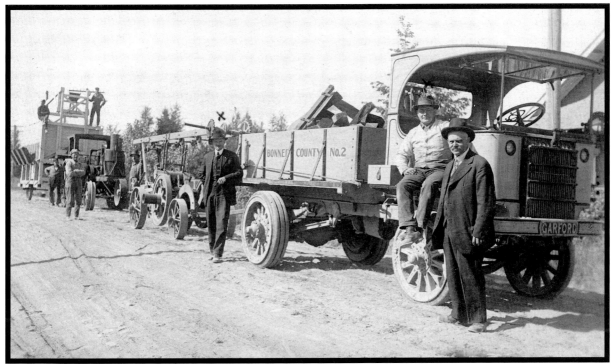

Bonner County road crew in the early 1920s. County Commissioner Harry L. Melder, who began his term in 1919, is standing at the rear of the lead truck. Guy Geaudreau, who later owned a sawmill in Blanchard, is sitting in the truck. Commissioner Albert Hageman is standing next to him. Melder laid out and supervised construction of the road from Spirit Lake to Newport, which began in 1916. *(Photo courtesy Fielden Poirier Jr.)*

Men from a logging camp washing their clothes in a creek near Sandpoint, circa 1908.
(EWSHS, Frank Palmer photo, L84-327.1242)

Looking north along Sand Creek during high water, circa 1930. Sandpoint's picturesque setting along the shores of Lake Pend Oreille and the banks of Sand Creek is an attraction for both residents and tourists. Tourism has become a major component of Sandpoint's economy. At the crossroads of two transcontinental railroads, businesses catering to the railroad workers clustered near the railroad tracks on the east side of Sand Creek in Sandpoint's early days. As the result of heavy flooding in 1894, the Northern Pacific Railroad raised its tracks ten feet. Divided by this ten-foot wall, the town moved to the west side of Sand Creek.

(Magee photo courtesy Spokane Public Library Northwest Room.)

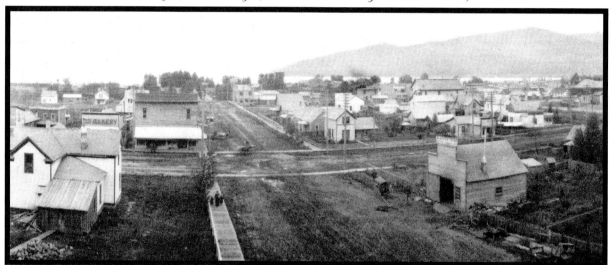

Looking east on Cedar Street at Third Avenue in Sandpoint, circa 1907. Sandpoint's earliest settlement began in 1880. Robert and Emma Weeks opened a general store, hotel, saloon and sawmill. The town was first called Pend Oreille. After the arrival of the Northern Pacific in 1882, the first post office in the area was moved from a settlement across the lake, called Venton, to Pend Oreille. About the time Emma Weeks became the second postmaster, the name changed to Sandpoint. The earliest recorded history of the area was a notation in David Thompson's journals in 1809 referencing a sandy point of land (now the city beach). In 1893 L.D. Farmin, Sandpoint's first station agent for the Great Northern Railroad, bought squatters rights to 160 acres of land, which today is most of Sandpoint's business district. In 1898 Mr. Farmin laid out and filed an eight-block townsite. Over the years, Farmin donated lots to churches, lodges and schools, and sold residential lots on easy terms to encourage newcomers to settle in Sandpoint. *(Photo courtesy Spokane Public Library Northwest Room.)*

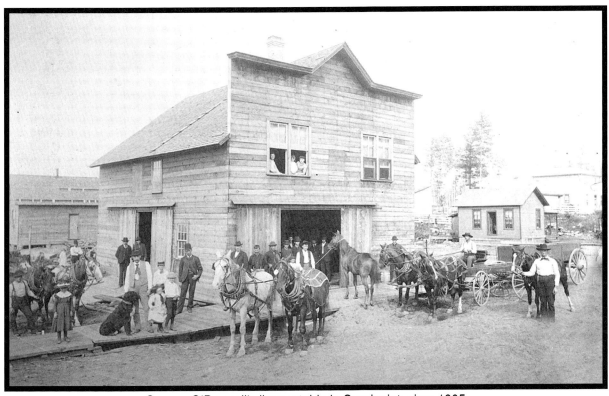

George O'Donnell's livery stable in Sandpoint, circa 1905.
(Photo courtesy Bonner County Historical Society.)

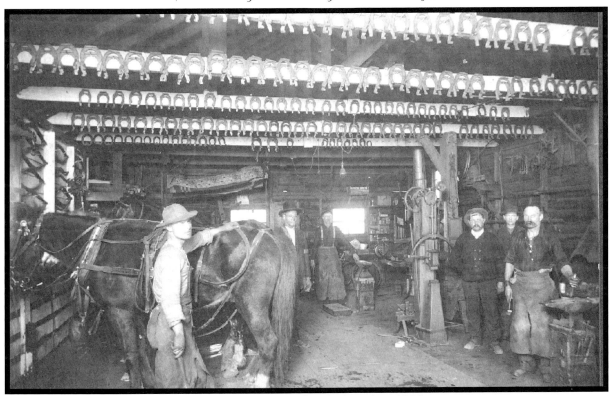

Blacksmith shop in Sandpoint, circa 1900.
(Photo courtesy Bonner County Historical Society.)

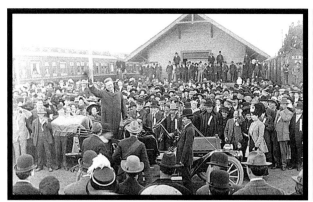 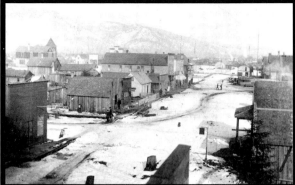

Left: A crowd gathered at the Sandpoint railroad station in 1912 to greet former President T. Roosevelt (in car).
Right: The intersection of First Avenue and Pine Street, circa 1901. *(Photos courtesy Bonner Co. Historical Society.)*

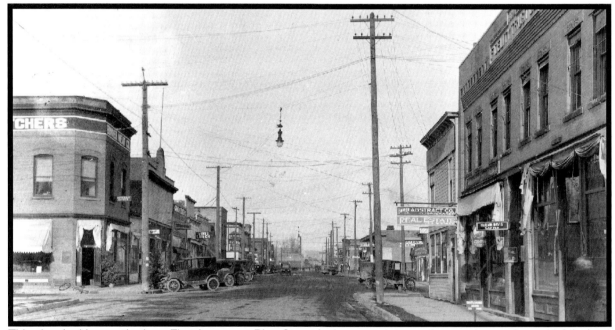

This view looking north along First Avenue at Pine Street is the same intersection as shown above (right) about 20 years later. Sandpoint suffered devastating fires in 1912. Many replacement buildings were built of brick. The building at the left was a butcher shop and now houses Sandpoint Computers and Tamarack Realty. At the right, the former Fidelity Trust Building is now the Inn at Sand Creek. *(Photo courtesy Bonner County Historical Society.)*

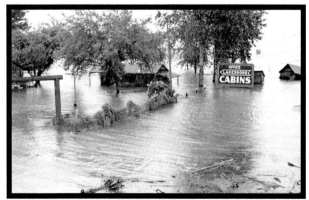 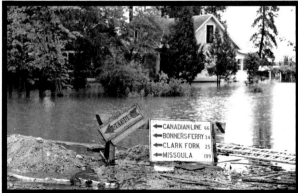

Flooding problems were severe in 1948 as reflected by these scenes in Sandpoint. *(Photo courtesy Wallace Gamble.)*

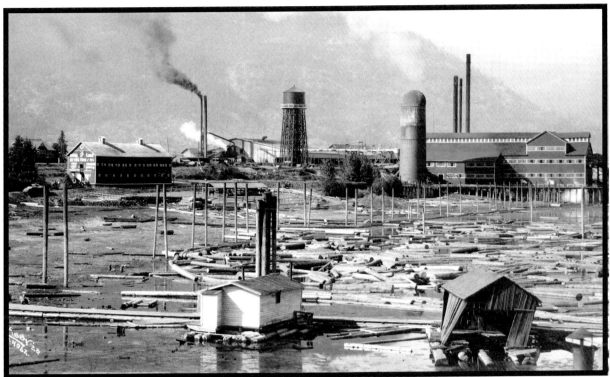

The Humbird Lumber Company at Kootenai in 1923. John A. Humbird, Frederick Weyerhaeuser and associates purchased the Sandpoint Lumber Company in 1901 and the Ellersick's Kootenai Bay Lumber Company in 1904. The company expanded, becoming one of the largest sawmill operations in the Inland Northwest. It provided a stable economic base for the Sandpoint area for nearly three decades. Although he remained a resident of Spokane, T.J. Humbird succeeded his father as president of the company. In 1930 the Humbird was sold to the Weyerhaeuser Lumber Company, who closed the mills. *(EWSHS, Libby photo, L87-1.24062-23)*

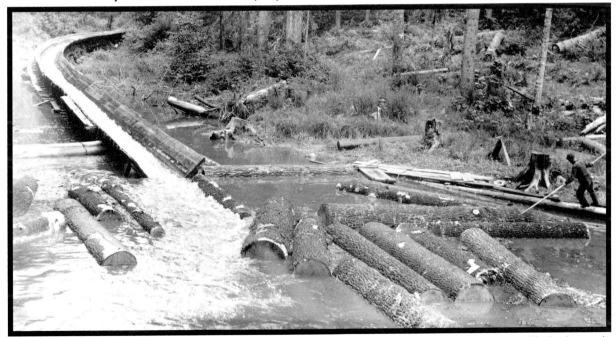

Logging flumes were the easiest way to transport logs from the mountainsides to the sawmills in the early days. By the 1940s modern logging equipment had replaced this familiar scene. *(Photo courtesy Wallace Gamble.)*

An unidentified group near Sandpoint. *(Photo courtesy Bonner County Historical Society.)*

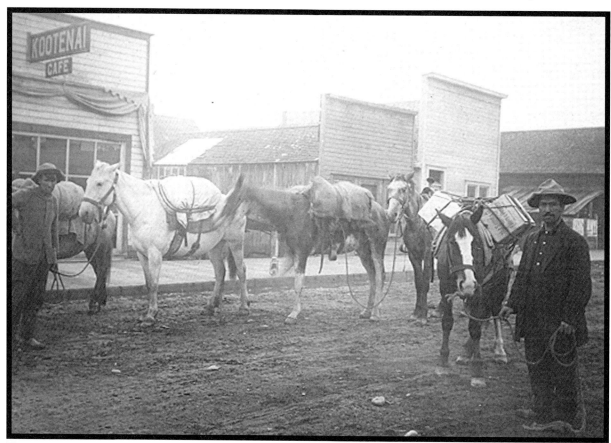
The town of Kootenai about four miles northeast of Sandpoint. This stop, originally Greenough's Spur, along the newly constructed Northern Pacific Railroad became the main supply point for the northern part of the state and the Kootenay Mining District in British Columbia. It was also a jump-off point for prospectors and miners on their way to the mines. In 1885 Dr. Wilbur Hendryx from Grand Rapids, Michigan, built a toll road to Bonners Ferry, where freight headed farther north was loaded on steamboats. Hendryx's road essentially followed and improved the centuries-old Indian trail, which led to the Wild Horse Creek gold fields in British Columbia. *(Photo courtesy Bonner County Historical Society.)*

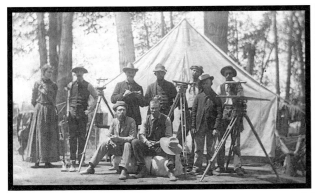
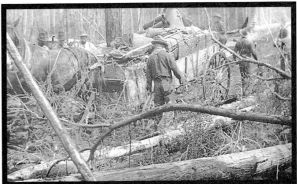
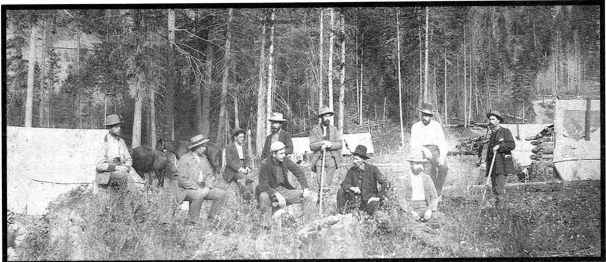

A Northern Pacific Railroad survey party in Bonner County in the early 1890s.
(Photo courtesy Bonner County Historical Society.)

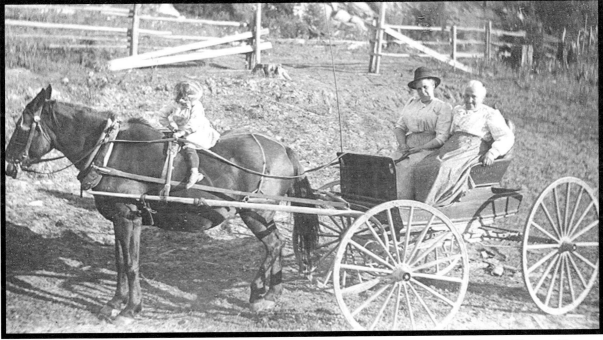

Members of the Sawyer family from Vay, near Seneacquoteen. *(Photo courtesy Bonner County Historical Society.)*

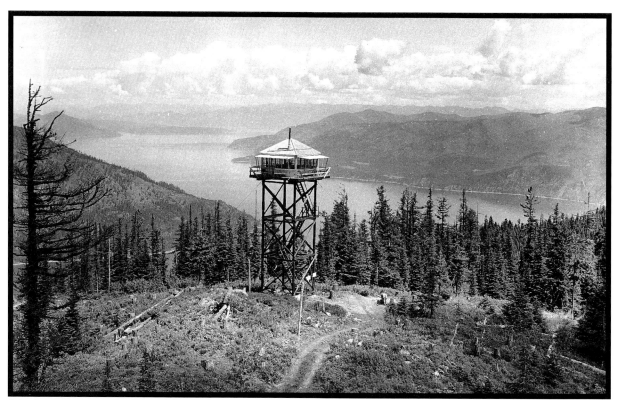

A lookout tower north of Pend Oreille Lake, circa 1940. The U.S. Forest Service began constructing fire lookouts on the tallest peaks in the 1920s and were assisted by the Civilian Conservation Corps in the 1930s. Modern equipment and the use of air and vehicle patrols rendered the lookouts obsolete. *(Photo courtesy Wallace Gamble.)*

The Pack River delta near Trestle Creek, northwest of the town of Hope, in the late 1920s. The stretch of track on the Northern Pacific line between Spokane and the Montana border (part of which is shown here) was some of the most difficult to lay. Thousands of Chinese who were willing to do the hard physical labor were employed to lay track and build trestles and bridges. *(Magee photo courtesy Spokane Public Library Northwest Room.)*

The town of Hope, circa 1930. Hope's origin was as a construction camp for the Northern Pacific Railroad. For years it was the Rocky Mountain Division Point. Situated on a terraced slope overlooking Lake Pend Oreille, Hope is a popular summer resort. The N.P.R.R. recognized this potential when it built the Highland House in Hope in 1886, designed as a place for tourists to stop and linger. Other first class hotels soon followed. The Hotel Rainier (shown above) was built around the turn of the century. The stairs from the business section on the upper bench led to the railroad tracks and sawmill below. *(Magee photo courtesy Spokane Public Library.)*

 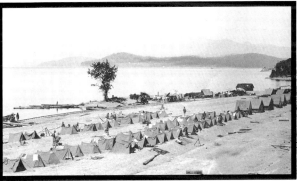

Left: Looking west along Hope's Main Street, circa 1910. Most of the business section was devastated by fire in 1900. The Jeannot Hotel (right), built by Joseph Jeannot, sustained some fire damage, but was not destroyed.
Right: U.S. Infantry companies K, L and M camped near Hope, circa 1915. *(Photo courtesy Bonner Co. Historical Soc.)*

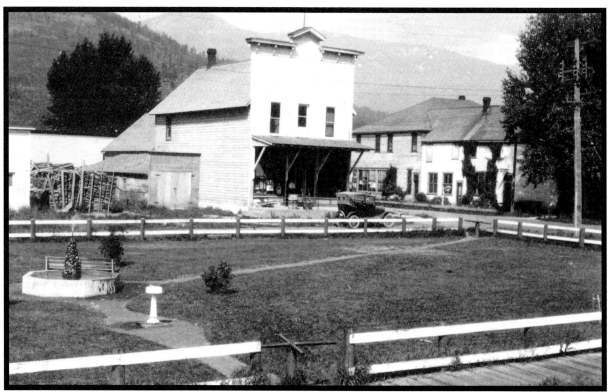

The town of Clark Fork, situated near the mouth of the Clark Fork River, circa 1910. This intersection at Railroad Avenue and Main Street was once the center of the community (the railroad tracks lay parallel to the park). After the construction of Highway 200, the Whitcomb Store (center) was moved to the highway on Fourth Street . The store, which included a hall on the second floor, was built about 1890 and is presently the Out-of-Bounds Tavern. *(Photo courtesy Spokane Public Library Northwest Room, Magee Collection.)*

Dr. Broady, a member of the Spokane Trail Club, is standing beside the Scotchman Peak Lookout in the Cabinet Range, circa 1930. *(Magee photo courtesy Spokane Public Library Northwest Room.)*

A home at the town of Lakeview, circa 1930. Lakeview is located on the southeast shore of Lake Pend Oreille in the midst of an extensive mining district. It is one of the older mining settlements in north Idaho. In 1888 the first mine was discovered and a general merchandise store was built by a Mr. Shelton, who sold it to Robert Baldwin two years later. Ernest Rammelmeyer was the postmaster of the first post office, established in 1892. *(Magee photo courtesy Spokane Public Library Northwest Room.)*

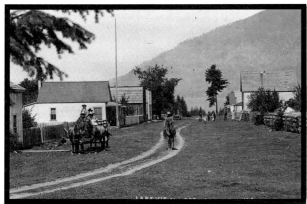 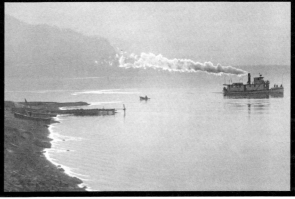

Left: The main "street" through the town of Lakeview in 1910. *(Photo courtesy Bonner County Historical Society.)*
Right: The steamer *Western* on Lake Pend Oreille at Lakeview. In the early days of Lakeview's settlement, steamers connected the little landlocked town to Hope, where a connection could be made with the Northern Pacific Railroad, or Steamboat Landing (now Idlewild Bay) in Kootenai County. Steamboats made their first appearance on Lake Pend Oreille in 1866 with the launching of the *Mary Moody* at Seneacquoteen. They provided an integral component of transportation into the northern part of the state, Montana and Canada. The steamboating heyday continued on the lake until the 1930s. *(Ulrich photo courtesy Spokane Public Library Northwest Room, Magee Collection.)*

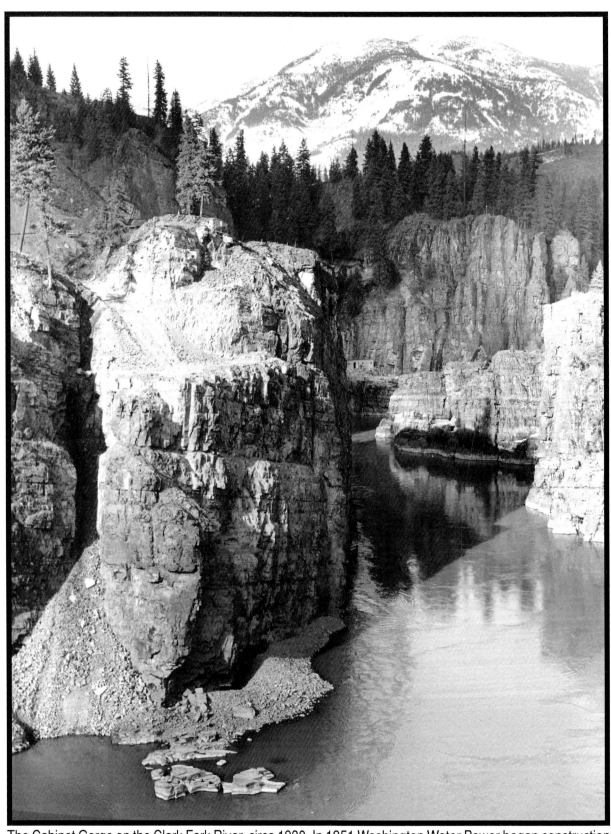

The Cabinet Gorge on the Clark Fork River, circa 1930. In 1951 Washington Water Power began construction of Cabinet Gorge Dam at this site, one-half mile from the Idaho-Montana border. *(Photo courtesy Wallace Gamble.)*

Chapter 11

Shoshone County

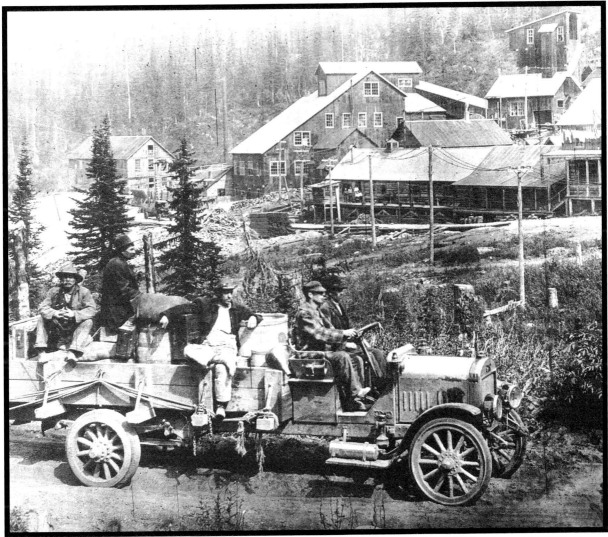

Supply truck at a flotation (silver, lead and zinc) mill in Shoshone County, circa 1910. *(Photo EWSHS, L84-122)*

The discovery of gold along the Clearwater River and Oro Fino Creek (east of Lewiston) in 1860 stimulated a rapid influx of prospectors, necessitating the formation of local government. Sources vary regarding the formation of Shoshone County, often confusing its formation with that of Spokane County. In *Spokane and the Inland Empire (1912),* N.W. Durham states, "At the sessions of 1860-1 and 1861-2, the [Washington Territorial] legislature carved, out of the original boundaries of Spokane, the counties of Missoula, Idaho, Nez Perce and Shoshone, that territory having received a large influx of gold miners;" The exact date of Shoshone's formation was January 9, 1861. Pierce City was designated the Shoshone County seat. With the discovery of gold around Pierce City and Oro Fino (now Orofino), Shoshone quickly became the leading county of the Washington Territory. In 1884, as the population base shifted with the discovery of gold

farther north, the county seat was moved from Pierce City to Murray. In 1898 it was moved to the present county seat of Wallace, which then was the largest city in Shoshone County.

New counties were formed and some boundary lines redrawn after Idaho became a territory in March of 1863. The First Territorial Legislature of Idaho, which convened on December 7, 1863, reorganized Shoshone County to include what is presently Shoshone and Clearwater counties. In 1904 the final change was made to Shoshone's boundaries. The southern portion, which is now in Clearwater County, was removed from Shoshone and annexed to Nez Perce. The county covers about 2600 square miles in the southeastern region of the Idaho Panhandle within the Coeur d'Alene and St. Joe National forests.

The first non-Indian settlement in what is now Shoshone County did not occur until the early 1880s. Prior to that, the Coeur d'Alene Indians' journeys through the Coeur d'Alene River Valley on their way to hunt buffalo on the Montana plains, and other such activities, created a network of trails throughout the area. When the Jesuits and the Coeur d'Alene Tribe began building the Old Mission Church (relocating the Sacred Heart Mission from its original site on the St. Joe River) on the Coeur d'Alene River (west of Shoshone County in Kootenai County) in 1846, it became the nucleus of tribal activity. Within a few years, Old Mission would serve as a way station for soldiers, trappers, prospectors, miners, homesteaders and other travelers. As a steamboat landing, it eventually would play a pivotal role in the development of the Coeur d'Alene Mining District. In 1853 Governor Isaac I. Stevens stopped at the mission during his survey to determine a direct railroad route from the Mississippi River to the Pacific Coast. Most of the surveying party traveled west along the Clark Fork River, but Stevens took a more direct route through Shoshone County.

In 1859, under the supervision of Captain John Mullan, construction began on a military road connecting Fort Walla Walla with Fort Benton in Montana. The road followed the old Coeur d'Alene trail through Shoshone County, roughly along the South Fork of the Coeur d'Alene River, crossing over Mullan Pass into (what is now) Montana. That section of the road through Shoshone County would become widely used by prospectors and miners heading to the newly-discovered Montana gold fields.

Although there was a measure of activity throughout the area and mineral deposits were suspected to lie near the military road (as later reported by John Mullan), until substantial proof of these deposits was presented, no settlement occurred. The rugged mountainous terrain held little allure for settlers. The narrow, densely-forested valleys were often swampy, winters were long and harsh and the growing season short. Yet, with the discovery of placer gold (loose surface gold) in the Eagle City, Prichard and Murray areas in 1882, none of these conditions was a deterrent. Delayed word of the discovery coincided with an advertising blitz by the recently-completed Northern Pacific Railroad. What better way to promote the railroad than with the promise of gold?

By the latter part of 1883, thousands of hopefuls were crowding the region and laying claims as fast as they could stake them. Even as the temperature hovered around 30 degrees below zero, claims were staked over blankets of snow, in spite of the gamble in not knowing what lay beneath. Tent and shack towns sprang up with more than the usual quota of saloons that flourished through the long winter months. These towns in the gold belt had few sustaining underpinnings. Once the gold was gone, so were the residents. In the meantime, it was a hard life, but the rewards could be significant. In the late 1800s, gold was worth $25 to $30 an ounce, which was a substantial amount. During the gold-rush era, even the poorest and least educated could fulfill dreams of becoming wealthy. Most significantly, placer gold was relatively inexpensive to obtain. The only equipment needed by the first prospectors was a shovel, pick and gold pan. To pan for placer gold, sand or

gravel from low areas in a gold-bearing stream is swirled in a pan with water, allowing the lighter material to overflow the gold pan. The heavier weight of the gold causes it to separate from the other material and remain at the tail of the swirling substance.

Although the placer gold attracted the attention of early prospectors, it was the silver, lead and zinc hidden deep beneath the earth's surface that produced many millionaires from the Coeur d'Alene Mining District (loosely defined as the mining region within the Coeur d'Alene River drainage system, also referred to as the "Silver Valley"). Discovery of these minerals followed close on the heels of the gold rush. Between 1884 and 1886, almost every silver-lead ore mine of importance in the Coeur d'Alene District had been discovered and claimed. Many of these early claims were purchased for almost nothing by experienced mining companies for what they suspected lay beneath the surface. Large amounts of capital and expertise are required to develop hard-rock mines. It was unusual for the discoverer of the ore deposit to also be the developer of the mining operation. (The Hercules Mines at Burke was a rare exception.) However, for those with the means and persistence, some of the richest silver-lead mines in the world were soon revealed in Shoshone County.

The Bunker Hill and Sullivan Mines were among the first major producing mines. Others soon followed. By 1891 there were about 40 developed mines and 13 concentrating mills. The Sunshine Mine alone has produced more silver than all the mines in Nevada's famed Comstock Lode combined. This has contributed to the district's rightful claim as the "Silver Capital of the World." The district also ranks among the nation's top lead producers. However, the Coeur d'Alene Mining District is not presently operating as fully as in earlier times. Mining activities ebb and flow with fluctuating metal prices and the costs associated with mining operations, and many ore bodies have been depleted. However, the district still retains a high level of potential.

Until the 1950s, the second major industry in Shoshone County was the timber industry. At one time, the largest stand of white pine in the world was located at Clarkia in Shoshone County. Currently, much of the valuable timber has been exhausted. However, Shoshone County has a fast-growing tourist trade. Several movies have been filmed in Wallace, communities are proudly promoting their historic mining heritage, and the longest single-stage gondola in the world, built from Kellogg to the Silver Mountain Ski Resort, operates year around.

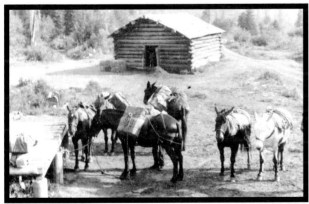 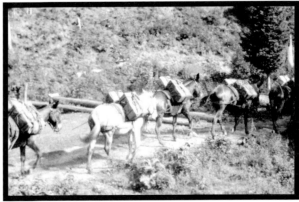

Left: U.S. Forest Service pack mules being loaded up at the Magee Ranger Station in the Coeur d'Alene National Forest in northern Shoshone County, circa 1930. **Right:** The same pack mules heading off to a fire at Beaver Creek. For decades, these sure-footed animals were the Forest Service's major supply haulers. Few roads existed to the lookout towers and, before the use of helicopters in later years, mules not only transported the supplies, they carried the materials and components used to construct the towers.

(Magee photos courtesy Spokane Public Library Northwest Room.)

The town of Eagle City in 1897. Located where Eagle Creek joins Prichard Creek, Eagle City was the first town in the Coeur d'Alene Mining District and was the initial destination for the gold-rush stampede that began in the fall of 1883. During the initial frenzy, lot prices skyrocketed and many claims were staked without knowing what lay beneath the deep snow. The town's decline within a year was as rapid as its rise. An estimated 2000 to 4000 people descended upon the town during this time, including the notorious Wyatt Earp and his brothers. They operated a saloon, called the White Elephant, in a 50' x 45' tent. *(Photo courtesy Spokane Public Library.)*

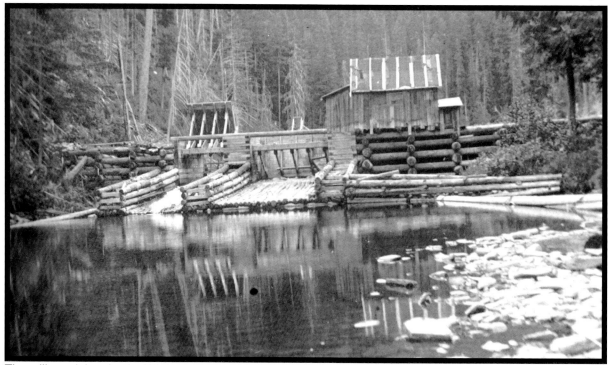

The mill pond dam for the Winton Lumber Company on Shoshone Creek (formerly Big Creek) north of Prichard, circa 1930. *(Magee photo courtesy Spokane Public Library Northwest Room.)*

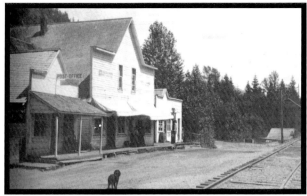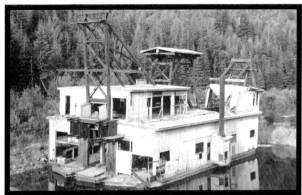

Left: The town of Prichard, circa 1925. Prichard is located along Prichard Creek, a tributary of the North Fork of the Coeur d'Alene River, slightly northwest of where Eagle City was established. The town was named for Andrew J. Prichard, who discovered the gold at the site of Eagle City, which started the stampede to what became the Coeur d'Alene Mining District. **Right:** Gold dredge on Prichard Creek near Raven, above the town of Murray, was moved from Alaska by the Yukon Gold Company. It was in operation nearly every day from 1917 until 1926, and dredged gold worth about $1,270,000. *(Magee photos courtesy Spokane Public Library.)*

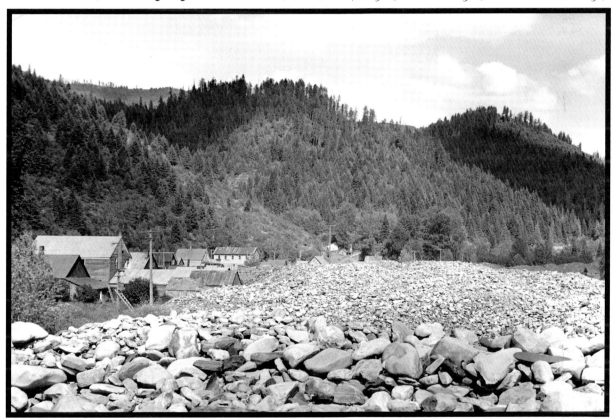

The town of Murray, circa 1885. It is the oldest existing town in the Coeur d'Alene District. The town's name-sake, George Murray, was part owner of one of the claims upon which the town was built. It was established as Murraysville in January of 1884 near the richest gold placer claims on Prichard Creek. Later that year, 2500 people were living in the vicinity of Murray. The array of business establishments included 50 saloons. Typical of many gold-rush towns, Murray sprang up almost overnight, with buildings, many of which were crude shacks and tents, situated in a haphazard fashion. It became the Shoshone County seat in 1885, as well as home to many colorful characters, including the legendary prostitute named Molly b'Damn. *(Photo EWSHS, L83-167.5)*

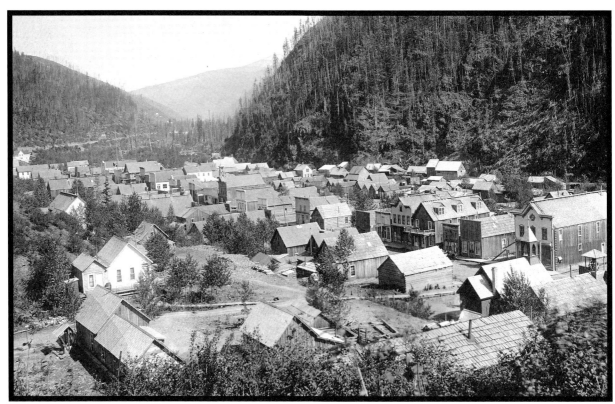

Murray in 1890. By this time, the placer deposits around Murray had been worked over and the miners had moved on to the silver and lead mines farther south. Murray was to suffer the effects, but it remained the county seat until 1898. *(Barnard Studio photo courtesy Spokane Public Library Northwest Room.)*

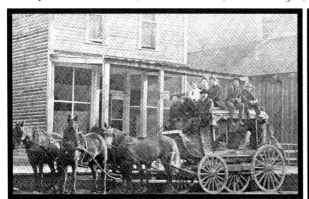 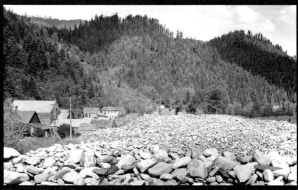

Left: The Murray-Wallace Stage at the station (sign reads "Express Office"), circa 1890. In 1955 the building became the Sprag Pole Inn and today is a museum-cafe-bar combination. Murray's rapid rise at the center of the mining activity was accompanied by the corresponding construction of roads (often little more than pack mule trails) connecting Murray to the railroads at Thompson Falls, Montana, and the steamship landing at Old Mission on the Coeur d'Alene River. The latter route connected Spokane Falls with the mining activity. Stage-coaches were in big demand for transporting people to and from the mines and between the mining communities. The Murray-Wallace stage operated from the mid-1880s until the fall of 1911. *(Photo EWSHS, L95-57.50)*
Right: Murray in 1943, long after the gold-rush frenzy had subsided. In the late 1800s, much of the loose gold was removed from the hillsides along the creeks by hydraulic mining. Powerful streams of water were directed at the banks of the creeks, washing away the dirt and loose gravel, leaving the heavy gold. The wide exposed gravel beds devoid of vegetation are what remain from this process. *(Photo courtesy Wallace Gamble.)*

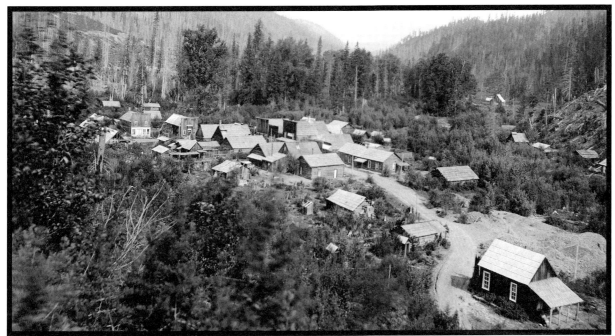

The town of Delta in the late 1880s. Delta was a placer gold mining town, located southwest of Murray on Beaver Creek. By 1900 the town was already drying up. *(Barnard Studio photo courtesy Spokane Public Library.)*

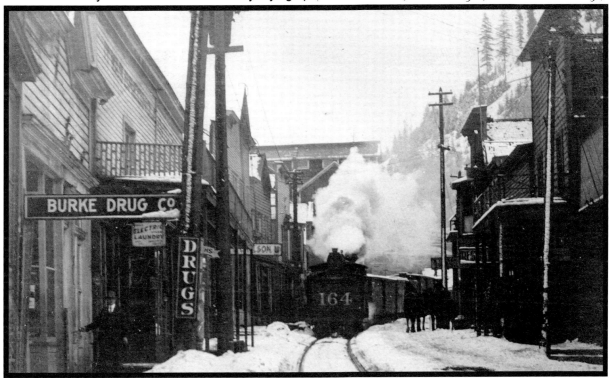

The main street of Burke in 1904. The Burke Drug Company (left) was Burke's first drug store. Built along Canyon Creek in a valley so narrow, Burke's main street was shared by the railroad tracks. Burke had a unique distinction of being the only mining town known to have a railroad before it had a wagon road. D.C. Corbin built a narrow-gauge railroad from Old Mission on the Coeur d'Alene River to Burke in 1887 (subsequently replaced by a standard gauge). In 1906 the Northern Pacific built a spur to the Hercules Mine loading platform at the east end of Burke, constructing its line through the four-story Tiger Hotel. *(Elsom photo courtesy Dean Ladd & Larry Elsom.)*

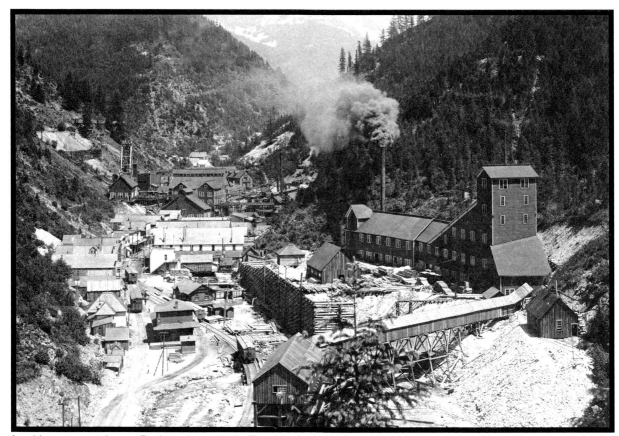

Looking east at lower Burke, circa 1905. The Hecla Mine is on the right and the Tiger-Poorman is in the distance. The Tiger-Poorman's boarding house (beanery) became the Tiger Hotel. In 1896 it was destroyed by fire. The Tiger Hotel was rebuilt farther up the canyon. Organized on June 13, 1885 and named for J.M. Burke, Burke became the center of union activity for the whole district. *(Photo courtesy Dean Ladd and Larry Elsom.)*

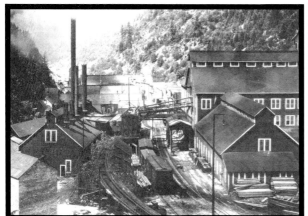 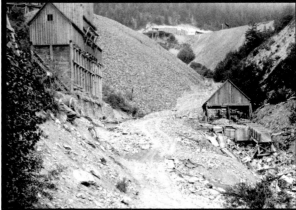

Left: The Tiger-Poorman Mine in Burke in the early 1900s. Numerous mines were located throughout the Canyon Creek region. The Hecla, Tiger-Poorman and the Hercules were Burke's most productive mines. The Tiger was the first discovery (1884) of silver-lead deposits in what became the greatest silver producing area in the world. In the mid-1890s, it was consolidated with the Poorman Mine, managed by Patrick "Patsy" Clark. *(Photo courtesy Spokane Public Library.)* **Right:** The Hercules Mine at Burke, circa 1930, after its closure in 1925. It produced over $43 million in silver and lead deposits. The "Mighty Hercules," as it was often called, was one of the richest silver discoveries ever made in Idaho. *(Magee photo courtesy Spokane Public Library.)*

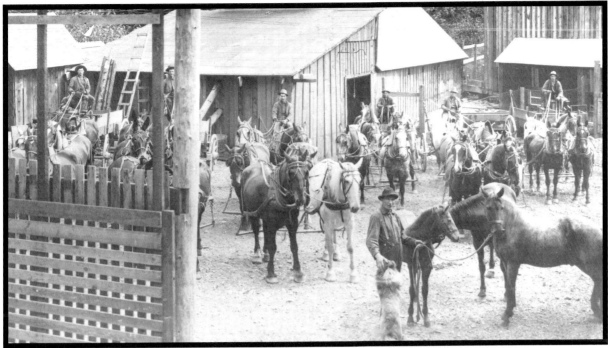

Eugene R. Day's Hercules teaming outfit at Burke in 1911. Eugene's brother Harry and partner Fred Harper discovered the Hercules in 1889. Harper sold his one-half interest before the true value of the mine was revealed in 1901 by Gus Paulsen. Drivers (L to R) are: Charles Cornelius, Tom Moore, Charley Williams, Jim Todd, Alonzo Sullivan and Ben Stringham. Andy Anderson (foreground) is with Eugene's dog Scot. *(Photo EWSHS, L86-325.30)*

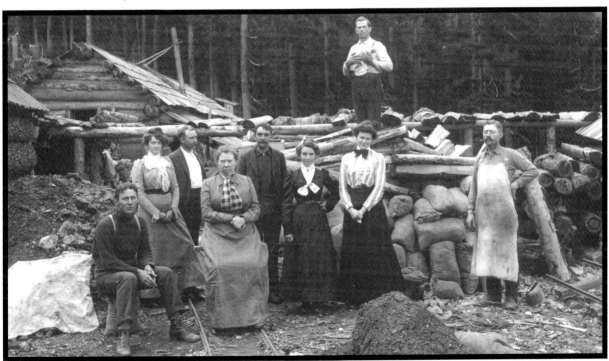

Some of the principal Hercules Mine owners. August "Gus" Paulsen is on the wood pile. Others are (L to R): Unidentified (sources vary on this man's identity), Emma Markwell, H.F. Samuels, May Hutton, Jerome Day, Miss Hedin (possibly Hadeen), Myrtle White Paulsen and Levi "Al" Hutton. The Hercules was developed and operated by the original group of owners, a unique situation in the district. *(EWSHS, Barnard Studio photo, L86-291)*

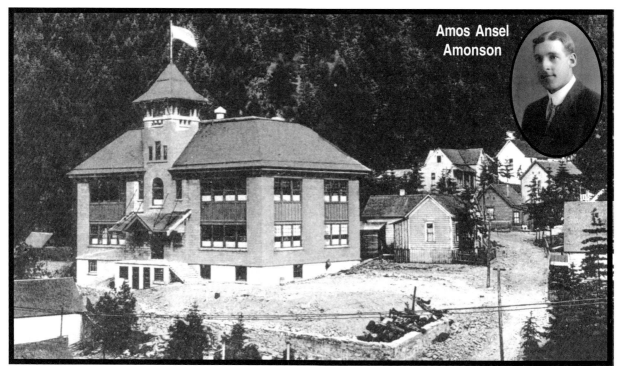

Burke School, circa 1900. A.A. Amonson (inset) grew up in Burke and graduated in 1911 in a class of two. He worked as a bookkeeper for numerous mining companies and an insurance company. His son John, a fount of knowledge about the area's history and its mining activities, has taught classes on the subject at Wallace High School and North Idaho College, and works at the Wallace District Mining Museum. John's great uncle, Carl Amonson, discovered the Hummingbird Mine. *(Photo courtesy Wallace District Mining Museum and (inset) John Amonson.)*

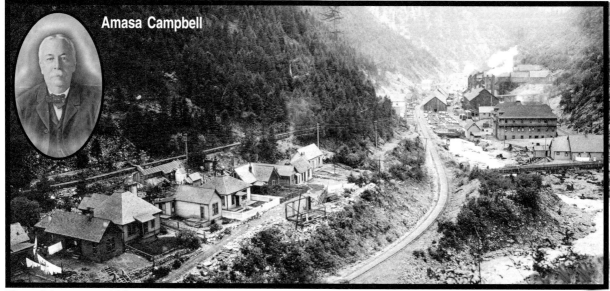

The mining town of Mace on Canyon Creek in June 1907. Mace was named for Amasa B. Campbell *(Inset-NWD)*, a mining magnate who was a principal owner of some of the most productive mining properties in the Coeur d'Alenes (including the Hecla, Standard and the Gem). He built a home in Wallace around 1890, but subsequently moved his family to Spokane, where he built a mansion in Spokane's historic Browne's Addition. The home was donated to the Eastern Washington State Historical Society by his daughter Helen (Campbell) Powell. It is part of the Cheney Cowles Museum and open to the public. *(Photo courtesy Spokane Public Library.)*

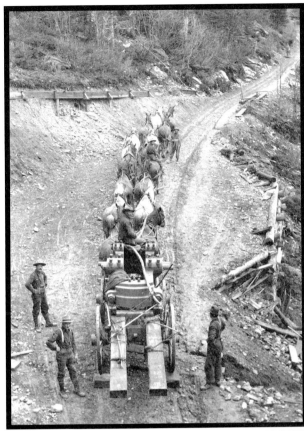

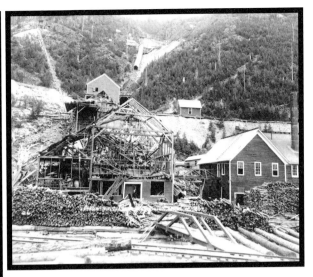

Above: The Frisco Mill (also called the San Francisco or Helena-Frisco) after it was blown up during labor problems in 1892. The Frisco mine, discovered in 1884, was located between Gem and Mace. **Left:** Transporting mining equipment (a babbitt bearing crusher) in the Coeur d'Alene mining region, circa 1900.

(Photos courtesy Spokane Public Library Northwest Room.)

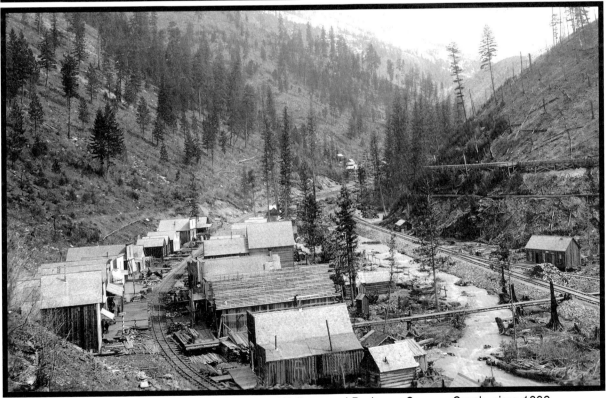

View of Gem, located midway between Wallace and Burke on Canyon Creek, circa 1892.

(Barnard Studio photo courtesy Spokane Public Library Northwest Room.)

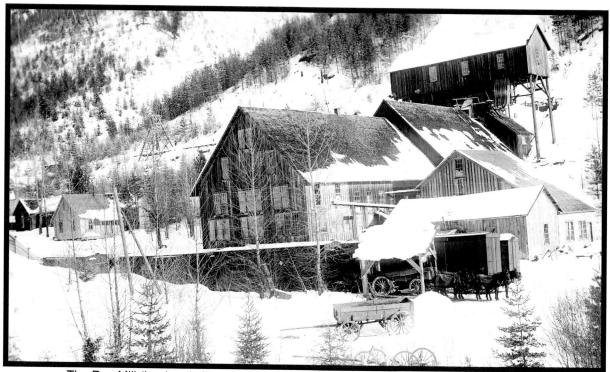

The Rex Mill (lead and silver) in Ninemile Canyon near Bradyville, January 15, 1911.
(EWSHS, Barnard Studio photo, L88-154.178)

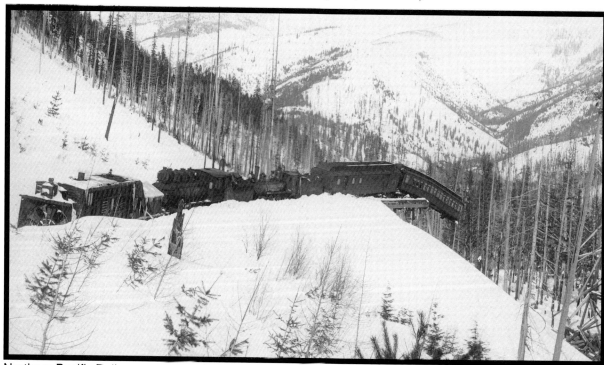

Northern Pacific Railway passenger train wreck at the "S" bridge over Willow Creek, 11 miles east of Wallace, June 10, 1903. Heavy snowpack on the steep mountains in the Coeur d'Alene region caused numerous deadly avalanches, especially along the canyon to Burke. An avalanche tore away 150 feet of this trestle, plunging the rear engine and caboose, carrying seven crew members, 75 feet to the creek below. Miraculously, although some were seriously injured, no one was killed. *(Barnard Studio photo courtesy Spokane Public Library.)*

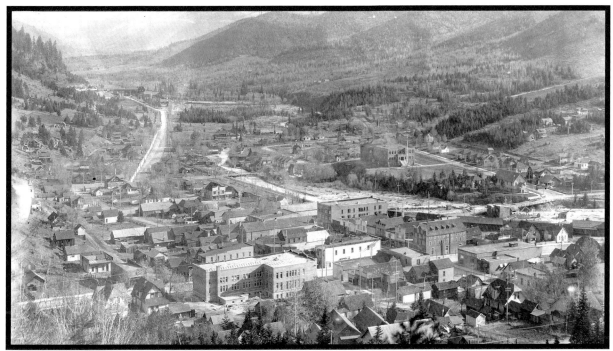

A bird's-eye view of Mullan looking east toward Mullan Pass (upper left), circa 1920. The townsite began to develop shortly after George Goode and C.A. Earle discovered the Morning and Evening Mines in July 1884. It was named for Captain John Mullan who supervised the construction of the Mullan Road (1858-1862). The road passed a few hundred yards from these ore bodies. In 1889 the N.P.R.R. tried to rename the town Ryan for Dennis Ryan, owner of the Gold Hunter Mine, discovered in 1884. *(EWSHS, Barnard Studio photo, L86-814)*

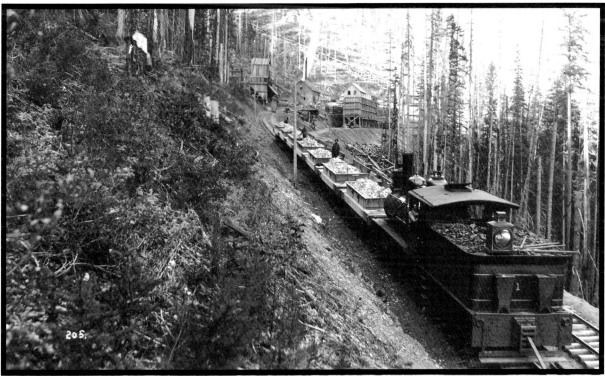

Hauling ore from the Morning Mine in its early days of operation. The Morning Mine was one of the first silver-lead mines in the Coeur d'Alenes and eventually part of ASARCO's holdings. *(Photo courtesy Spokane Public Library.)*

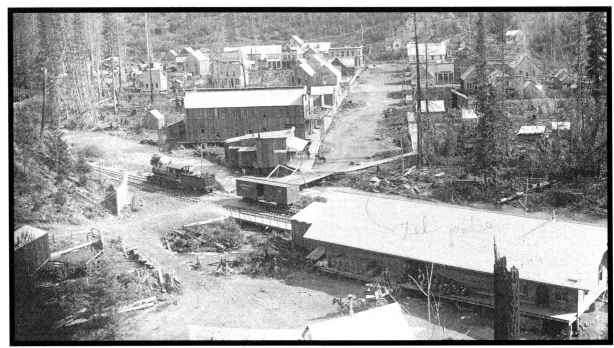

The town of Wallace in 1888. Situated at the confluence of Canyon, Placer and Ninemile creeks with the South Fork of the Coeur d'Alene River in the heart of the Coeur d'Alene District. It was a cedar swamp when Colonel William R. Wallace built his log cabin in 1884 and laid out a town called Placer Center. By 1885 the nearby gold was nearly exhausted, but the silver-lead properties on the South Fork of the Coeur d'Alene River had begun producing and attracting attention. Unlike many early mining towns, Wallace survived primarily due to its location on the main transportation route through the central valley. *(Elsom photo courtesy Dean Ladd & Larry Elsom.)*

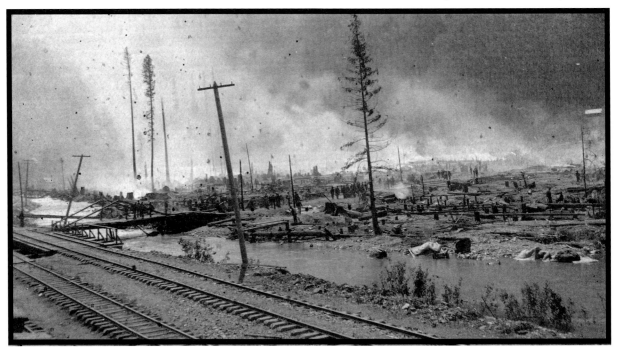

Wallace's business district after a fire on July 27, 1890. The town rebuilt, only to have another disastrous fire in 1898 and again in 1910, when the entire east side was destroyed by a forest fire that raged through the Inland Northwest. New buildings were masonry or brick construction. *(Barnard Studio photo courtesy Spokane Public Library.)*

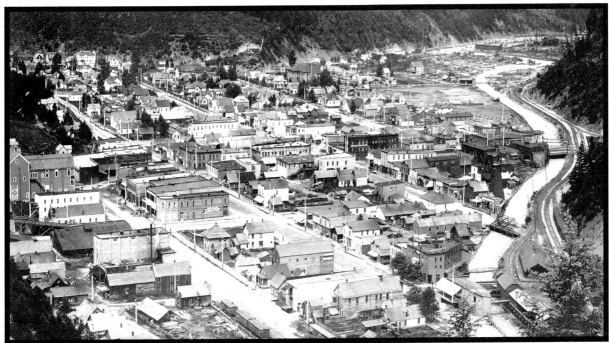

Looking west at Wallace in 1904. Wallace, the county seat since 1898, is one of the few cities in the United States to be listed in the National Historic Register in its entirety. *(Elsom photo courtesy Dean Ladd & Larry Elsom.)*

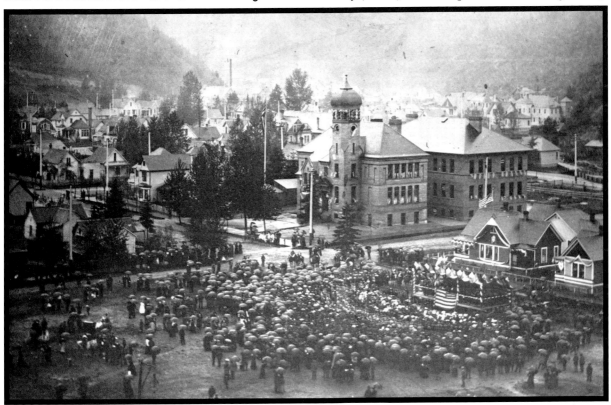

A crowd greeted President Theodore Roosevelt at Third and River Streets in spite of inclement weather on May 26, 1903. While Roosevelt was in town, he was a guest at the home of Al and May Hutton at 221 Pine. The beautiful school with the Moorish tower (center) was built in 1892. The large annex on the right was added in 1901. The school is barely visible at the top center of the above photo. *(EWSHS, Barnard Studio photo, L95-6.10)*

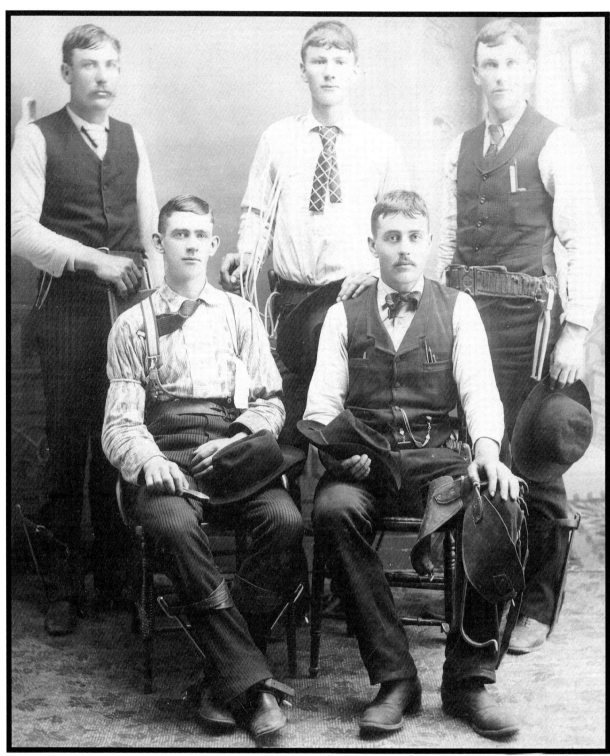

First telephone installers in Wallace, circa 1888. Thomas Elsom (front row, right) supervised the installation of the lines into the mining district. By November 1888, every mining town in the Coeur d'Alenes was connected by telephone. Elsom kept meticulous diaries. The entry of January 15, 1888 (while in the midst of stringing the telephone lines from Spokane into the mining district) read: "At Mission. Thermometer frozen at 40 below. I am a fool if I am here a year from now." The following year, he took charge of the Wallace office. Elsom was in Wallace when he received word of Spokane's disastrous fire. *(Elsom photo courtesy Dean Ladd & Larry Elsom.)*

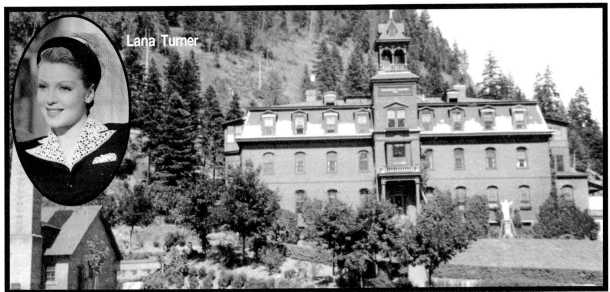

Lana Turner

The Providence Hospital in Wallace, circa 1925. The mines and miners had been paying into a fund for a much-needed hospital when they enlisted the aid of the Sisters of Charity, who built Providence in 1893. On February 8, 1921, it became the birthplace of movie actress Lana Turner, born Julia Jean Turner. In 1927 her family moved to San Francisco. At age 15, Lana was approached while sipping a coke at the Top Hat Cafe by W.R. Wilkerson, publisher of the *Hollywood Reporter,* who had noticed her beauty. With his help and connections, she was on the way to stardom as one of the greatest natural beauties in movie-screen history. She became known as MGM's "Sweater Girl" and was one of its leading ladies. *(Magee photo courtesy Spokane Public Library; Inset MGM Studios.)*

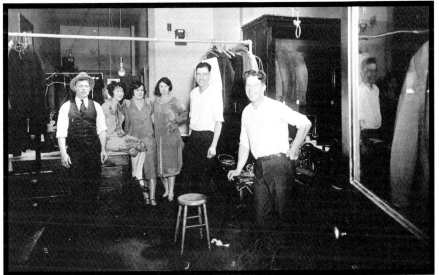

Left: The City Dye Works at 505 Bank Street, Wallace, in 1925. This dry cleaning business was owned by Lana Turner's father Virgil Turner (far left) and Merle Tidd (far right). The others shown are (L to R): Viola Tidd, Marjorie Robinson, Grace Powell and Jim Spain. When the dry cleaning operation failed, Virgil went to work in the mines. He later moved the family to California. On the evening of December 14, 1930, Virgil's body was found slumped against a wall at Mariposa and Minnesota Streets in San Francisco. Earlier that evening, he hit a winning streak at a crap game held in the basement of the San Francisco Chronicle Building. He had stuffed his winnings into his left sock. When his body was found, his head was bashed in and his left foot was bare. *(Photo courtesy Wallace District Mining Museum.)* **Right:** Lana Turner in Wallace at age 5.

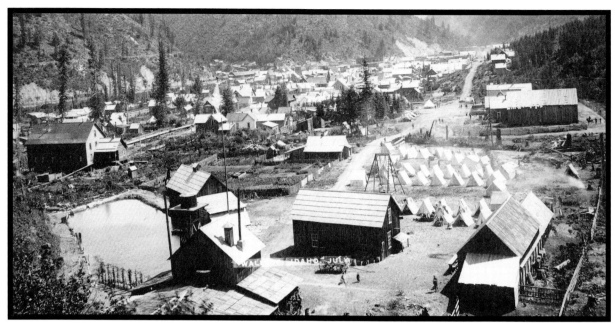

Wallace during the mining labor disputes in 1892, showing the "bull pen" (the large barn-like building with the fence to the right) and soldiers' tent camp. *(Barnard Studio photo courtesy Spokane Public Library.)*

The Mining Wars in the Coeur d'Alenes

With the discovery of the mineral deposits that lay beneath the earth's surface, hard-rock mining operations, requiring significant capital and expertise, began extracting the buried wealth. Mines were often managed by absentee owners and financiers from the east and west coasts. Unions formed to represent the laborers and, early on, strikes occurred. The miners lobbied for better wages and labor conditions. Many owners had boarding houses and company stores (with inflated prices), which required the miners' patronage.

The mine owners wanted to pay some of the underground laborers, such as muckers and shovelers, a lesser wage ($3.00 a day) than miners. The work was hard, dirty and dangerous for all the underground laborers, and they felt an equal wage should be paid (at $3.50 a day). Tensions escalated, resulting in the dynamiting of the Frisco Mill, gunfights at the Gem Mine and threats on the Bunker Hill on July 11, 1892. Six men died in the melee.

Federal and state troops were dispatched and martial law declared. Every able-bodied man was an instant suspect (even businessmen) and hundreds were arrested and put in concentration camps ("bull pens") in Wallace and Wardner. The conditions of the bull pens were miserable. Because of pressures from the union and the strain on the state's small treasury, most of the miners were released without further consequences. Only one man was brought to trial. Little was resolved in this labor dispute, but the unions were inspired to strengthen their position; they formed the Western Federation of Miners. Strikes continued during a tumultuous time for both miners and mine owners. In 1893 an economic panic swept the nation. The price of silver dropped, forcing many mines to either close or operate on an irregular basis.

The Bunker Hill and Sullivan Mining Company, located at Wardner Junction (now part of Kellogg), was the only major mine in the district to remain nonunion. However, as the economy began to recover in late 1893, even Bunker Hill agreed to the higher union wage – but not for long. The mines were prospering. As the mine

owners' prosperity increased, so did the militancy of the unions. Bunker Hill refused to unionize and attempted to employ only nonunion workers. A scheme to secretly unionize the company enrolled about 250 Bunker Hill employees in the union by April 1899, but when an attempt to openly unionize them failed, tensions increased.

Finally, on April 29, 1899, a mass movement was organized. A Northern Pacific train, with engineer Al Hutton, was hijacked at Burke. It was later dubbed the "Dynamite Express." An estimated 1000 men and 3000 pounds of dynamite were loaded en route to Wardner Junction. The enraged group blew up the Bunker Hill's mill and concentrator, which had been one of the largest and most advanced lead and silver concentrators in the world.

Again, martial law was declared (which lasted nearly two years) and troops dispatched. The aftermath of the 1892 labor insurgence was replayed in 1899. About 1000 miners were imprisoned in a bull pen near Kellogg and the state's budget strained under the weight of housing these men. (Most of the area's miners were in the bull pen, which essentially shut down all mining operations.) Among those arrested was Al Hutton. Although he was a quiet man, his wife May Arkwright Hutton was a force to be reckoned with. Two weeks later, her husband was released. Only one man was eventually convicted, but he was later given a full pardon.

The mine owners, backed by Governor Frank Steunenberg (later assassinated by Harry Orchard for his role), were intent on destroying the Western Federation of Miners. Any miner who did not swear to an anti-union pledge was blacklisted from working in the Coeur d'Alenes. Although this was illegal under an 1893 Idaho statute forbidding employers to deny employment because of union affiliation, instead of being upheld, the statute was repealed as being unconstitutional. The strength of the unions was gone. Most of the miners were released after several months, but few ever worked in the Coeur d'Alene mines again.

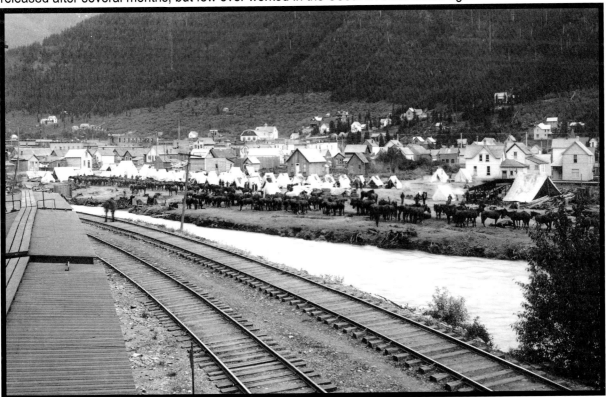

The town of Wallace housed many of the troops (note the tents) dispatched to the area after the explosion of the Bunker Hill Mill near Kellogg during the 1899 labor riots. *(Photo courtesy Spokane Public Library.)*

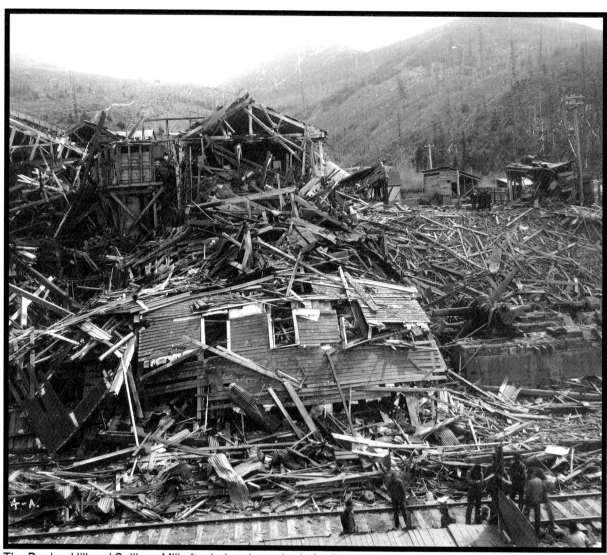

The Bunker Hill and Sullivan Mill after being dynamited, April 29, 1899. This was the Bunker Hill's second mill, which was built near present-day Kellogg (Wardner Junction) in 1890. *(EWSHS, Barnard Studio photo, L86-926)*

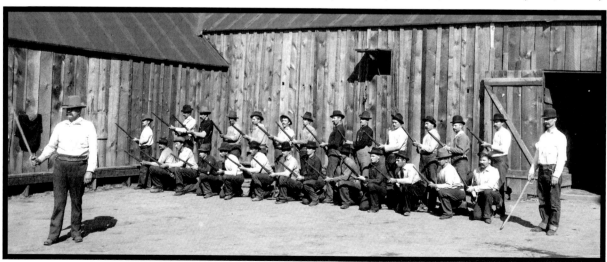

Drilling with wooden guns and swords in the Kellogg bull pen, 1899. *(Barnard photo courtesy Spokane Public Library.)*

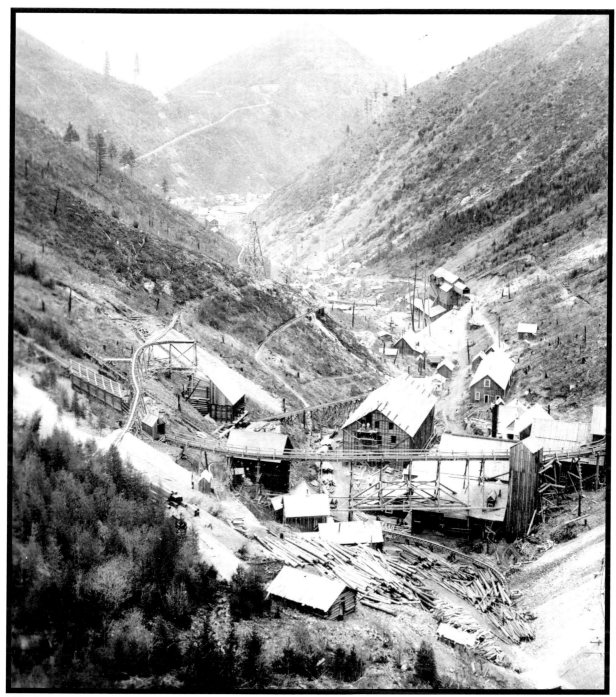

Milo Gulch, which extends from the base of Kellogg Peak north to Kellogg, circa 1890. In September 1885 the Bunker Hill deposit was discovered here by Noah S. Kellogg. Within days, the Sullivan mine, on the other side of the gulch, was discovered by Kellogg's prospecting partner Phil O'Rourke. James Wardner quickly claimed the water rights, giving him a large measure of control. (Sufficient water is an integral component of mining operations.) As the entrepreneur of the operation, Wardner secured financial backing from Governor Samuel T. Hauser of Montana. In 1887 financier Simeon Reed from Portland, Oregon, purchased the claims and incorporated the Bunker Hill and Sullivan Mining and Concentrating Company, which became the most successful mine in the district. Bunker Hill built additional mills and, in 1917, a smelter. Numerous other deposits and outcroppings were also discovered in Milo Gulch. *(Barnard Studio photo courtesy Spokane Public Library.)*

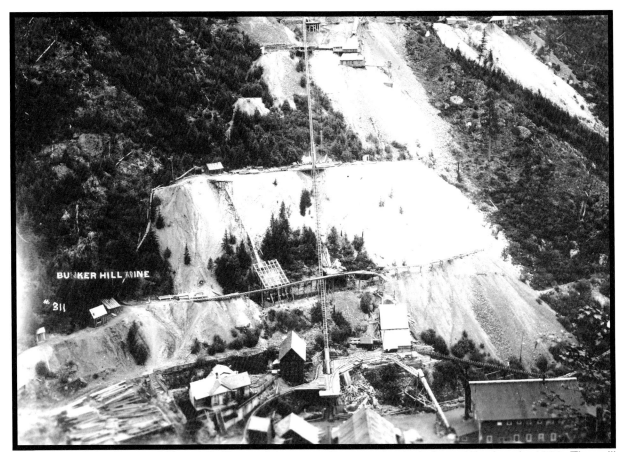

Early view of the Bunker Hill and Sullivan mining operation constructed above Wardner in 1886. The mill destroyed during the labor disputes was the concentrating mill, built in 1890, near the railroad at Wardner Junction (now part of Kellogg). In 1902 a two-mile-long tunnel was built to the mill, which bypassed Wardner. This had a negative impact on the town's economy and development. Before the tunnel, ore was transported to the concentrator by steel buckets over a 10,000-foot tramway. *(Photo courtesy Spokane Public Library.)*

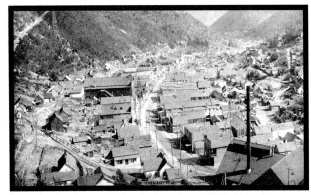
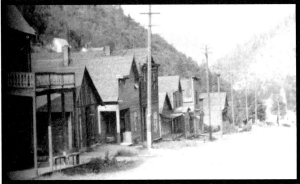

Left: At the time of this photo, circa 1900, Wardner was the second largest town (next to Wallace) in the mining district. The townsite was laid out and named Kentuck (also Kentucky) at a meeting in Dutch Jake's (Jacob Goetz) cabin on Milo Creek in October 1885. The post office application was denied, so they named it after Jim Wardner. *(Photo courtesy Chuck & Mary Lou Peterson, Wardner Museum.)* **Right:** Wardner, circa 1925, showing the present Wardner Museum at 652 Main when it was a store (far left). Chuck Peterson, Wardner's mayor for 20 years (1973-1985 and 1990-1998), always had a dream of owning a museum. He is now the curator of the Wardner Museum, which adjoins his and wife Mary Lou's gift shop. *(Magee photo courtesy Spokane public Library.)*

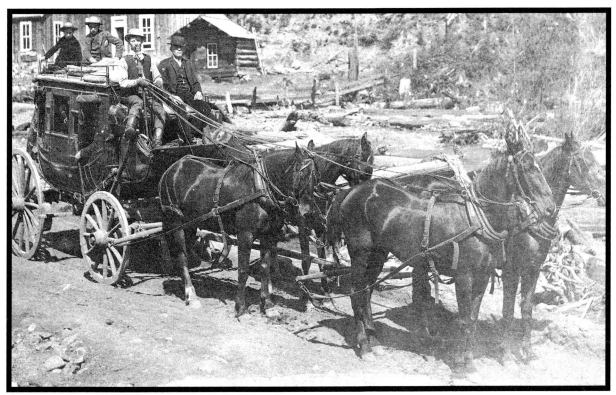

The Wardner-Wardner Junction *Black Mariah* stage coach in 1887. *(Photo courtesy Dean Ladd and Larry Elsom.)*

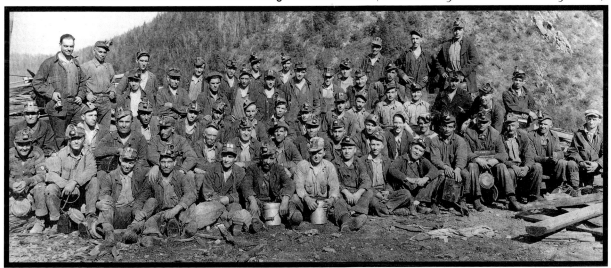

The Dobbins Stope crew at Bunker Hill, May 1931. Start bottom row (L to R): Chet Mielke, Ed Butler, Chet Grant, Cordy Parker, Billy Bishop, Bob Roberts, Maurice Williams, Ben Davey, Glenn Reynolds, Mr. Burns, Tony Valentine, Fred Mast, Tom Williams, Sid Caddy, Billy Sandow, Frank Huber, Joe Petrinovich, Walt Baade, Walt Reynolds, Billy Williams, "Sailor" Wm. C. Tregoning, Dick Jenkins, Ray Parker, Mr. Johnson, Harold Carlson, Burt Hughes, "Rolly" Williams, Clarence Weaver, Stanley ?, Merle Hooper, Henry Simmonds, Clifton Kemp, Sam Temby, Joe Gordon (Joe Gordon later became general manager of the Bunker Hill Mine), Earl Perkinson, Joyce Warren, John Matson, Tommy Rummerfield, unidentified, Lou Allison, Howard Reynolds, Forest "Coug" Farley, Pete Vasiloff, Curtis Redding, Cyril Sawyer, Sr., Chris Stendall, Max Sanger, Henry Roberts, Noble Hoffman, Little Mac ?, Esten Klontz, Dick Turnbow, Ernie Hoffman, Eddie Tregoning, Gather Johnson, Art Roose, Art Judah, Billy Besley, Walt Roose, Watkin Williams and Howard Simmonds. *(Photo courtesy Chuck & Mary Lou Peterson, Wardner Museum.)*

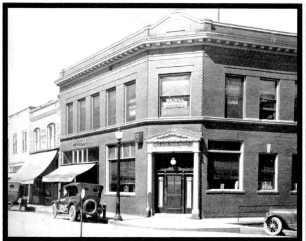
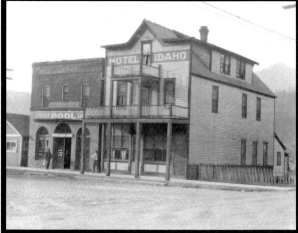

Left: First State Bank of Kellogg, corner of Main and McKinley, circa 1925. **Right:** The Hotel Idaho, circa 1925.

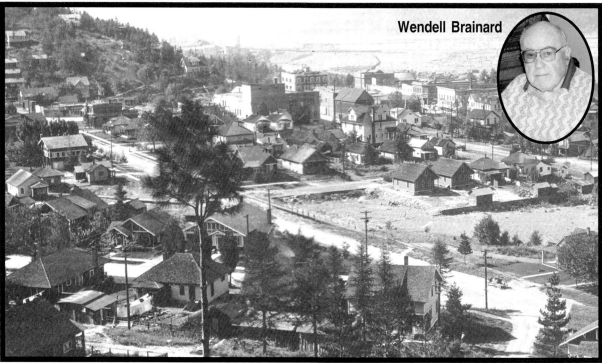

Wendell Brainard

View of Kellogg, circa 1925. Following the discovery of the Bunker Hill Mine in 1885, Robert and Jonathan Ingalls staked out a ranch site on a flat below Wardner. In January 1886 they laid out the town of Milo, later called Kellogg. Dutch Jake, proprietor of the Coeur d'Alene Theater in Spokane at the time, was one of the eight original owners of the town site. In addition to the Bunker Hill and Sullivan, Kellogg's economy prospered from the discovery and development of the Sunshine Mine, one of the world's largest silver producers. In May 1972, a tragic underground fire in this mine took the lives of 91 men. A monument was erected at the mouth of Big Creek in remembrance of the tragedy that affected every family in the Silver Valley. Kellogg's economy today is also supported by tourism. It boasts the longest single-stage gondola in the world. The gondola to the Silver Mountain Ski Resort operates year around. For 30 years beginning in 1948, Wendell Brainard (inset), a native of the Wardner-Kellogg area, reported on the area's changing developments as editor (succeeding his father) of the *Kellogg Evening News*. He coauthored a book entitled *Golden History Tales* and continues to write historical stories of the mining area. *(Magee photos courtesy Spokane Public Library; Inset courtesy Wendell Brainard.)*

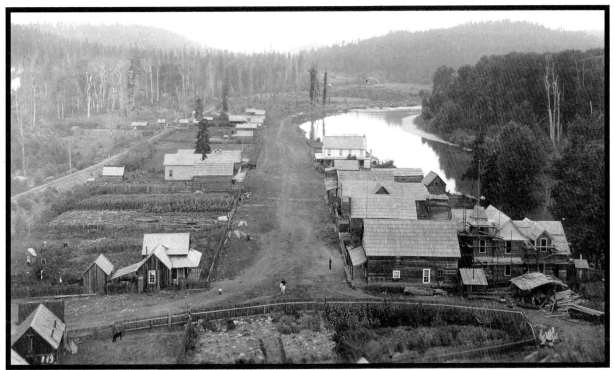

The town of Kingston in 1893. It was established in 1884 at the confluence of the North and South Forks of the Coeur d'Alene Rivers. During high water, the steamboats from Lake Coeur d'Alene could make it to Kingston (only to Old Mission, five miles west, in low water). *(Barnard Studio photo courtesy Spokane Public Library.)*

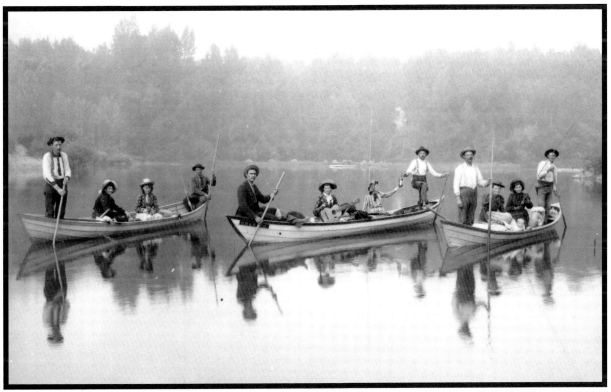

A boating party on the North Fork of the Coeur d'Alene River near Enaville in 1897.

(Barnard Studio photo courtesy Museum of North Idaho, Rec-7-2)

Right: A glimpse of the serenity and beauty of a cedar grove in the Pine Creek area, circa 1925. When the settlers began arriving in the Coeur d'Alenes, they reported forests of western red cedar so densely blanketing the valley bottoms along the streams and rivers that sunlight rarely found its way through the canopy.

Below: Pine Creek, a tributary of the South Fork of the Coeur d'Alene River, near McGoldrick Lumber Company's cedar camp southwest of Kellogg, circa 1925. McGoldrick's main operation was the largest sawmill to ever operate in Spokane, but it also had mills and substantial timber holdings in northern Idaho.
(Magee photos courtesy Spokane Public Library.)

Chapter 12

Kootenai County

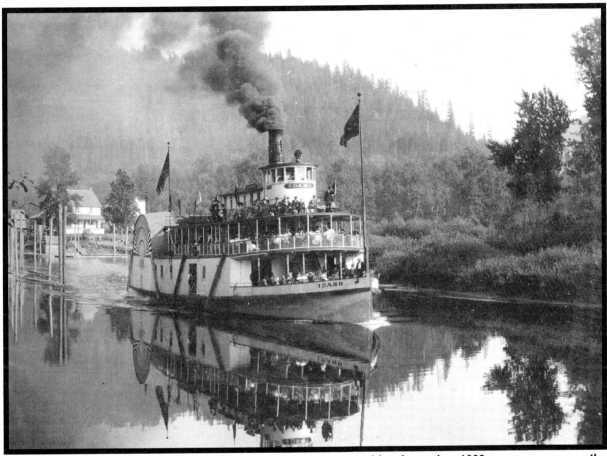

The steamer *Idaho*, circa 1908. The 147-foot side-wheeler, capable of carrying 1000 passengers, was the most palatial boat on Coeur d'Alene Lake. From its earliest known history, the lake has been the focal point and center of activity for Kootenai County: the native Indians depended on it for their survival; steamboat operations serviced the county's industries and entertained tourists; the timber industry used it as a giant millpond. Today it continues as the focal point for tourism and recreational activities.

(Photo courtesy Spokane Public Library Northwest Room.)

Kootenai County lies within the ancestral homelands of the Coeur d'Alene Tribe, but was named for the Kootenai Indians. As outlined in chapters 9 and 10, when Kootenai County was created in 1864, its boundaries were those of present-day Boundary and Bonner counties, which overlapped Kootenai aboriginal lands. An act in 1867 extended the county boundaries to include the area now occupied by Kootenai and Benewah counties. A provision to "perfect a county organization" required a population of at least 50 citizens, delaying the organization until October of 1881. At that time, the county seat was moved from Seneacquoteen (now in Bonner County) to Rathdrum. The boundary lines remained stable until 1907 when Bonner County became a separate entity and the county seat was moved to Coeur d'Alene. The formation of Benewah County followed in 1915, resulting in Kootenai County's present boundaries.

In 1842 Father DeSmet met with the Coeur d'Alene Indians on the shore of Lake Coeur d'Alene at the present site of the city of Coeur d'Alene. This meeting fulfilled a 100-year-old vision and prophecy by Chief Circling Raven that men in black robes would bring spiritual power and teachings to the Coeur d'Alenes. That prophecy was fulfilled with the construction of the Sacred Heart Mission, first wilderness mission in the state of Idaho, located on the St. Joe River about a mile south of the lake. Due to flooding problems, the mission was relocated in 1846 to a site along the Coeur d'Alene River near present-day Cataldo (see photos on page 20). The tribe assisted the Jesuit priests in building their beautiful "House of the Great Spirit" (also known as Old Mission and the Cataldo Mission), which is the oldest existing building in Idaho.

Old Mission was a silent witness to the region's early history. During its active years, the mission and its resident Jesuits played an active role in treaty and peacekeeping efforts during and after the Indian wars (see discussion about the wars in chapter 3). It also served as the headquarters for Captain John Mullan during the military road construction, a supply station and resting place for the ensuing rush of miners, prospectors and settlers into the area, and as a transfer point between the steamboats and railroads servicing the Coeur d'Alene Mining District. When Governor Stevens passed through the area in 1853 in search of a railroad route, he was a guest at the Old Mission. However, first and foremost, the mission was the center of the Coeur d'Alenes Indians' activities, a place to which their spirits were deeply connected and from which their eventual departure was filled with grief.

The Coeur d'Alene Indians' ancestral lands covered four million acres in the Idaho Panhandle and Eastern Washington. They were a Salish-speaking tribe whose villages were concentrated along Lake Coeur d'Alene and the Coeur d'Alene, St. Joe and upper Spokane rivers. The French-Canadian fur traders are credited for the name by which they are presently known, which literally translates "heart of the awl." Available literature suggests various interpretations and reasons for the name, but generally seems to reflect upon the shrewd ways in which these Indians traded and bargained with the fur traders. The fur traders were not allowed to establish trading posts within their territory and trade was by the Coeur d'Alenes' terms.

During the Colonel Wright campaign, the Coeur d'Alenes sustained material losses, but no loss of lives or lands. They signed the Treaty of Peace and Friendship with the United States Government, which they honored. They agreed to allow non-Indians to pass through their country, effectively opening the way for the construction of the Mullan Road. This road passed through Kootenai County from the Spokane River's intersection with the Idaho-Washington border, east along the north shore of Coeur d'Alene Lake (present site of the city of Coeur d'Alene), and exited just beyond Old Mission. (Originally the road was built south of Lake Coeur d'Alene, angling northeast to the mission, but because of flooding, was rerouted along the northern shore of the lake.)

Talk of moving the Coeur d'Alenes to a reservation was interrupted in 1858 by the wars involving Steptoe and Wright. The issue was taken up again in 1873 and stretched through two decades of complicated and frustrating negotiations. In the process, the proposed reservation, which originally included all of Lake Coeur d'Alene, was systematically reduced in size relative to the growing population and demands of the newcomers. In time it became evident Old Mission would not be within the bounds of the reservation, and the Jesuits convinced the reluctant tribe to relocate to the present mission site at De Smet in Benewah County. An 1889 treaty was signed a few years later, establishing the present triangular-shaped reservation covering the lower southwest corner of Kootenai County and half of Benewah County. This reservation, designed in favor of the newcomers' demands, still did little to protect the Coeur d'Alenes from the loss of their lands. The reservation was subsequently opened to homesteaders. The Coeur d'Alenes' lands were effectively reduced from 4,000,000 to 58,000 acres.

In 1877 General Sherman led an inspection tour through the Northwest in search of suitable military fort sites. With the embers from the war in southern Idaho against Chief Joseph and the Nez Perce still smoldering, and relations between the native people and the newcomers tentative, military forts provided a sense of security. Favorably impressed with the Coeur d'Alene region, Sherman recommended Congress establish a military fort on the north shore of the lake. This proved to be one of the most significant events in the county's history. The fort was built in 1878 and garrisoned the following year. A need for troops to settle problems between the newcomers and the Indians never arose, but the fort quickly became the hub around which the town of Coeur d'Alene developed. The first steamboat on the lake, the *Amelia Wheaton*, was built at the fort and launched in 1880 to transport feed for the fort's mules and cordwood. The launching of the *Amelia Wheaton* heralded the start of a steamboating industry on Lake Coeur d'Alene and its network of waterways that thrived for 35 years. It was key to the development of the county's timber, mining, agricultural and tourism industries. In 1898 the Fort Sherman troops were called to serve in the Spanish-American War and the fort closed soon thereafter. Years later, another military base was established in Kootenai County. Farragut Naval Training Center, the second largest training station in the United States, was built on Lake Pend Oreille near Bayview in 1942.

Almost simultaneously in 1883, the gold discovery in the Coeur d'Alenes was announced and the Northern Pacific Railroad completed its transcontinental line, crossing diagonally through the northwest corner of Kootenai County. The train stopped at the little community of Rathdrum and, with hoards of prospectors requiring supplies, the population exploded to around 1000. In the spring of 1886, Daniel C. Corbin stopped in Rathdrum on his way to investigate the viability of a railroad into the mining district. The distance from Rathdrum to the steamboats on Lake Coeur d'Alene was a grueling 15-mile journey by stagecoach and from the steamboat landing at Old Mission to the mines was even worse, to say nothing of the difficulty of transporting ore from the mines. Corbin immediately began arrangements for the construction of two railroad lines, steamboats to connect the two lines and a new dock at the town of Coeur d'Alene. Within a few months, a connection to the Northern Pacific at Hauser Junction bypassed Rathdrum en route to the Coeur d'Alene dock. This move drained much of the mining district business away from Rathdrum, putting the city of Coeur d'Alene in the spotlight.

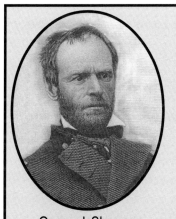

General Sherman

The famous Civil War general William Tecumseh Sherman, could technically be considered the "Father of Coeur d'Alene" as he chose the site upon which the city was built. The main street in the business district of Coeur d'Alene bears his name and the fort originally named Fort Coeur d'Alene was later changed to Fort Sherman in honor of the general. The former site of Fort Sherman is now the campus for North Idaho College.

Sherman was originally from Lancaster, Ohio, and was educated at the U.S. Military Academy. Following an undistinguished military career, he resigned from the army in 1853 to became a partner in a banking firm in San Francisco. He later became the president of what is now Louisiana State University. When the Civil War broke out, he rejoined the army, was put in command of a volunteer infantry regiment and promoted to the rank of brigadier general. During his time as an officer for the Union Army, he received a number of promotions and major assignments. He is most noted for his capture and burning of Atlanta, which was followed by his famous "Sherman's march to the sea." This was a decisive blow to the Confederate armies, bringing an end to the Civil War. In 1868 Sherman was promoted to the rank of full general and given command of the entire United States Army. The phrase "war is hell" came from him.

Left: A large quiet pool in the upper reaches of the North Fork of the Coeur d'Alene River, circa 1897. *(Photo courtesy Spokane Public Library Northwest Room.)* **Right:** Beauty Bay, Coeur d'Alene Lake, circa 1940. In 1880 Fort Coeur d'Alene launched the *Amelia Wheaton,* the first steamboat on Lake Coeur d'Alene. Captain C.P. Sorenson skippered the boat through the uncharted waters and named most of the bays and points as they appear on maps today. The lake is about 25 miles long but, because of its irregular shape with numerous bays and inlets, the shoreline distance is about 104 miles. *(Photo courtesy Wallace Gamble.)*

Scene at Fernan Lake in 1920. *(Photo courtesy Museum of North Idaho, Fer-1-8)*

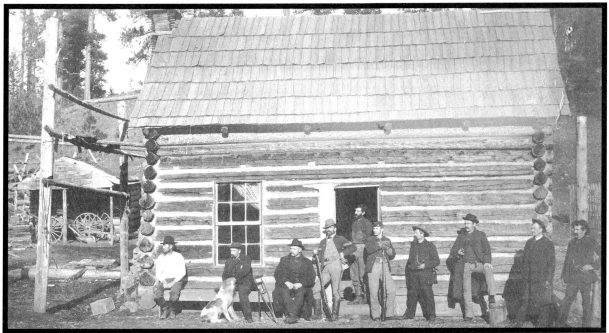

Wolf Lodge telephone test station in 1888. Thomas Elsom supervised the installation of the first telephone lines and sets from Spokane to the Coeur d'Alene Mining District. *(Elsom photo courtesy Dean Ladd & Larry Elsom.)*

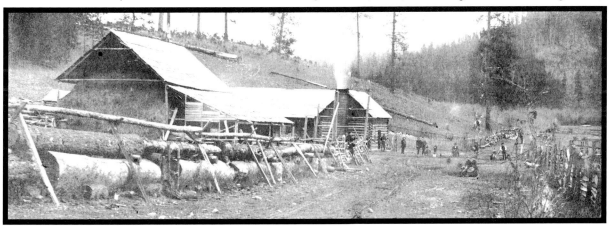

The telephone office at Wolf Lodge (northeastern end of Lake Coeur d'Alene) in 1890.

(Elsom photo courtesy Dean Ladd and Larry Elsom.)

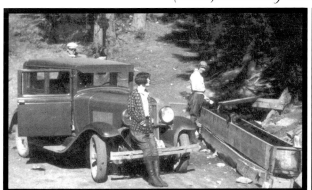

Left: On the Wolf Lodge road, circa 1930. *(Magee photo courtesy Spokane Public Library.)* Right: Norman's Telephone System (see page 204) office at Old Mission in 1889. *(Elsom photo courtesy Dean Ladd & Larry Elsom.)*

From about 1920 until his death in 1953, Charles Dickens Magee (center, circa 1931) actively combined his interests in photography, hiking and climbing. Over the years, Magee belonged to three hiking clubs and the Spokane Camera Club. He joined the Spokane Mountaineers around 1920. A group who wished to do more strenuous hiking formed the Spokane Trail Club. In 1952, just before his 67th birthday, he founded the Hobnailers Hiking Club. Magee was also a commercial artist who created much of the art work his employer, The Engraving Company, sold to the local newspapers for advertising. He compiled several well-documented albums of unique, beautiful and historical photos of the Inland Northwest, which now belong to the Spokane Public Library's Northwest Room and the Eastern Washington State Historical Society. Many of Magee's photos appear throughout this publication. *(All Magee photos on this page courtesy Spokane Public Library.)*

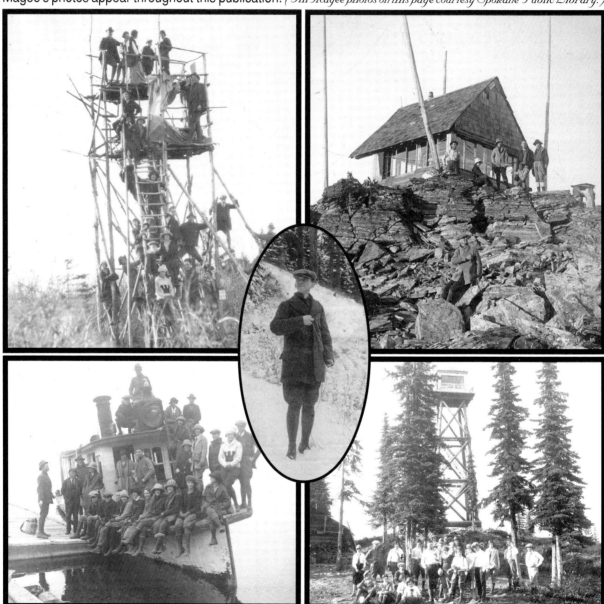

The Spokane Trail Club in the 1920s (clockwise from upper left): Summit of Coeur d'Alene (formerly Sticker) Mountain; Chilco Mountain lookout cabin and (L to R) L.O. Altman, Elizabeth Hampe, Ruth Newman, Wilmer Froistad and William Turner. Charles Magee is barely visible on the rocks below; an overloaded "charter boat" on Lake Coeur d'Alene's Turner Bay; and Copper Mountain Lookout in the Coeur d'Alene National Forest.

Upper left, right and lower left: Bear cubs investigating the photographer's camera and exploring the area at Fourth of July Summit, circa 1925. **Lower right**: Friendships only go so far when it comes to sharing dinner. *(Magee photos courtesy Spokane Public Library.)*

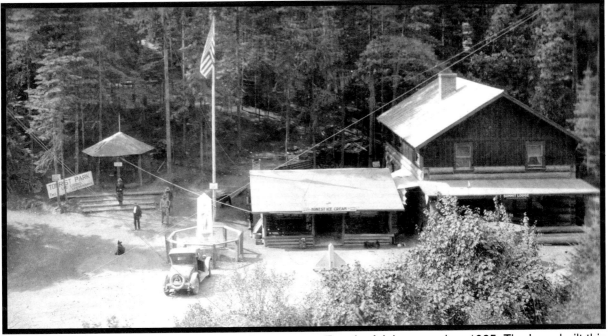

Lees' Summit Lodge, the Mullan Tree and Monument on Fourth of July pass, circa 1925. The Lees built this lodge and gas station on leased forest service land. Their trained bear and pet deer entertained travelers who stopped to rest at this popular spot. *(Postcard courtesy Spokane Public Library, Magee collection.)*

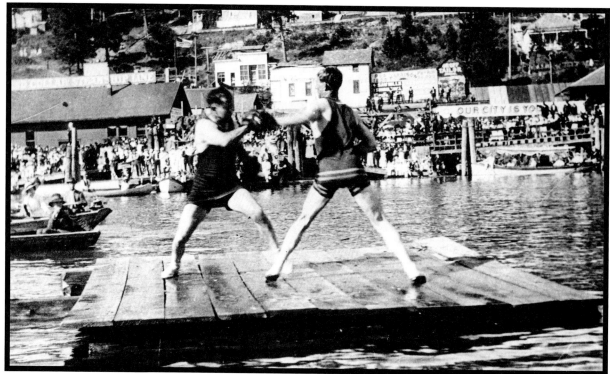

A boxing match between Harvey Kelly and George Moyers during a regatta at Harrison on July 4, 1916. Harrison was Kootenai County's largest town at the time of the 1900 census. *(Photo courtesy Museum of North Idaho, Har-3-3)*

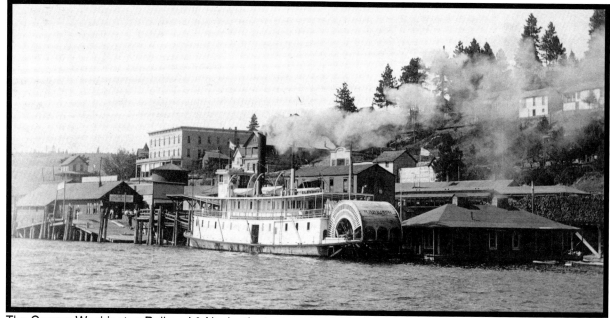

The Oregon Washington Railroad & Navigation's steamboat *Harrison* docked at Harrison, located on the east side of Lake Coeur d'Alene near the mouth of the Coeur d'Alene River, circa 1915. The *Harrison* was built around 1912 at the Harrison docks and was one of the largest boats on the lake. It met the trains from the mining district and connected to trains in Amwaco (west side of the lake) and Coeur d'Alene, making Harrison the transportation hub for the area. Fred Grant's sawmill, established in 1891, was the first of many around Harrison. In 1917 much of the town was destroyed from a fire at the sawmill on the waterfront. The large building on the upper bank to the left of the steamer is the Harrison Hotel. *(Magee photo courtesy Spokane Public Library.)*

Hotel Conkling at Conkling Park, near the south end of Lake Coeur d'Alene, circa 1925. In earlier days, two daily Red Collar steamers connected Conkling Park with Coeur d'Alene. *(Magee photo courtesy Spokane Public Library.)*

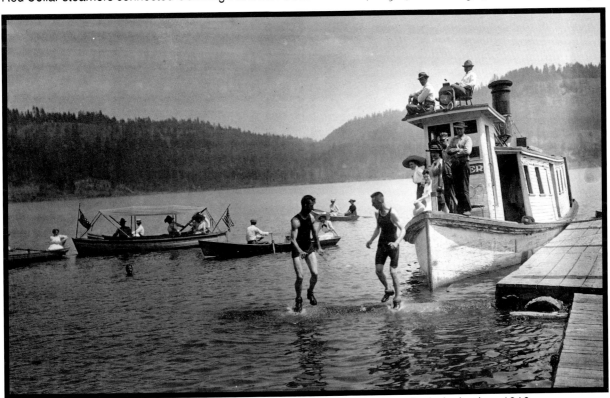

Log rolling contest on Coeur d'Alene Lake at the Conkling Park dock, circa 1910.
(Frank Palmer photo courtesy Museum of North Idaho, Rec-16-10)

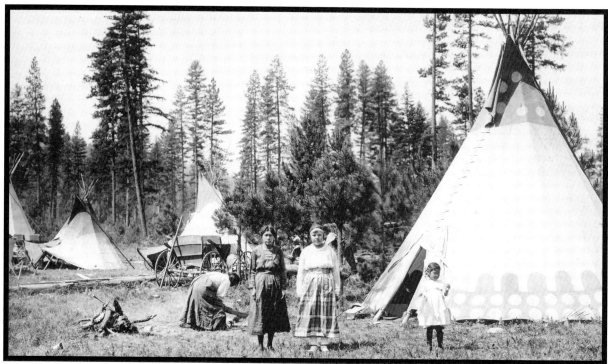

A family encampment on the Coeur d'Alene Reservation, circa 1900. The arrival of the Whites and subsequent move to the reservation was filled with adversity and difficulties. The Coeur d'Alene Tribe was fortunate to have the leadership of Chief Andrew Seltice, head chief from 1865 until his death in 1902. He was recognized as one of the most intelligent and influential chiefs in the Northwest. *(Frank Palmer photo courtesy Spokane Public Library.)*

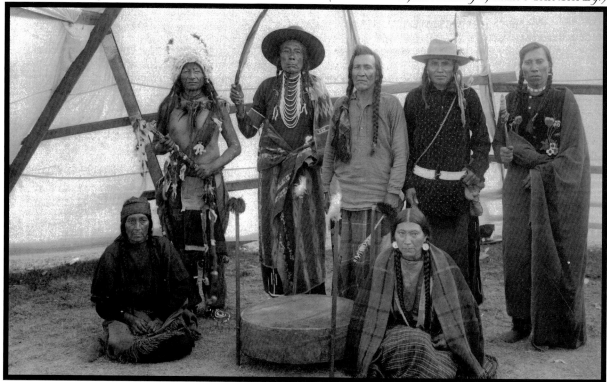

Members of the Coeur d'Alene Tribe in 1915.
(Photo courtesy Spokane Public Library.)

The Trail Club on Shasta Butte, circa 1930. The view is overlooking the Spokane River valley near Post Falls. Mount Spokane, Hauser and Newman Lakes are in the distance. *(Magee photo courtesy Spokane Public Library.)*

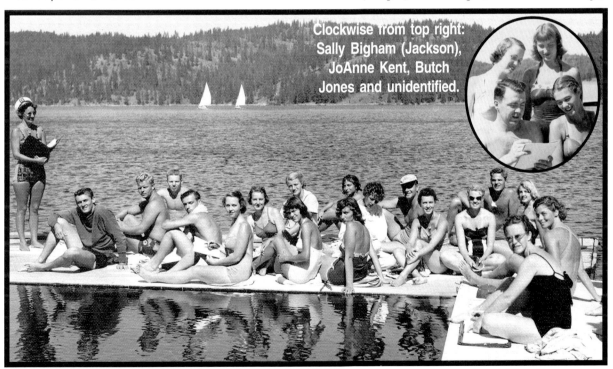

Clockwise from top right: Sally Bigham (Jackson), JoAnne Kent, Butch Jones and unidentified.

National Aquatic School at Camp Sweyolakan, the Camp Fire Girls' recreation center at Mica Bay on Lake Coeur d'Alene, in 1952. Butch Jones (inset) was head of aquatic instruction in Spokane County. Sally Bigham Jackson (inset and front row, 5th from instructor) received a scholarship to this school and is presently in her 48th year of teaching swimming lessons in the Spokane Valley. JoAnne Kent (inset) was also a Valley swim instructor.

(Photos courtesy Sally Bigham Jackson.)

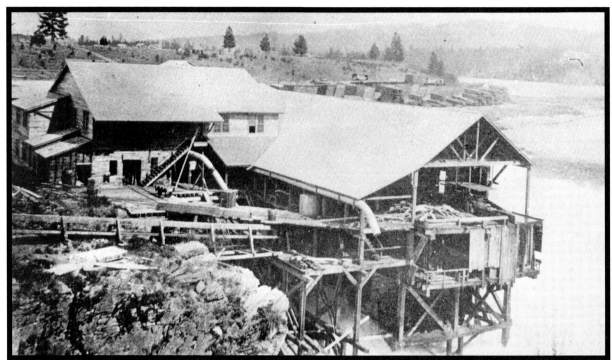

Idaho Lumbering and Manufacturing Company at Post Falls prior to being destroyed by fire in December 1902. Frederick Post, for whom the town of Post Falls was named, built the original mill in 1880 and sold it in 1894. He came through the area in 1871 and negotiated with Chief Andrew Seltice to secure the land at this site for a sawmill. While awaiting for approval from the Department of the Interior, James Glover enticed him to move to Spokane Falls and build a flour mill. He completed the mill in 1877, the first in Spokane, but soon returned to Post Falls to build his sawmill. His was the first commercial sawmill in Kootenai County.

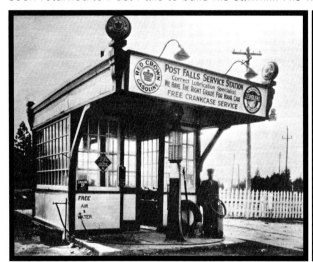 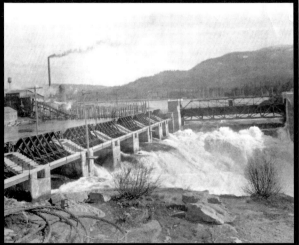

Left: Post Falls Service Station built by Joe Falter (standing at the corner of the station) and Mr. Sherwood. It was built about 1928 and demolished around 1939. **Right:** The WWP operations as they looked on March 29, 1923. This dam was built in 1906 on the north channel of the Spokane River. Frederick Post was the original owner of these water rights. A group of mine owners purchased the rights from Post to provide power to the mining district. The Washington Water Power Company later purchased the site and by 1903 ran power lines from Spokane to Burke. Post Falls Lumber and Manufacturing Company (in the background) was built in 1905 by H.M. Strathern, president of the company that purchased Frederick Post's mill in 1894. *(Photos courtesy Post Falls Historical Society.)*

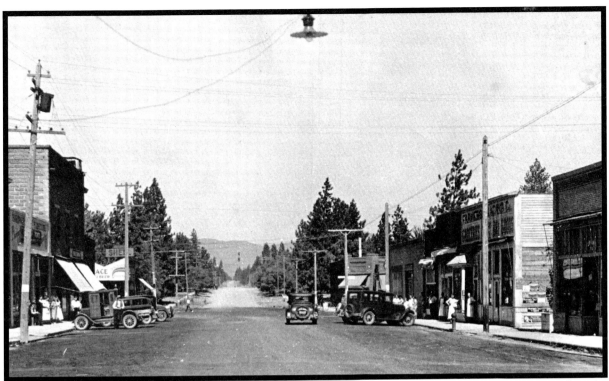

Spokane Street in downtown Post Falls on September 9, 1936. Before the new settlers began to arrive, the Coeur d'Alene Indians had a village here known as Q'emilin (spellings vary) meaning "throat of the river." Today the city park on the south side of the Spokane River bears the name. They also had prosperous farms in this area before moving to DeSmet in 1878. The town grew quickly after D.C. Corbin built the railroad line between Hauser Junction and Coeur d'Alene, passing through Post Falls, and prospered with the construction of Washington Water Power's dam. *(Photo courtesy Post Falls Historical Society.)*

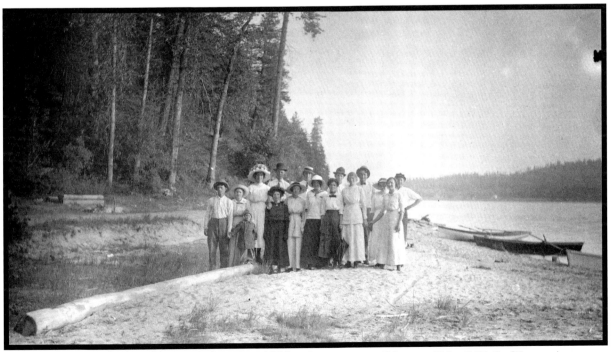

A group picnic at Hauser Lake, circa 1910. *(Photo courtesy Museum of North Idaho, Hau-1-2)*

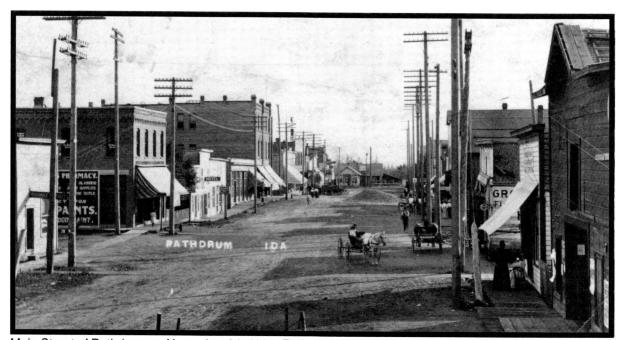

Main Street of Rathdrum on November 24, 1908. Rathdrum is one of the oldest towns in north Idaho. The first cabin was built in 1861 by a hunter and trapper named Connors who sold his squatter's rights to Frederick Post in 1871. The cabin became a relay point on the pony express route from Walla Walla, Washington, to Missoula, Montana. Post eventually transferred title to his son-in-law Charles Wesley Wood. When the post office was established in 1881, it was named Westwood for Wesley Wood. Since there were too many similar names, the application was rejected. M.M. Cowley, then living at Spokane Bridge, came up with the name Rathdrum after his hometown in Ireland. Rathdrum is located at the north edge of the Rathdrum Prairie and the town site, which was platted in July 1881, was covered with yellow pine. Frederick Post built a sawmill in 1882 and installed a water works system the following year. After the timber was harvested, the agricultural potential was realized and it is now a major Kentucky bluegrass seed growing area. Settlers started arriving as a result of the Northern Pacific survey and it became an important stop on the line as it was being built through the area in 1881. In 1883 when the gold rush ensued, a rivalry developed between Spokane and Rathdrum to outfit the prospectors. Both towns ran stage lines to Coeur d'Alene, where the prospectors met the steamboats. Rathdrum was the county seat from 1881 until 1907. *(Photo courtesy Museum of North Idaho, Rat-1-2)*

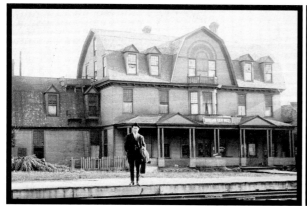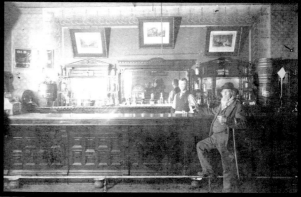

Left: Mountainview Hotel (originally the Wright Hotel) in Rathdrum was built in 1890 by M.D. Wright and Benjamin F. Butler. *(Photo courtesy Pend Oreille County Historical Society.)* **Right:** McGinty Bar in Rathdrum in the late 1890s. Antoine Rusho is standing at the bar. *(Photo courtesy Fielden Poirier Jr., great-great grandson of A. Rusho.)*

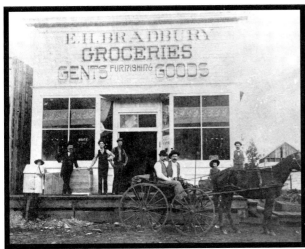
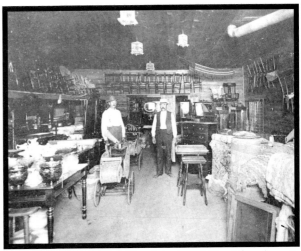

Left: E.H. Bradbury's grocery store was one of the first in Rathdrum. **Right:** The interior of Fred Bradbury's general store, circa 1885. Before moving to Rathdrum, Fred Bradbury had a freight line in Walla Walla and ran freight wagons during the war against Chief Joseph and the Nez Perce in 1877. *(Photos courtesy Fielden Poirier*

Boating at Twin Lakes in the 1920s. With the construction of Frederick Blackwell's Idaho and Washington Northern Railroad, Twin Lakes, first known as Sturgeon, became a popular recreational spot. Summer homes and resorts quickly followed. The railroad had a depot with passenger and freight service. The first train stopped on January 25, 1908, and made daily trips until about 1920. *(EWSHS, Tolman photo, L84-286.19)*

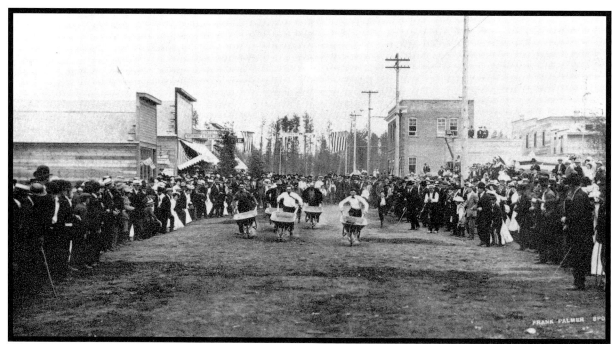

Wheelbarrow races on Fourth Street in Spirit Lake, July 4, 1908. Although already becoming a popular resort area by 1891, the town was laid out by Frederick A. Blackwell in 1907. An honest, decent man with dreams of creating the ideal town, he contributed extensively to the development of the region. His Idaho and Washington Northern Railroad, a first-class line with connections to Spokane, began near Post Falls, and extended to Metaline Falls, Washington, in 1910. He was also instrumental in the development of Ione and Usk in Pend Oreille County, Washington. He founded the Panhandle Lumber Company, with sawmills in Spirit Lake and Ione, and was a financial backer and officer of the cement plant in Metaline Falls. *(Photo EWSHS, L86-980)*

Left: Panhandle Lumber Company sawmill at Spirit Lake, as viewed from the bridge, circa 1928. The I.& W.N.R.R. Depot is visible at the upper right. During the construction of the railroad, Kirtland Cutter designed depots at Spirit Lake, Rathdrum and Newport, Washington. (The Newport depot is now the Pend Oreille County Historical Society Museum.) The area around Spirit Lake was heavily timbered when Frederick Blackwell and his associates built the mill in 1907, but most of timber came from the east slope of Mt. Spokane. On August 5, 1939, a fire began on Mt. Spokane and six days later spread to Spirit Lake. It destroyed the lumber yard and most of the mill. The following year, the company began liquidating, which was disastrous for the economy of both Spirit Lake and Ione. The company's office building (left of the depot) survived the fire and was later moved to the lake shore. Today it is a restaurant and bed-and-breakfast called the Fireside Lodge. **Right:** Brickel Creek, which flows into the west end of Spirit Lake, in 1923. *(Magee photos courtesy Spokane Public Library.)*

322

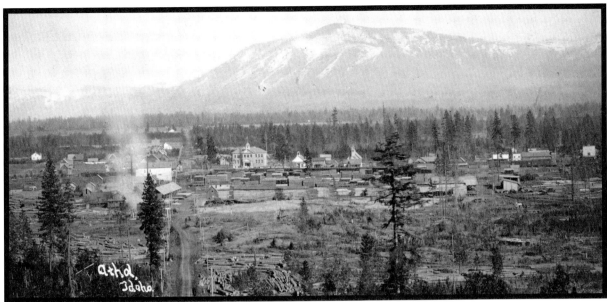

The town of Athol in 1910. The large building at the center was the school. Athol was situated in the midst of a heavily timbered region. Once the timber was harvested, the area became a productive agricultural and stock raising center. D.C. Corbin, railroad entrepreneur from Spokane, established the Corbin Ranch between Athol and Hayden Lake. With the help of Japanese laborers, he produced fruit, grain, hay and beets, which were processed at his beet sugar factory in Waverly, Washington. Athol became a stop on the Northern Pacific line and two of its first settlers were foremen on the railroad. *(Photo courtesy Museum of North Idaho, Ath-1-4)*

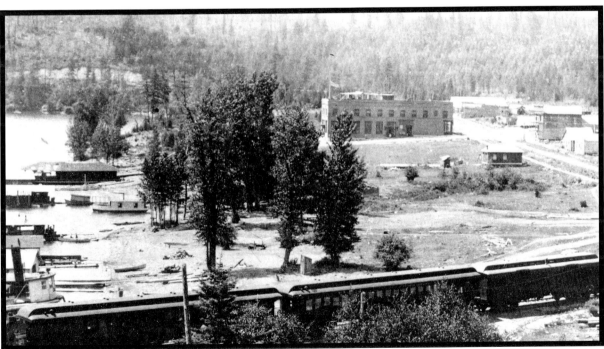

The town of Bayview on Pend Oreille Lake's Scenic Bay in 1908. The bay and the town were originally called Squaw Bay. In the early 1900s, the little resort and fishing village became known as Bayview. After construction of a spur line in 1911 from the Spokane and International Railroad, Bayview flourished as a tourist spot and a new town site was laid out by Spokane's Prairie Development Company. During WWII it was the site of Farragut Naval Training Station. There were about 55,000 men stationed there at any one time. *(Photo EWSHS, L86-48.54)*

Golfers at the Bozanta Tavern at Hayden Lake in 1912. In 1907 the Hayden Improvement Company purchased land from C.B. King and built this first-class resort, designed by Kirtland Cutter and landscaped by the Olmsted Brothers. They also laid out the town site on John Hager's homestead. Hayden Lake received its name from one of the first homesteaders at the lake, Matthew Hayden, a soldier from Fort Sherman. This had been a popular gathering spot for the Coeur d'Alene Indians. The name Bozanta is an Indian word meaning "meeting place by the lake." The resort offered an array of lodging, dining, entertainment and sport facilities. It had one of the first golf courses and also the first 18-hole course in Idaho. Bozanta became a destination spot heavily promoted by the Spokane and Inland Empire, the electric line owned by Jay P. Graves. (The railroad and the resort had some of the same owners.) Frequent trains ran between Spokane and Hayden Lake. A preview event prior to the formal opening was hosted for some of the Spokane and Coeur d'Alene social elite. In 1909 it was visited by United States President William H. Taft. After the Depression and the war years took their toll on the resort, it was rescued by members of the local golf community as the Hayden Lake Country Club. *(Photo EWSHS, L94-57.1)*

Bing Crosby behind the bar of the Red House at the Bozanta Tavern, circa 1935. The Red House was the former Hager farmhouse turned nightclub. The only known identities are (R to L): Dr. Harold Anderson (holding drink), Ralph Bockmier, Charles McCoubray, Gladys McCoubray and Turner Bockmier. Bing Crosby, an avid golfer, was a regular summer visitor and later built a summer home at the lake. *(A.T. Lacey photo courtesy Museum of North Idaho, Peo-2-32)*

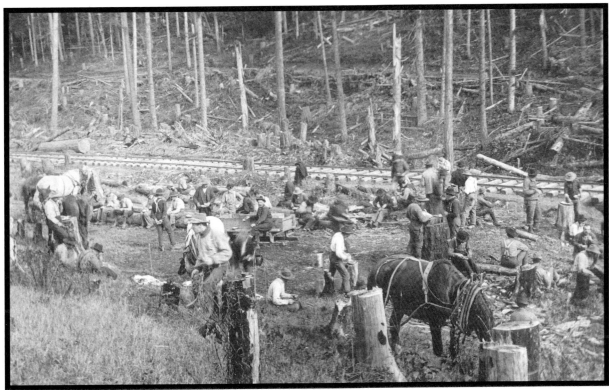

B.R. Lewis Lumber Company logging operation on a lunch break, circa 1908.
(Photo courtesy Spokane Public Library.)

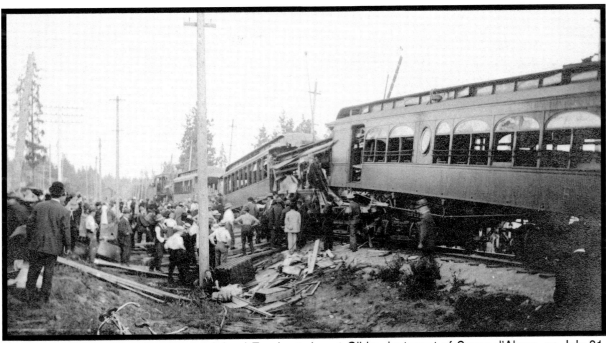

Head-on collision of two Spokane & Inland Empire trains at Gibbs, just west of Coeur d'Alene, on July 31, 1909. The trains were crowded as people rushed to register for land openings on the Coeur d'Alene Indian Reservation. This was the Inland Northwest's most tragic railroad accident, resulting in 17 deaths and over 200 passengers injured. The accident and related damage claims sent the S.& I.E., already facing financial difficulties, into a downward spiral from which it never recovered. *(Photo courtesy Museum of North Idaho, Irr-2-7)*

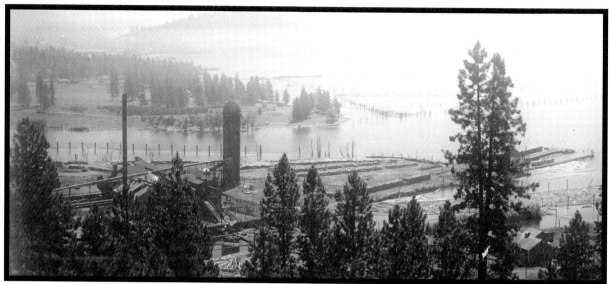

Looking southeast at the Blackwell Lumber Company sawmill and the Spokane River as it exits Lake Coeur d'Alene. Fort Sherman was located across the river (now the North Idaho College campus). The first sawmill on this site was built in 1903 by brothers Donald and J.J. Kennedy. The following year B.R. Lewis bought them out and began expanding the operation. In January of 1909, Frederick A. Blackwell incorporated the Blackwell Lumber Company, acquired the sawmill and operated it until its closure on May 4, 1937. By 1908 six large lumber companies were operating in or near Coeur d'Alene. Tubbs Hill, named for early homesteader Tony Tubbs, is in the distance. With the influx of people during the gold rush, Tubbs divided his homestead into town lots and built the Hotel d'Landing near the steamboat landing. *(Magee photo courtesy Spokane Public Library.)*

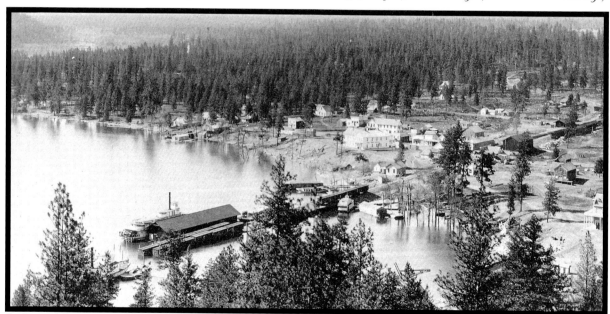

A view of Coeur d'Alene from Tubbs Hill, circa 1889. The Northern Pacific Railroad dock (foreground) was built in 1886. C.F. Yeaton and Tony Tubbs were the first owners of the town site. In 1883 James Monaghan and C.B. King purchased Keaton's land and platted it as an addition to Tubbs' fledgling town. They also built the second steamboat on the lake, the *General Sherman,* and entered into stiff competition for the mining traffic business with the *Coeur d'Alene,* built about the same time. In 1886 D.C. Corbin purchased both boats and built the *Kootenai,* which transported the bulk of the freight for the mines. *(Photo courtesy Spokane Public Library.)*

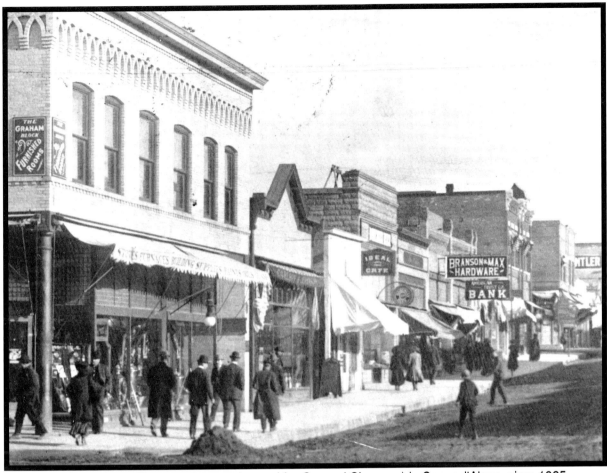

Looking east on Sherman Avenue (named for General Sherman) in Coeur d'Alene, circa 1925.
(EWSHS, M.B. Martin photo, L83-249.6)

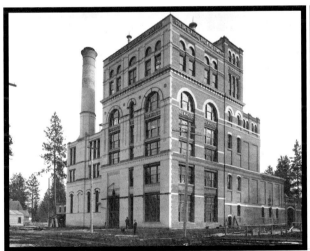

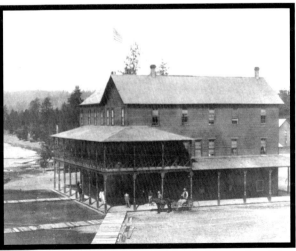

Left: The Coeur d'Alene Brewing Company brewhouse was built between 1908 and 1910. About six million bricks were used in its construction and the walls were seven bricks thick. *(Photo EWSHS, L84-54)* **Right:** The Coeur d'Alene Inn at 210-214 Sherman Avenue, circa 1887. Originally built as a two-story hotel near Fort Sherman, it was moved to the shore of the town site in 1884 and named the Lakeside. It was subsequently enlarged and improved. *(EWSHS, F.U. Yeager photo, L86-1094)*

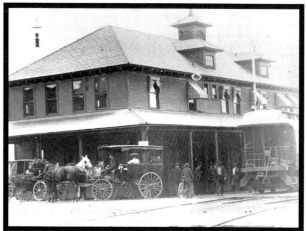 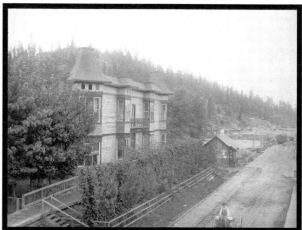

Left: The S.& I.E. Station in Coeur d'Alene, circa 1910. The electric S.& I.E. was a very busy line, which connected Coeur d'Alene and Spokane with many of the popular lakes and resorts. *(Photo EWSHS, L86-48.29)*
Right: Sorenson House at South Third and Front. This hotel, built about 1890 next to the Northern Pacific tracks leading to the steamboat docks, burned down in 1904. *(Photo courtesy Museum of North Idaho, Cda-11-9)*

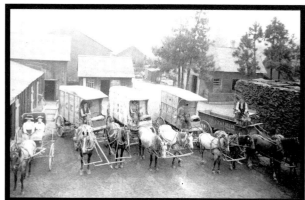 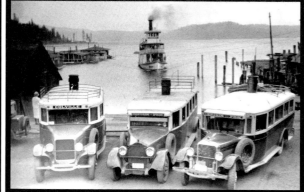

Left: Fernan Ice and Fuel in Coeur d'Alene, 1909. *(Photo EWSHS, L86-95).* **Right:** The steamboat docks at the city of Coeur d'Alene became a hub of activity from the town's inception. These busses awaiting the arrival of the steamboat were headed to Colville and Spokane. *(Photo EWSHS, L94-9-97)*

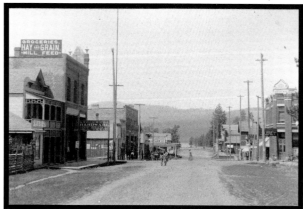 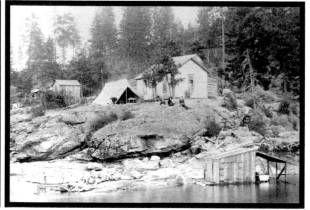

Left: Looking west on Sherman between Fourth and Fifth, circa 1890. The Merriam Building is on the right; a grocery, hay and feed store is on the left. This photo was taken about the time services were being installed including the electrical and water works system built by James Monaghan, C.B. King and D.C. Corbin. *(Photo courtesy Museum of North Idaho, Cda-8-5)* **Right:** Lake cabins on Lake Coeur d'Alene. *(Photo EWSHS, L84-432.18.1)*

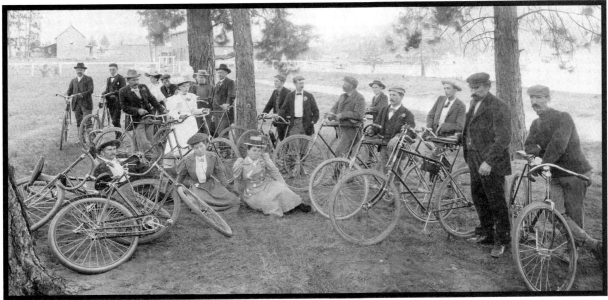

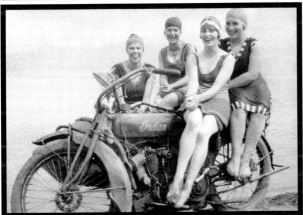

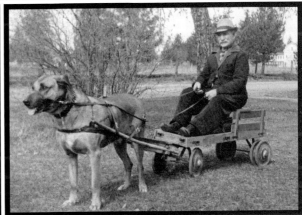

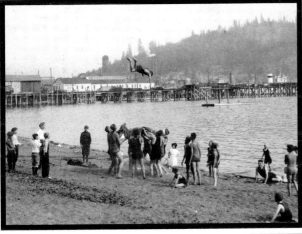

Top: Coeur d'Alene Bicycle Club near West Lakeshore Drive and Hubbard (by Fort Sherman) in 1895. **Left:** Ora Swan, Ela Horn, Lora Stinhart and Laisse Meyers on a 1917 Indian Power Plus motorcycle on the Coeur d'Alene beach, circa 1920. **Right:** Frank Sanders and his dog King, circa 1946. He was very popular with the neighborhood kids as he often let King pull them in the wagon. **Bottom:** A blanket toss on the beach at Coeur d'Alene, circa 1920. The Coeur d'Alene Lumber Company at the base of Tubbs Hill is in the background. *(All photos courtesy Museum of North Idaho. In order described: Rec-9-2, Ird-10-1, Rec-8-4, Rec-6-16)*

Kootenai County, especially the city of Coeur d'Alene, is a tourist haven and popular convention location with its numerous resorts and beautiful lakes. The Coeur d'Alene Resort claims the longest floating boardwalk and the first and only floating golf green in the world. Scenic cruises are available on the lake, Silverwood Theme Park is located just 15 miles north of Coeur d'Alene, and the Post Falls Factory Outlet Stores are just minutes west of Coeur d'Alene. There is truly something for everybody.

Selected Bibliography:

Bamonte, Tony & Suzanne, *History of Pend Oreille County*. Spokane, WA: Tornado Creek Publications, 1996.

Bohm, Fred C and Holstine, Craig E., *The People's History of Stevens County*. Colville, WA: 1983.

Bond, Rowland, *Earlybirds in the Northwest*. Nine Mile Falls, WA: Spokane House Enterprises, 1971.

Bonner County History Book Committee, *Beautiful Bonner: The History of Bonner County, Idaho*. Dallas, Texas: Curtis Media Corporation, 1991.

Boundary County Historical Society, *History of Boundary County, Idaho*. Portland, OR: Taylor Publishing Company, 1987.

Boutwell, Florence, *The Spokane Valley*, Volumes 1-3. Spokane, WA: The Arthur H. Clark Co., 1994 - 1996.

Brainard, Wendell and Chapman, Ray, *Golden History Tales*, Wallace, Idaho: Crow's Printing, Inc., 1995.

Brosnan, C.J., *History of the State of Idaho*. New York: Charles Scribner's Sons, 1918.

Brown, William Compton , *The Indian Side of the Story*. Spokane, WA: C.W. Hill Printing Co., 1961.

Chance, David H., *People of the Falls*. Colville, WA: Don's Printery, 1986.

Collier Publisher, *Chambers Encyclopedia*. New York: Collier Publisher, 1895.

Dahlgren, Dorothy and Kincaid, Simone Carbonneau, *In all the West No Place Like This*. Coeur d'Alene, Idaho: Museum of North Idaho, 1991.

DeSmet, Pierre-Jean, S.J., *Father DeSmet's Life and Travels Among the North American Indians*, Volumes I-IV. New York: Francis P. Harper, 1905.

Drury, Clifford M., *The Diary of Elkanah Walker*. Glendale, Calif.: The Arthur H. Clark Company, 1976.

Durham, Nelson W., *Spokane and the Inland Empire*, Volume I-III and Deluxe Editions I & II. Spokane-Chicago-Philadelphia: The S.J. Clarke Publishing Company, 1912

Edwards, Jonathan, *History of Spokane County, State of Washington*, W.H. Lever, 1900

Fahey, John, *Inland Empire, D.C. Corbin and Spokane*. Seattle, Wa: University of Washington Press, 1965.

- - -, *Shaping Spokane, Jay P. Graves and His Times*. Seattle and London: University of Washington Press, 1994.

Federal Writers' Project of the Works Progress Administration, Compiled by, *The Idaho Encyclopedia*. Caldwell, Idaho: The Caxton Printers, Ltd., 1938.

Ficken, Robert E. and LeWarne, Charles P., *Washington: A Centennial History*. Seattle and London: University of Washington Press, 1988.

Fuller, George W., *A History of the Pacific Northwest*. New York: Alfred A. Knopf, 1960.

- - -, *The Inland Empire*, Volume 1-III, Spokane-Denver: H.G. Linderman, 1928.

Gates, Charles Marvin, *Readings in Pacific Northwest History*, Seattle, WA: University Bookstore, 1941.

Glover, James N., *Reminiscences of James N. Glover*. Fairfield, WA: Ye Galleon Press, 1985.

Graham, Patrick J., *Colville Collection*. Colville, WA: Statesman-Examiner, Inc., 1989.

Greenwood Park Grange, *Pioneers of the Columbia*. Hunters, WA: Greenwood Park Grange #590, 1998.

Hart, Patricia and Nelson, Ivar, *Mining Town*. Seattle and London: University of Washington Press, and Boise, Id.: Idaho State Historical Society, 1984.

History of North Idaho. Western Historical Publishing Co.,1903.

History of North Washington. Spokane, WA: Western Historical Publishing Co., 1904.

History of the Big Bend Country. Spokane, WA: Western Historical Publishing Co., 1904.

Hult, Ruby El, *Steamboats in the Timber*. Portland, Oregon: Binfords & Mort, 1952.

Hyslop, Robert B., *Spokane Building Blocks*. Spokane, WA: privately published, Standard Blue Print Co., Inc., 1983.

Josephy, Alvin M. Jr., *The World Almanac of the American West*. New York: Newspaper Enterprise Association, Inc., 1986.

Klockmann, A.K., *The Klockmann Diary*. Sandpoint, Idaho: Keokee Co., 1940.

Kowrach, Edward J. and Connolly, Thomas E., *Saga of the Coeur d'Alene Indians*. Fairfield, WA: Ye Galleon Press, 1990.

Lakin, Ruth, *Kettle River Country*. Colville, WA: Statesman-Examiner, Inc., 1976.

Lewty, Peter J., *Across the Columbia Plain: Railroad Expansion in the Interior Northwest*. Pullman, WA: WSU Press, 1885-1893.

McGoldrick, James P. II, *The Spokane Aviation Story*. Fairfield, WA: Ye Galleon Press, 1982.

McLean, Robert Craik, *The Western Architect, Volume 12*. Minneapolis, Minn.: American Institute of Architects, September, 1908.

Montgomery, James, *Liberated Woman: A Life of May Arkwright Hutton*. Fairfield, WA: Ye Galleon Press, 1974.

National Park Service, *Lewis and Clark*. Washington D.C.: U. S. Department of the Interior National Park Service, 1975.

Ogle, George A. & Co., *Standard Atlas of Spokane County*, Chicago, Ill.: George A. Ogle & Co., 1912.

Overland, Virginia Judge, *Morton Valley Memories*. Sandpoint, Idaho: Pend Oreille Printers, 1996.

Pash, Joseph J. (Reverend), *Immaculate Conception Church, One Hundred Years*. Colville, WA,: The Statesman Examiner, 1962.

Peltier, Jerome, *Northwest History: Articles from the Pacific Northwest Quarterly*. Fairfield, WA: Ye Galleon Press, 1996.

Raufer, Maria Ilma (Sister), *Black Robes and Indians on the Last Frontier*. Milwaukee: The Bruce Publishing Co., 1966.

Ruby, Robert H. and Brown, John A., *The Spokane Indians, Children of the Sun*. Oklahoma: University of Oklahoma Press, 1970.

Schoenberg, Wilfred P., *Gonzaga University: Seventy-five Years, 1887-1962*. Spokane, WA: Lawton Printing Co., 1963

Schrapps, Marcia O'Neill, SNJM and Compau, Nancy Gale, *Our City . . . Spokane*. Spokane, WA: Lawton Printing Company, 1996.

Silver Valley Economic Development Corp., *Gold Strikes and Silver Linings*. Wallace, Idaho: Silver Valley EDC, 1995.

Smith, Peter, *Photography and the American Scene, 1839-1889*. New York: Dover Publications, Inc., 1964

Stewart, Edgar I., Ph.D, *Washington Northwest Frontier*, Volumes I-IV. New York: Lewis Historical Publishing Company, Inc., 1957.

Strong, Clarence C. and Webb, Clyde S., *White Pine: King of Many Waters*, Missoula, Mont.: Mountain Press Publishing Co., 1970

Thomas, Bob, *The One and Only Bing*. New York: Grosset & Dunlap, 1977.

Turner, Lana, *The Lady, the Legend, the Truth*. New York: Dutton, 1982.

Ward, Geoffrey C., *The West: An Illustrated History*. New York: Little Brown and Company, 1996.

Warren, W.T. Hon., *Lincoln County, Washington*. The Coast Magazine, Volume XV, Number 2, February 1908.